The Charged Image

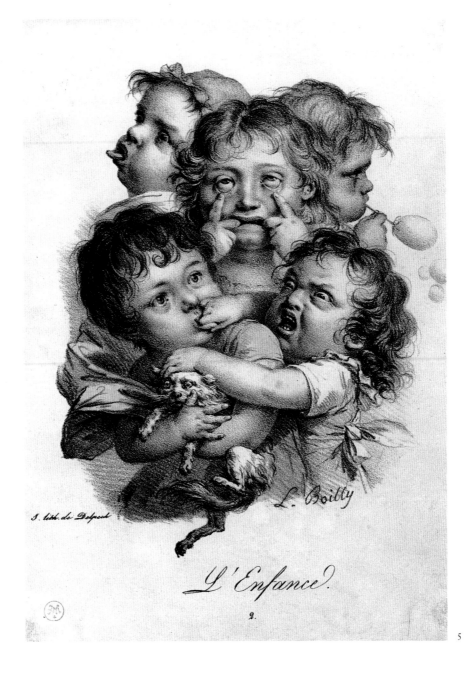

S. lith. de Delpech

L. Boilly

L'Enfance.

2.

5

The Charged Image

French Lithographic Caricature
1816-1848

by
Beatrice Farwell

SANTA BARBARA MUSEUM OF ART
1989

The Charged Image
French Lithographic Caricature
1816 - 1848

This publication and the exhibition which accompanies it
are funded in part by the National Endowment for the
Arts, a federal agency, and a generous contribution from
Etablissements Casino and Smart & Final Stores. The
exhibition is an officially recognized project of the
American Committee on the French Revolution.

Designed by Shelley Ruston and John Balint
Edited by Cathy Pollock and Robert Henning, Jr.

Photographs by Wayne McCall
Galliard display and Janson text set by Balint/Reinecke
Printed in Hong Kong by Everbest Printing Company
through Asiaprint, Ltd. U.S.A. in an edition of 2,500.

Published by the
Santa Barbara Museum of Art
1130 State Street
Santa Barbara, California 93101-2746

Cover (detail) and Frontispiece:
Louis-Leopold Boilly, *L'Enfance* (no. 5) (see page 41)

Curators of the Exhibition:
Beatrice Farwell and Robert Henning, Jr.

Library of Congress Cataloging-in-Publication Data

Farwell, Beatrice.
The charged image.
Bibliography: p.
1. Caricatures and cartoons—France—History—19th century—
Exhibitions. 2. France—Social life and customs—19th century—
Caricatures and cartoons—Exhibitions. 3. French wit and
humor, Pictorial—Exhibitions. 4. Cartoonists—France—
Biography. I. Kadison, Stuart. II. Henning, Robert.
III. Santa Barbara Museum of Art. IV. Title.
NC1495.F37 1989 741.5'944'074749491 89-10427
ISBN 0-89951-075-2

CONTENTS

INTRODUCTION

by Robert Henning, Jr.

This exhibition deals both with the fascinating history of caricature as an art form and with an important stage in the evolution of lithographic printmaking as a valid artistic medium. It is also the initial overview exhibition of the Santa Barbara Museum of Art's important representative collection covering the early decades of French popular lithography, a collection that is comprehensive in its coverage of the first two decades of the lithographic era (1820-1840) and remarkably strong in rare early examples from these pioneering years. The exhibition surveys the work of thirteen artists from the period of 1816-1848 including not only the familiar names of Daumier and Gavarni but also lesser-known masters of the caricature genre, some of whom had a formative influence on the great genius, Daumier. These are artists who worked consistently in the new printing medium of lithography and in response to the emerging phenomenon of a popular press that communicated timely ideas through pictures as well as words. They lived in a period of constant political and social change, experimentation and invention, artistic evolution and revolution.

Their telling caricatures first illustrated important political developments and reflected a broad segment of public opinion. More importantly, they led and shaped anti-government opinion. With the appearance of the first numbers of *La Caricature* in 1830, a new era of caricature as a powerful weapon began, with a handful of artists and a bold publisher arrayed against a king and his government. This would have been a completely uneven contest were it not for the resources of penetrating wit and the imaginative powers of the artists—exemplified in Philipon's alliance of *la presse et l'image*.

Despite the pressure of producing for weekly or daily papers, these artists quickly caught up with and surpassed the accomplishments of the earlier English school of political caricature. Their images (and it's difficult to imagine their full effect on audiences of the time) range from the cogent and simplistic to those with covert, ingenious, complex layers of meaning. The transformation of a corpulent king into a pear or the mock pompous processions and *cortèges* invented by Grandville are unsurpassed in their effect because ridicule compellingly expressed creates an indelible impression, destroying any chance of dignity or credibility to its victim. How could anyone respect a king who looked like a pear? Today, if some of these images seem vulgar or excessive in expression, we should remember the degree of corruption and arrogance of the institutions being attacked.

When censorship placed political subjects out of bounds, there was still the whole world of *la comedie humaine* available to the caricaturists and their publishers. The resulting images display the same qualities of keen observation and skillful depiction; although quotidian and clearly aimed at their contemporary audience, they remain appealing and interesting today.

The skillful artistry in these prints far exceeds the basic requirement of caricature to communicate a simple idea in a direct manner. In strength of design, imaginative force, variety, nuance of expression, powerful character delineation, details of setting and atmosphere, and other appealing qualities, these lithographs play a very important role in the history of the graphic arts. Yet many studies of early lithography overlook these pioneering works while emphasizing the well-known lithographs of Géricault, Delacroix, and Goya. Our exhibition clearly demonstrates the contribution—the range of styles and innovative effects—made by artists working for the popular press. Thus, we hope to create here a more balanced view of the history of early lithography. Clearly these are artists who met the challenge of a new medium in imaginative ways while giving a vital impetus to nineteenth-century French art. Their prints bridge the gap between the history of art and social or cultural history. Consequently, they enhance our understanding of a historical period and of artistic innovation. While observing, recording, commenting, and criticizing, these artists in our exhibition were also participating in a larger process—their assertion of the basic right to freedom of expression. This exhibition, therefore, is highly appropriate to a year in which we celebrate the anniversary of the French Revolution and the Declaration of the Rights of Man and of the Citizen.

Some of these images—charged with meaning in their own time—now need an intermediary to be understood fully. Because they are timely and topical, some of their details require explanation. While we readily appreciate the skillful draftsmanship that qualifies them as true works of art, our appreciation is further enhanced if we can penetrate their meaning. Like the translation of their captions from French to

English, the interpretation of their subject matter often hinges on an idiom of manners or other topical details not familiar to the modern audience. The two essays that follow and the individual catalogue entries provide vital information for this purpose. The essayists Beatrice Farwell, eminent art historian and specialist in this field, and Stuart Kadison, a lawyer and collector, present two viewpoints on this complex subject. Both writers find in these prints and their creators a rich field for study and speculation which cannot be explored fully within the limits of a single exhibition and publication. Their contributions, however, bring us closer to understanding this complex and fascinating subject.

Acknowledgements

The collection of prints that forms the basis for this exhibition numbers over four thousand, the generous gifts of Albert and Dana Broccoli, Mr. and Mrs. Michael Wilson, and Mr. and Mrs. Stuart Kadison. Special credit for these donations must go to Dennis Rader who first suggested to the Broccolis and the Wilsons that this Museum would be an appropriate home for their extensive collection, and to Beatrice Farwell whose residence in Santa Barbara convinced all the donors that their collections would be studied and appreciated once under our care. Grants from the Institute of Museum Service and the National Endowment for the Arts have made possible extensive conservation and the initial cataloguing of the prints.

Beatrice Farwell's specialized knowledge of the subject and her involvement from the beginning have been crucial to the success of this project. Preparations for this exhibition began in Professor Farwell's winter quarter 1986 seminar at the University of California, Santa Barbara. Research from that seminar by students Geoffrey Barraclough, Patricia Halloran, Ann Lenard, Karen Oakley, Robin Ptacek, and Nadine Stern is incorporated in various parts of this catalogue; initials identify the work of individual students on artists' biographies and the entries. In addition, Geoffrey Barraclough, Robin Ptacek, Holly Wilson, and Brian Parshall worked independently on research for the catalogue. Delphine Chauvineau, a special intern, helped with the task of translation from the French, as did Ernest Sturm. Lesley Hovey was indispensable in looking after the many organizational details involved in this four-year project. Katie Dabney somehow managed to meld all these efforts into typed form.

Many members of the Museum staff were involved in exhibition-related activities and particular thanks go to Barry Heisler for overseeing all details of the lengthy conservation project. I am also grateful to Shelley Ruston for designing and coordinating the production of this catalogue, to Cathy Pollock for editing the manuscript, and to Wayne McCall for his excellent photographs. Finally, I would like to thank all those members of the Museum's support staff who looked after the myriad details of publication and exhibition preparation from the beginning of this project to its successful conclusion.

It has been my very satisfying responsibility to serve as midwife and referee to our project—from the first invitation to view the prints while still in the donors' possession, through the process of acquisition to this inaugural exhibition. This group of lithographs has given depth and focus to our collection of French art while establishing a reputation for our holdings among scholars and collectors. Inevitably it has led to further gifts and a long-range plan for continuing acquisitions to enhance our holdings. Without doubt the collection of nineteenth-century French lithographs will be a source for future exhibitions and will continue to influence the direction of our future acquisitions. Thus, they have proved to be very important gifts indeed.

THE CHARGED IMAGE

by Beatrice Farwell

Beatrice Farwell has a long established reputation as a scholar of the art and popular lithographic imagery of nineteenth-century France. She has published extensively in this field, including the primary reference catalogue used throughout this exhibition. In 1977 she assembled a pioneering exhibition, The Cult of Images: Baudelaire and the 19th Century Media Explosion, *probably the most comprehensive exhibition catalogue and publication in English on the artists and repertory of subjects involved in this early period.*

All man-made images are charged with meaning. But a special portion of them, those meant to be funny or to comment satirically on contemporary manners and politics are called caricature, after the Italian *caricato*: loaded, charged, given weight, and *caricatura*: loading or charging. Our daily cartoons and comic strips deserve the name of caricature, displaying as they do the distortions and exaggerations that characteristically puncture pretension or single out vulnerable features in a target that may be as specific as an individual or as broad as a political movement or an entire world view.

These trivia, these ephemera, providing us with a daily dose of chuckles, are soon forgotten. But in the aggregate they constitute a serious business carried on by talented artists and astute entrepreneurs and involving considerable amounts of money. This commercial activity has been going on for some two hundred years or more, and its products have begun to seem valuable to us culturally. Scholars of art have been conducting serious research on the humorous and the topical in images left to us from past times. The images themselves have appreciated in market value as well. A brisk trade has long since developed in comic books of the 1930s, for example, which now command higher prices than some Daumier lithographs of the 1830s.

Does caricature belong in an art museum? Where does one draw the line between engravings by Hogarth and mass-produced, line-cut, color-printed strips by Charles Schulz? Conferences on the artistic and social implications of the comic strip are held annually in Lucca, where European specialists gather to exchange information on historic American cartoons and their creators. A recent scholarly exhibition gathered together nearly two hundred caricatures and other prints made during the French Revolution, celebrating its two hundredth anniversary.[1] Books and exhibitions have been produced since the nineteenth century on the folkloric French woodcut *images*, the anonymous art of the people, and on the history of woodcut as a propaganda medium heavily-exploited in Europe since the fifteenth century.[2] A charitable foundation now devotes its resources entirely to the funding of research and exhibitions on caricature of all kinds.[3] Despite this range of scholarly activity, have the *artists* who made these images ever been given their due?

This exhibition is designed to feature the subjects, the styles, and the salient characteristics of individual caricaturists of a particular time and place: the Restoration and the July Monarchy in France, 1815-1848. It is also limited to images made in the medium of lithography. A complex web of circumstances makes such a selection both possible and meaningful. The strands of this variegated tapestry include the very invention of lithography, the development of urban culture that included a new bourgeois and popular mass market, the vicissitudes of press freedom and press censorship and the violently shifting political climates that governed them, the romantic movement in art and literature that placed new value on individual expression, and, by no means least, the interest of collectors in gathering and preserving this lithographic art for love of its form as well as its content.

Printed Pictures

William Ivins, one of the great curmudgeons of the twentieth century, made it clear in his cantankerous book *Prints and Visual Communication* that prints, from the beginning, have always been commodities and only incidentally and occasionally works of art. Speaking of the earliest European woodcuts, he says,

> Well before the end of the [fifteenth] century the cloven hoof of manufacture showed itself in these prints, for there are some that have changeable heads and attributes printed from little blocks dropped into slots left for the purpose in bigger blocks. Thus different saints would have identical bodies, clothes, backgrounds, and accessories, all printed from one identical block. The people for whom these prints were made obviously looked to them not for information but for the awakening of pious emotions.[4]

We might add that another thing people did not particularly look to them for was aesthetic pleasure. In

the history of printmaking there have of course been many virtuoso technicians like Claude Mellan in the seventeenth century and Henriquel-Dupont in the nineteenth, but only an occasional Durer, Rembrandt, or Goya.

Moreover, says Ivins, prints have been made by and large for a market different from that for high art, and woodcut was the first and the most "popular" of printed images—an early mass medium:

> The engraved plate wore out much faster than the wood-block and was more expensive to make and to print. While the functions of the two were the same, the engraving was, in comparison with the woodcut, an article of luxury. It is to be doubted that either woodcuts or engravings became objects of interest to the great and the wealthy until towards the end of the fifteenth century. Such intellectual interests as they represented were thus distinctly of bourgeois kinds. It may be said that this has in general been true through most of the history of prints.[5]

More basic still are Ivins' thoughts on the nature of pictorial images altogether. Why do people need pictures? How do visual images function in our private, social, and professional lives? He dwells mainly on the difference between visual images and verbal descriptions in developing his argument about the utility to science, technology, and knowledge in general of the "exactly repeatable visual statement" (his definition of the print).[6] For Ivins, the operative word with respect to prints is *repeatable*. It is this that makes prints the stuff of popular art, and that led to their mass production when a mass market emerged in the early nineteenth century along with new mass media to serve it.

It has been noted that a connoisseur can know all of the prints made in Europe before 1800. Adam Bartsch, the great cataloguer, was such a mine of knowledge. What this claim really indicates, however, is that the total number of prints made in all previous centuries is a mere fraction of the number made in the nineteenth century alone. No individual can know them all, and moreover new categories of prints have entered the scene (photography and photoengraving, for example) that raise questions about what should be called a print, and what should be collected and preserved by museums. Add film and television to the list, and the sheer volume of images becomes astronomical. The sharp rise in print production in the early nineteenth century was the starting point for what has become a massive industry with worldwide distribution in our time. It is a prime example of the commodity culture created by capitalism, which leaves far behind the traditional production of unique aesthetic objects—"works of art," for a luxury market. Although the major technical innovations in image-making were invented elsewhere, by virtue of unknown factors in national character they were most rapidly developed and most heavily exploited in France. The French liked pictures and were eager to buy them.

The flood of cheap pictures that inundated Europe and America in the nineteenth century was the result, at least until mid-century, of the invention of lithography in Germany in 1797, and of wood engraving in England at about the same time.[7]

The advantage these media had over all previous methods for printing pictures was that the surface from which image was transferred to paper was now capable of yielding editions of thousands instead of mere hundreds without breaking down. This was virtually the only advantage of wood engraving (cutting the image in relief on end-grain rather than side-grain wood, with engravers' tools), since it was otherwise slow and difficult to produce, and the final result was much reduced in aesthetic quality compared with the drawing from which it was made. Lithographs printed from a flat surface of quarried limestone, on which the image and its transfer depend on the antipathy between oil and water, are relatively easy to draw, and the final result is an image virtually identical with the initial drawing on the stone. The quality depends absolutely on who does the drawing. These rival media underwent different development because of these and one other technical difference: they were printed in different kinds of presses. The blocks of wood engraving could be formed up together with relief type and printed in one operation on the same press. Hence their inevitable association with illustrated books, papers, and magazines, which multiplied exponentially from the 1830s onward. Lithography, incompatible with letterpress, gave rise instead to the single sheet and album production that, with one historic exception, created a world of pictures apart from texts, a world of pure images.

The historic exception was of course the conjunction of lithographs with newspapers under the entrepreneurship of Charles Philipon at the beginning of the July Monarchy, with the collaboration of his great stable of writers and artists headed by Balzac and Daumier. Philipon, originally trained as a lithographer, came to exploit his talent for journalism and his passionate political views by founding two opposition newspapers, the weekly *La Caricature* (1830-1835), and the daily *Le Charivari* (1832-1893) which long outlived its founder. They were among the world's first illustrated papers, and they were illustrated with lithographs. Philipon found two different solutions to

the incompatibility of lithography with letterpress: the two pictures per issue in *La Caricature* were printed separately and inserted; for *Le Charivari* he combined letterpress and lithograph in two press runs.[8] A great many of the prints in the exhibition originally appeared in these two papers, and among the artists represented, Daumier, Gavarni, Grandville, Monnier, Raffet, and Traviès were regulars on the team that Philipon gathered together for his historic enterprise. Needless to say, it was this conjunction of pictures and journalism that gave lithography its association with the political opposition in the nineteenth century, a reputation that became difficult to live down. Philipon's enterprise has recently received extensive treatment by art historians and other scholars, and the reader is referred to these for greater detail on its history.[9]

The increasing success of these ventures made the intellectual world aware of lithography, and brought the superior talent of Daumier before an audience capable of appreciating it in terms of art as well as entertainment or utility, with the result that Daumier is the only early lithographer whose name is universally known among the visually literate.

The relation of the rival media, lithography and wood engraving, to high art in their day is a chapter in itself. Wood engraving did not conform in any way to the purposes of art of the high culture except as it came to be used to illustrate classics of fiction and other literary genres, and to reproduce paintings. The famous Dubochet edition of Lesage's *Gil Blas* (1835) carried six hundred illustrations and vignettes, all originally drawn by the Salon painter Jean Gigoux, and cut on woodblocks by a team of engravers, some English and some French. England produced the first generation of skilled wood engravers, some of whom were enticed to France where they trained French engravers in the trade, forming workshops for specific publishing ventures. Thus names like Best and Leloir will be found together with some frequency in the *Gil Blas* illustrations, but it is Gigoux who gets the star billing on the title page, not the artisans who cut the blocks. No wood engraver ever became a famous artist. Indeed for the team to work properly in producing the blocks for one published work, the engravers needed to suppress any tendency toward individuality so that the pictures would not differ greatly from one another in style. Later, when very large wood engravings were called for in *L'Illustration* or the *Illustrated London News*, a team of engravers might work on a single image, each of them cutting blocks to be assembled for printing and cleaned up by a master craftsman who would adjust the joins between blocks with judicious cutting. This was done not only because of the large size, but also in order to produce the image faster for use in a journal that purported to present recent news.

Lithography on the other hand was a protean medium. Individual artists taking it up could make prints stamped with their personal styles which became saleable on that very account. Early in its history, lithography was practiced by Goya, Géricault, and Delacroix, with results that introduced lithography into the annals of high art. This medium had already merited a place in the Salon, where it remained, alongside engraving and etching, throughout the century.[10] Little such acknowledgement was made of wood engraving, which was a trade of craftsmen, not a profession of creative artists.

In presenting a new picture every day in *Le Charivari*, something virtually impossible to do with wood engraving, Philipon exploited lithography's ease of production. As for costs, it was a trade-off between the two media. Wood engraving cost more in manpower and time; lithography cost more in the required second press run.

Anyone familiar with the amount of time it takes to print a lithograph from stone might wonder how a newspaper with a circulation between one and two thousand could manage to print that many pictures overnight. Lithographers early learned that an image in greasy ink on one stone can be readily transferred by an offset roller to another stone, so that separate stones bearing the same image could be printed from simultaneously, on as many presses as the enterprise could commandeer. This meant teams of printers working day and night, while the teams of wood engravers were doing the same thing in another workshop for their weekly deadlines. Philipon's papers were virtually the only ones to be illustrated with lithographs, except for some later, unsuccessful imitations, including those published by the photographer Carjat in the 1850s and 1860s.[11]

Thus it was Philipon's persistence in joining two incompatible media—lithography and letterpress—that accounted for the production of a large corpus of lithographic imagery on themes of politics and social satire, which is well represented in this exhibition. Lithography's true mission, however, from the beginning to the 1860s, was the production of images for the single-sheet market, not for two small-circulation republican-sympathizing newspapers. The entrepreneurs who published these pictures, meant for framing or for viewing in albums, actually distributed more prints than did Philipon, and to a far more heterogeneous audience than the relatively restricted world of bohemians and bourgeois intellectuals who read Philipon's papers. The publishers for the single-sheet market sold through dealers scattered throughout the city and the provinces, and the larger houses soon established outlets in London, Berlin, New York,

Madrid, and St. Petersburg. They also commanded large markets in Latin America as is attested to by the many lithographs, particularly religious images, that bore bilingual captions in French and Spanish. These markets, at least within France, were established in the 1820s or even earlier (the first viable lithographic publishing houses were founded in 1816), and it was for them that the many prints in the exhibition dating before 1830 were made. Nevertheless, since the lithographs made for Philipon's papers are the best known and perhaps the most interesting both intellectually and artistically, the newspaper phenomenon will be taken up before the more general production, even though these fields overlap in the work of some of the individual artists involved.

La Caricature and *Le Charivari* carried lithographic pictures largely political in content until the September Laws of 1835.[12] *La Caricature* then closed its doors, and *Le Charivari* turned to a rich vein of social satire that figuratively thumbed its nose at the regime while staying just within the permissible in order to survive. Philipon frequently paid fines for political infractions during the *Caricature* years. In order to pay these fines, he devised *L'Association mensuelle*, an exclusive print production for subscribers, consisting of big pictures on good paper designed by his best artists.[13] Several of Daumier's most famous sheets were made for this series—*Rue Transnonain* (no. 29) and *Liberty of the Press*, for example—and two by Traviès are included in the exhibition as well (nos. 166 and 167). Daumier's earliest lithographs were made for the single print market, but he began to publish in *La Caricature* in 1832. As a result of his extremely contentious early work, he found himself serving a jail sentence along with Philipon in the Sainte-Pélagie prison for political offenders that year. It was there that the two of them created *Le Charivari*, which began publishing in December 1832. Philipon had already enhanced the careers of Monnier, Grandville, Traviès, and to some extent Raffet, as well as a few lesser figures in *La Caricature*. It remained for *Le Charivari* to exploit the talents of Gavarni, who never drew political cartoons and would have been out of place in *La Caricature*, whereas his social satire was a perfect foil for that of Daumier in the long life of *Le Charivari* after 1835.

Philipon and his stable carried on a valiant war against the regime of Louis-Philippe and against the dominant bourgeois culture and bourgeois economics for which the king was the symbol. It was Philipon who first caricatured Louis-Philippe as a pear, defending himself in court on the grounds that it was not his fault if the king resembled that fruit (as he demonstrated with drawings). He lost the legal argument and

was convicted of the offense, but the pear, used universally to stand for the king after his likeness in caricatures was forbidden, came into such wide currency that Flaubert claimed to have found one carved into the stone at the top of the pyramid of Khafre while touring Egypt with Maxime DuCamp.[14] Probably for the most part the cartoons were preaching to the already converted, but they honed the genre for generations to come and kept their constituency informed with biting analyses of topical political news.

The "illustrated press," an accurate term for describing *L'Illustration* or the *Illustrated London News*, is a misnomer when applied to Philipon's papers. The picture did not illustrate editorial copy, but rather paralleled it or complemented it: a piece by Balzac, a piece by Daumier. The cartoons have always been justifiably considered on their own merits. Differences in market economics mentioned above notwithstanding, it is this fact that puts Philipon's pictures ultimately in the same class as the single-sheet lithographs, the entire class differing vastly from the truly illustrative role played by wood engraving.

Philipon's Lithographers

A few attempts were made to establish journals with lithographs before the brilliant success of *La Caricature* in 1830. Chief among these was the short-lived *La Silhouette* (1830), to which Daumier contributed a few images, as did Achille Devéria. But it was Philipon who had the true talent scout's nose. Before he adopted Daumier he had already taken on Monnier, Grandville, and Traviès, all of whom were well known before 1830. Gavarni was added to his team in the mid-1830s. Each of these artists had unique qualities, but the greatest of them was unquestionably Daumier.

The fame of Honoré Daumier (1808-1879) is discouraging to the chronicler who would write on the rest of Philipon's graphic collaborators. His career and his work are documented and dissected in countless studies, and his entire prodigious oeuvre as a printmaker has been recorded and illustrated by Loÿs Delteil.[15] He is the only one of the commercial lithographers to have merited the attention of that great cataloguer of fine prints of the nineteenth century. At a time when few critics deigned to consider caricature seriously, both Champfleury and Baudelaire sang Daumier's praises, though they disagreed in their assessments of many other graphic artists.[16]

Champfleury's praise of Daumier was chiefly for iconographic rather than formal excellences. Half his admiration was reserved for the devastating wit of Philipon's captions (Daumier did not write his own), which he quotes at length in his piece in *Histoire de la*

caricature moderne on Robert Macaire, the central focus of his entire study of Daumier. He sees Daumier as more of a caricaturist than any of Philipon's other artists, and his work as the surest guide to an understanding of the July Monarchy.[17] But he also recognizes Daumier's superiority over his colleagues in the formal realm in remarks following on his disclaimer regarding knowledge of Daumier's métier: "...his hand found [in the Macaire series] an independence that one only encounters in the sketches of the great painters. All the fire with which the master's soul was filled was able to translate itself spontaneously onto the stone without being hindered by the physical procedure."[18]

Baudelaire responded more unreservedly to the genius of Daumier's draftsmanship, while equally entranced with the wit and justice of his caricature. The poet, in his debut as an art critic, moved to a position far out on a limb in an incidental reference to Daumier while discussing Delacroix: "We know, in Paris, only two men who draw as well as M. Delacroix, one in an analogous manner, the other in a contrary method.—One is M. Daumier, the caricaturist; the other, M. Ingres, the great painter.[19] In this prophetic comparison, Baudelaire may have been the first to put Daumier in the company of the greatest high artists of his day. Although Daumier was still prolific in 1846 when Baudelaire wrote the first version of *Quelques caricaturistes françaises*,[20] his early caricatures were ancient history, looked upon as a curiosity from the vantage point of the late July Monarchy. "It is a veritably curious oeuvre to contemplate today, this vast series of historic buffooneries that was called *Caricature*."[21] The essay was not published until 1857, and was reworked in the meantime to include extensive remarks on Louis-Philippe and Daumier's merciless treatment of him, remarks which probably could not have been published before the end of the regime in 1848. Of the caricatures of government figures Daumier drew from the sculptures he had modeled, Baudelaire says, "Every poverty of spirit, every ridiculousness, every mania of the intelligence, every vice of the heart is read and clearly makes itself seen in these animalized faces...Daumier was at the same time supple as an artist and exact as Lavater."[22] He describes with relish numerous plates, recounting their captions inaccurately but appropriately. "Leaf through his work, and you will see parading before your eyes in all its gripping and fantastic reality everything that a great city contains of living monstrosities."[23] Daumier knows them all. And "all the stupidities, all the vanities, all the enthusiasms, all the despairs of the bourgeois... Daumier has lived intimately with him, he has spied on him by day and by night, he has learned the mysteries of his alcove, he has allied himself with his

wife and his children, he knows the shape of his nose and the construction of his head...."[24] The justice of this description will be recognized by everyone who knows the work. Yet, knowledgeable as he was about the bourgeois, there is a whole side of life that is never touched by Daumier, a side that became the province of the other most popular contributor to *Le Charivari*, Gavarni.

Guillaume Sulpice Chevallier, called Gavarni (1804-1866), was a well-known fashion illustrator, journalistic entrepreneur, and man-about-town before he came to be a regular on *Le Charivari* in 1837. A reveler and womanizer, his art came to be devoted largely to the battle of the sexes, a social area given a wide berth by Daumier. Asked by Philipon to create a female counterpart to Daumier's Robert Macaire (the con-man charlatan symbolizing the spirit of Louis-Philippe's reign), Gavarni devised a series built not around an individualized symbolic type, but around the subterfuges of women of all classes on the adulterous domestic front: *Fourberies de femmes* (Subterfuges of women). If Daumier's art engaged in the counter-discourse in political and economic terms,[25] Gavarni's did so in terms calculated to undermine the ideals of orderly family life and domestic social structure of the dominant discourse. In a world of official male dominance, Gavarni presents women as having the upper hand in matters of the heart. A whole subservient class is presented as consistently victorious in the domestic and the extra-domestic contests of wit, wisdom, and will between men and women, of which at least half of daily life is made up. Men are consistent losers. A deceived husband, untying his wife's corset lacings, remarks with innocent wonder the strange fact that the knots are tied differently from the way he had done them up in the morning. (*Fourberies de femmes* is unfortunately not represented in the Broccoli/Wilson collection that is the basis of this exhibition, but most of Gavarni's work is in the same vein.)

But Gavarni is by no means the biting satirist that Daumier is. According to Champfleury, Daumier makes you think; Gavarni makes you smile.[26] Gavarni's caricature is not in his drawing, but in his subject matter. It is an art of devised comic situations, attractively drawn, for which the caption (Gavarni wrote his own, unlike Daumier) is necessary and smacks of the dramatist. Baudelaire noted this difference, that Daumier's captions can be removed and the drawing still tells all, whereas Gavarni's pictures need the caption. Further, he says, "Gavarni is not essentially satirical; he often flatters rather than bites; he does not blame, he encourages. Like all men of letters, man of letters himself, he is lightly tainted with corruption... his cynical thought... caresses prejudices and makes of the world

his accomplice."[27] Despite his reservations, Baudelaire regarded Gavarni as an artist of considerable importance, recognizing that many people preferred him to Daumier (as Degas apparently did). He also recognized that "the veritable glory and the true mission of Gavarni and of Daumier were to complete Balzac, who for his part knew it well, and esteemed them as auxiliaries and as commentators."[28]

Champfleury too had reservations about Gavarni, whom he saw as the very antithesis of the rustic innocence and child-like artistry he championed in the folkloric woodcuts he collected and promoted. Gavarni's most favorable critical supporters were Théophile Gautier, a lifelong friend, and the brothers Goncourt, who wrote his first biography.[29] Gautier promoted Gavarni as an artist, the equal of the great painters, as Baudelaire had done with Daumier: "Despite his frivolous appearance, he is more serious at heart than many a history painter..."[30] The Goncourts contrasted Gavarni with Daumier, considering the former a realist and the latter a fantasist whose work they deplored. Like many others, they hesitated to call Gavarni a caricaturist since he seldom used the exaggerations and distortions of the caricaturist. He fulfilled their criteria for the ideal realist, since he dealt with contemporary realities, but realities manifested in human figures that were not ugly or disagreeable (by contrast with, for example, Courbet's realism). They gave his art the title *Comédie de moeurs au crayon* (Comedy of manners in crayon), and characterized it as *un genre nouveau* (a new genre).[31]

Gavarni curiously spent the entire period of the Second Republic in England, an experience that provided material for the illustrations (in wood engraving) for a book on London published in 1849.[32] What apparently impressed him most profoundly was his observations of the poor in the city of Dickens. The most abject of Parisian poor in both Daumier and Gavarni at least wear shoes. Gavarni never regained his former joie-de-vivre, and his art became more cynical until, in the late 1850s, he gave up lithography altogether. In his latest work for *Le Charivari* he lampooned the pretensions to political savvy of the man in the street and manifested bitter disillusion with the world in *Les Propos de Thomas Vireloque*, spoken by a disgusting tramp masquerading as a *chiffonnier-philosophe* (no. 82). In a summing-up, the repulsive Vireloque, grotesquely parodying Louis XIV for the nineteenth century, declaims "L'état, c'est moi!"

At times Gavarni commented seriously on humanitarian and political matters. He joined his colleagues in merciless ridicule of the bourgeois exploiter: a well-dressed misanthrope passes a derelict who has just panhandled him, muttering, "He says he's hungry, the lazy bum... I'm hungry too, but I take the trouble to go and dine." He took a wry view of the results of 1848 and 1851: as a young gentleman and a laborer pass in the street, the latter sneers, "So we're not brothers any more?" And most characteristic of his major preoccupation is an image that in its time needed no caption: a husband crouches over the river of the *Code civil*, and bears on his back his wife and her lover, in a posture suggesting a penance in an adolescent game.[33] The print bears the simple caption *Le Pont d'amour* (The bridge of love). Here Gavarni seems to close ranks with social reformers from Hogarth to Fourier in deploring a range of deleterious social effects of the laws governing marriage and divorce (the institution of divorce, established by the Revolution, was rescinded in Napoleon's civil code and not reinstated until 1884.)[34]

Throughout his work, and perhaps throughout his life, Gavarni interested himself in the plight of women, and in the brave and ingenious ways in which they managed to circumvent the restrictions laid upon them. He was no advocate of reform; he simply enjoyed the battle. As an assiduous patron of the popular costume balls in carnival season and as an arbiter of fashion, he published extensive suites of ideas for costumes, one of which, the *débardeur*, caught on so well that variations of it were still current in 1873 when Manet painted a re-run of the *bal masqué de l'Opéra*. The costume, worn by both men and women, featured velvet mid-calf trousers that gave women the opportunity to indulge in the freedom of men's casual dress now universally enjoyed by western women. The saturnalian license of carnival was thus enhanced for the Parisian working-class woman whose sign this costume became. Gavarni not only created the costume, he drew the wild antics of the *débardeur* in a suite of lithographs of that name, and in other suites on carnival subjects (see nos. 72, 74, and 78).[35] In a long series for *Le Charivari* he created the figure and the character of the Parisian *lorette*,[36] the type of the mercenary predator on the fortunes of the middle-aged bourgeois male whose sentimental life she cynically dominated, while deceiving him in a thousand situations requiring improvised subterfuges. Though at times Gavarni seemed to champion the *lorette* and to applaud her triumphs, he nevertheless reinforced conventional views which saw such women as lying, treacherous gold diggers, women without heart or sentiment. In walking this tightrope he was able to maintain the approval of all parties, thus enhancing his popularity and at the same time greatly reducing the polemical element in his work. With this strategy he was able to continue his commentary on a seamy but increasingly visible aspect of Parisian life that the populace at large found both

laughable and intrinsically interesting (see no. 76).

Gavarni did all of this in a drawing style of characteristic elegance and verve, with a sure command of anatomy and the fit of clothing. Like Daumier's, his manner was firm and tight at the outset, becoming broader and looser with time and experience. He studied in depth the postures and gestures of the nineteenth-century female. No draftsman except Degas is more eloquent on the subject, and Degas in later life, long after Gavarni's death, is observed in his letters to have been a passionate collector of Gavarni's work.[37]

Henry Monnier (1799-1877) was no more a major contributor to topical political matters than Gavarni, but with his theatrical background he managed to create the image of the quintessential bourgeois man, all paunch and pretension, uttering wise inanities, epitomized in the character called Monsieur Joseph Prudhomme. Monnier, an actor and playwright as well as lithographer, created Prudhomme on the stage as he did in cartoons, and some of his images are self-portraits in the role of this monumental stuffed shirt (no. 116). His take-offs on the egotism and pedantry of the character endeared him to the anti-bourgeois world of creators, particularly Balzac, who based his unattractive character Bixiou on Monnier's.[38] Most of his graphic caricature belongs to the early period of Philipon's papers, and even before. He had already made a name for himself with several albums on the subject of grisettes, Parisian working girls, whose character he "created" as Gavarni later did the lorettes. Like Gavarni, he played to a wide audience and had, if anything, less sympathy with the political left, although his earliest cartoons for Philipon's Le Caricature were aimed at the easy target of the overthrown Restoration regime. His characterization of the bourgeois began with the middle-aged would-be Lothario pursuing the light-hearted grisette who consistently rejected him in favor of the mythical student, her preferred lover (nos. 102-105). These frivolous and innocent games display a sharp contrast with the malicious commentary of Gavarni on the predatory lorette whose victim was the very bourgeois rejected by the grisette. These pictures are myth-makers in a way that Daumier's more topical art usually is not. I say usually, because Daumier's art does at times contain ideology shared with the dominant culture, particularly with respect to women, but in a different sphere: that of the early feminist movement (see nos. 41 and 42).[39]

Baudelaire's opinion of Monnier showed his appreciation more of a dogged effort than a valuable accomplishment. "Il n'a jamais connu le grand art" (He never knew great art).[40] But his Prudhomme was "monstruesement vrai" (monstrously true).[41] Baudelaire found Monnier somehow cold, unspontaneous, calculated—the sign of the actor. But Monnier had the wit to introduce unusual subject matter. He is virtually the only caricaturist to derive material from the new bureaucracy of fonctionnaires who pompously carried out the rituals and protocols of the business office (Monnier had been a clerk in such an office). Moeurs administratives was the result, a series documenting the relations between bosses and subordinates that are still the subject of caricatures in The New Yorker. In doing so, he furnished to posterity images of a new reality, of the beginnings of modernity, as did Daumier (nos. 107-108).

Balzac too found Monnier's talent cold, calculated, and ironic, piercing as a steel poignard. But "he knows how to put a whole political life in a wig, a whole satire worthy of Juvenal in a fat man seen from the back."[42] It is hard to know whether Balzac is speaking of Monnier's caricatures or his stage presentations, but it is the caricaturist of whom he said, "It's to be regretted that an artist so astonishingly deep hasn't embraced the career of political pamphleteer through strokes of the crayon."[43] All of Monnier's early work, that for which he is best known, is executed in the sharp line of pen lithography,[44] with a minimum of dark areas to accommodate the application of color, which was added in delicate watercolor washes under the artist's personal direction. The resulting effect of prettiness is often at odds with the sardonic content. More than any of the others, Monnier displays affinities with English caricature, having spent over two years in the early 1820s in London, where he became friendly with George Cruikshank.[45] Cruikshank worked in linear intaglio media, leaving broad areas without tone until color was added, though it was color very different from Monnier's. Perhaps Monnier derived the predilection for line and color from that source, though he also shared this technique with Grandville in work of the late 1820s. The work of both Monnier and Grandville was in marked contrast to the velvety gray to black gradations rendered in lithographic crayon favored by most of the lithographers working in the period around 1830. Either type could of course be hand colored; single sheets were normally sold in black and white for fifty centimes or a franc, and colored for fifty centimes more (see nos. 83-84 and 114-115). One of the petits métiers in Paris in those times was that of coloriste, normally practiced by women. Color lithography was not a practical reality until the 1850s.

Charles-Joseph Traviès de Villers, called Traviès (1804-1859), devoted more of his art to images of the lower classes than did any other caricaturist, including Daumier. It is not that he was a political radical, but he had, as Baudelaire noted, a profound feeling for the joys and sorrows of the people. "Il connaît la canaille

au fond, et nous pouvons dire qu'il l'a aimé avec une tendre charité" (He knew the mob to its depths, and we can say that he loved it with a tender charity), said Baudelaire.[46] This sympathy is manifested in Traviès' work in picture after picture of the life of the *barrières* with all its endearing and drunken shabbiness. Traviès is the celebrator of ragpickers and of wine at six sous, without the slightest hint of the reformer. He implies that the wisdom of *le peuple* is born of misery, yet he is more interested in displaying the wisdom than the misery. His *Scènes bacchiques* reflect his own proclivity to drink,[47] which in turn accounts for his profound understanding of the collapsed *clochard* who waves away an offer of help with "I'm waiting for one of my friends."[48] It is no coincidence that Traviès chose, or was chosen, to illustrate Eugène Sue's *Les Mystères de Paris* with its scenes and characters from the Parisian underworld. These were not pictures to accompany the text, but rather scenes from a text that the public knew well and was entertained to see visualized in images sold in an album (they were not made for newspapers). Traviès even made a picture of a delegation of underworld characters calling on Sue to entreat him, in translated thieves' cant, to alter the outcome of the novel, which was originally published in newspaper installments in 1842-43. In the exhibition is another example showing two of the down-and-out politely sharing the newspaper's current installment of *Les Mystères* (no. 178).

Traviès is probably best known for his creation of Mayeux, the little hunchback with the simian face, rascal and outrageous womanizer, representative of *le peuple* and the lower ranks of the bourgeoisie, who symbolized the Gallic spirit. Both Champfleury and Baudelaire recognized here a rival to Monnier's Prudhomme and Daumier's Robert Macaire. Traviès even produced a series in which the two rascals, Mayeux and Macaire, collaborate in their charlatan schemes to fleece the innocent and the naive. Mayeux is however not the flim-flam artist that Macaire is. Mayeux often appears in scenes with pretty girls who seem to flock to him; most of them were drawn by Philipon in an unusual collaboration. Traviès created a world of social reality in fantasy, using a technique that is at times mock-childlike, and that gives his work a specially poignant character. Baudelaire found in his talent "quelque chose de sérieux et de tendre qui le rend singulièrement attachant" (something serious and tender, that renders him singularly endearing).[49]

There is no proper biography of Traviès, nor is there a published *catalogue raisonnée* of his oeuvre, though the efforts of Claude Ferment form the basis on which further study needs to be done.[50] The account of Traviès by Champfleury in *Histoire de la caricature moderne* is entirely on the subject of Mayeux and has little to say about Traviès as an artist. Thus, Traviès is the last of the Philipon regulars to remain uncatalogued and unsung. This appealing artist has attracted the attention of collectors, however. One of these is Stuart Kadison, who has given a significant collection of Traviès' work to the Museum. Through his generosity we are able to feature this underrated artist with substantial representation.

Jean-Ignace-Isidore Gérard, called Grandville (1803-1847), began his Parisian career as a lithographer but was in reality an all-purpose draftsman and comic creator of fantasy whose ideas appeared in a variety of media. The many political lithographs attributable to him that appeared in *La Caricature* or *Le Charivari* were nearly all executed from his drawings by others whose names as collaborators or copyists frequently appear with his on the stone.[51] As a social satirist he took aim at no one specific target (such as Monnier's Prudhomme) but rather at the entire range of human pretensions, of victims and victimizers, and of follies of every sort. Among his earliest works are the suites called *Les Métamorphoses du jour* (1828-29) designed, like Monnier's, in pen lithograph anticipating coloring, in which human figures with animal heads acted out the human comedy. This genre, stemming from Aesop and La Fontaine and their illustrators, was in turn influential upon Lewis Carroll and his illustrator John Tenniel: the White Rabbit and the Dormouse are cousins of Grandville's gallery of human animals.[52] Traviès made some similar imagery early in his career, but soon abandoned the field to Grandville. Typical of Grandville's bizarre, even macabre, imagination is a lithographic suite of 1830, *Voyage pour l'éternité*, a sort of Dance of Death in which the grim reaper calls on representatives of every class and station. A quaking servant who has just admitted Death says, "Monsieur le Baron, on vous demande?" (Monsieur le Baron.....someone asking for you?) The fat and gouty baron replies, "Dites que je n'y suis pas" (Say I'm not in). The subtitle for the series reads "Service Général des omnibus accélérés. Départ à toute heure et de tous les points du globe. Nota. Le Directeur de l'entreprise prévient MM les Voyageurs qu'il ne se charge d'aucun paquet" (General Service of accelerated omnibuses. Depart at all hours and from all points of the globe. Note. The Director of the enterprise warns all passengers that no baggage will be accepted).[53] The series was not a popular success, but was much admired by both Balzac and Champfleury.[54] Grandville's appeal to an educated audience is further evidenced by his elaborate captions so full of topical references for political images in *La Caricature* that they can scarcely be deciphered today.

Baudelaire called him "artiste par métier et homme de lettres par la tête"[55] (artist through his hands and man of letters through his head), and found his work frightening. "This man, with superhuman courage, spent his life remaking the creation. He took it in his hands, twisted it, rearranged it, explained it, commented on it; and nature transformed itself into apocalypse."[56] He recognizes Grandville's importance, but is more impressed by his command of ideas than his ability to translate them plastically. Accurate as always, Baudelaire diagnoses the reason for Grandville's excessive captions and labels.

Grandville's talents after the demise of *La Caricature* were directed principally to book illustration, for which he made drawings translated by others into wood engraving. An endearing parody of Balzac's *La Vie publique et privée* was brought out by Balzac's publisher J. Hetzel as *La Vie publique et privée des animaux* (1842), and later Grandville's bizarreries embellished *Un Autre monde*, in which he earned a place as a forerunner of surrealism.

New interest in Grandville's art has led to a major exhibition of his original drawings, organized by Clive F. Getty, in Nancy, the artist's birthplace, and to several publications.[57] In a review of the exhibition catalogue, James Cuno pays tribute to Grandville's achievements as a draftsman. The exhibition, he says, revealed

> what a talented and often very brilliant artist Grandville was. He could draw softly, with graphite, making very simple and light-filled studies after nature that prefigure the drawings of Manet or even Seurat... And he could draw incisively, with pen and ink, bringing his full, penetrating talents to the description of life in modern Paris or to the composition of haunting and bizarre, fantastic projections like no one else in nineteenth century French art—not Daumier, or Delacroix, or Redon.[58]

Philipon the publisher is also represented in the exhibition as a lithographic caricaturist. The selection shown here confirms the generalities that can be made about his art. Before 1830 it is devoted almost entirely to pretty girls, seen as Parisian types in the same genre as the street cries and peddlers of Pigal and Carle Vernet, his predecessors. Some of his cartoons may be seen as criticism of social ills, such as the *Petites annonces* (nos. 119–120), but not as criticism of the Restoration regime, which would not have been tolerated. His humorous *diableries*, which link him with some of the themes of romantic high art, are among his most effective designs graphically (see no. 122, from *Les Tentations du Diable*). Immediately following the lifting of censorship, Philipon proceeded to assume the role for which he is famous, as journalistic entrepreneur and publicist of the opposition view that was quick to emerge after the euphoria of victory in the overthrow of the Bourbon monarchy. In addition to giving currency to the famous pear as caricature of Louis-Philippe (see the accompanying essay by Stuart Kadison), he continued to make caricatures for a year or two for his satirical publications in the style that came to be their hallmark (nos. 123, 124).

Baudelaire does not discuss Philipon as an artist though he recounts the story of the pear.[59] Champfleury, whose treatment of all caricature is more literary than visual, wrote what amounts to a eulogy of Philipon the man—potent and energetic impresario, beloved and loyal friend, benefactor of the unfortunate—who had recently died.[60] He loyally but erroneously credits Philipon as the first to use caricature as a political weapon, ignoring the rash of caricatures produced during the 1789 Revolution, not to mention a long tradition of political caricature in England. Philipon was clearly not a major creator of caricatural art of his own, but he figures so overwhelmingly in the work of others that he cannot be omitted in any account of the subject. We shall probably never know the full extent of his intellectual participation in the work that others signed. Photographs of him by Nadar confirm the identity of the figure of *La Caricature* in Grandville's *Ah! je te connais paillasse* (no. 97) as Philipon, who appears too in many other prints as the spirit of caricature. Balzac once addressed this man in a letter as "mon cher Pompon, duc de la Lithographie, marquis du Dessin, comte de Boisgravé, baron de Charge et chevalier de Caricature..." (My dear Pompon, Duke of Lithography, Marquis of Drawing, Count of Woodcut, Baron of Charge and Knight of Caricature...).[61]

Many other lithographic artists on occasion worked for Philipon's papers, but this array of the five major figures was sufficient to put its stamp upon the epoch, at least insofar as its ideas and passions could be expressed in satirical visual imagery. These men were, moreover, individual creators, each with a style of his own and known to an audience, as Balzac was known. Their repeated appearance in daily and weekly papers and in albums made of their collected plates guaranteed their professional reputations, which in turn sold their works. All were participants, to one degree or another, in the political counter-discourse in which Daumier and Philipon were the principal spokesmen. In these characteristics they were at an opposite pole from the fabricators of wood engraved images, men who simply translated any drawing furnished them into a printable relief surface on a block of wood. Between these two extremes was a whole world of

artists of varying degrees of originality, working with widely differing perspectives, many having nothing to do with satire or caricature. They marketed their work through a variety of outlets which more and more took the form of image-publishers, entrepre-neurs who employed artists to make saleable commodities and who knew how to distribute their products to a grow-ing mass market.

Before Philipon

Philipon had come to Paris from Lyons in 1823, to find a world of lithographic artists already at work there. Although he had come to study painting under Baron Gros and Abel de Pujol, like many other art stu-dents of his time he took up lithography to make a liv-ing, with the results we know. He must have encountered the already well-known lithographers of older generations—Carle and Horace Vernet, Charlet, Pigal—as well as contemporaries just launching their careers like Raffet and Achille Devéria. One among the older group, Louis-Léopold Boilly, was an anomaly—a successful painter with a long career behind him who renounced painting for lithography in his old age. The connection of Boilly with lithography is important because of his iconographic lineage as a painter of the neoclassic age who disdained current pictorial heroics and who kept alive into the nine-teenth century the eighteenth-century tradition of contemporary genre painting. His caricatures of social types linked his forebear Hogarth with his descendant Daumier; his appealing children and pretty young girls served as precedent for Achille Devéria and some of Philipon's own work, and his depictions of street urchins playing games offered models for the non-mil-itary works of Charlet, and for an artist such as Pigal.

Edme-Jean Pigal, of the same generation as Charlet, created a world of the streets of Paris, and something of a humorous "upstairs-downstairs" in his contrasts of servants and gentlefolk under the heading *Scènes de société*. These are all done, however, from the viewpoint of the working class. In Pigal one finds again and again themes in caricature that were later to be treated by Daumier: skinny bathers in the public baths of the Seine, mountebanks on the move, pompous lawyers. Pigal created an oeuvre considerable enough to be described by Baudelaire, who said of his work, "Ce sont des vérités vulgaires, mais des vérités." (They may be vulgar truths, but nevertheless truths).[62] He is amply represented in this exhibition with works in a manner he shared with Boilly: large figures silhou-etted or vignetted on the sheet without backgrounds. By 1830 however, following practice that had become current, framing and settings became standard treat-ment in the work of both artists.

Lithography may have come to be known as the medium of the political opposition through Philipon's papers, but its liberal reputation had more complex origins than that association alone. Lithographs were much faster and cheaper to produce than engravings. Within the first lustrum of the medium's viability, 1815-1820, lithography was adopted by the forces of an earlier opposition, that of Bonapartists in response to the repressive Restoration regime. The market for Bonapartist images encompassed a ready-made audi-ence of the mustered-out soldiers of the Napoleonic army and their discharged officers in retirement at half pay. This meant a largely working-class market, that of the *soldat-labourer*.[63] Perhaps the earliest realization of the commercial potential of lithography came through the discovery of this market. Its first artist-suppliers were Carle and Horace Vernet, father and son, and Nicolas-Toussaint Charlet. Throughout the late 1810s and the 1820s a flood of lithographic sheets and albums appeared, reminiscing on the life in camp and in battle of the infantry soldier, or detailing the uni-forms of all units of the *Grande Armée*, or commiserat-ing with the current status of former soldiers plagued by unemployment and poverty. There were illustra-tions of the popular Bonapartist songster-poet Béranger, and clandestine sheets commemorating martyred conspirators of the Carbonari. The contribu-tion of lithography to the burgeoning Napoleonic leg-end, particularly after Napoleon's death in 1821, is vast and incalculable. By 1830, when censorship of the image of Napoleon (imposed with the Restoration) was lifted, this market gave rise to a new wave of Napoleonic imagery created by Auguste Raffet who became a major caterer to the pent-up demand. And, although lithographers rallied under the *tricolore* to the cause of the Revolution of 1830, their sympathies were not with the propertied bourgeoisie who won that Revolution, but rather with the lower rungs of the socio-economic ladder whose interests were champi-oned soon after July 1830 by the likes of Philipon and his stable. Thus lithography, the cheap medium, had a long association with the lower classes, and although new bourgeois markets came to be developed during the 1830s, lithography always bore the stigma of being not quite respectable. This was especially true in England where it was disdained in favor of the devel-opment of steel engraving for the genteel bourgeois market and of wood engraving for the lower ranks.

One of the group of older lithographers had aspira-tions to a place in the high culture: Horace Vernet. His career as a lithographer was limited to his youth; while he did produce images calculated to appeal to the veterans of Bonaparte's army during this time (see nos. 199, 203-5, 208), he also created romantic illus-

trations for Byron and other high literature (no. 200) comparable in subject to some of his later Salon paintings. Working side by side with his father Carle, the two men made contemporaneous evocations of the military and military life (compare nos. 192 and 199) at the very beginning of commercially viable lithographic production. For Carle these productions were a swan song, while for Horace they were more a launching pad for a career as a military painter, most notably under Louis-Philippe, though he continued to work through all the regimes from the Restoration to the Second Empire. His art, though Bonapartist in its early phase,[64] came to be strongly associated with the *juste milieu* (he had been a friend of the future bourgeois king during the Restoration), and hence he occupied a different political corner from Philipon and his team. His devout Catholicism and his loyal patriotism differentiated him sharply from those who were as skeptical about religion as they were about the values of the ruling establishment.

Charlet too was a painter, but was certainly better known to the general populace as a maker of lithographic pictures. Early and intensively associated with the Napoleonic legend, he too proved to be an establishment sympathizer rather than a gadfly, and although in later imagery produced during the July Monarchy he featured the aging veteran and his grandchildren, it was to show them as loyal patriots. He frequently portrayed naughty schoolboys (no. 26), some manifesting their Gallic independence and their propensity for the glamor of the military, sometimes mingled in the same image (see no. 21). Charlet is seen as a true romantic in pictures of contraband-running guerrillas of the Spanish border (no. 19), but more typically he is the celebrator of the every-day pleasures of the little man (no. 20) and woman (no. 25). Career soldiers are said to have imitated the figures in his cartoons in their speech and bearing.

Baudelaire was not enchanted with Charlet. While admiring the soldiers of the early work before Charlet had any pretensions to being a great man, he finds that later, Charlet's drawing "is hardly more than chic... his sentiments are taken whole from vaudevilles... He has patterned his opinions and shaped his intelligence from fashion. The public was truly his *patron*" [*patron* in a double sense: patron and pattern].[65] Baudelaire recognized Charlet's great popularity, and it was with some diffidence that he criticized him: "Nevertheless one must have the courage to say that Charlet did not belong to the class of eternal men and cosmopolitan geniuses."[66] That distinction Baudelaire reserved for Daumier.

Baudelaire tells us he would not have included Charlet as a caricaturist, but fears he would have been accused of a grave omission if he left him out. He does in fact leave out Raffet,[67] who was as illustrious as Charlet in his military subject matter, and who, moreover, contributed substantially to the political raillery in *La Caricature* (nos. 149, 151, 154, 156). But Raffet is at his best and most typical in his ghostly visions of Napoleon calling up his dead troops in a midnight *reveille*, or contemplating his fate in 1813 (no. 159). Raffet was respected enough as an artist to have pleased Edouard Manet enormously by commenting favorably on his work as a student.[68]

Caricature is associated in our minds with politics. Many of the so-called caricaturists, however, depicted the world without exaggeration of features in scenes of ordinary contemporary life, *scènes de moeurs*, which were sometimes good for a laugh or at least a smile, but were never intended to make biting or hilarious inroads on the sensibility of their viewers. In the spectrum of their subject matter, ranging from the political cartoon to the recording of social types and manners, it is probable that production was much higher at the latter end. Nevertheless many lithographic artists specializing in genre were definitely considered caricaturists in the nineteenth century, and Baudelaire remembered some of them fondly as historians "des graces interlopes de la Restauration" (of the illicit graces of the Restoration). Among these was Achille Devéria.[69] In his *Salon of 1845*, Baudelaire takes notice of a painting by Devéria, but says more about his lithographs, "...ravishing vignettes, charming little pictures of people at home, gracious scenes of elegant life... All these coquettish and sweetly sensual women were the idealizations of the ones one would see and desire in the evenings at concerts, at the Bouffes, at the Opera or in the great salons."[70] Baudelaire was the only major writer to appreciate, in candid human terms, these visions of middle-class sensuality of which Achille Devéria made a specialty.

Achille Devéria and his brother Eugène both began their artistic careers as painters. Eugène was perceived to have the greater talent, and Achille deferred to him, undertaking to make money as a commercial lithographer in order to support the painter of the family. It was a useless sacrifice. Eugène was hailed as a new talent at the Salon of 1827, but achieved no glory after that, and virtually disappeared from the scene. Perhaps Achille took the wiser course in not intensively pursuing his own ambitions as a painter, remaining a lithographer of modest talent but prodigious output throughout his life until he was appointed *conservateur*, in 1848, and later *conservateur-en-chef* of the print room of the Bibliothèque nationale, a post he held until his death in 1857. He wielded considerable influence on the print cabinet in organization and adminis-

tration, and his own immense collection of prints was posthumously acquired by the cabinet. Early in his career Devéria made a few political lithographs and did some illustrating in intaglio media, but by 1828 he was deeply involved in the market for libertine prints which seems to have flourished particularly about 1829-30, perhaps as an antidote to the repressive climate of Charles X's reign. While he continued with erotic subjects throughout his career, he added portraits, fashion plates, historical suites, and a large number of religious images.

Some of Devéria's early work was published by Charles Motte, who was not only his father-in-law, but also the publisher of Delacroix's lithographic suites illustrating Shakespeare and Goethe. Devéria's household, in fact, was one of the meeting places for the cenacle that included Delacroix and Hugo.[71] Devéria was a sophisticated, well-connected artist with a knack for making things work. What is surprising is his enormous output, almost as large as that of Gavarni and approaching that of Daumier. Devéria had wide knowledge of art and its history; he was an expert on historic costume. His historical compositions (he combined erotica with history) rely as often and as eclectically on familiar works of the great masters of the past as do his religious images. The work varies widely in quality, as might be expected. Among the most brilliant and technically most appealing of his lithographs are portraits of contemporaries of the literary world: Alexandre Dumas *père* on a sofa; Philipon in his dressing gown. The informality of these portraits, in contrast to the well-dressed, correct postures of official portraits in oil, was not adopted in high art until Manet, Degas, and the Impressionists, probably with the intervening influence of photographic portraits, especially the informal *carte-de-visite*.

Devéria's body of work stands in marked contrast to that of an artist such as Daumier, who was motivated by social and political convictions, whereas Devéria followed the demands of the market. Lithographers were not the entrepreneurs of their production. They worked for publishers, who were probably instrumental in determining the genre of their subject matter. But Aubert, Daumier's publisher and the publisher of *La Caricature* and *Le Charivari*, was Philipon's brother-in-law, so that the intellectual energy behind those enterprises was of a quite different kind from Devéria's publishers—usually Bulla or Jeannin in Paris who were among the largest in the business, with outlets through Charles Tilt in London, and Bailly Ward and Co. in New York.

A new generation of lithographic artists marked by slicker styles and more obvious commercialism emerged in the 1840s and dominated the field in the 1850s, the period when lithography is generally considered to have been in decline. Lithographic pictures were probably more numerous than ever before but their artistic quality considerably less. It was as a result of this state of affairs that the fine art publisher Cadart sent lithographic stones to the young Manet, Fatin-Latour, and Legros in 1862, with the intention of enlivening the lithographic scene with new young talent. While this move did not succeed in its immediate objectives, it presaged the adoption of lithography by high artists in the decades to come, and its transformation into a respectable high art medium at last in the hands of Renoir, Lautrec, and the Intimistes.

The majority of the works in this exhibition were made during the heroic days of lithography, when the medium was new and as yet unchallenged by photography. Among important exceptions are a few later works of Daumier and Gavarni, two artists so committed to their medium that they continued to produce lithographs virtually throughout their active lives, even into a time when lithographic pictures were considered old-fashioned. The record contained in these pictures of the life and the political storms of their time is a precious legacy, only lately beginning to receive its due once again. And while the importance of these images to social history has been progressively realized, their qualities as art have been downplayed (always excepting Daumier) by scholars and critics fearful of making an aesthetic *gaffe*.

Perhaps it is time to rejoin the extraordinarily wide-ranging sensibility of Baudelaire who saw these products as art. "En vérité," he said, "faut-il donc démontrer que rien de ce qui sort de l'homme n'est frivole aux yeux du philosophe?" (In truth, does one need then to demonstrate that nothing that comes out of man is frivolous in the eyes of the philosopher?).[72] In the introduction to his essay "The Essence of Laughter," he noted a relation between beauty and caricature: "A strange thing and really worthy of attention, the introduction of this elusive element of beauty even in works destined to represent to man his own moral and physical ugliness!"[73]

Endnotes

1 James Cuno, *French Caricature and the French Revolution, 1789-1795* (Los Angeles: Grunwald Center for the Graphic Arts, Wight Art Gallery, University of California, Los Angeles, 1988).

2 See J. Adhémar, *Imagerie populaire française* (Milan: Electa, 1968); also D. Kunzle, *The Early Comic Strip: Narrative Strips and Picture Stories in the European Broadsheet from c. 1450 to 1825* (Berkeley: University of California Press, 1973).

3 The Swann Foundation, New York City.

4 William M. Ivins, Jr., *Prints and Visual Communication* (Cambridge, MA: Harvard University Press, 1953), 28.

5 Ibid., 29

6 Ibid., chap. 3, especially. pp. 54-60.

7 For a short overview, see B. Farwell, *Cult of Images* for general history; see A. Hind, *An Introduction to a History of Woodcut*, also W. Weber, *A History of Lithography*, and M. Twyman, *Lithography 1800-1850*.

8 This incompatibility was eventually resolved with the invention of *gillotage*, a photomechanical method developed in the 1860s for converting lithographs into letterpress-compatible line cuts. The process reduced aesthetic quality and faithfulness of reproduction considerably, thereby emasculating, for example, the last and greatest of Daumier's lithographs.

9 See B. Farwell, *Cult of Images*; Judith Wechsler, *A Human Comedy*; James Cuno, "Business of Caricature"; Edwin de T. Bechtel, *Freedom of the Press*; Richard Terdiman, *Discourse/Counter-Discourse*, especially chap. 3.

10 See W. McAllister Johnson, *French Lithography*, and Salon catalogues.

11 Le Diogène, 1859-60; Le Boulevard, 1861-63, which carried lithographs by Daumier at a time when he had temporarily left *Le Charivari*.

12 See the essay by Stuart Kadison in this catalogue.

13 Ibid., and Bechtel, *Freedom of the Press*.

14 Terdiman, *Discourse/Counter-Discourse*, 241.

15 Loÿs Delteil, *Le Peintre-graveur illustre*, vols. 20-29.

16 Baudelaire, "Quelques caricaturistes francais," *O.c.*, and Champfleury, *Histoire*.

17 Champfleury, *Histoire*, 10.

18 Ibid., 135. "Sa main trouva une independance qu'on ne rencontre que dans les esquisses des grands peintres. Tout le feu dont était remplie l'ame du maître put se traduire spontanément sur la pierre sans être gêné par le métier."

19 Baudelaire, *O.c.* 2:356.

20 Ibid., 1342.

21 Ibid., 549. "C'est véritablement une oeuvre curieuse à contempler aujourd'hui que cette vaste série de bouffonneries qu'on appelait la *Caricature...*"

22 Ibid., 552. "Toutes les pauvretés de l'esprit, tous les ridicules, toutes les manies de l'intelligence, tous les vices du coeur se lisent et se font voir clairement sur ces visages animalisés.... Daumier fut a la fois souple comme un artiste et exact comme Lavater."

23 Ibid., 554. "Feuilletez son oeuvre, et vous verrez défiler devant vos yeux, dans sa réalité fantastique et saisissante, tout ce qu'une grande ville contient de vivant monstruosités."

24 Ibid., 555. "Toutes les sottises, tout les orgueils, tout les enthousiasmes, tous les désepoirs du bourgeois.... Daumier a vecu intimement avec lui, il l'a épié le jour et la nuit, il a appris les mystères de son alcove, il s'est lié avec sa femme et ses enfants, il sait la forme de son nez et la construction de sa tête....."

25 See Terdiman, *Discourse/Counter-Discourse*, chap. 3.

26 Champfleury, *Histoire*, 304.

27 Baudelaire, *O.c.* 2:561. "Gavarni n'est pas essentiellement satirique; il flatte souvent au lieu de mordre; il ne blâme pas, il encourage.

Comme tous les hommes de lettres, homme de lettres lui-même, il est légèrement teinté de corruption..... sa pensée cynique... caresse les préjujes et fait du monde son complice."

28 Ibid., 560. "La véritable gloire et la vraie mission de Gavarni et de Daumier ont été de compléter Balzac, qui d'ailleurs le savait bien, et les estimait comme des auxiliares et des commentateurs."

29 Edmond and Jules de Goncourt, *Gavarni, l'homme et l'oeuvre* (Paris: Plon, 1873 and 1925).

30 As quoted in T. D. Stamm, *Gavarni and the Critics* (Ann Arbor: UMI Research Press, 1981), 75. "Malgré son apparence frivole il est plus sérieux au fond que bien des peintres d'histoire."

31 Ibid., 119.

32 Albert Smith, ed., *Gavarni in London* (London: D. Bogue, 1849).

33 The game called *Le Savant de société*. See B. Farwell, FPLI 6:19.

34 Ibid., 6:7-8.

35 Nancy Olson, *Gavarni: The Carnival Lithographs*. Also B. Farwell, *FPLI* 4, 5C9-5E5 and 6C11-6D4.

36 Named by Nestor Roqueplan for the quarter of Notre Dame de Lorette, where many such women lived.

37 Marcel Guérin, ed., *Lettres de Degas* (Paris: Grasset, 1945), vols. 98-99 and 185-87.

38 Edith Melcher, *Henry Monnier*, 169-72.

39 *Daumier, intellectuelles (bas-bleus) et femmes socialistes.*

40 Baudelaire, *O.c.* 2:557.

41 Ibid.

42 In an article in *La Caricature*, 31 May 1832, signed Comte Alex. de B... (one of Balzac's pseudonyms), as quoted in Champfleury, *Histoire*, 239.

43 Ibid. "Il est à regretter qu'un artiste aussi étonnant de profondeur n'ait pas embrassé la carrière politique du pamphletaire à coups de crayon."

44 In pen lithography, a pen charged with greasy ink is used to lay down the lines of the design (as opposed to the more usual lithographic crayon).

45 Melcher, *Henry Monnier*, 33. Research remains to be done on the relation of English to French caricature altogether.

46 Baudelaire, *O.c.* 2:562.

47 Ibid.

48 B. Farwell, *FPLI* 4, 3G12.

49 Baudelaire, *O.c.* 2:563.

50 See Claude Ferment, "Le Caricaturiste Traviès: la vie et l'oeuvre d'un 'Prince de Guignon' (1804-1859)," *Gazette des Beaux-Arts*, ser. 6, 99 (Feb. 1982):63-77. This article is extracted from Ferment's unpublished essay and catalogue on Traviès' life and works (Bibliothèque nationale, Cab. Est. Yb32774).

51 See Clive F. Getty, *Grandville: Dessins originaux*, 207-08.

52 See M. Mespoulet, *Creators of Wonderland* (New York: Arrow Eds., 1934); also Ségolène Le Men, Les Fables de la Fontaine, Quatre siècles d'illustration (Paris: Promodis, 1986).

53 B. Farwell, *FPLI* 6, 4F11-4G8.

54 Renonciat, *Grandville*, 37; Champfleury, *Histoire*, 293-8.

55 Baudelaire, *O.c.* 2:558.

56 Ibid.

57 Besides the Getty catalogue (see no. 51), see Clive F. Getty, "Grandville: Opposition Caricature and Political Harassment," *Print Collector's News Letter* 14 (Jan.-Feb. 1984):197-201; and Philippe Kaenel, "Le Buffon de l'humanité: La Zoologie politique de J.-J. Grandville (1803-1847)," *Revue de l'art* 74 (Jan.-Feb. 1986):21-28; and Renonciat, *Grandville*.

58 James Cuno, "*Grandville: Dessins originaux* by Clive F. Getty," review, *Art Bulletin* 70 (Sept. 1988):533.

59 Baudelaire, *O.c.* 2:549-50.

60 Champfleury, *Histoire*, 271-281.

61 *Honoré de Balzac, 1795-1850*, exh. cat. (Paris: Bibliothèque nationale, 1950), p. 47, no. 172.

62 Baudelaire, *O.c.* 2:545.

63 See Nina Athanassoglou-Kallmyer, "Sad Cincinnatus: *Le Soldat-Laboureur* as an Image of the Napoleonic Veteran After the Empire," *Arts Magazine* 60 (May 1986):65-75.

64 See Nina Athanassoglou-Kallmyer, "*Imago Belli:* Horace Vernet's *l'Atelier* as an Image of Radical Militarism under the Restoration," 268-280.

65 Baudelaire, *O.c.* 2:548. "...n'est guère que du chic... Les sentiments, il les prenait tout faits dans les vaudevilles... Il a decalqué l'opinion, il a decoupé son intelligence sur la mode. Le public était vraiment son *patron*."

66 Ibid., 546. "Cependant il faut avoir la courage de dire que Charlet n'appartient pas à la classe des hommes éternels et des génies cosmopolités."

67 According to C. Pichois, in a revision of themes never completed Baudelaire lists Raffet among those to be treated. See Baudelaire, *O.c.* 2, pp. 1400 and 1343.

68 Antonin Proust, *Edouard Manet: Souvenirs* (Paris: H. Laurens, 1913), 22-23.

69 Baudelaire, *O.c.* 2:687.

70 Ibid., 365. "...de ravissantes vignettes, de charmants petits tableaux d'intérieur, de gracieuses scènes de la vie élégante... Toutes ces femmes coquettes et doucement sensuelles étaient les idéalisations de celles qu'on avait vues et desirées le soir dans les concerts, aux Bouffes, à l'Opéra ou dans les grands salons."

71 See Maximilien Gauthier, *Achille et Eugène Devéria*, 12-17.

72 Baudelaire, *O.c.* 2:526.

73 Ibid., 526. "Chose curieuse et vraiment digne d'attention que l'introduction de cet élément insaisissable du beau jusque dans les oeuvres destinées a représenter à l'homme sa propre laideur morale et physique!"

THE POLITICS OF CENSORSHIP

by Stuart Kadison

Stuart Kadison, a partner in the Los Angeles law firm of Sidley & Austin, has had a long-standing interest in the legal aspects of free expression. With the late Ashton Phelps, publisher of the New Orleans Times Picayune, he was the first co-chairman of the American Newspaper Publishers Association-American Bar Association Task Force on Freedom of the Press. He is a collector of French lithographs of the "heroic" period and has generously donated an extensive collection of the works of Traviès to the Museum.

Fully to appreciate the works illustrated in this catalogue and the motives of the artists who created them, one must approach them with some understanding of their times. Without this understanding, the appeal of the exhibition is no more than visual. While Daumier, Grandville, Traviès and the other extraordinarily gifted artists represented here often had quite different, or at least mixed, motivations in applying their talents to the lithographic medium, it does not go too far to say that for some their aim as political caricaturists was no less than to bring down a government. They lived in turbulent times, in a nation emerging from feudalism to the beginnings of modern statehood. Like their counterparts of today, they saw themselves as social critics. In important periodicals published by Charles Philipon, they employed caricature in lithography as a means of emphasizing the emperor's lack of wearing apparel.

Thomas Nast in the last century, Winsor McCay and the prominent political cartoonists of our own day, are thoughtful and skillful caricaturists and their work can be enjoyed for that reason alone. Their political caricature, however (like that of the French caricaturists whose work is seen here and who preceded them by many years), has a broader purpose and is not intended simply to please the eye. To understand their work, one must know something of the socio-political history of the times in which they worked, of Tammany Hall, the Tweed Ring, Richard Croker, and Richard Nixon. Herblock's political cartoons would be a mystery in an historical vacuum, divorced from Watergate and contemporary events.

In much the same way, the graphic political and social comment which appeared in *Le Charivari* and *La Caricature*, and the twenty-four publications of *L'Association mensuelle lithographique*, are also incomprehensible except in the context of the times. To

understand them, one must have an understanding of aspects of the Terror, the Directory and the Consulate, the First Empire, the two Bourbon Restorations, and the July Monarchy of Louis-Philippe.

The purpose of this essay is to furnish a broadbrush account of some of the relevant events which led to the July Revolution and those which occurred in France between July 1830 and September 1835. This will provide additional background and context for the political caricatures which many will find the most important, or in all events, the most interesting, in the exhibition.

A word of caution, however, is appropriate. Not only must the caricatures be placed in context, but this essay must be read in perspective. Its main thrust is freedom of expression and the place of nineteenth-century French caricature in the struggle to attain it. The French Revolution, however, was not a protest against restrictions upon free expression, and the several upheavals which followed it were not occasioned in any large part by repressive press laws. Wars are not fought, nor blood shed, over denials of press freedom. Nonetheless, history teaches that tyranny cannot survive where there are a free press and a literate public. Moreover, caricature is a medium the understanding of which does not call for a high degree of public literacy, and thus it appeals to a broader and less sophisticated audience than the written word. Invariably, among the first steps of a tyrant, or of a government unsure of its stability, is the restriction of press freedom.

Aesthetics apart, it is not without interest to note in passing that Nast, McCay, Herblock, and Conrad have been more successful in their efforts than their Gallic precursors were in theirs. When all is said and done, and as will be seen, Philipon and his nineteenth-century artist-lithographers, however great their talents, were failures if success is measured against all that they set out to accomplish. But as Professor Farwell observes, theirs was an heroic effort, one which history ought not to ignore.

Some historical perspective is in order. In England, as early as 1644, Milton published his unlicensed and unregistered *Aeropagitica*, consistent with the long tradition of press freedom and freedom of speech and thought in that country, in which he addressed the Parliament, eloquently calling for the repeal of their

ordinance of the prior year, and attacked the system of licensing and press censorship imposed by it. Milton wrote, "Give me the liberty to know, to utter and to argue freely according to conscience, above all liberties." To make his point even more clear, he went on to say, "As good almost kill a man as kill a good book: who kills a man kills a reasonable creature, God's image; but who destroys a good book kills reason itself."

In the next century, John Peter Zenger was the victim of repressive measures taken against him and his newspaper, the *New York Weekly Journal*, in 1733. His acquittal by a royal tribunal in 1735 marked the first major victory for, and a reaffirmance of, press freedom in the English colonies in North America. Through brilliant and courageous advocacy, his lawyer, Andrew Hamilton of Pennsylvania, at considerable personal risk in light of the court's lack of sympathy for him and his cause, persuaded a jury that truth should be a defense to an action for libel. This principle continues as a vital element in press freedom to this day. There followed in 1798 the successful campaign against the insidious Alien and Sedition laws which had been enacted by a fearful and reactionary Congress. Under these laws, writing "with intent to defame" the Government, the Congress, or the President was rendered a crime.

Freedom of expression and of the press came late to France. It was not until 1789 that the press moved even temporarily from under the shadow of a monarchy that since the reign of Louis XIV (1643-1715) had controlled the media, prohibiting and punishing criticism of the regime as a crime against the state.

After the surrender of the Bastille by the Marquis de Launay on 14 July 1789, the Constituent Assembly on 27 August 1789 promulgated the Declaration of the Rights of Man and of the Citizen. Among the enumerated inalienable natural rights was the freedom to express ideas in a free press on condition only that expressions of opinion not disturb the legally established order, and subject to responsibility for defamatory publications. The operative term is "natural rights." Natural rights inhere in humankind. They do not belong to the sovereign and are not for him to grant or take away.

And, for approximately three years, the press in France was indeed free. Publishers, writers, and printers were allowed to publish, write, and print what they wished and what they thought, including critical political commentary, without governmental prevention or hindrance and subject only to the limitations noted. Then, as will be seen, began a fifty-year period throughout which the pendulum oscillated in giant swings between liberty, almost to the point of license, and the opposite extreme of censorship and repression.

This unstable condition was, as noted above, a function of the general governmental insecurity of the time.

Commencing in 1792, and throughout the Terror, *ancien régime* and anti-revolutionary publishers were jailed and, in some cases, executed. Later, as First Consul and then as Emperor, Napoleon used his control of the press as a medium of state propaganda. Newspapers carrying political comment, which had proliferated dramatically after the Revolution, vanished no less spectacularly under Bonaparte and the First Empire. Napoleon's control of the press was no less state-monopolistic than that of Louis XIV. However, upon his abdication in 1814, press freedoms were temporarily restored in the short-lived reform movement which replaced him. Indeed in April of that year, the Senate condemned the perverse use of the press for the advancement of governmental ends.

With the Restoration of the Bourbon line, Louis XVIII undertook to preserve press guarantees. The *Charte Constitutionelle*, promulgated in June 1814, "accorded and conceded" to the press freedom from prior restraint—as a matter of royal dispensation, however, and not of fundamental civil and natural rights as in the Declaration of the Rights of Man. This was ominous: what the king concedes, the king can take. Within a matter of months, the government had second thoughts and in October of 1814, the legislature, responding to the will of the monarch as formulated by his ministers, enacted press laws calling for censorship and imposing criminal sanctions for their violation.

With the return of Bonaparte from Elba and during the Hundred Days that followed, the repressive press laws were repealed. Curiously, on Louis XVIII's second return from exile after Waterloo, they were not immediately reenacted and the liberties called for by the *Charte* of 1814 were restored. But predictably, they did not last.

Reaction and internal strife set in. Censorship, this time by royal fiat, followed. The novel requirement of newspaper licensure was imposed. This was an extreme form of censorship. Journals containing matter unacceptable to the government were denied the right to publish at all. Intransigent royalists called Ultras, who were anti-republican and anti-Bonapartist by definition, gained control of the Chamber of Deputies. Their mission, as they saw it, required that they control political and social thought and eliminate those who were not committed to a return to the eighteenth century and the *ancien régime*. The Ultras regarded those sympathetic to Napoleon as traitors, and dismissed and replaced Bonapartist officials, some of whom were executed. Press freedoms were again suppressed. Criticism of the new government was punished as treason.

France at the time was still occupied by the armies of the allied powers who had finally defeated Napoleon and sent him into exile on the island of St. Helena. The extremes of the Ultra-royalist movement gave concern to the allies as to the ability of the monarchy to survive. These concerns were communicated to the king. Obliged to make a choice, and notwithstanding his sympathy with the views of the Ultra-dominated Chamber of Deputies, Louis named a moderate royalist ministry in 1815, which included Armand Emmanuel du Plessis, the Duc de Richelieu, and Elie Decazes. The allies were confident that men of their moderate convictions would not countenance a return to the absolutism of the preceding century, and that a government controlled by them would be stable and would meet with popular approval. Their tenure was reinforced in 1816 when they persuaded the king to dissolve the Chamber of Deputies and order new elections. The electorate returned a majority of moderate royalists who had supported the policies of the ministry, to replace the Ultras. Thereafter, freedom of expression and freedom to print without prior restraint became the rule. But once more, only for a time.

In 1820, the Duc de Berri, nephew and heir to Louis XVIII, was assassinated by a fanatical Bonapartist. The Ultra-royalists rode back into power on the wave of popular outrage which followed. The moderate ministry of Richelieu and Decazes was dismissed and the Ultras regained control of the Chamber of Deputies.

Joseph, Comte de Villèle, an ardent royalist, was named first minister in 1821. In early 1822, following the suppression of an armed insurrection by a radical Bonapartist group, the *Charbonnerie*, the legislature adopted a measure known as the *loi de tendance*. Under this harsh and restrictive measure, the requirement of licensure was reimposed and all criticism of the state, even if no more than indirect or by way of suggestion or innuendo, was once again declared a crime and prosecuted as such. Due process of law, to the extent that it had previously existed, was eliminated in trials for press crimes. A kind of martial law was imposed and violations seen as sufficiently egregious were punished by death. There were enacted and enforced a number of other extreme and reactionary substantive measures. There was no free press to report their enforcement and any efforts to do so were prosecuted vigorously.

On his death in 1824, Louis XVIII was succeeded by his younger brother, the Comte d'Artois, who ruled for a mercifully brief period as Charles X. He was a throw-back to former times, and a believer in the divine right of kings. Such vestiges of constitutional government as had survived Louis quickly expired. Ultra-royalist measures were adopted by the government—in which Villèle continued for a time as first minister—ranging from the imposition of the death penalty for impious acts in churches, to indemnification at public expense of the survivors and descendants of the old nobility who had emigrated from France and were now encouraged to return in large numbers to enjoy life under a sympathetic regime. Measures were proposed under which books, pamphlets, and other materials published at irregular intervals (as well as periodicals) were to require prepublication approval. While these were never enacted into law, censorship, nonetheless, was reinstated by ordinance, a procedure which did not require legislative consent.

Charles X, an irreconcilable absolute monarch, unable to accept or adapt even to moderate change, replaced Villèle with like-minded reactionary ministers—first Martignac and then the Prince de Polignac. Each was somewhat further to the right than his predecessor and thus each was more acceptable to the Ultras whose power and influence flourished under Charles X. Prosecution of any government criticism by the press accelerated. Burdensome fines and sentences of imprisonment were imposed upon recalcitrant publishers. It was at about this time that the aging Marquis de Lafayette, a hero of the American Revolution, and other like-minded republicans who were committed to democratic reform, including recognition of civil liberties and press freedom, moved into, and for a time, dominated, the political arena. A liberal newspaper, *Le National*, became their voice. Its editors and writers were outspoken in their criticism of the regime. Revolution became inevitable.

On 25 July 1830, Charles X announced ordinances which called for the dissolution of the Chamber, restricted those eligible to vote, and suspended whatever press freedom that survived. These are known as the July Ordinances. Under them, printing plants were invaded and impounded by the authorities. Journals were seized; presses were destroyed. In response to these and other infringements of their civil rights, the people went to the barricades and bloody revolution ensued. This was the July Revolution.

27 July through 29 July were three days and nights, known as *les trois glorieuses*, of insurrection. In spite of Charles' belated decision on 30 July to annul the July Ordinances and to replace Polignac, the rebels (who had originally sought only to accomplish the objectives the king was now prepared to concede) decided to replace the regime in its entirety.

On 9 August 1830, the Duc d'Orléans, a highly popular figure, was named "by the grace of God and the will of the nation" Louis-Philippe, King of the

French. In the frenetic six-day interim following the abdication of Charles X on 3 August, Lafayette and other republicans met with the Chamber of Deputies and reached agreement to revise a repromulgated *Charte* in such a way that it was made manifest that prior restraint of publication or censorship could "never" again be imposed. Never is a very long time.

Louis-Philippe, whose ascent to the throne dashed republican hopes, pledged himself to the principles of the *Charte*. However, he soon disappointed those who thought of him as a constitutional monarch and their greatly admired citizen-king. Despite his lengthy exile in the United States, democracy had taught Louis-Philippe little and he had learned nothing from the fate of the Alien and Sedition Laws. In trying to satisfy all constituencies, from extreme royalists on the right to the republicans on the left, he succeeded in satisfying few and pleasing none. His centrist government, known as *juste milieu*, found itself at odds with both sides. Predictably, press freedom was among the first casualties. Government can avoid the consequences of much misgovernment when there is no one to report its deficiencies.

Censorship was soon reimposed in the interest of governmental stability. As in the McCarthy era of the 1950s, the early nineteenth-century equivalent of a communist conspiracy was feared, possibly with greater justification than in this country. Clandestine associations structured much like the communist cells of the twentieth century, calling themselves the Society of the Rights of Man, spread throughout France. Among their objectives was redistribution of wealth and property. Their suppression—and suppression of the right of free assembly which had made their existence possible—was quick and bloody.

It should be noted here that by no process of reasoning or rational philosophy does freedom to publish imply freedom to publish that which is untrue. Press freedom absolutists to the present day will agree that it is no infringement of civil right to hold the press accountable when its freedom from prior restraint is abused and those of whom it writes are defamed. Under the July Monarchy, much of what appeared in the press aimed at public figures was both libelous and malicious, and defamatory by any definition, even that of the Supreme Court of the United States in this century.

Publishers and editors were prosecuted for defamation. They and their artists were imprisoned for outrageously disrespectful and merciless caricatures of the king and his ministers. With the imposition of a stamp tax (the stamp to be prominently placed so as to deface the publication), there was, in practical effect, a resumption of censorship. Charles Philipon, publisher of *La Caricature* and of *Le Charivari* and an indefatiga-ble critic of *juste milieu*, spent six months among common criminals in the Sainte-Pélagie prison for publishing a caricature, the joint work of Grandville and Forest. It was titled *The Resurrection of the Censor*, and in it they cruelly depicted a resurrected Comte Antoine Marie Appollinaire D'Argout, a cabinet minister whose Department of the Interior was charged with enforcing the laws designed to control the press. D'Argout, whose gross and unmistakable pointed nose exposed him inevitably to gross and unmistakable caricature, is shown brandishing a huge pair of censor's shears. This powerful caricature appears as no. 86 in the exhibition.

Honoré Daumier went even further by caricaturing the king as the Rabelaisian monster Gargantua, in an unflattering and indeed revolting pose. Not unexpectedly, Louis-Philippe took offense. As a result, Daumier was tried, convicted, and incarcerated for five months during 1832 and 1833.

Louis-Philippe, who was given to dining well and had developed an ample and pear-shaped *embonpoint*, is frequently encountered in caricature depicted in the form of a pear. Despite the fact that Philipon was prosecuted and convicted for originating this disrespectful caricature, the pear became the universal convention for the king (nos. 96, 97, 165).

The fines imposed for defaming the king grew to enormous proportions and soon exceeded the ability of publishers to respond. Funds were needed to meet this increasing cost of doing business. On 30 July 1832, two years to the day from the night of the barricades following which so much had been promised and so many promises reneged upon, Philipon conceived *L'Asssociation mensuelle lithographique* (Monthly lithographic association). Through it he sought to create a source of revenue that would enable him to meet the fines he anticipated would continue to be imposed, because he had no intention of discontinuing the activities they were designed to discourage. Each month for twenty-four months, an enlarged caricature was published and sold for an annual subscription of twelve francs. Grandville, Raffet, Forest, David, Desperet, Julien, Daumier, and Traviès all contributed plates to the monthly series.

The publications of *L'Association mensuelle* were enthusiastically awaited and received; many thousands were sold. Perishable and frequently not carefully preserved, notwithstanding Philipon's accurate prediction that they would in time be valued at many times their cost, they are today rare and difficult to come by. The exhibition contains three of the twenty four: two by Traviès and one by Daumier, who contributed five in all to the project.

The lithograph by Daumier, *Rue Transnonain, le 15 Avril, 1834* (no. 29) is generally considered the most

powerful and moving of all the publications of *L'Association mensuelle* and is thought by many critics to be the greatest of Daumier's lithographic works. Béraldi names it Daumier's masterpiece and Baudelaire writes that it transcends caricature. Philipon disclaimed it as caricature and called it blood-soaked modern history, prompted by heroic rage. In this last publication of *L'Association mensuelle*, Daumier depicts the tragic detritus of the events of 15 April 1834—the massacre of innocents by undisciplined soldiers of the thirty-fifth Regiment of the Line. These inexperienced troops had been mobilized in Paris to restore order when the citizenry revolted against the law of 10 April 1834 which, among other things, repudiated the right of free assembly. Infantrymen attacked and slaughtered unarmed and aged men and women, as well as children, in a tenement building at No. 12 rue Transnonain. Daumier's fury is manifest in the powerful and dramatic image he created in this print.

Charles-Joseph Traviès de Villiers, called Traviès, was born in Switzerland in 1804 of English stock, but became, and is thought of as, a French artist. He was regarded as a man of formidable talent. His caricature portrait by Benjamin Roubaud carries the legend '*De Traviès le nez est saillant—comme le nez est le talent*' (the talent is as prominent as the nose). Baudelaire, who called Traviès "the Prince of Misfortune" for his tragic life, equated him with Daumier. Largely forgotten today and frequently overlooked in accounts of the period, he is well represented in this exhibition. His two contributions to the publications of *L'Association mensuelle* are among the most powerful and notable criticisms of the regime to be found among the twenty-four.

Les Faux monnayeurs (The counterfeiters), (no. 166), was published in October 1833 as the fifteenth of the series. It is a subtle description of Louis-Philippe's judges grinding out fines, or "counterfeit currency," which the king, whose ample posterior appears behind the machine, bears off in a basket. The figure feeding journals into the mill to be ground into counterfeit money is Attorney General Persil, one of Louis-Philippe's ministers. The rest of the individuals caricatured are identifiable as other ministers. The king is seen doubly in his conventional form as a pear atop the machine with both his head and his posterior assuming this form.

The penultimate of the *mensuelle* series (no. 167), bears the supremely ironic legend, '*Le Docteur Gervais prétendait avoir vu cela, les prisonniers prétendaient avoir été assassinés par les sergents de ville et les mouchards—la justice leur a prouvé le contraire.*' Dr. Gervais had in fact observed the murder of prisoners by plain-clothes officers of the *Brigade de Sûreté*, whom he calls *mouchards*,

or sneaks, and the uniformed police *sergents de ville*. Although his account of the incident, in which he referred to the police as "assassins", was corroborated by witnesses, he was tried and convicted for defamation. Thus Traviès in his lithograph describes the event as one in which Dr. Gervais mistakenly "pretended" to observe, and the prisoners mistakenly "pretended" to have been killed. Justice under Louis-Philippe, Traviès points out, corrected those erroneous impressions and ultimately proved that quite the opposite had occurred, the eye-witness accounts to the contrary notwithstanding.

Perhaps the best-known of Traviès' creations is the mischievous hunch-back dwarf, Mayeux (no. 162), who was also frequently borrowed and used by Traviès' contemporaries. No. 173 depicts Mayeux in company with Robert Macaire, a creation of Daumier's (no. 32), who embodies the ultimate confidence man. Mayeux and Robert Macaire were parodies of different aspects of the middle class during the reign of the bourgeois king, Louis-Philippe.

In July 1835, there was an unsuccessful attempt to assassinate Louis-Philippe. A concerned government promptly took extreme steps to protect his person and itself. Thus some of the most repressive press laws known to history were enacted. For all practical purposes, they rendered all forms of political satire impossible owing to the severity of the penalties prescribed for their violation. *La Caricature* closed its doors and suspended publication in August 1835. Philipon revived it for a few years from 1839 to 1842, but not as the political weapon it had originally been.

Caricature thereafter, as can be seen in the later plates shown in the exhibition, confined itself to entertaining, but largely innocuous, social comment on the customs of the day. As in another celebrated caricature by Daumier, *Baissez le rideau, la farce est jouée*, the curtain had fallen. The heroic era of political caricature had come to an end.

In preparing this essay, I have consulted only standard historical works which have come readily to hand. I have also turned to statutes, ordinances, and contemporary commentary, both textual and graphic, particularly Le Charivari *and* La Caricature, *and those to which primary sources led. The Henry E. Huntington Library in San Marino, California, and the libraries of the University of California have been more than accommodating in making materials from their collections available and I take this means of expressing my appreciation. Edwin de T. Bechtel's* Philipon versus Louis-Philippe *(New York: The Grolier Club, 1952) was most useful. Indeed, there is little here which is not discussed in greater scholarly detail in Bechtel's account of the origins, birth, and death of* L'Association mensuelle lithographique *which I commend to the reader who wishes further to pursue the subject.*

COLOR PLATES

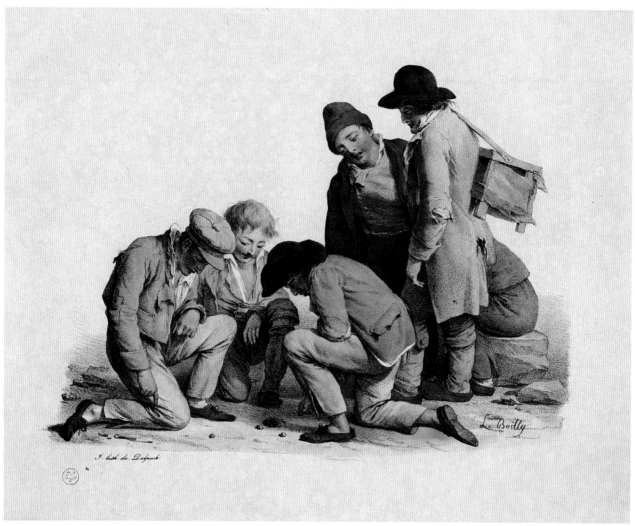

2. Louis-Leopold Boilly, *Le Jeu de Billes* (see p. 40)

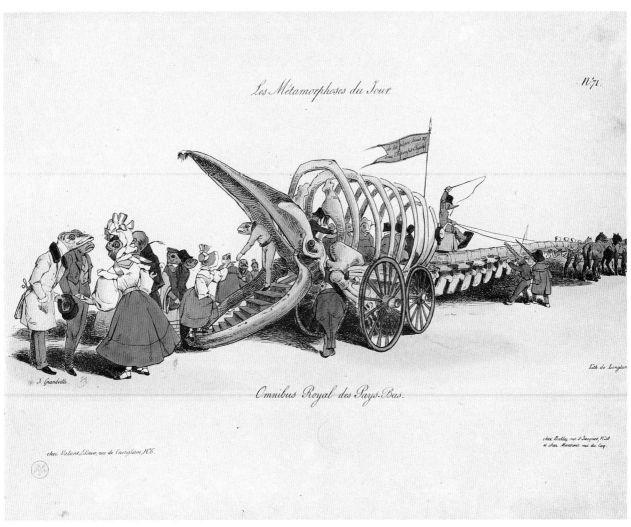

84. Grandville (Jean Ignace Isidore Gérard), *Omnibus Royal des Pays-Bas* (see p. 95)

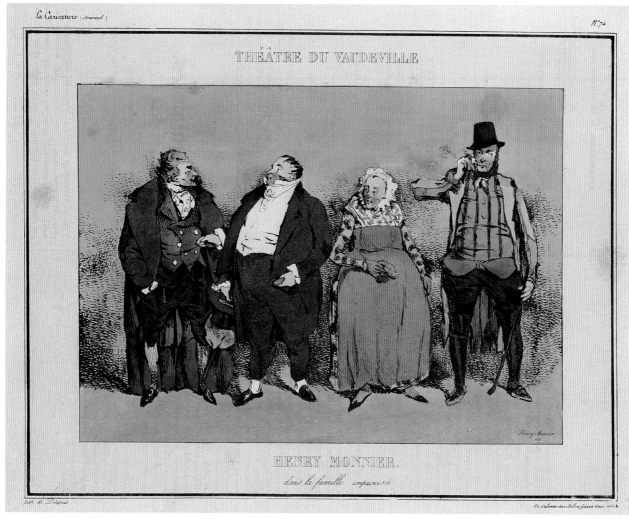

THÉÂTRE DU VAUDEVILLE

HENRY MONNIER.

dans la famille improvisée

111. Henry Monnier, *Thèâtre du vaudeville: Henry Monnier dans La Famille improvisée* (see p. 114)

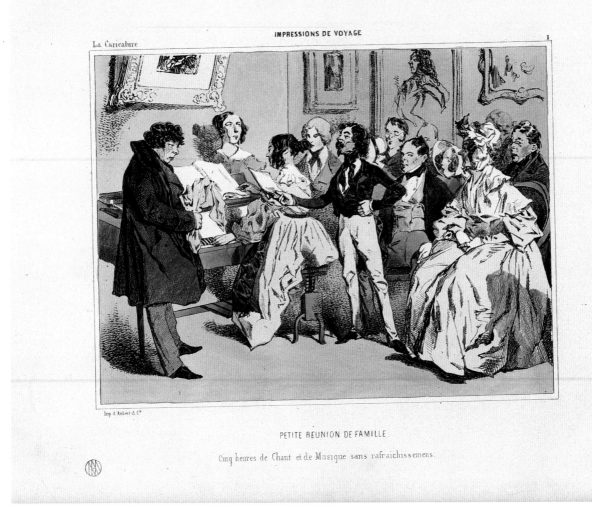

PETITE RÉUNION DE FAMILLE.

Cinq heures de Chant et de Musique sans rafraichissemens.

115. Henry Monnier, *Petite réunion de famille* (see p. 116)

123. Charles Philipon, *Armes du peuple* (see p. 123)

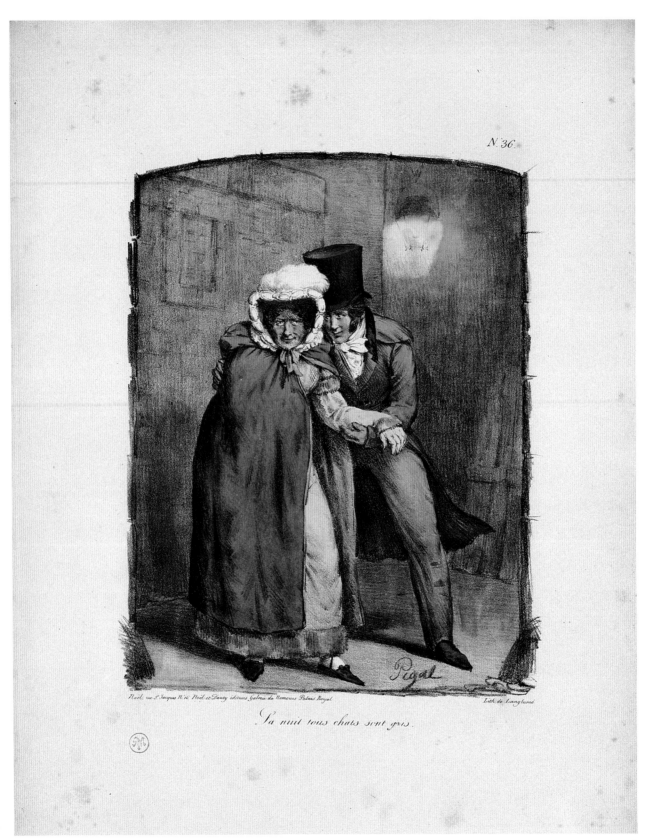

La nuit tous chats sont gris.

136. Edme Jean Pigal, *La nuit tous chats sont gris* (see p. 135)

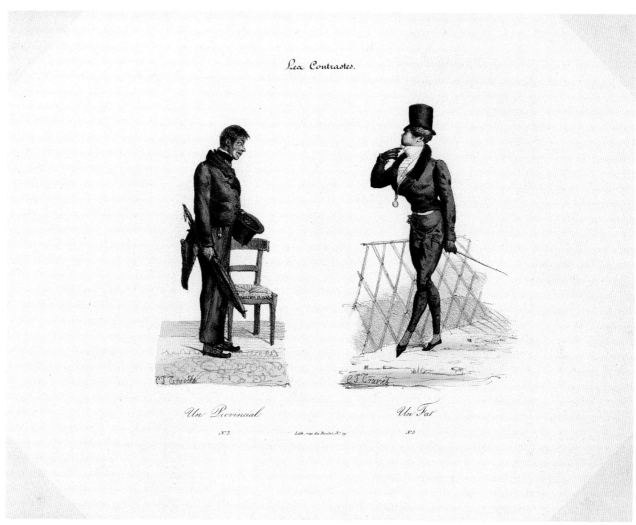

160. Charles-Joseph Traviès, *Un Provincial/Un Fat* (see p. 149)

carle Vernet

J. lithog de Delpech

Marchand de Tisanne.

a la fraiche, qui veut boire? v.. la l'coco!

189. Carle Vernet, *Marchand de tisanne* (see p. 169)

CATALOGUE NOTES & ABBREVIATIONS

All the works in this exhibition were given to the Santa Barbara Museum of Art by Albert and Dana Broccoli, Mr. and Mrs. Michael Wilson, and Mr. and Mrs. Stuart Kadison, except for a small number of special purchases and three loans. The donors are identified in each entry by the initials ADB, MW, or SK, and lenders are identified by name.

The prints are lithographs, some with hand-coloring as indicated. Many of them are impressions extracted from newspapers and were never published in any other form. Others were printed *sur blanc* (on better quality white stock) for separate sale and for framing. No distinction between these types is made in the catalogue.

Individual entries identify each print with the original French caption transcribed as it appears on the print, followed by the English translation. In some cases, letters or diacritical markings missing in the original have been supplied and minor idiosyncrasies of orthography corrected to avoid confusion. The publisher, printer, and distributor are indicated where known, and standard catalogue or monographic citations are given when available. We have chosen not to include individual measurements since most of the lithographs are similar in page size.

The catalogue is organized alphabetically by artist, with the lithographs ordered chronologically, with a few unavoidable exceptions. Prints published as a series are so identified and prints which appeared in the periodicals *Le Charivari* and *Le Caricature* are identified and dated accordingly.

Most of the translations of captions and quotations are the combined efforts of several researchers.

The following abbreviations are used throughout the catalogue to indicate standard references.

Inventaire... Adhémar, Jean, et al. *Inventaire du fonds français après 1800*. 15 vols. Paris: Bibliothèque nationale, 1930 –.

Armelhaut and Bocher... Armelhaut, J., and E. Bocher. *L'Oeuvre de Gavarni*. Paris: Librairie des Biblio-philes, 1873.

Béraldi... Béraldi, Henry. *Les Graveurs du XIXe siècle*. 11 vols. Paris: C. Conquet, 1891.

Dayot... Dayot, Armand. *Carle Vernet: Etude sur l'artiste*. Paris: Le Goupy, 1925.

D... Delteil, Loÿs. *Le Peintre-graveur illustré*. 32 vols. Paris: Chez l'auteur, 1906-70.

Farwell, *FPLI*... Farwell, Beatrice. *French Popular Lithographic Imagery, 1815-1870*. Vols. 1-8. Chicago: University of Chicago Press, 1981- .

Ferment... Ferment, Claude. "Charles-Joseph Traviès, catalogue de son oeuvre lithographié et gravé." Cabinet des Estampes, Bibliothèque nationale, Yb³2774.

Giacomelli...Giacomelli, Hector. *Raffet, son oeuvre lithographique*. Paris: Bureau de la Gazette des Beaux-Arts, 1862.

Harrisse... Harrisse, Henry. *L.-L. Boilly*. Paris: Société de propagation des livres d'art, 1898.

La Combe... La Combe, Joseph Felix Leblanc de. *Charlet, sa vie, ses lettres*. Paris: Paulin et Le Chevalier, 1856.

Marie... Marie, Aristide. *Henry Monnier (1799-1877)*. Paris: Floury, 1931.

Sello... Sello, Gottfreid. *J.-J. Grandville, 1803-1847: Das Gesamte Werk*. 2 vols. Munich: Rogner V. Bernhard, 1969.

Thieme-Becker... Thieme, Ulrich, and Felix Becker. *Allegmeines Lexicon der Bildenden Küntsler*. 37 vols. Leipzig: Seeman, 1907-50.

Vanhevhe... Vanhevhe, Marie-Anne. *Henry Monnier, l'homme et l'oeuvre, 1799-1877, dessins et lithographies*. Thesis and catalogue, Brussels: Université Libre de Bruxelles, 1953-54.

Authorship of biographies and entries, sometimes multiple, is indicated by initials, as follows:

GB Geoffrey Barraclough
BF Beatrice Farwell
PH Patricia Halloran
AL Ann Lenard
KO Karen Oakley
BP Brian Parshall
RP Robin Ptacek

Louis-Leopold Boilly (1761-1845)

Louis-Leopold Boilly, a painter and lithographer, made images of contemporary genre that form a bridge between the eighteenth and nineteenth centuries. Born in La Bassée, a village in northeastern France which had at times been under Flemish influence, Boilly's interest in genre follows a long Flemish realistic tradition. He received his first drawing lessons from his father, a wood sculptor. As a youth he left La Bassée to become an itinerant portrait painter in the nearby towns of Douai and Arras, where he came in contact with seventeenth-century Dutch and Flemish genre painting in the homes of his patrons. Dutch genre formed an important source of themes for the lithographic work that he adopted late in life, and his painting technique retained the influence of the seventeenth-century Dutch artist Gerard Dou in its smooth and meticulous realism.

In 1786 Boilly travelled to Paris, where he became successful as a painter of aristocratic amorous intrigues and "refined genre" in a manner reflecting the influence of Fragonard. Another, more sentimental, trend in eighteenth-century genre came from the middle class, and in the 1780s and 1790s Boilly also produced genre paintings of bourgeois subjects.

During the French Revolution and the First Republic, Boilly, essentially a royalist, continued to depict the aristocracy at play.[1] In 1793 he was called before the Société Republicaine and cited for immorality.[2] Aware that other artists had been sent to prison or the guillotine, Boilly immediately composed *The Triumph of Marat*, thereby gaining a pardon from the revolutionary tribunal. This painting marks the beginning of Boilly's adoption of the then-current neoclassical style, in which he created a large and well-known body of works though his subjects remained contemporary.

In 1804 Boilly exhibited paintings of the outdoor life of the city, beginning a new phase in his career. Scenes of the arrival of a diligence and the promenade in the gardens of the Palais Royal relate his art to the eighteenth-century engraver Debucourt, yet prefigure the urban subjects of such realists as Manet

and the impressionists of sixty years later.

Today, at least outside France, Boilly is best known for his lithographs. Although credited with having drawn the first dated lithograph in France in 1802, he did not return to the medium until 1822, when he more or less abandoned oil painting.[3] The caricatural aspects of his lithographic work go back to the English caricaturists Cruikshank, Gillray, and Rowlandson and the earlier innovations of Hogarth. His most popular series of lithographs, *Recueil de grimaces* (Collection of grimaces), was published between 1823 and 1828, and is well represented in this exhibition. The vignetted subjects of these prints appear to be cut out and applied to a plain background, a format also used by Pigal during the Restoration. The series was so popular that Philipon's printer Aubert re-published it in 1837 under the new title *Groupes physionomiques* (Physiognomic groups).

Boilly produced only two other major series: *Recueil de dessins lithographiques* (Collection of lithographic drawings) of 1822, and *Recueil de sujets moraux* (Collection of moral subjects) of 1827. A suite entitled *Recueil de croquis dessiné à Rome par J. Boilly et lithographiés par son père* (Collection of sketches drawn in Rome by J. Boilly and lithographed by his father) appeared in 1826. Boilly committed to stone these views of Rome produced by his son Julian.

While belonging mainly to the eighteenth century in both style and subjects, Boilly nevertheless was also one of the first artists to depict modern types, including the fallen woman and the Parisian *gamin*. While in his lithographs he most often employs eighteenth-century styles derived from the English caricaturists and Greuze, some of his prints from the Restoration period anticipate the realism of the mid-nineteenth century. His art displays skilled artistry, life, grace, and charm, reflecting its eighteenth-century sources.

Boilly's lithographic oeuvre was made before the era of illustrated newspapers; they were printed on good paper, usually hand colored, and intended for the single sheet and album market, like the engraved works of an earlier time. His royalist politics would

never have aligned him with a publisher like Philipon in any case, though Philipon did later reprint his more popular series. Nevertheless, Boilly stands as a pioneer in the use of the new lithographic medium, prophetically manifesting its historic association with the contemporary, the intimate, and the lowly.

AL/RP/BF

[1] Champfleury, *Histoire*, 239.
[2] Mabille de Poncheville, *Boilly*, 56-59.
[3] *Inventaire* 2:53.

1

Les Fumeurs.
1822 (hand-colored)
The smokers.

Series: *Recueil de dessins lithographiques*
Printer: Delpech
Catalogued: Harrisse, no. 1245;
 Inventaire, no. 2
Reference: Farwell, *FPLI* 2, 4G7

This lithograph represents two working class men: a Parisian porter, identified by the *crochet-de-portefaix* (a wooden chassis porters strapped on their backs to carry their loads), gets a light from a co-worker. Their image forms a link between the Dutch and Flemish realism of the seventeenth century and that of Courbet's *Stone Breakers* in the mid-nineteenth. Pipe smoking, imported from America, had been common in Europe since the seventeenth century. The theme of workmen smoking can be seen in such paintings as Brouwer's *The Smoker* of 1636 and many others. Manet was also to treat the smoker theme in several pictures, and Cézanne gave it specifically working-class flavor in *The Card Players*. Boilly depicted smokers in three other lithographs from the series *Recueil de grimaces*.

AL/BF
1985.48.172 (ADB)

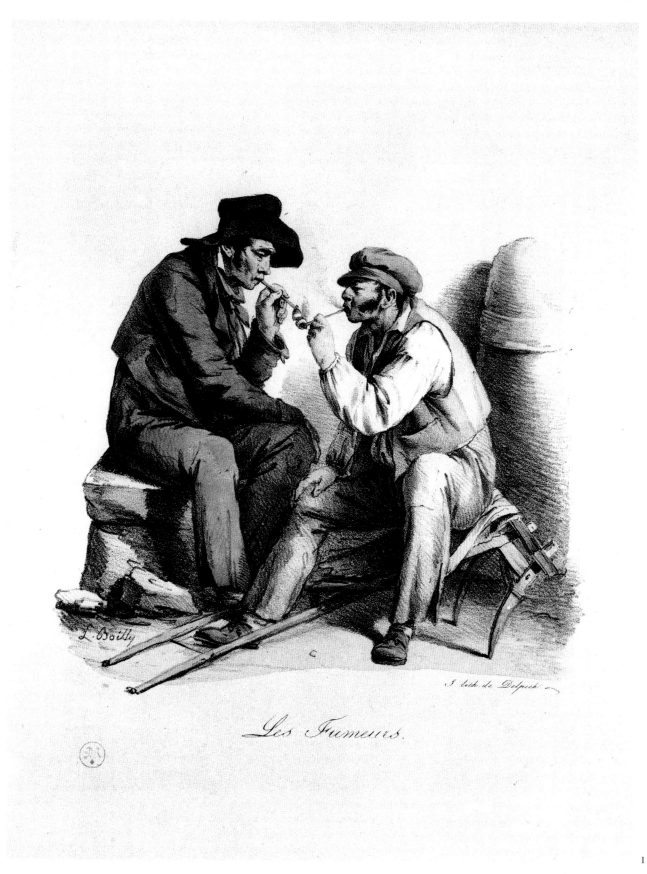

Les Fumeurs.

2

Le Jeu de Billes.
c. 1822 (hand-colored; illustrated on
 page 29)
Marbles.

Printer: Delpech
Catalogued: Harrisse, no. 1250;
 Inventaire, no. 5
Reference: Farwell, *FPLI* 3, 3A10

Children's games had been a subject
for painters since at least the time of
Pieter Bruegel the Elder. Boilly, in his
quest for contemporary Parisian subject
matter, frequently represented the pas-
times of both young and old, as here in
a group of Parisian *gamins* playing a
game of "megs" (the marbles of the
poor, made of clay). At a later date
Boilly represented a similar group
pitching pennies.[1]

These prints represent pastimes of
the children of the poor, who used the
city streets for playgrounds and consti-
tuted that special category of the urban
population, the *gamin de Paris*.[2] Other
representations of this impertinent,
streetwise type may be seen in works by
Pigal (nos. 127 and 130) and Traviès
(no. 171) in this exhibition. The *gamin*
is usually shown fighting or challenging
authority. Boilly, although he shows his
urchins in rags, makes them peaceable
and appealing. In these images his mode
is genre rather than caricature.

AL/BF
1985.48.156 (ADB)

[1] Farwell, *FPLI* 3, 3A8.
[2] Jules Janin, "Le Gamin de Paris,"
 Les Français peint par eux-mêmes
 2, 161.

3

Le Défi.
1823 (hand-colored)
The challenge.

Printer: Delpech
Catalogued: Harrisse, no. 1241, p. 192;
 Inventaire, no. 3

This print is essentially a good-
humored caricature of working-class
style in street fighting. Although it rep-

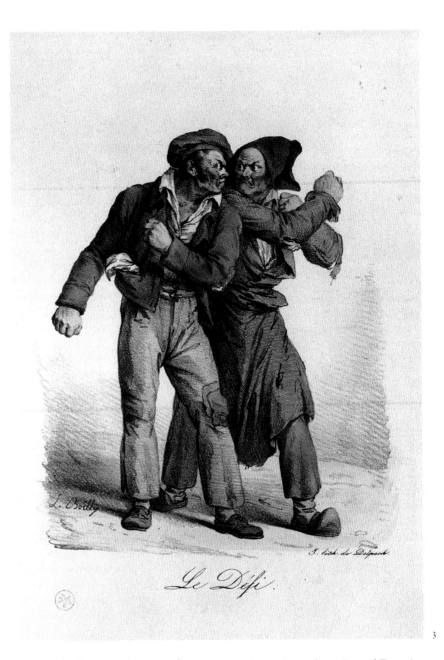

resents the urban poor in rags and
patches, as an image it certainly presents
no threat to the status quo as it might
have done in the 1840s, when two hun-
dred thousand poor laborers inhabited
Paris and a working-class Revolution
was brewing.

The battered Napoleonic bicorne
worn by the figure at the right, no doubt
a discard from some more prosperous
individual, does suggest the plight of vet-
erans of the Napoleonic army, among
whom unemployment and bitter poverty
were at their height in the period of this
print. Boilly was, however, no radical, and
nothing in his art suggests the kind of

social conscience that animated Daumier
in the early thirties, or a painter like
Courbet at mid-century.

BF
1985.48.167 (ADB)

4

Le baume d'acier.
1823 (hand-colored)
The solace of steel.

Series: *Recueil de grimaces*, pl. 33
Printer: Delpech

Catalogued: Harrisse, no. 1282;
 Inventaire, no. 7(33)
References: Pindborg, J. J. and L.
 Marvitz, *The Dentist in Art* (London:
 G. Proffer, 1961), p. 104, ill. p. 105;
 Mabille de Poncheville, *Boilly*, p.
 136, ill. opp. p. 136.

Until the mid-nineteenth century,
dentistry was only occasionally carried
out by a specialized surgeon, and more
often by wandering market performers,
quack doctors, local blacksmiths, and
other untrained practitioners. While the
theme of dentistry was known in Greek
and medieval art, closer prototypes for
the image of the dentist in nineteenth-
century prints are found in seventeenth-
century genre paintings, where the
image of the dentist was often used to
illustrate the sense of touch in series
depicting the five senses. During the
eighteenth century, the subject appears
in prints by Thomas Rowlandson, who
often drew satirical caricatures of the
medical and dental professions, as did
Daumier and his immediate forebears in
the following century.

AL
1985.48.165 (ADB)

5

L'Enfance.
1823 (hand-colored; illustrated as
 frontispiece)
Childhood.

Series: *Recueil de grimaces*, pl. 14
Printer: Delpech
Catalogued: Harrisse, no. 1280;
 Inventaire, no. 6(14)
Reference: Grand-Carteret, *Moeurs et
 caricature*, ill. p. 141

The series *Recueil de grimaces*, pub-
lished over the course of five years,
included ninety-six lithographs, five of
which are included in this exhibition.
L'Enfance is one of two lithographs of
the same title from the series, both of
which represent various humorous
expressions of children.
 Boilly's popularity during the
Restoration was largely due to this
series. The interest in expressive heads
had precedent in France in the work of
Charles Le Brun, who, inspired by

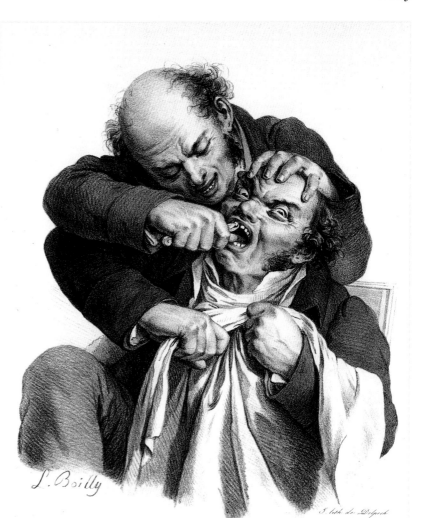

L. Boilly

Le baume d'acier?

Descartes, wrote and illustrated *Traité
sur la physionomie de l'homme comparée à
celle des animaux* (Treatise on the phys-
iognomy of man compared to that of
the animals). During the late eigh-
teenth century, physiognomy, the art of
reading inner character by means of
facial characteristics, was popularized
by engravings illustrating Lavater's
well-known *Essays on Physiognomy*,
which may well have influenced the
format of Boilly's *Recueil de grimaces*.

AL
1985.48.159 (ADB)

6

La Félicité parfaite.
1823 (hand-colored)
Perfect happiness.

Series: *Recueil de grimaces*, pl. 18
Printer: Delpech
Catalogued: Harrisse, no. 1279;
 Inventaire, no. 6(18)
References: Farwell, *FPLI* 3, 4D7;
 Haraucourt, *L'Amour et l'esprit
 gaulois*, vol. 4, ill. p. 219

Harisse describes this print as "Two
drunkards: a man and a woman. They
are drinking wine, each holding a bottle

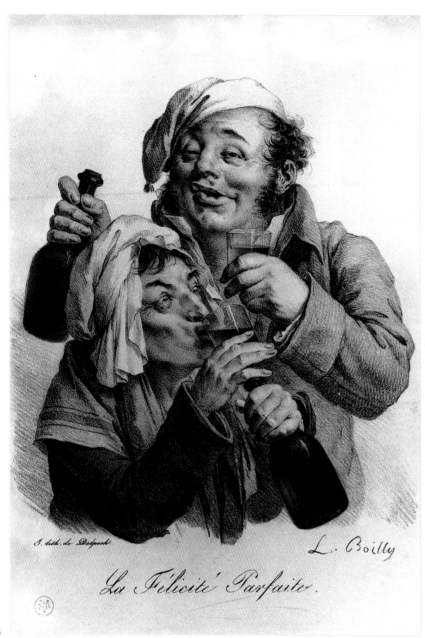

J. lith. de Delpech.

Le Félicité Parfaite.

L. Boilly

in one hand and a glass in the other."[1] In servants' dress, they are most likely drinking the cheap wine of the Parisian poor,[2] though perhaps it is of better quality and the property of their masters.

The theme of drinking relates this print to such seventeenth-century Dutch and Flemish prototypes as tavern scenes by Franz Hals, Gerard van Honthorst, and Adriaen Brouwer. In these works, drinking was associated with other themes of merry-making, including smoking, dancing, playing cards, and love-making. Often seventeenth-century drinking scenes were inspired by the theme of the Prodigal Son. Boilly's depic-

tion of drinkers is, however, apparently without moral content.[3]

The theme of drinking and merry-making may also be seen in Daumier's cabaret and *barrière* scenes of the 1850s, and in the drinking poor in the prints of Traviès, to which these figures are even more closely related (Traviès, no. 174).

AL
1985.48.163 (ADB)

[1] Harrisse, *Boilly*, 204.
[2] Farwell, *FLPI* 3:12.
[3] Bob Haak, *The Golden Age: Dutch Painters of the Seventeenth Century* (New York: Abrams, 1984), 89.

7

Ah! Le chie-en-lit-lit-lit.
1824 (hand-colored)
Oh! What a funny face.

Series: *Recueil de grimaces*, pl. 36
Printer: Delpech
Catalogued: Harrisse, no. 1294;
 Inventaire, no. 7(36)

This is the same print that was later published by Aubert under the title *Le Vilain masque*. Here two children are taunting a costumed figure, while another blows on a carnival horn. The costume of the masquerader consists of a *chaperon*, a hooded outfit dating from the Middle Ages, and a mask, which appears to be that of Satan the Devil or Mago the Warlock, characters who were the last surviving vestiges of medieval mystery plays. They are apparently participating in the popular carnival festivities.

Annual carnival celebrations which take place in many Roman Catholic countries during the period preceding Lent may have their origin in the ancient Roman Saturnalia, to which they often have been compared. In Paris during the nineteenth century, carnival began at Epiphany (6 January) and culminated in the celebration of Mardi Gras, the day before Ash Wednesday. During this period, the streets of Paris were crowded with masked, costumed figures and spectators. Festivities continued throughout the night at costume balls, which had been a part of carnival in France since the fifteenth century. Being incognito encouraged a freedom from convention in the behavior of the participants, and is seen more frequently in carnival pictures of adults than of children (Gavarni, nos. 74 and 78).

AL
1985.48.154 (ADB)

Bibliography:
Olson, N., *Gavarni: The Carnival Lithographs.*
Sand, Maurice. *The History of the Harlequinade.* London: M. Secker, 1915.

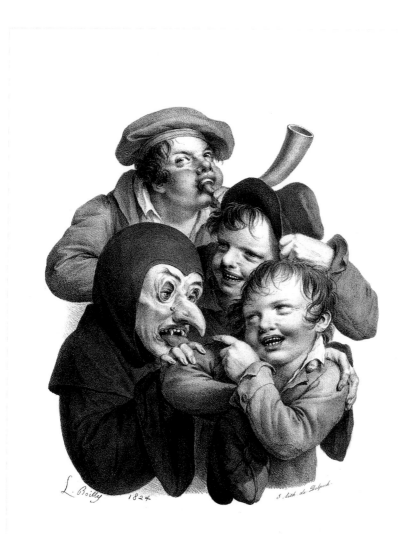

ah! le chie-en-lit, lit, lit.

9

L'Orgueil.
1824 (hand-colored)
Pride.

Catalogued: Harrisse, no. 1304

Representations of the seven deadly sins were no novelty in the nineteenth century, being familiar from medieval decorative programs for churches in both painting and sculpture. Boilly followed an age-old tradition in this image which must have belonged to a moralizing suite.

The sin of pride is here represented in the contemporary terms of the Bourbon Restoration: an aristocratic "Ultra" casts a withering glance at his servant who cringes as he delivers his master's mail. Though Boilly held royalist sympathies, this image comes close to being a caricature of the portly Louis XVIII who died in the year the print was made.
BF
1985.48.161 (ADB)

10

Les Petits ramoneurs.
1824 (hand-colored)
The young chimney sweeps.

Printer: Delpech
Catalogued: Harisse, no. 1289

Boilly's characteristically appealing renderings of children appear here in a group of young chimney sweeps, in the same vignetted format as in the *Grimaces* series.

In a period without child labor laws, and one in which children were put to work once it was clear they were going to survive, youngsters like those depicted swelled the labor force. They were commonly found in the chimney sweep's trade, as their small size was appropriate to the narrow spaces in which they worked. Most Parisian chimney sweeps were boys from the poverty-stricken province of Savoy, hence their frequent epithet of *Savoyard* (no. 11).[1]
BF
1985.48.177 (ADB)

7

8

L'Envie.
1824 (hand-colored)
Envy.

Series: *Recueil de grimaces*, pl. 46
Printer: Delpech
Catalogued: Harrisse, no. 1309;
 Inventaire, no. 7(46)

Although included in *Recueil de grimaces*, this print was also published in 1824, along with six other pieces, as a separate series entitled *Les Sept péchés capitaux* (The seven deadly sins). In *L'Envie*, a ladies' maid in bonnet and

fichu is admiring enviously the jeweled cross of her elegant mistress.

In the hands of a more radical artist, the theme of class distinction in this print might be interpreted as subversive, but such a reading is probably not warranted here.
AL/BF
1985.48.160 (ADB)

[1] Farwell, *FPLI* 2:23. See also A. Frémy, "Le Ramoneur," *Les Français peints par eux-mêmes*, 1:146-52.

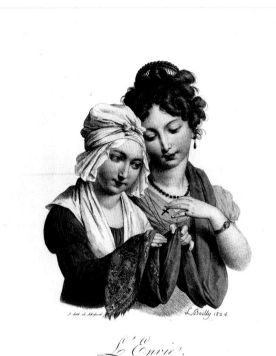

L'Envie.

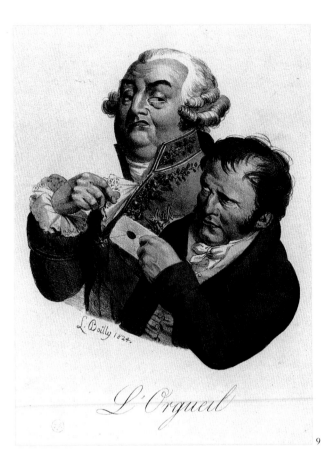

L'Orgueil

8

9

11

Les Savoyardes.
1824 (hand-colored)
The girls of Savoy.

Printer: Delpech
Catalogued: Harrisse, no. 1290

Five young girls are depicted in vignette, in the traditional folk costume of Savoy with its distinctive headdress. In the early nineteenth century, Savoy was an independent kingdom ruled by the Piedmontese royalty. Culturally and linguistically a part of France, it was politically linked to Italy until later in the century when Napoleon III brought the province into his Empire as a new *département* of France. A mountainous place of great natural beauty, it was also, in the first half of the nineteenth century, one of the economic hinterlands of Europe, isolated and bypassed by the Industrial Revolution. Much of the burgeoning population emigrated to France where poor Savoyard boys and girls became street musicians and performers and filled the lowest paid jobs where education was

not needed. The girls often became laundresses, seamstresses, or shopgirls.
RP
1985.48.178 (ADB)

12

Je te donne ma malédiction.
1827 (hand-colored)
I put my curse on you.

Series: *Recueil de sujets moraux*
Printer: Delpech
Catalogued: Harrisse, no. 1221;
 Inventaire, no. 35
References: Brookner, *Greuze*, p. 149,
 pl. 107

A popular theme in nineteenth-century prints was that of the country girl who goes to the city, either as a domestic or seduced by a young dandy who soon abandons her; she eventually returns to her village home for the inevitable *accouchement*.[1] Brookner suggests the continuity of this theme with that of the *Malediction paternelle*, in which the son leaves his country home

to seek his fortune in the city. While the ungrateful son was generally the stock figure of the eighteenth century (as in Greuze's *The Punished Son)*, the nineteenth century preferred the fallen girl.[2]

Here a village mother curses her daughter who has arrived home from the city attired in the latest fashion. While the theme of the print relates it to the nineteenth century, the style is decidedly based on the eighteenth-century theatrical poses and gestures of Greuze, whose incorporation of moral teachings in his work was derived from the didactic aesthetic theories of Diderot.

AL
1985.148.157 (ADB)

1 Farwell, *FPLI* 3:4.
2 Anita Brookner, *Greuze* (Greenwich, Conn: New York Graphic, 1972), 149.

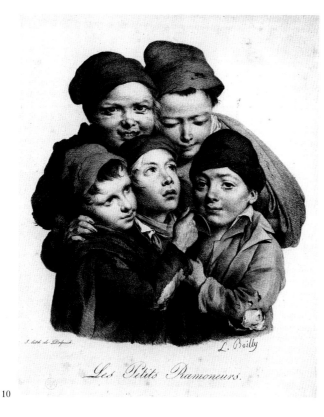

J. lith. de Delpech. *L. Boilly*

Les Petits Ramoneurs.

10

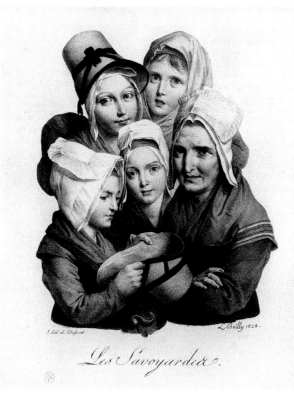

J. lith. de Delpech. *L. Boilly 1824.*

Les Savoyardes.

11

13

Le Jeu de dames.
1836
Checkers.

Printer: Lemercier
Catalogued: Harrisse, no. 1246;
 Inventaire, no. 45
Reference: Farwell, *FPLI* 3:3A7

The game of checkers does not appear to have been played in Europe prior to the middle of the sixteenth century. Its name in French, *jeu de dames*, derives from the fact that the men were called *pions*, or pawns, until they reached the other side of the board, then became *dames*, or queens.[1]

Here, two men are playing checkers in a cafe, while a group of older men watch or engage in conversation. Cafes, which developed from the eighteenth-century coffee house, proliferated in Paris during the nineteenth century as places to eat, drink, and relax.

The format of this work, with its double rectangular border, is characteristic of lithographs of the 1830s. In style, it displays Boilly's progressive blend of realism and neoclassicism. In both theme and composition, this, like *The Smokers*, prefigures Cézanne's paintings of card players of the 1890s. *Le Jeu de dames* is similar to a painting by Boilly entitled *Un Café*, which was exhibited at the Salon of 1824 and purchased by the Duc d'Orléans, who was to become King Louis-Philippe in 1830.[2] An undated lithograph by Boilly reproducing the painting is entitled *L'Interieur d'un café*.[3] Such subject matter prefigures the work of other lithographers such as Monnier, Gavarni, and Daumier, and later, paintings by Degas.

AL
1985.48.168 (ADB)

1 A. Howard Cady, *Checkers: A Treatise on the Game* (New York: American Sports Publishing Co., 1896), 9.
2 Mabille de Poncheville, *Boilly*, 195.
3 Harrisse, no. 1266.

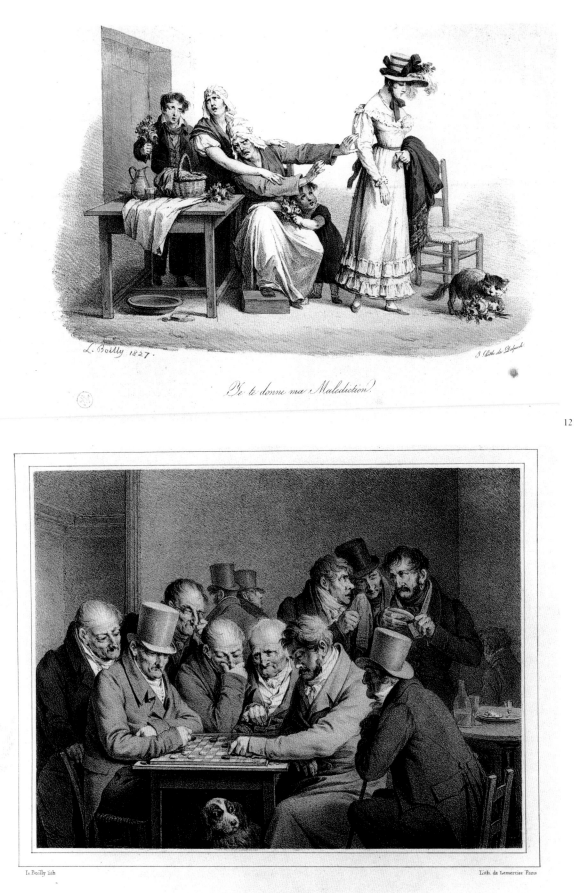

Je te donne ma Malédiction!

12

LE JEU DE DAMES.

13

Nicholas-Toussaint Charlet (1792-1845)

Famous for his depiction of the common military man, Charlet was born in Paris and grew up during the Napoleonic era. His father, a dragoon of the Republic, died while Charlet was still quite young. After receiving basic education in the Napoleonic public schools, Charlet entered the atelier of Antoine-Jean Gros in 1815 at the moment of Napoleon's downfall. His first images of military nostalgia were done under the tutelage of this famous master, who had been Napoleon's favored painter.

The only time Charlet himself engaged in military action was in 1814 at the Barrière de Clichy during the collapse of the First Empire. Charlet went on to champion the cause of the neglected Napoleonic veteran, however, through his lithographs and drawings.

Charlet quit the Gros atelier in 1820, and went with his close friend Theodore Géricault to London. (Tradition has it that Charlet introduced Géricault to the art of lithography, but Géricault actually produced some lithographs as early as 1817, before he met Charlet. Géricault had learned the technique from Carle Vernet, and indeed became one of the earliest high artists to work in the lithographic medium.) Charlet was best known for his lithographic work, though he also exhibited paintings occasionally at the Salon, and painted historic military exploits for Louis-Philippe's military museum at Versailles.

Under the Bourbon Restoration, Charlet remained an ardent Bonapartist, which cost him the civil service job he held early in the Restoration. From then on, he devoted himself to his art. His recurring theme of the neglected, unemployed Napoleonic veteran is credited with helping bring about the downfall of the Bourbon regime in 1830. Indeed, Charlet remained a "fly in the ointment" to Louis-Philippe's government as well.[1]

Other popular themes in Charlet's work include the image of the average working man, a subject that overlaps with the Napoleonic veteran, and in particular, children. He was truly an illustrator of the people and had an active following for his prolific output. In 1838 he became a professor at the Ecole Polytechnique in Paris where he taught until his death in 1845.

His biographer, La Combe, considers the suitability of Charlet's words to his designs to be a distinguishing factor in his work. La Combe also compares him to Balzac in his approach to the human comedy, which includes moral and philosophical perspectives on life as well as circumstantial humor. Delacroix praised the lithographs of Charlet as never repeating a face or an action. But Charlet also had his detractors. Baudelaire offers this criticism: "Charlet is a topical artist and an exclusive patriot—two impediments in the way of genius... Charlet always paid court to the people. He was a slave, not a free man... Charlet's draughtsmanship hardly ever rises above the chic—it is all loops and ovals. Once, however, he produced something quite good. This was a series of costumes of the old and new guard. The figures have the stamp of reality... Charlet was young then."[2]

Baudelaire's criticism has proven valid with time. Charlet, who was considered a major artist in his own day, has not survived among the great. His charming portrayals of everyday life among the soldiers, working people, and children of the Restoration and the July Monarchy, however, give us an exceptional window into those times.

PH/RP

1 See M. P. Driskel, "Singing 'The Marseillaise' in 1840," 605-625.
2 Baudelaire, *The Mirror of Art*, 156-159.

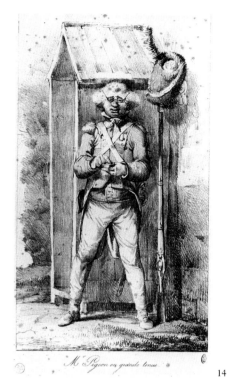

M. Pigeon en grande tenue.

14

glasses and absurd coiffure, are in extreme and humorous contrast with the trim and natty professional soldiers Charlet was so adept at representing. The figure's unmilitary address is more readily visualized in a business suit at the office.

BF
1985.48.339 (ADB)

14

Mr. Pigeon en grande tenue.
1818
Mr. Pigeon in dress uniform.

Printer: Delpech
Catalogued: Béraldi, no. 53; *Inventaire*, no. 44; La Combe, no. 53

Mr. Pigeon is a bourgeois who has been assigned to sentry duty as a member of the civic guard. His lumpy body and ill-fitting uniform, no less than his

15

La Forme avant la couleur.
Form before color.

Series: *Croquis lithographiques par Charlet* (Lithographic sketches by Charlet), 1823, no. 5
Printer: Villain
Distributor: Gihaut frères
Catalogued: Béraldi, no. 520; *Inventaire*, no. 130; La Combe, no. 520

The scene is another typical example of Charlet's renderings of working-class people in everyday life. The sign painter at work is joined by a friend who shares his drink and his artistic philosophy. His toast, "form before color", parodies the neoclassic dictum of the French Academy, punning on the word *forme*.

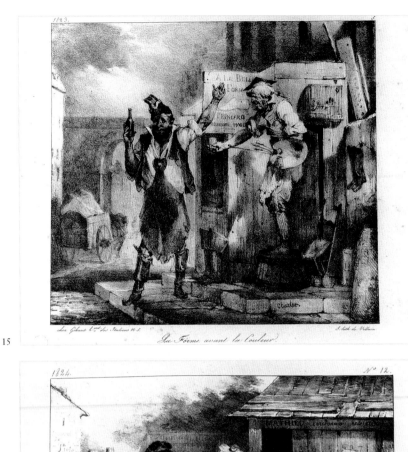

In a sort of pendant to No. 15, though it appeared a year later, Matthew the cobbler stands before his place of business on the first morning of Lent, still dressed in his Turkish costume of the previous night's carnival, sporting a black eye and an intransigent stance. Probably he suspects the baker of having beaten him up, for he apparently refuses to buy bread despite the entreaties of his hungry family. Charlet has humorously given his composition and the gestures of his figures the look of a neoclassical painting on a high moral subject.

BF
1985.48.331 (ADB)

17

Le Marchand de dessins lithographiques.
1818-19
The lithograph merchant.

Printer: Delpech
Catalogued: Béraldi, no. 85; *Inventaire*, no. 66; La Combe, no. 85

A soldier and his buddy survey the merchandise at the street stall of a print seller who naps with sublime unconcern. The soldier appears to be explaining the pictures to his friend, and the object of their attention is no doubt a depiction of a battle or a bivouac by Charlet. The *colporteur*, or street retailer, displays his images in a permanent stall that can be locked up at night, such as may still be seen on the quais of Paris. To acquire the rights to a stall, the seller must first wait for a previous proprietor to retire or die, and then apply to the Ministry of the Interior to succeed him, paying a fee and providing recommendations from at least two established colleagues in the business. He is also the subject of a secret police report, which must give him a clean record on finances, morals, and politics. Although lithography was only two or three years old in Paris when this print was made, the calling of printseller was, of course, much older. Therefore the specification in the title that lithographs are being sold constitutes an advertisement for the new product of the printer Delpech (see C. Vernet, no. 188).

BF
Anonymous Loan

For in the background, the sign on which the artist works reads '*A la belle forme*; *Trincard, cordonnier envieu...*' which roughly translates "At the beautiful [shoe] form; Trincard the ... cobbler."

PH
1985.48.328 (ADB)

16

Le Lendemain du Mardi-gras.
1824
The day after Mardi-Gras.

Series: *Croquis lithographiques par Charlet*, 1824, no. 12
Printer: Villain
Distributor: Gihaut frères
Catalogued: Béraldi, no. 545; *Inventaire*, no. 147; La Combe, no. 545

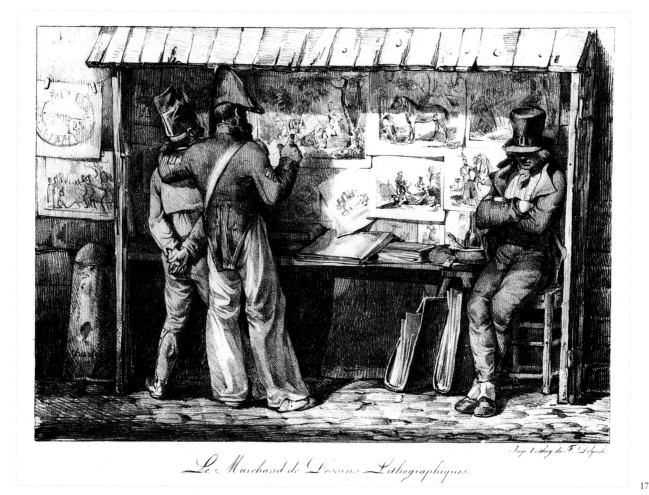

Le Marchand de Dessins Lithographiques.

Imp. Lithog. de F. Delpech

17

18

L'Ecole Chrétienne.
The Christian school.

Series: *Album lithographique par Charlet*
 (Lithograph album by Charlet),
 1826, no. 13
Printer: Villain
Distributor: Gihaut frères
Catalogued: Béraldi, no. 634; *Inventaire*,
 no. 173; La Combe, no. 634

With the decline of the apprentice-ship system came the rise of schools, and by the late eighteenth century the church had come to provide a consider-able portion of the nation's instruction. This print, made during the reign of Charles X when religious influence was at its height, represents a familiar sight near the portals of a large parish church.
 Schooling took on new importance in a bourgeois world where verbal skills came to be more saleable than craft skills. It will be noted that there are no girls in this crowd of youngsters.

Although separate primary schools for both boys and girls (*petites écoles*) had existed for centuries, boys were far more likely than their sisters to receive schooling.
BF
1985.48.327 (ADB)

Bibliography:
Ariès, P., *Centuries of Childhood.*

19

Le Navarois.
The man of Navarre.

Series: *Album lithographique par Charlet*,
 1826, no. 11
Printer: Villain
Distributor: Gihaut frères
Catalogued: Béraldi, no. 632;
 Inventaire, no. 173; La Combe, no.
 632

Along the mountainous French-Spanish border during the Carlist wars of the Restoration, local inhabitants smuggled contraband arms and muni-tions into Spain. Border peasants of Navarre acted as guides for Carlist agents, speaking Catalan and imitating the Catalan *montagnards'* savage ways, wearing the same costumes, and affect-ing the same disposition to murder and violence, according to the "mythology" of these types. "*Leur visage presque olivâtre porte l'empreinte de l'énergie, et leurs grands yeux noirs jettent des éclairs où la vengeance et la férocité sont peints*" (Their olive complexions carry the imprint of energy, and their huge black eyes cast beams in which vengeance and ferocity are painted).[1] This somewhat tongue-in-cheek description, written in the 1840s, looked back with nostalgia at the romantic figure conjured up by Charlet, and perhaps derived much of its content from such images as this.

BF
1985.48.332 (ADB)

1 Victor Gaillard, "Le Contrebandier," *Les Français peints par eux-mêmes* 6:63.
 Trans. by BF.

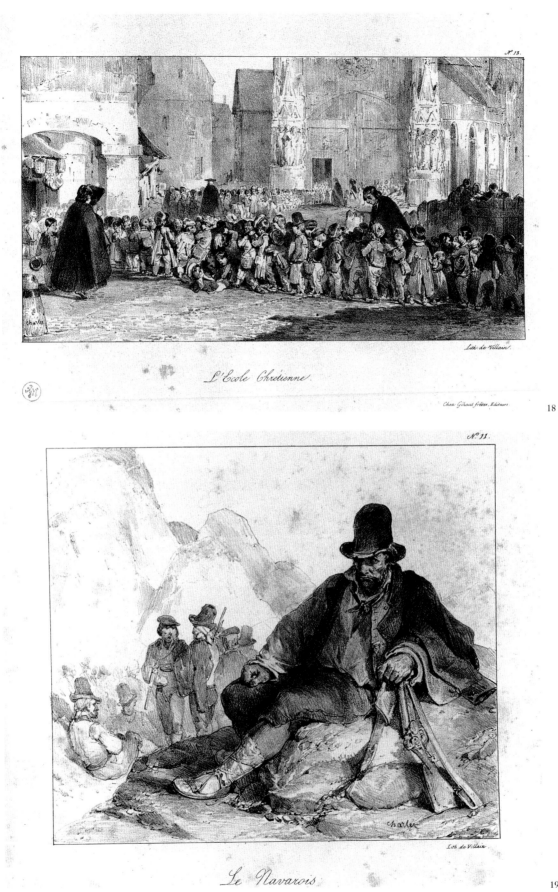

Lith. de Villain.

L'École Chrétienne.

Chez Gihaut frères, Éditeurs.

18

N° 11.

Lith. de Villain.

Le Navarois.

19

20

Qui vive? Patrouille grise!
Who goes there? A drunk patrol!

Series: *Album lithographique par Charlet*, 1829, no. 13
Printer: Villain
Distributor: Gihaut frères
Catalogued: Béraldi, no. 739; *Inventaire*, no. 236; La Combe, no. 739

Among the most common of Charlet's subjects are scenes of drinking in the barracks or at the *barrières*. Frequently there is a lone, older soldier from Napoleonic times in the company of civilians, as in this image. At the sign of *Le Roi Jupiterre*, wine at four sous has had its effect on a trio of workmen who are challenged by the old *vivandière* in the mock role of a sentry. The spectacle is received with equal good humor by the old soldier whose weapon she has borrowed, and by the child eating his supper. The characters in this genre scene conform to a typical formula in Charlet's oeuvre.

PH/BF
1985.48.340 (ADB)

21

C't' hardiesse. Ha Monsieur l'Callognie donnez moi z'en un petit peu... d'la poudre pour fiche un pétard au chat du maitre d'école.
What nerve. Hey mister Colonel, give me a little of your powder so I can stick a firecracker on the schoolmaster's cat.

Series: *Album lithographique par Charlet*, 1829, no. 14
Printer: Villain
Distributor: Gihaut frères
Catalogued: Béraldi, no. 740; *Inventaire*, no. 236; La Combe, no. 740

Charlet often brings children and soldiers together with a special camaraderie, as he does in this lithograph. Here the child approaches a cavalry gunner to ask for a bit of his gun powder so that he can play a prank on the schoolmaster's cat. The soldier calls him impudent but appears pleasantly amused by the request. The boy's working-class speech indicates a bond between him and the soldier, whom Charlet regularly treated as belonging to *le peuple*.

PH/BF
1985.48.320 (ADB)

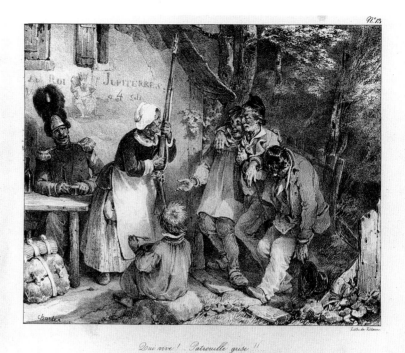

Qui vive! Patrouille grise!!

20

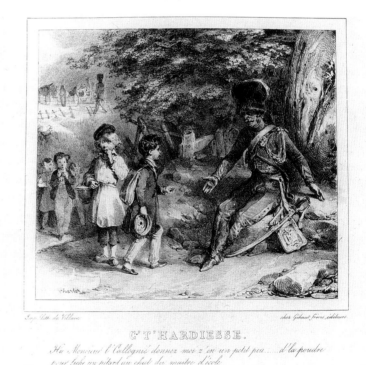

C'T'HARDIESSE.
Ha Monsieur l'Callognie donnez moi z'en un petit peu.....d'la poudre pour fiche un pétard au chat du maitre d'école

21

LE LAPIN EST TIMIDE ET NOURRISSANT

Mangé par le petit et même par le grand, on le trouve chez le militaire de tout grade comme chez le magistrat le plus recommandable.

(Buffon)

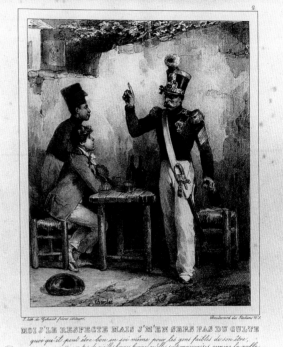

MOI J'LE RESPECTE MAIS J'M'EN SERS PAS DU CULTE

quoi qu'il peut être bon en soi même pour les gens faibles de son être, comme pour aussi un tas de vieilles bonnes femmes qu'elles sont mauvaises comme la galle.

22

23

22

Le Lapin est timide et nourrissant. Mangé par le petit et même par le grand, on le trouve chez le militaire de tout grade comme chez le magistrat le plus recommandable. (Buffon)

The rabbit is shy and nourishing. Eaten by the poor as well as the great, it is served to all military ranks and to the most commendable magistrate. (Buffon)

Series: *Album lithographique par Charlet*, 1829, no. 15
Printer: Villain
Distributor: Gihaut frères
Catalogued: Béraldi, no. 741; *Inventaire*, no. 236; La Combe, no. 741

This sheet, inspired by a very domestic entry in Buffon's *Bestiary*,[1] was evidently made for children, perhaps to be pinned up in the nursery. French children were brought up on Buffon, as they were on La Fontaine and Aesop. These staples of domestic education were regularly exploited by the earliest generation of lithographers. Despite the caption's passage on rabbit as a typical French food, the children are not shown eating rabbit, but rather helping to care for the furry creatures and their young.

BF
1985.48.330 (ADB)

[1] Le Chevalier le Clerc de Buffon (1707-1788) was the first effective director of the Jardin des Plantes, founded in 1640 as a museum of natural history, now the Paris Zoo. His works, first published piecemeal, were later collected and published as *Oeuvres complètes* (Paris: Imprimerie royale, 1774-78).

23

Moi, j'le respecte mais j'm'en sers pas du culte quoi qu'il peut être bon soi meme pour les gens faibles de son être, comme pour aussi un tas de vieilles bonnes femmes qu'elles sont mauvaises comme la galle.

Me, I respect religion, but I don't go to church although it can be good in itself for faint-hearted people, as well as for a heap of old women be they nasty as gall.

Series: *Fantaisies par Charlet* (Fantasies by Charlet), 1831, no. 2
Printer and Distributor: Gihaut frères

Catalogued: Béraldi, no. 779; *Inventaire*, no. 282; La Combe, no. 779

Again Charlet presents the old soldier offering wisdom to youth. To an actual and a would-be conscript he expostulates from an anticlerical and drunken stance, his rambling diatribe belying the respect he avows and betraying his inebriation. The scene appears to be a *guinguette* at the *barrière*, the site of cheap taverns outside the city gates where import taxes were imposed on liquors entering the city.

BF
1985.48.337 (ADB)

24

Croquis.
Sketches.

Series: *Fantaisies par Charlet*, 1831, no. 5
Printer and Distributor: Gihaut frères
Catalogued: Béraldi, no. 782; *Inventaire*, no. 282; La Combe, no. 782

Sketches put in the *macédoine* format were very popular around 1830 and were not peculiar to Charlet (see Devéria, no. 54). The many unrelated drawings were like a sampler of the artists' varied talents. The smaller sketches on this sheet provide a sort of frame around the central motif of workmen in a tavern, drinking. Vignettes of the common man is the overall theme, and as usual, Charlet does not fail to make the association between the workman and the soldier.

PH/BF
1985.48.343 (ADB)

25

Rêver d'ours vous donne quatorze, quarante-neuf, soixante-sept; si vous avez été terrassée par ce même ours, quatre-vingt sept.

To dream of a bear gives you fourteen, forty-nine, sixty-seven; if you have been overwhelmed by this same bear, eighty-seven.

Series: *Croquis lithographiques*, 1823, no. 7
Printer: Villain
Distributor: Gihaut frères
Catalogued: Béraldi, no. 523; *Inventaire*, no. 131; La Combe, no. 523

The scene is a market, where an ambulatory peddler of dead fowl is consulted by an elderly customer on the interpretation of dreams with respect to the lottery. A chuckling third party appears to take less seriously than the others the superstitious information being offered. Lottery numbers above their heads suggest the working-class foible that is the subject of this print. It would seem that the caption was printed without numbers, allowing the purchaser to enter his or her own. The numbers given here are as reported in La Combe's catalogue.

BF
1985.67.103 (MW)

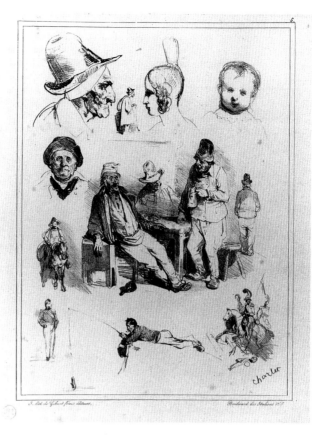

24

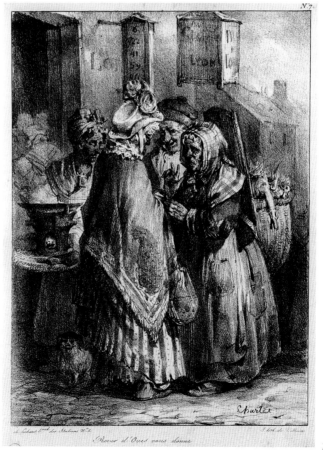

25

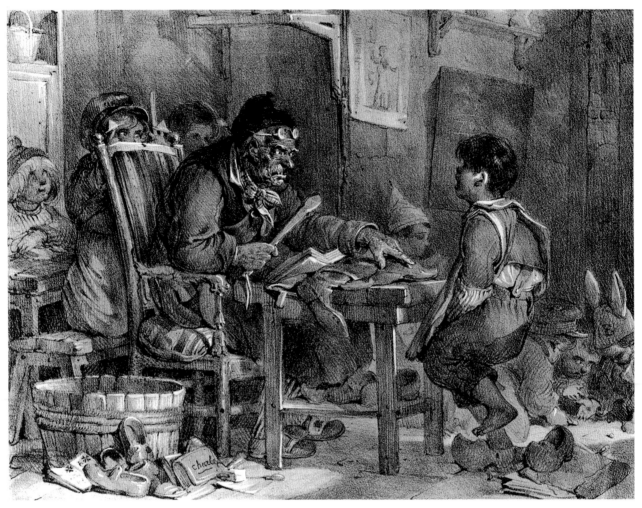

26

26

L'Ecole de village.
1823 (two-color lithograph)
The village school.

Catalogued: La Combe, no. 282

 In this chaotic schoolroom scene, a fierce and ugly schoolmaster gives a hard time to a boy who needs to be excused, while two mischievous boys behind him await their chance to launch the equivalent of paper airplanes. In a corner, three younger boys, one in a dunce cap, appear to be playing marbles or gambling. This is no church school, but the old medieval system under which a schoolmaster offered classes to boys who came from neighboring communities, or even farther, to learn their three R's and to find living accommodations wherever they could.

 The lithograph is executed *à deux crayons*, with a black and a white stone,

the latter heightening with highlights the forms rendered against a dark ground. Printed on brown stock and cropped to the edge of the image, this lithograph was probably planned as the cover for an album.

PH/BF
1985.48.2907 (ADB)

54

Honoré Daumier (1808-1879)

Honoré Daumier, the master of caricature, was born in Marseilles, the son of a glazier. His father, who aspired to become a poet and playwright, moved the family to Paris in 1815, where their poverty caused them to lead an unsettled existence. Artisan, bohemian, poor, and rootless, from his youth Daumier did not fit into any particular social class or political group.

After preliminary training under the academic painter and art patron Alexandre Lenoir, Daumier became an apprentice to the lithographer and publisher Zépherin Belliard, who produced lithographic portraits. He later enrolled in the ateliers of the minor artists Suisse and Boudin (not the seascape painter), where he met other young artists, importantly the liberal Philippe-Auguste Jeanron, and perhaps Charles Philipon who was to play a major role in his life. Of equal importance for the young Daumier was the friendship he retained with Lenoir. Lenoir's collection of portraits, chosen for their dramatic and diverse facial expressions, are said to have inspired Daumier to draw his first caricatures, of which the earliest were published in the illustrated newspaper *La Silhouette* in 1830. That year saw the political crisis of the July Revolution, and the personal crisis of his father's mental illness which meant that Daumier's caricatures became the family's only source of income. He became a regular contributor to *La Caricature*, and from 1832 on, two or three of his lithographs appeared each week as well in *Le Charivari*, the longest-lived of Philipon's papers, with which Daumier was associated for the rest of his life.

Between 1830 and 1870, under the pressure of constant production, Daumier created nearly four thousand lithographs and a thousand wood engravings. His work set the standard by which all other caricature was judged, influencing other caricaturists, artists, and writers, as well as helping to shape the political opinion of the nation. *Rue Transnonain*, which dates from 1834 and is perhaps his most famous political cartoon, was created in response to brutal reprisals against Parisian citizens in an uprising inspired by sympathy with a suppressed workers' revolt in Lyons (no. 29).

During Daumier's lifetime the political constitution of France changed completely no less than six times, with accompanying radical swings in the form and tenor of governments. For the most part, he savagely criticized the status quo from a personal stance as a cynical but egalitarian republican. After the government outlawed almost all political caricature in 1835 and instituted a renewed program of repression and censorship, Daumier turned to social commentary in his prints. Only in 1848-51 and again in 1870 was he able to return to overtly political themes.

After thirty years of employment with *Le Charivari* and the Aubert publishing house, Daumier found himself dismissed by Philipon's successors when readers lost interest in his work and the editorial staff changed. He had taken up painting seriously by 1848, evidently hoping to change his professional status. He continued with lithography for his livelihood, however, and published in Etienne Carjat's paper *Le Boulevard* during his "leave" from *Le Charivari*.

By 1863 he had resumed working for his former publisher and continued there until his retirement in 1872. His latest works covered the devastations of 1870-71 in a handful of monumental images that survived their reduction to *gillotage*, a photographic method for rendering lithographs printable in letterpress.

With his eyesight failing, Daumier retired from Paris to Valmondois where he worked very little. A large exhibition of his works, mostly oils and watercolors, was organized in 1878, a year before his death. Critical acclaim on that occasion has grown with time. Daumier is considered among the great in art by any standard.

RP/BF

27

Le bois est cher et les arts ne vont pas.
Wood is expensive and the arts aren't going well.

Printer and Publisher: Aubert
Appeared: *Le Charivari*, 6 May 1833
Catalogued: D. 146; *Inventaire*, no. 86
References: Abélès and Cogeval, *La Vie de Boheme*, p. 10, no. 64

Champfleury said of this print, "...ce n'est plus une satire, mais une sorte de confiance au publique" (...it's not so much a satire as a sort of confiding in the public).[1]

Arsène Alexandre pictures Daumier among his contemporaries, waiting for success: "While waiting, all these young men got together to work in a shared studio, which ended up as a sort of improvised academy, where more work was done, and better, than in an official academy. This famous place was called the nurses' office of the Rue Saint-Denis."[2]

This group included the landscape artists, Huet and Cabat, two friends of Daumier's who no doubt influenced his choice of subject matter for the painting on the easel in this print.

GB
1985.48.2486 (ADB)

1 Champfleury, *Histoire*, 103.
2 Cailler, *Daumier raconté par lui-même*, 35-6. "En attendant, tous ces jeunes se réunissent pour travailler dans un local commun, qui constitue une sorte d'académie improvisée... où l'on fait plus de besogne et de meilleure que dans une académie officielle. Ce local célèbre, c'est le bureau des nourrices de la rue Saint-Denis."

28

Soul en enfant de coeur.
Soul as a choir boy.

Series: *Bal de la cour* (Court dance)
Printer and Distributor: Aubert
Appeared: *Le Charivari*, 23 February 1833, no. 4
Catalogued: D. 139; *Inventaire*, no. 83

This print is fourth in a series by Daumier satirizing the court of King Louis-Philippe, showing members of the court in fancy dress costumes that reveal their individual vices and foibles. The title of the print, no doubt the creation of Philipon, is a web of puns and *double-entendres*. "Soul" refers to Nicolas Soult (1765-1851), first minister in the July Monarchy and well-known hero of the Napoleonic Wars, punning on both the religious aspect of his costume and the other meaning of "*soul*"—a drunken, disreputable person. "*Coeur*"

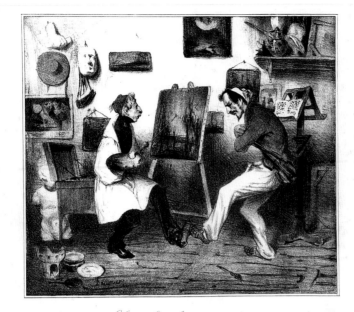

Le bois est cher et les arts ne vont pas

27

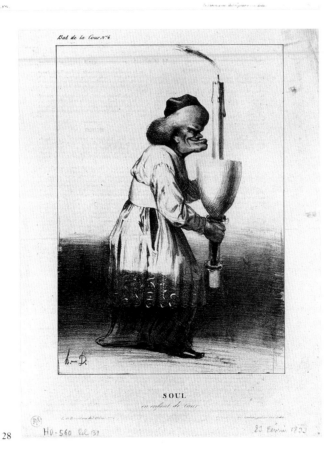

SOUL
en enfant de chœur

28

HD-560 R.C. 137

refers to his hearty enthusiasm and the choir (*chœur*) boy costume and also to the court (*cour*) and his courtly office. Soul/Soult is seen stealing a church candlestick, a reference to Soult's noted collection of paintings "borrowed" from the churches of Spain during his tour of duty there.

In one simple image, the artist and his editor not only show Soult's distinctive physiognomy but also reveal his character wrapped in a series of puns and layers of meaning—while hinting at the corruption of members of the current government.

RP
1985.48.2728 (ADB)

29

Rue Transnonain, le 15 avril, 1834.
Rue Transnonain, April 15, 1834.

Series: *L'Association mensuelle*
Printer and Distributor: Aubert
Catalogued: D. 134; *Inventaire*, no.82
References: In virtually any work on
 Daumier; please see bibliography
 for a partial list.

Celebrated as the greatest work of art to come from his crayon, this print stands as stark testimony to Daumier's "noble anger," as Philipon called it, in response to an atrocity committed by Louis-Philippe's troops. The facts, differently reported by different chroniclers, seem to be these: republican workers in Lyons on 9 April 1834 rose against the government's imposition of a ban on the right of assembly. It took four bloody days to put down the uprising. Sympathetic Parisians in the working-class district of the Marais began to build barricades, and government troops quickly swarmed in to dismantle them, including one on the rue Transnonain (once part of the present rue Beaubourg and no longer in existence). Two shots rang out, coming from the house at no. 12 in that street. It is not certain these shots did any damage, but edgy troops stormed the house with fixed bayonets, killing most of the residents—old men and women and children. Twelve people were killed; a woman and child were left wounded.[1]

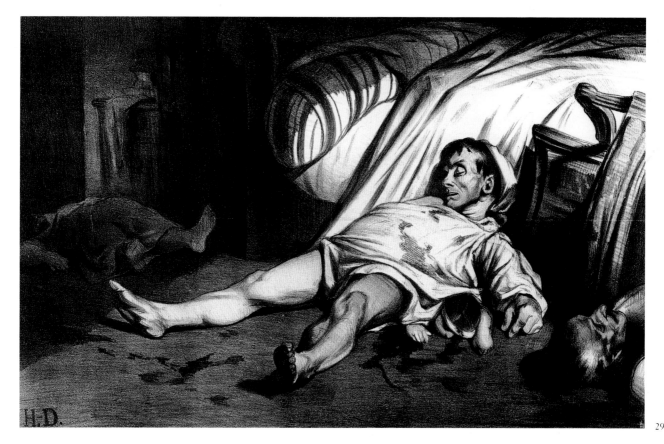

29

Daumier's print was the last of the twenty-four published by Philipon's *Association mensuelle*. The series of over-size prints for special sales to sub-scribers was terminated by new enforcement of a law requiring a tax and a stamp signifying payment of it to be placed on the surface of the print. Total political censorship came in the following year, and Philipon's *La Cari-cature* closed its doors forever.

Baudelaire noted that this print could scarcely be called caricature. Indeed Daumier normally abandoned his exaggerated mode when depicting the victims rather than the perpetrators of the corruption and violence he saw in the bourgeois king's regime. In *Rue Transnonain* he rose to the occasion with an image worthy of a Rembrandt or at least a Géricault, his monumental mar-tyred figure bathed in baroque *chiaroscuro* lying in the deadly silence that follows violence.

BF
Lent by Stuart Kadison

[1] Passeron, *Daumier*, 102-107.

30

Une Lecture entraînante.
An absorbing subject.

Series: *Galerie physiognomique*
(Physiognomic gallery), no. 3
Printer and Distributor: Aubert
Appeared: *Le Charivari*, 25 November 1836, pl. 3
Catalogued: D. 328; *Inventaire*, no. 115
1985.48.2820 (ADB)

31

Voilà une lecture amusante!!
What a delightful reading!!

Series: *Galerie physiognomique*
Printer and Distributor: Aubert
Appeared: *Le Charivari*, 1 May 1837, no. 13
Catalogued: D. 338; *Inventaire*, no. 115
1985.48.2845 (ADB)

In these pseudo-pendant prints pub-lished a year apart, Daumier, disenfran-chised from political image-making by the September laws of 1835, displays his virtuoso talent in recording facial and bodily expressions of ordinary folk at an ordinary activity: reading.

The title of the series as well as the images themselves indicate Daumier's participation in the then-current vogue for the writings of Lavater and Gall on human physiognomy and the assess-ment of character and mental states based on outward form. Daumier's comic exaggerations give rise to laugh-ter of a sort analyzed a few years later by Baudelaire: "I said that laughter con-tained a symptom of failing, and in fact what more striking token of debility could you demand than a nervous con-vulsion, an involuntary spasm compara-ble to a sneeze and prompted by the sight of someone else's misfortune?.... what is there so enjoyable in the sight of a man falling on the ice or in the street or stumbling at the end of a pavement, that the countenance of his brother in Christ should contract in such an intemperate manner, and the muscles of his face should suddenly leap into life like a timepiece at midday or a clock-work toy?"[1]

Since Baudelaire in this essay attributes laughter to the devil and orig-inal sin, there is something disingenu-

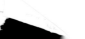

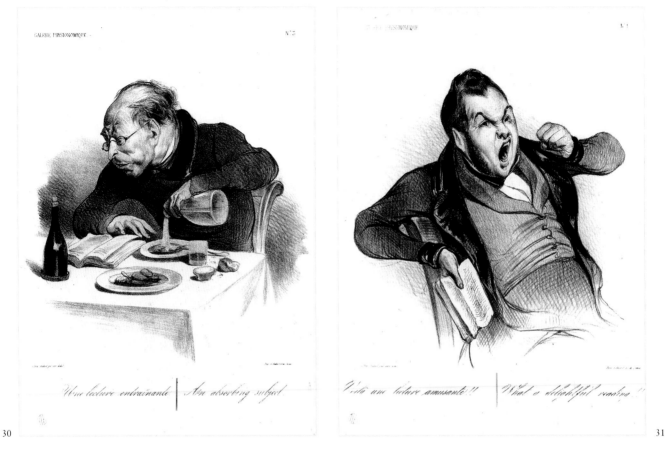

ous about this puzzlement that we should find the misfortune of others so funny, as we surely must do in the case of the eager reader pouring water onto his food instead of into his glass. In no. 31, Daumier shows another convulsion, another involuntary spasm, the mysterious physical effect produced in us by boredom.

GB/BF

1 Baudelaire, *The Mirror of Art*, 138.

32

Robert Macaire magnétiseur.
 Voici un excellent sujet... pour le magnétisme...Certes! il n'y [a] pas de commerage, je n'ai pas l'honneur de connaître Melle de St. Bertrand et vous allez voir Messieurs, l'effet du somnambulisme... (Melle de St. Bertrand donne dans son sommeil des consultations sur les maladies de chacun, indique des trésors cachés sous terre et conseille de prendre des actions dans le papier Mozart, dans les mines d'or et

dans une foule d'autres fort belles opérations.)
Robert Macaire hypnotist.
 Here is an excellent subject... for hypnotism... Certainly, there won't be any collusion, I don't have the honor of knowing Miss de St. Bertrand and you're going to see, gentlemen, the effects of somnambulism... (Miss de St. Bertrand gives in her sleep consultations on everyone's diseases, indicates hiding places of buried treasures, and recommends investments in Mozart paper, in gold mines and in many other very attractive operations.)

Series: *Caricaturana*
Printer and Distributor: Aubert
Appeared: *La Caricature*, 26 August 1838, no. 88
Catalogued: D. 443; *Inventaire*, no.116

 Needless to say, this scene has all been prearranged. Mlle. de St. Bertrand is Macaire's accomplice, Bertrand, in drag. The investments suggested may even be operations with which Macaire

may not be entirely unconnected. Robert Macaire is a shameless racketeer who is intended in Daumier's world to represent all businessmen and the spirit of the new bourgeois rulers. Belief in the general corruption of entrepreneurial enterprises and financial institutions extends beyond Daumier's caricatures. The enormously popular novelist Charles Paul de Kock devoted a novel called *The Schemers*[1] to describing the exploits of two Macaire-like swindlers.

 Not only were the captions of these lithographs all written by Philipon, but the character of Macaire was not Daumier's creation either. Robert Macaire originated in a role created by the actor Frédéric Lemaître in a comedy first performed in 1823 and revived in the early 1830s, *L'Auberge des Adrêts* by Antier, Saint-Amand, and Polyanthe.[2] Although the play was suppressed, Daumier continued to depict Macaire, accompanied by his sidekick Bertrand, as a manipulative, corrupt, dissembling swindler. He became the symbol of an age of feverish speculation, a supporter

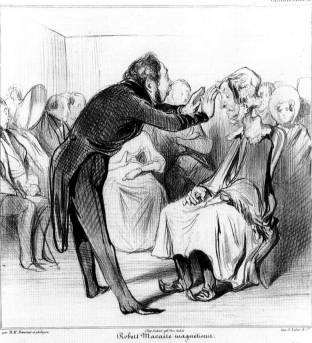

par M.M. Daumier et philipon

Imp. d'Aubert et C.

Caricaturana 65.

Chez Aubert gal Véro-dodat

Robert Macaire magnétiseur.

Voici un excellent sujet pour le magnétisme... Certes! il n'y a pas de commérage, je n'ai pas l'honneur de connaître M. de S.ᵗ Bertrand et vous allez voir Messieurs, l'effet du somnambulisme.

(M. de S.ᵗ Bertrand donne dans son sommeil des consultations sur les maladies de Macaire, indique des trésors cachés sous terre et conseille de prendre des actions dans le papier Macaire, dans les mines d'or et dans une foule d'autres fort belles opérations.)

32

LA CARICATURE PROVISOIRE.

PARIS N° 28

INTÉRIEUR D'UN OMNIBUS.
Entre un homme ivre et un Charcutier.

12 MAI 1839.

POUR LES CONDITIONS D'ABONNEMENT, VOIR A LA DERNIÈRE PAGE.

33

28

of the bourgeois monarchy in his own interest.

GB
1958.48.2715 (ADB)

1 Charles Paul de Kock, *The Masterpieces of Charles Paul de Kock*, trans. by George Burnham Ives (Philadelphia: G. Burrie, 1903-04), vol. 1.
2 Farwell, *FPLI* 2:12.

33

Intérieur d'un omnibus entre un homme ivre et un charcutier.
Interior of an omnibus between a drunk and a butcher.

Series: *Types parisiens*, no. 8
Appeared: *La Caricature [provisoire]*, 12 May 1839; also in *Le Charivari*, 13 November 1841
Catalogued: D. 566-2; *Inventaire*, no. 132

This print shows the versatility of Daumier's technique when faced with the problem of representing modern life. He depicts the different ways in which the upright ox-faced butcher and the lolling drunk cope with the swaying motion of the bus, to the dismay of the girl between them. The notice on the wall behind them informs us that drunks on the bus are not allowed. The omnibus, which was introduced into Paris in 1828, and the railroad, which came in 1837 and was particularly exploited by Daumier, soon provided subjects for caricatures based on the theme of people rubbing shoulders with total strangers.

At about the same time as this print, Charles Dickens was describing the strange experiences of those who rode the omnibus in his *Sketches by Boz:* "The passengers change in an omnibus as often in the course of one journey as the figures in a kaleidoscope, and though not so glittering, are far more amusing... It is rather amusing that the people in an omnibus always look at newcomers as if they entertained some undefined idea that they have no business to come in at all."[1]

La Caricature provisoire, later simply called *La Caricature, journal*, was the revived but apolitical version of Philipon's original *La Caricature* which had been shut down in 1835. The new

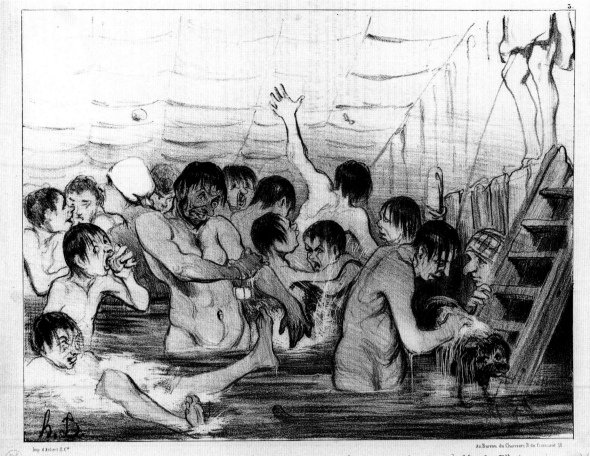

La Seine est une rivière qui prend sa source dans le département de la Côte d'Or, et va se perdre dans la Manche. Elle traverse

version ran from 1839 to 1842, and frequently allowed *Le Charivari* to reissue its pictures.

GB
1985.48.2390 (ADB)

[1] Charles Dickens, *Works of Charles Dickens* (London: Merrill and Baker, 1900), 1:160.

34

La Seine est une rivière qui prend sa source dans le département de la Côte d'Or, et va se perdre dans la Manche. Elle traverse Paris: les habitans de cette Cité, se dérobant aux feux de l'été viennent chercher la fraîcheur et la pureté de ses eaux.

The Seine is a river which has its source in the department of the Côte d'Or, and empties into the English Channel. It passes through Paris: the inhabitants of this City, stealing away from the heat of the summer, come to seek the freshness and purity of its waters.

Series: *Les Baigneurs* (The bathers), no. 3
Printer: Aubert
Distributor: Bureau du Charivari
Appeared: *Le Charivari*, 21 September 1839
Catalogued: D. 762; *Inventaire*, no. 146

This print appeared in *Le Charivari* in September, following *les jours caniculaires* or "the dog days" of summer, when for many the public baths of the Seine were the only escape from the intense, humid heat. The Parisian municipal government borrowed the idea of providing low-cost or free facilities for bathing and laundry from the British. Designed to instill habits of cleanliness in the working classes, these facilities were also frequented by those of a higher station, who would put aside their dignity along with their clothing to take advantage of the cooling waters.[1]

The subject provided Daumier with opportunities to refute the claims of idealizing Salon painters regarding the essential beauty of the nude human form. Daumier drew thirty prints for this series, which was later reissued as a bound volume, advertised in the 2 August 1843 issue of *Le Charivari* at sixteen francs, a price that certainly put it beyond the reach of the working class.

BP
1985.48.2479 (ADB)

[1] Ramus, *Daumier*, 125-6. See also Farwell, *FPLI* 4: 8-9.

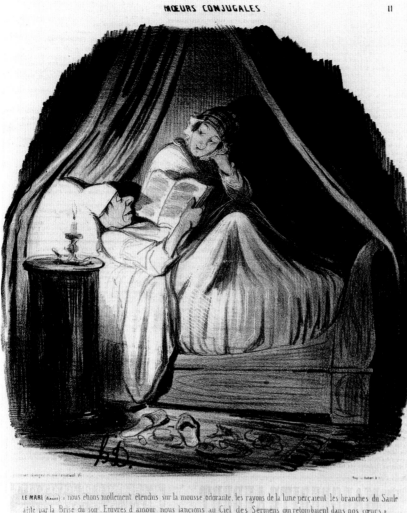

MOEURS CONJUGALES II

LE MARI (lisant) : « nous étions mollement étendus sur la mousse odorante, les rayons de la lune perçaient les branches du Saule agité par la Brise du soir. Enivrés d'amour nous lancions au Ciel des Sermens qu'retombaient dans nos cœurs » LA FEMME (à part) Peut-on lire ces choses avec un bonnet de coton, et une boule comme la sienne!....

35

romantic fiction encouraged dissolute behavior. However, Daumier presents another side of this coin: so far from being aroused to any indiscreet passion by this prose, the wife is forced to laugh at the disparity between the fantasy and the real-life situation.

GB
1985.48.2524 (ADB)

36

J'ai trois sous!
I have three sous!

Series: *Emotions parisiennes* (Parisian emotions)
Printer: Aubert
Distributor: Bureau de Charivari
Appeared: *La Caricature [provisoire]*, 1 September 1839, pl. 3
Catalogued: D. 686; *Inventaire*, no. 139

Emotions parisiennes was a series of fifty-one prints issued between July 1839 and November 1842 concerning the diverse feelings of typical Frenchmen. Like Traviès who was perhaps an even more eloquent spokesman for the poor, Daumier here depicts an indigent but still smiling Parisian, perhaps savoring the aroma of a meal he knows he can ill afford. Three sous was about one-eighth of the cost of a meal in a cheap restaurant. Unlike Gavarni, Daumier did not write his own captions, and bothered little about those which others assigned to them, feeling that the images spoke for themselves.

BP
1985.67.133 (MW)

37

–*Eh te vlà mon pauvre fieu! comme te vlà beau! viens donc baiser ton père!– Le fils qui s'est formé l'esprit et le cœur à Paris, répond avec âme: Connais pas!!*
–Eh! there you are my poor fellow! how handsome you are! come and kiss your father!–The son, whose heart and soul were formed in Paris, answers with soul: I don't know you!!

35

Le Mari (lisant): "nous étions mollement étendu sur la mousse odorante, les rayons de la lune perçaient les branches du saule agité par la brise du soir. Enivrés d'amour nous lancions au ciel des Sermens qui retombaient dans nos coeurs." La Femme (à part): Peut-on lire ces choses avec un bonnet de coton, et une boule comme la sienne!...
Husband (reading): "we were softly stretched out on the sweet-smelling moss, the moon's rays were piercing the willow branches, shaken by the breeze of the evening. Drunk with love, we threw promises to the sky, which fell back into our hearts."
Wife (aside): How can he read such stuff with a nightcap on, and a noggin like his!...

Series: *Moeurs conjugales* (Conjugal manners)
Printer: Aubert
Distributor: Bauger
Appeared: *Le Charivari*, 29 October 1839, no. 11
Catalogued: D. 634; *Inventaire*, no. 137

The boom in leisure reading with increased literacy among the populace is a subject Daumier also treats in a series on *Professeurs et moutards*, where a schoolboy reads a novel by de Kock inside his Greek dictionary. This image, with the husband reading to his wife in bed, refers to the assumption that

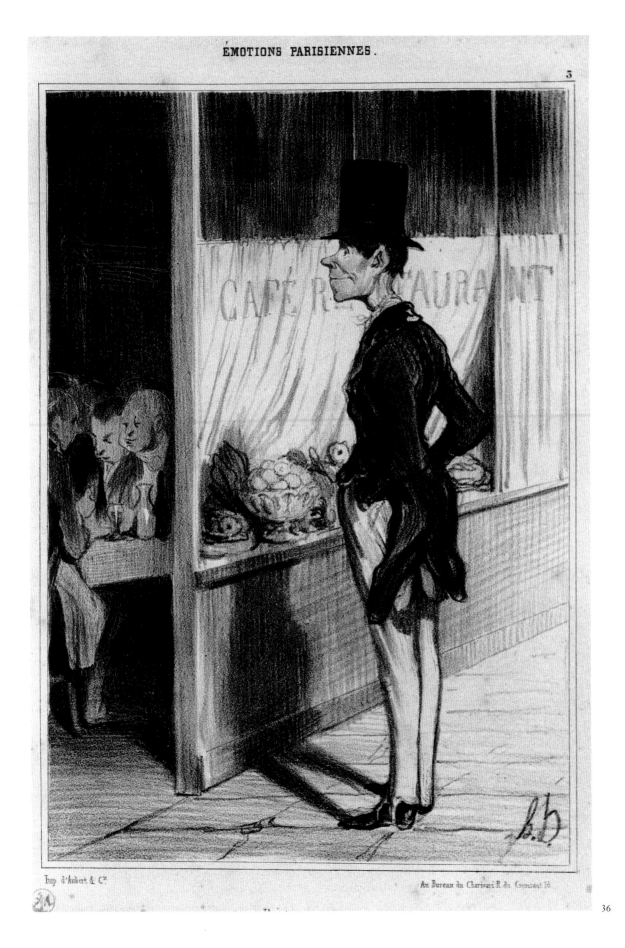

Imp. d'Aubert & Cⁱᵉ.

Au Bureau du Charivari R. du Croissant 16.

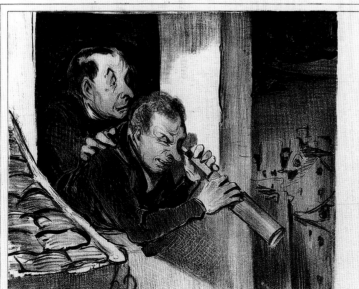

EMOTIONS PARISIENNES.

28.

h.D.

chez Bauger, R. du Croissant. 16. Imp. d'Aubert & C.ie

37

— Eh te vlà mon pauvre fieu! comme te vlà beau! viens donc baiser ton père! —
Le fils qui s'est formé l'esprit et le cœur à Paris, répond avec âme?... Connais pas!!...

Series: *Emotions parisiennes*, no. 28
Printer: Aubert
Distributor: Bauger
Appeared: *Le Charivari*, 9 April 1840
Catalogued: D. 712; *Inventaire*, no. 139

This lithograph demonstrates the cultural difference—always extreme in France—between the country and the city, particularly Paris. Massive migration from the country to Paris in this period resulted in social dislocations reflected in the art of Courbet as well as that of Daumier.[1] Instead of the more common theme of the country girl who goes to town and becomes a prostitute, Daumier depicts a young man whose soul has preferred to forget his peasant father under the influence of life as a dandy in Paris.

BF
1985.48.2331 (ADB)

[1] T. J. Clark, *Image of the People: Gustave Courbet and the 1848 Revolution* (London: Thames & Hudson, 1973), especially chap. 6.

38

Oh! absolument comme si on y était; la grande ôte son corset, et la petite cherche une puce.

Oh! just like being there; the big girl is taking off her corset, and the little one is looking for a flea.

Series: *Types parisiens*, no. 24
Printer: Aubert
Distributor: Bauger
Appeared: *Le Charivari*, 1 December 1841
Catalogued: D. 583; *Inventaire*, no. 132

This is set in the rabbit warren that was Paris before Haussmann's renovations in the Second Empire. In the cranny of some high building, a middle-aged lecherous-looking type is peeping through a telescope, watching two women in a room below. His friend looks over his shoulder, struggling to catch a glimpse of what is going on. They are respectably dressed and do not have the air of the sort who frequent brothels, but they are caught in the act by Daumier, who makes his viewers spies in their turn. These men are either bourgeois bachelors or bour-

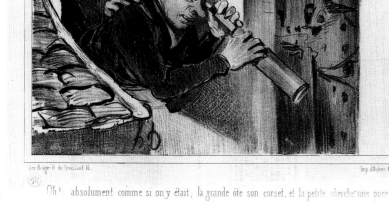

TYPES PARISIENS.

27.

chez Bauger R. du Croissant. 16. Imp. d'Aubert & C.ie

38

Oh! absolument comme si on y était; la grande ôte son corset, et la petite cherche une puce

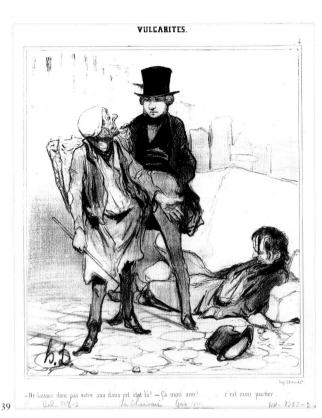

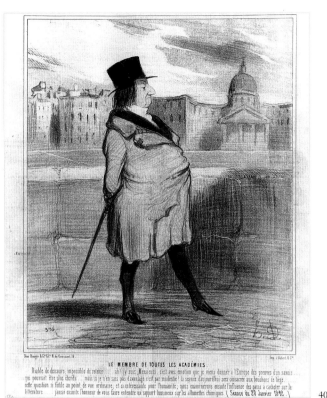

geois husbands, more likely the latter in view of their vicarious mode of pleasure-seeking and their expensive new toy, the spy-glass.

What is unusual about this print is its mildly prurient subject, an area of human experience which Daumier by and large avoided. The caption was of course supplied by Philipon or his staff, but it is hard to conceive of any other interpretation that would match this image.

GB/BF
1985.48.2644 (ADB)

39

–Ne laissez donc pas votre ami dans cet état là!–Ça mon ami...c'est mon portier.

–Don't leave your friend in that condition! –That my friend? …that's my doorman.

Series: *Vulgarités*, (Vulgarities), no. 4
Printer: Aubert
Appeared: *Le Charivari*, 1 June 1841
Catalogued: D. 908-3; *Inventaire*, no. 163

The *chiffonnier*, or rag-picker, was seen by the poet and the artist, all equally poor, as a sort of comrade-in-arms. He earned only enough to keep himself in drink, along with an occasional meal, but at the least he was not a beggar. Believing himself to be free, he could openly speak his mind. This greatly endeared him to the poet and artist during this time of censorship and repression.

The *chiffonnier* and the bourgeois confront one another again and again in lithographic imagery. In this case Daumier's print carries a subtle and ironic message: the *chiffonnier* wins in a game of one-upmanship, as the bourgeois is shown to be wrong in his assumption about the comradeship of two equally disreputable-looking members of the lower class.

BP/BF
1985.67.141 (MW)

40

Le Membre de toutes les académies.
Diable de discours, impossible de retenir...ah! j'y suis; Messieurs, c'est avec émotion que je viens donner à l'Europe des preuves d'un savoir... qui pourrait être plus étendu... mais si je n'en sais pas d'avantage c'est par modestie! la séance d'aujourd'hui sera consacrée aux bouchons de liège... cette question si futile au point de vue ordinaire; et si intéressante pour l'humanité; nous examinerons ensuite l'influence des pains à cacheter sur la littérature... j'aurai ensuite l'honneur de vous faire entendre un rapport lumineux sur les allumettes chimiques. (Séance du 20 Janvier 1942 [sic])

The Member of all the academies. Cursed speech, impossible to remember... ah! I've got it: Gentlemen, it is with some emotion that I come to give Europe proofs of a knowledge... which could be more extended... but if I don't know more about it myself, it is because of my modesty! Today's meeting will be devoted to wood corks... a futile question from an ordinary point of view; yet so interesting for humanity; we will then examine the influ-

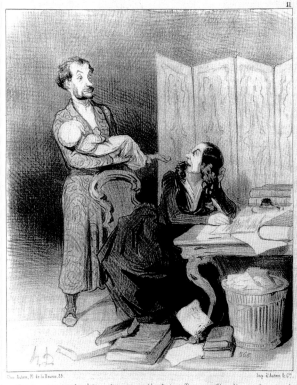

LES BAS-BLEUS. *Le Charivari 2 mars 1844*
11

Emportez donc ça plus loin... il est impossible de travailler au milieu d'un vacarme pareil. allez vous promener à la petite provence , et en revenant achetez de nouveaux biberons pas-sage Choiseul !... Ah! M^r Cabassol c'est votre premier enfant, mais je vous jure que ce sera votre dernier !

41

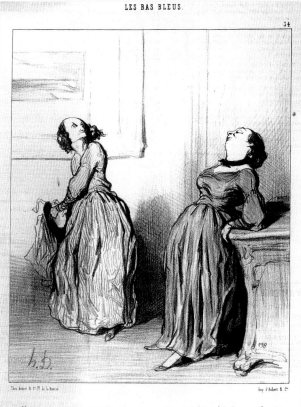

LES BAS BLEUS.
34

Ah vous trouvez que mon dernier roman n'est pas tout-à-fait à la hauteur de ceux de Georges Sand... ! Adélaïde, je ne vous reverrai de la vie !

42

ence of wafers on literature... I will then have the honor of letting you hear a luminous report about chemical matches. (Meeting of 20 January 1942 [sic])

Series: *Bohemiens de Paris* (Bohemians of Paris), no. 25
Printer: Aubert
Distributor: Bauger
Appeared: *Le Charivari*, 6 March 1842
Catalogued: D. 846; *Inventaire*, no. 157

This member of all the academies strolls along the Seine, memorizing his next speech opposite Daumier's schematized version of the Institut building. Daumier sets out to ridicule this form of institutionalized knowledge: his academician is a bohemian, that is, a wandering charlatan, a producer of side shows in the form of scientific trivia. His work is presented as unintentionally humorous.

At the time this lithograph was made, there was a boom in the production of scientific investigations. For example, reports presented at the Insti-

tut in the last quarter of 1843 and the first quarter of 1844 included work on the lemniscate curve (a figure of eight), steam engines, the population of France, crime in England, the spinal column, on gastric sugar and artificial digestion, dissection of bees, tracheotomy, lead poisoning, and the rings of trees, among other things.[1] Taken as a whole, to a lay audience it must have seemed as if the technological millennium had come. But this is not what Daumier believed. Louis Blanc saw "all the discoveries of science... transformed into instruments of oppression";[2] Daumier prefers to ridicule it all as futile and irrelevant, and one of its perpetrators as a pompous fool.

GB
1985.48.2527 (ADB)

[1] *L'Illustration*, 3 (Mar.-Aug. 1844):134.
[2] Louis Blanc, *Histoire de Dix Ans* 3:85.

41

Emportez donc ça plus loin... il est impossible de travailler au milieu d'un vacarme pareil... allez vous promener à la petite provence, et en revenant achetez de nouveaux biberons passage Choiseul!... Ah! Mr. Cabassol c'est votre premier enfant, mais je vous jure que ce sera votre dernier!

Take that away... it is impossible to work in the midst of such an uproar... go for a walk to "la petite provence," and on your way back buy some new baby bottles in the passage Choiseul!... Ah! Mr. Cabassol it's your first child, but I can swear to you that it will be your last!

Series: *Les Bas-bleus* (The blue-stockings)
Printer and Distributor: Aubert
Appeared: *Le Charivari*, 2 March 1844
Catalogued: D. 1231; *Inventaire*, no. 184
Reference: *Daumier; Intellectuelles*, no. 32

"Bluestocking" was originally a term used in eighteenth-century Britain to describe a group of men who met at Montague House in London to discuss literary matters, instead of playing cards as others did. They defied a dress code by wearing blue worsted rather than the traditional black stockings. In nineteenth-century France, this term was translated as "*bas-bleu*" and used to ridicule a newly risen feminist literary movement. Many of the prints in the series attribute to literary women attitudes of scorn, indifference, and rebellion toward their husbands and children, whom they supposedly neglected while occupying themselves with their personal ambitions. The feminists' demands ranged from the legalization of divorce to a women's reading room at the Bibliothèque nationale.

BP
1985.48.2335 (ADB)

42

Ah vous trouvez que mon dernier roman n'est pas tout-à-fait à la hauteur de ceux de Georges Sand...! Adélaïde, je ne vous reverrai de la vie!

Ah, you find that my latest novel doesn't quite reach the heights of George Sand's works...! Adélaïde, I shall never see you again!

Series: *Les Bas-bleus* (The bluestockings), no. 34
Printer and Distributor: Aubert
Appeared: *Le Charivari*, 18 July 1844
Catalogued: D. 1254-2; *Inventaire*, no. 184
Reference: *Daumier, Intellectuelles*, no. 13

Daumier's caricatures in the *bas-bleu* series created and perpetrated the image of the pretentious, overly aggressive woman writer of limited ability which was cherished by the male community. A number of intelligent and gifted writers had emerged— Cécile Fournel, Suzanne Vailquin, and Claire Demar—and these were overshadowed only by George Sand, Flora Tristan, and Madame de Staël. While men such as Stendhal and Victor Hugo offered qualified support, the feminists were vehemently opposed by the patri-

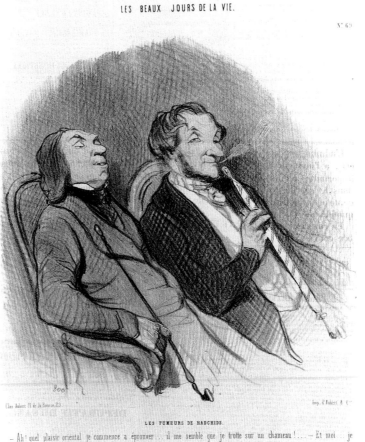

LES BEAUX JOURS DE LA VIE.

N° 69

LES FUMEURS DE HADCHIDS.

— Ah! quel plaisir oriental je commence a éprouver... il me semble que je trotte sur un chameau!.... — Et moi... je crois recevoir une bastonnade!...

43

PROFESSEURS ET MOUTARDS.

4.

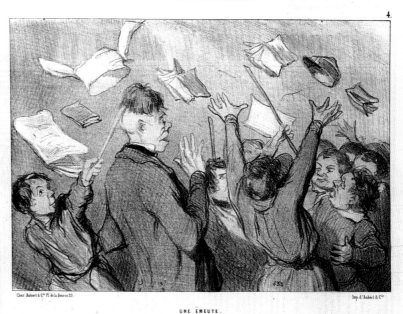

UNE ÉMEUTE.

— Po po po lisson!.... je vais dou dou....bler tous vos devoirs!..... —— De quoi des devoirs....... sous un gouvernement despotique c'est l'insurrection qui est le seul devoir!.....

44

archal literary establishment, including Balzac, Baudelaire, Proudhon, and the Goncourt brothers, a sentiment shared by Daumier. Following this series of forty prints with two others addressing with equal ridicule the liberation of women, *Les Divorceuses* and *Les Femmes socialistes*, Daumier is often perceived as harboring an unsympathetic attitude towards women in general, a charge which misses the ideology underlying his mocking satire. Although later paintings such as *Third Class Carriage* and the many versions of *The Laundress* appear to refute this allegation, they make it clear that only as long as women could be seen as victims did they receive his sympathy. It was their pretensions to intellectual achievement that elicited his scorn.

BP
1985.48.2202 (ADB)

43

Les Fumeurs de hadchids.
 Ah! quel plaisir oriental je commence à éprouver... il me semble que je trotte sur un chameau!... –Et moi... je crois recevoir une bastonnade!...
The hashish smokers.
 Ah! What Oriental pleasures I begin to feel... I seem to be trotting along on a camel!... –And to me, it seems that I am receiving a basti-nado!...

Series: *Les Beaux jours de la vie* (Life's beautiful days)
Distributor: Aubert
Appeared: *Le Charivari*, 13 September 1845
Catalogued: D.1157; *Inventaire*, no. 182

 Little triumphs and little pleasures of the bourgeoisie are the subjects of Daumier's *Les Beaux jours de la vie*. At the time when this print was made there was no sanction against hashish, legal or moral, and some healing qualities were even attributed to it. Many literary figures left accounts of its effects: Theophile Gautier was a member of The Hashish Club that was devoted to its study; Baudelaire's *Les Paradis artificiels* concerns hashish and other stimulants and narcotics.

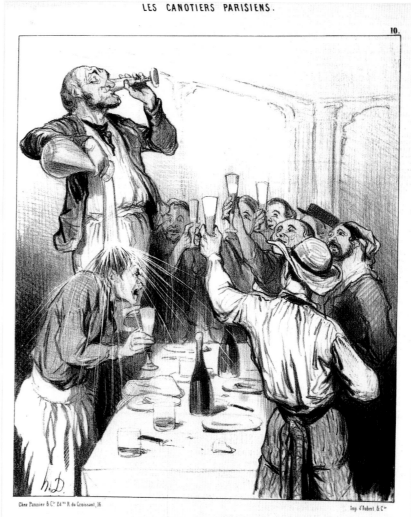

LES CANOTIERS PARISIENS.

10.

Chez Pannier & Cⁱᵉ Edᵗˢ R du Croissant, 16. Imp d'Aubert & Cⁱᵉ

UNE RECEPTION.
Messieurs.....buvons à la santé des marins français en général et a celle de notre nouvel équipier Greluchon en particulier!.... et en attendant le baptême du feu, qu'il reçoive celui de l'eau!..

45

 Although hashish and the paraphernalia for smoking it came to France from North Africa and the Near East, there is little here to suggest that Daumier had in mind any sort of political statement about the French colonial conquests that facilitated such imports. It appears rather that he (or his caption-writer Philipon) is lampooning the smug ignorance of these bourgeois smokers who haven't the faintest idea of what it is like to ride on a camel, or to receive the traditional Arab punishment of the bastinado, a beating on the soles of the bare feet, which they dreamily call "oriental pleasures."

GB/BF
1985.48.2561 (ADB)

44

Une Emeute.
 –Po po po lissson!... je vais dou dou...bler tous vos devoirs!...–De quoi des devoirs... sous un gouvernement despotique c'est l'insurrection qui est le seul devoir!...
A revolt.
 –Ra ra rascal!... I'm going to dou dou...ble all your duties (homework)!... –What duties... under a despotic government, the only duty is insurrection!...

Series: *Professeurs et moutards* (Professors and kids)
Printer and Distributor: Aubert
Appeared: *Le Charivari*, 20 December 1845
Catalogued: D. 1441; *Inventaire*, no. 196

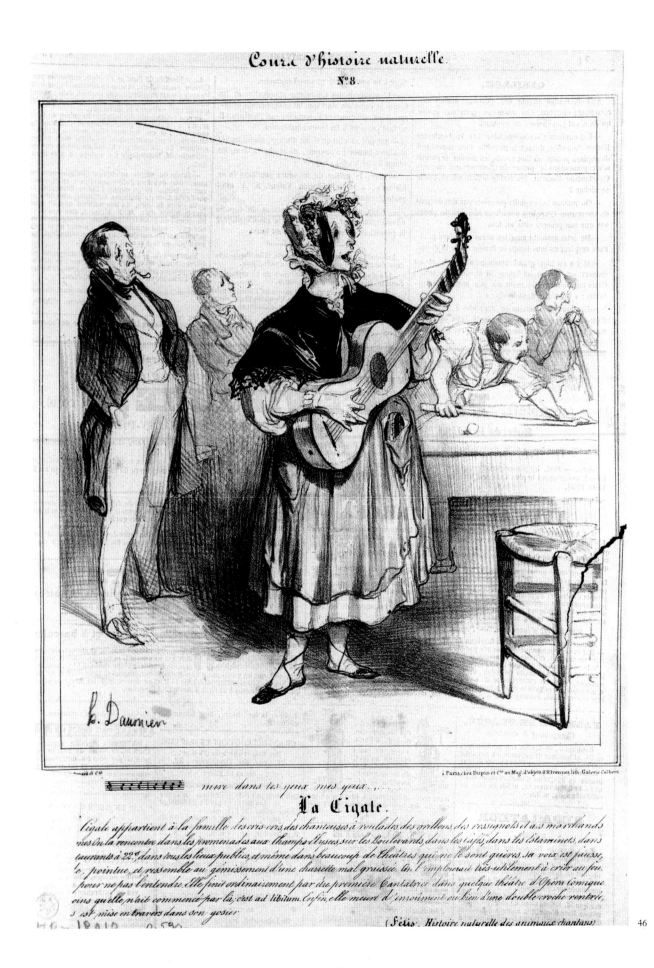

mire dans tes yeux mes yeux...

La Cigale.

La cigale appartient à la famille des cris cris, des chanteuses à roulades, des grillons, des rossignols et des marchands
des On la rencontre dans les promenades aux Champs Elysées, sur les Boulevards, dans les cafés, dans les estaminets, dans
taurants à 22.ᵉ; dans tous les lieux publics, et même dans beaucoup de théâtres qui ne le sont guères, sa voix est fausse,
le pointue, et ressemble au gémissement d'une charrette mal graissée. On l'emploierait très-utilement à crier au feu.
pour ne pas l'entendre. Elle finit ordinairement par être première Cantatrice dans quelque théâtre d'Opéra comique
eins qu'elle n'ait commencé par là, c'est ad libitum. Enfin, elle meurt d'enrouement ou bien d'une double croche rentrée,
s est mise en travers dans son gosier.

(Fétis. Histoire naturelle des animaux chantans)

46

68

In the series *Professeurs et moutards*, Daumier documented the perpetual war between law and order on the one hand, and the assertion of individual freedom or group license on the other. Drawn in the mid-1840s, when censorship was in full force but Louis-Philippe's regime was heading for disaster, these scenes of control and uprising formed an innocent vehicle as a microcosm for the world of adults: government and subjects.

There is a certain correspondence between Daumier and Dickens, both in their origins, and in their attitudes toward such things as the legitimately constituted governments of their day and to the education of children. In *Hard Times* (1854), Dickens describes a school in which the children constitute "an inclined plane of little vessels then and there arranged in order, ready to have imperial gallons of facts poured into them until they were full to the brim."[1]

Later in the book, it emerges that this "education" is to fit the students to a lifetime of thoughtless obedience. Thus his description contains more than compassion for the children; it is, in a way, a political analysis. For Daumier, under censorship, the impulse to use children to refer also to an adult world was even stronger.

The title of this print resonates with the idea of popular uprisings, and indeed Daumier made a painting of such a scene among downtrodden adults with the same title. Here the students, quoting on Daumier's behalf some revolutionary theorist, shout "under a despotic government the only duty is insurrection." Not only has the teacher lost control over the students but, unequipped with an army like the king, he is unable to even save himself from personal mockery.

GB
1985.48.2813 (ADB)

[1] Charles Dickens, *Hard Times* (London: Oxford University Press, 1983), 1-4.

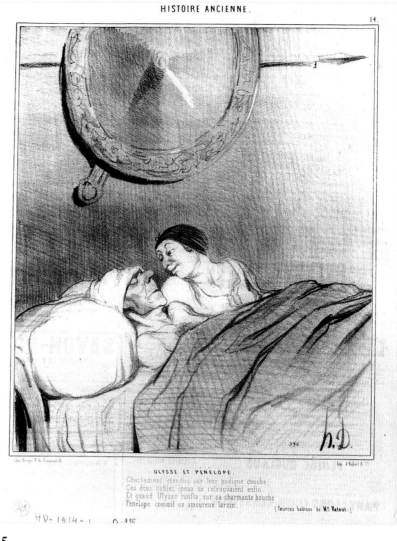

45

Une Réception.
Messieurs... buvons à la santé des marins français en général et à celle de notre nouvel équipier Greluchon en particulier!... et en attendant le baptême du feu, qu'il reçoive celui de l'eau!...

A Reception.
Gentlemen... let's drink to the health of French sailors in general and to that of our new team member Greluchon in particular!... and, while we're waiting for the baptism by fire, here is one by water!...

Series: *Les Canotiers parisiens* (Parisian boatmen), no. 10
Printer: Aubert
Distributor: Pannier
Appeared: *Le Charivari*, 26 May 1843
Catalogued: D. 1032; *Inventaire*, no. 176

A mania for boating on the Seine and the Marne raged in the 1840s among salesmen, law clerks, students, and other bourgeois youths who discarded their coats and ties for picturesque sailors' garb, and formed societies, sometimes to purchase a boat, but chiefly for revelry and "copious libations."[1] In this series on Parisian boatmen, Daumier lampooned their inept pretensions to maritime professionalism and documented their urban high jinks.

BP
1985.67.157 (MW)

[1] Charles Fries, "Les Canotiers," *Les Français peints par eux-mêmes* 9:224-27.

46

...mire dans tes yeux mes yeux...La Cigale.
La Cigale appartient à la famille des
cris-cris, des changeuses à roulades, des
grillons, des rossignols et des marchan-
des de légumes. On la rencontre dans
les promenades aux Champs-Elysées,
sur les boulevards, dans les cafés, dans
les estaminets, dans les restaurants à 22
sous, dans tous les lieux publics, et
même dans beaucoup de théâtres qui ne
le sont guère. Sa voix est fausse, forte,
pointue, et ressemble au gémissement
d'une charette mal graissée. On
l'emploierait très utilement a crier au
feu. On la paierait pour ne pas l'enten-
dre. Elle finit ordinairement par être
la première cantatrice dans quelque thé-
âtre d'opéra comique, à moins qu'elle
n'ait commencé par là, c'est ad libitum.
Enfin, elle meurt d'enroûment ou bien
d'une double croche rentrée, qui s'est
mise en travers de son gosier.

...see in your eyes my eyes...The Cicada.
The Cicada belongs to the family of
crickets, singers of trills, chirpers,
nightingales, and sellers of vegeta-
bles. She can be met on walks on
the Champs-Elysées, on the boule-
vards, in cafes, restaurants that
charge 22 sous, in all public places,
and even in many theatres hardly
worthy of the name. Her voice is
false, loud, sharp, and resembles the
squeals of a badly greased cart. She
could be usefully employed as a fire
alarm. You would pay her to stop
singing. She usually ends up as the
lead singer in some comic opera
theatre, unless she has started thus,
it's your choice. Finally she dies of
hoarseness or because of a semi-
quaver swallowed and stuck in her
throat.

Series: *Cours d'histoire naturelle*
 (Course in natural history)
Printer: Benard
Distributor: Dupin
Appeared: *Le Charivari*, 13 December
 1837
Catalogued: D. 530; *Inventaire*, no. 122

Cours d'histoire naturelle is another
series of *physiologies* characterizing some
of the denizens of Parisian lowlife. The
pseudo-scientific caption for *La Cigale*
starts out innocently but degenerates
rapidly into satire when 'nightingales'

are followed by 'vegetable sellers'. The
rest makes the street singer's musical
qualities monotonously painful.
Another contemporary observer, Maria
d'Anspach, gives a similar verbal
description, calling this street enter-
tainer "la cigale dont parle La
Fontaine."[1]

Daumier does not in this image
show any particular sympathy for the
poor. Rather he ridicules the preten-
sions of the untalented, performing for
an unresponsive audience in a pool hall.

BF
1985.48.2449 (ADB)

[1] M. d'Anspach, "Les Musiciens Ambu-
lants," *Les Français peints par eux-mêmes*
9:184.

47

Ulysse et Penelope.
 Chastement étendus sur leur pudique
 couche; Ces deux nobles époux se
 retrouvaient enfin. Et quand Ulysse
 ronfla, sur sa charmante bouche Péné-
 lope commit un amoreux larcin.
 (Oeuvres badines de Mr. Vatout)
Ulysses and Penelope.
 Chastely stretched out on their
 modest couch; These two noble
 spouses finally find each other
 again. And while Ulysses snores,
 upon his charming mouth Penelope
 commits an amorous larceny.
 (Droll works of Mr. Vatout)

Series: *Histoire ancienne* (Ancient history)
Printer: Aubert
Distributor: Bauger
Appeared: *Le Charivari*, 26 June 1842
Catalogued: D. 938; *Inventaire*, no. 166

As part of his commentary on the
battle between the romantics and the
classicists, this series of fifty prints
issued between December 1841 and
January 1843 seems to be a satirical
equivalent of the famous complaint,
"Who will deliver us from the Greeks
and the Romans?," and P.-J. Proud-
hon's questioning of David's and
Ingres' need to go back twenty-three
centuries for subjects to reach the heart
of the modern Frenchman. The titles,
and perhaps the subjects of the Ancient
History series as well, were chosen by

the scholar and writer Alberic Second.
Earlier, Daumier had completed a
short series of satirical sketches called
Physionomies tragico-classiques (Faces
from the tragic drama), of scenes from
the classical tragedies successfully
staged in Paris in the late 1830s star-
ring Mademoiselle Rachel. In 1852 he
designed costumes for a theatrical par-
ody of Ponsard's play *Ulysses*, written by
Louis Huart, one of Philipon's collabo-
rators.

In this image, as in the entire series,
Daumier capitalizes on the humor to
be found in turning the heroes and
heroines of ancient myth and epic into
the image of the *bons bourgeois* of Paris
(see also no. 35). In poking fun at the
emphasis on classical values, Daumier
is clearly living by his own dictum,
"One must be of one's own time."

BP
1985.67.151 (MW)

Bibliography:
 Mongan, Elizabeth. *Daumier in Retrospect,*
 1808-1879.

Achille Jacques Jean-Marie Devéria (1800-1857)

Achille Devéria was born in Paris and, together with his younger brother Eugène, became a student of Louis Lafitte, and later of Girodet at the Ecole des Beaux-Arts.

Devéria created more than three thousand lithographs and engraved illustrations for over three hundred books during his career. While his prolific output of lithography between 1819 and 1848 provided the real basis for his fame, he was also active as a painter throughout his career. The Salon of 1822 introduced him as a painter of religious and historical scenes and, despite the existence of a lithography section at the Salon, Devéria continued to exhibit only paintings. It was his younger brother Eugène, however, who was the aspiring painter of the family. Achille devoted considerable resources to promoting Eugène's career, which unfortunately foundered after an early success at the Salon of 1827.

In 1827 Achille married Céleste Motte, the only child of the lithographic publisher Charles Motte. This advantageous marriage gave Devéria access not only to a well-known publisher but also to the increasingly important circle of young romantics including Delacroix, Dumas *père*, and Victor Hugo. The Motte-Devéria home became one of the regular gathering places for this avantgarde group of artists and writers.

The lithographs of Devéria vary widely in style and content. His subjects include portraiture, religious imagery, literary and historical themes, historical and ethnic costume, contemporary fashion, art reproductions, depictions of social mores and manners, as well as libertine subjects including nudes and pinups and intimate scenes of modern life. Devéria reportedly would do whatever his editors asked of him, although Maximilian Gauthier states that the artist refused to do the "diableries" that were extremely popular with audiences in the Restoration period. He also avoided any political comment, except in a few works at the outset of his career. Although examples of his work appeared in the newspapers *La Silhouette, La Caricature, Le Journal des gens du monde*, and *La Mode*, the bulk of his lithographs

were offered for sale at printsellers in the form of independent suites of prints.

The corpus of over four hundred and fifty lithographic portraits created by Devéria beginning in 1823 constitutes a gallery of romantic Restoration society: Marie Dorival, Chateaubriand, Dumas *père*, Géricault, the Grisi sisters, Victor Hugo (and family), Mlles. Mars, Rachel, and many others. A political conservative, Devéria did not portray lower-class types as did many other lithographers of his time. He would often combine themes in his fashion plates which are at the same time portraits of relatives and friends.

In 1848 Devéria's friends convinced him to become a republican. Shortly thereafter, friends procured for him the position of assistant curator of the Cabinet des Estampes at the Bibliothèque nationale. He was awarded the chief curatorship in April 1857 but died of tuberculosis nine months later. During his nine-year career at the Cabinet des Estampes, he organized the chaotic collection along the lines of his own important collection of graphic art, thereby putting these extensive holdings into an orderly, accessible state. During Devéria's stewardship, *cartes de travail* were issued to many artists, including Degas and Fantin-Latour, permitting them to consult the collection. After his death, Devéria's important collection of 113,000 engravings, lithographs, and drawings was acquired by the Cabinet des Estampes from his heirs for the nominal sum of thirty thousand francs.

While much of his imagery may seem sentimental to twentieth-century taste, Devéria's usually excellent draftsmanship, sense of composition, attention to detail, and accurate portrayals delight the modern viewer.

His greatest artistic contribution was as a forerunner of realism in the visual arts. He and other French lithographers of the Restoration and July Monarchy, like Balzac and Stendhal in their novels, laid the groundwork for the iconography of Manet and Degas in the 1860s and 1870s.

RP/BF

Bibliography:
Gauthier, *Achille et Eugène Devéria*.
Delaborde, *Le Département des Estampes à la Bibliothèque nationale*.

48

Victor Hugo.
1828

Printer: C. Motte
Reference: Farwell, *FPLI* 1:10, 2D4

Among the earliest of Achille Devéria's lithographic portraits, this one represents the young Victor Hugo at a time when his fame was already considerable, and when romanticism was just being defined by such statements as his *Preface to Cromwell* (1827). Hugo was an esteemed poet at this time, but not yet the renowned author of the novels *Notre Dame de Paris* (1831), or, far in the future, *Les Misérables* (1861).

Devéria's lithographic portraits constitute a veritable gallery of the notables of the July Monarchy and the Second Republic, most of them drawn between 1828 and 1835. Among the best known are those of Alexandre Dumas *père* and the two or more he made of Victor Hugo, who was a close friend. The rich *chiaroscuro* of romantic portraiture in graphic media is well developed here, and even more so in no. 49, which was made slightly later.

RP/BF
1985.67.183 (MW)

49

E. Devéria.
c. 1829-35

Printer and Distributor: C. Motte
Catalogued: Béraldi, no. 229
Reference: Béraldi, 5 (supplement): 39-40

Achille Devéria's brother Eugène, a painter, achieved his only fame at the Salon of 1827 with a history painting, *The Birth of Henri IV* (see no. 94 for a parody of that work). Although wellloved by his self-sacrificing and doting family, Eugène was described by Baudelaire as a "ruined genius" and a "defunct talent"—the perfect makings of a bohemian artist.[1]

This image, however, displays the high quality that Achille Devéria sometimes achieved in lithographic portraiture. Its angular outlines and rich *chiaroscuro* exploit the fully developed

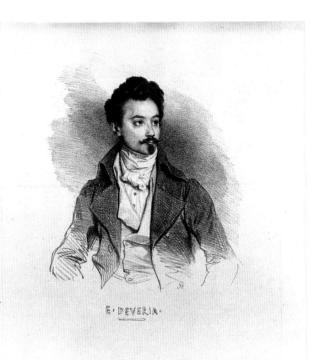

characteristics of the medium, which reached its apogee about 1830. The Devéria monogram to the right just above the title is common to most of his lithographic portraits after 1829, and the high collar, stock, and wide lapels point to the extreme of romantic dress in the early 1830s. A dating of 1829-35 therefore seems appropriate.

Both Béraldi and Adhémar acknowledged that Devéria was one of the best romantic portrait lithographers and that his portraits are among his finest lithographs.[2]

RP/BF
1985.48.515 (ADB)

[1] Baudelaire, "Salon de 1845," *O. c.* 2:364-365.
[2] Béraldi, 5:221; *Inventaire* 6:483.

50

Le Coin du feu.
The hearth.

Series: *Album lithographique* (Lithographic album), 1829, pl. 5
Printer: C. Motte
Catalogued: Béraldi, no. 442; *Inventaire*, no. 70
References: Béraldi, 5:215 and 5 (supplement):72; Gauthier, *Devéria*, p. 89; *Inventaire* p.491

This charming lithograph, while representing motherhood, also presents a portrait of Victor Hugo's wife Adèle and their eldest son Charles. The image of the good mother and the joys of family and motherhood were concepts introduced in the late eighteenth century. These ideas represented a rebellion against traditional prearranged marriages in favor of romantic love, and reflected the recently developed nuclear family as opposed to the older extended family.[1] In contrast to this theme, the nineteenth century often portrayed the bad mother in art and literature.[2] The mother in these depictions ignores her children for professional work or for a rendezvous with her lover. Michel Melot has pointed out that this theme served as a bourgeois response to the early feminist movements of the time. The woman seeking independence in place of submissiveness to her role as mother and wife underwent punishment in this scenario, with disasters befalling her children as the result of her neglect.

RP/BF
1985.48.476 (ADB)

[1] Duncan, "Happy Mothers," 570-583. See also Ariès, *Centuries of Childhood.*
[2] Melot, "La Mauvaise Mère," 167-176.

51

9 Heures du soir.
9 o'clock in the evening.

Series: *Les Heures du jour* (The hours of the day), no. 15, 1829
Printer: Fonrouge
Distributors: Fonrouge; Ostervald aîné
Catalogued: Béraldi, no. 425; *Inventaire*, no. 106
References: Béraldi, 5:218, and 5 (supplement):69, and 5:42, no. 236; Gauthier, *Devéria*, p. 88; *Inventaire*, p. 495

This suite of twenty-four lithographs was published as fashion plates in the journal *L'Artiste*. The suite

depicts fashionable women from seven a.m. through noon and midnight until five a.m., in appropriate attire for the activities of each hour. Nine o'clock in the evening finds the fashionable Parisienne of 1829 at a soirée sitting on an overstuffed divan stirring her tea. The elegant satin evening gown has lace trim, a daring *décolletage*, exaggeratedly puffed sleeves, and a full skirt. Long gloves, a fan, and a fantastic coiffure of ribbons and plaits complete this example of the *haute couture* of late Restoration Paris.

Like many of Devéria's prints, the lithographs of this suite do double duty as portraits. The fashionably plump young woman in this lithograph is in fact Mlle. Laure Devéria, the artist's beloved younger sister. She appears in a number of his lithographs and was taught the art of lithography by him.

RP
1985.48.447 (ADB)

52

Le Sommeil.
Sleep.

Series: Unknown, pl. 42, c. 1829
Printer: Aubert
1985.48.501 (ADB)

53

A Qui rêve-t-elle?
Of whom does she dream?

Printer: Lemercier
Distributors: François et Louis Janet
(Paris); Ch. Tilt (London); Bailly
and Ward (New York)
1985.48.449 (ADB)

This image typifies Devéria's lithographs of coquettish, pretty girls. A young girl daintily sleeps while her shift has slipped down to reveal her shoulder and a portion of her breast. The bed curtains, bell pull, cup and saucer, and a *bibelot* suggest a life of bourgeois comfort. Devéria produced so many of these titillating images of girls in inviting or vulnerable circumstances that one can characterize it as a signature motif in his oeuvre. He created at least two other

LE COIN DU FEU.

50

9 HEURES DU SOIR.

51

73

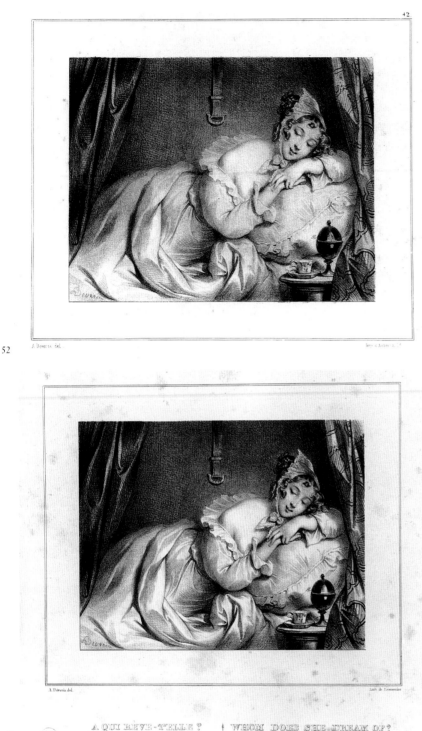

42

52

A Deveria del. Imp. c. Aubert & C.ᵉ

53

A. Déveria del. Lith. de Lemercier

A QUI RÊVE-T-ELLE ? | WHOM DOES SHE DREAM OF ?

same iconography of bedclothes and bedside bric-a-brac, but depicts two nude sleeping women. The waking *Olympia* of Manet does the same. Reclining women, usually nude, had a long history with classical overtones, but the contemporary accessories as used by Devéria derive from the Dutch and French versions of biblical subjects such as Bathsheba and Susannah.[3]

RP/BF

1 *Inventaire*, no. 96, p. 413, printer and distributor Charles Motte; Béraldi, 5:216, printer Lemercier and distributor Schroth. It may be significant that Schroth published many of Devéria's libertine images instead of Charles Motte (Farwell, *Cult of Images*, no. 108.) One could assume that perhaps Motte would be reluctant to publish libertine images by his son-in-law. The fact that Motte both printed and distributed the *Sommeil* and its pendant *Reveil* of 1829, however, contradicts this idea. The fact that No. 53 was printed by Lemercier and distributed by foreign dealers complicates the matter further.

2 *Inventaire*, no. 281(6). Janet distributed this lithograph in Paris, Tilt in London, and Bailly and Ward in New York. It was printed by Lemercier. The museum owns an impression from this reissue edition as well.

3 Farwell, "Courbet's *Baigneuses* and the Rhetorical Feminine Image," *Woman as Sex Object*, 64-80.

54

Macédoine.
Medley.

Series: *Treize macédoines* (Thirteen medleys), 1829-30, pl. 12
Publisher: C. Motte (Paris and London)
Catalogued: *Inventaire*, no. 105

The term *macédoine* as used in lithography describes a single sheet that carries multiple vignetted images on a variety of subjects. The word originated in cuisine where it meant a salad of mixed fruit or vegetables whose hallmark ingredient was *persil macédoine* (Macedonian parsley). The item was adopted by literature, with groups of short stories called *macédoines littéraires*. Finally it came to mean any potpourri or medley of things without a unifying

lithographs entitled *Sommeil*, both printed and distributed by different firms.[1] This image was popular enough to be reissued under another, even more eroticized title, *A Qui rêve-t-elle?* in 1833.[2] It was not uncommon for publishers to buy or borrow stones and reissue the lithographs with new titles. In this case, the recycled lithograph

was intended for export to London and New York as indicated by the bilingual French/English title and the London and New York distributors.

Lithographs like *Le Sommeil* provide an important link to realist painting later in the century, as in the work of Courbet and Manet. *Le Sommeil* of 1866 by Courbet provides much the

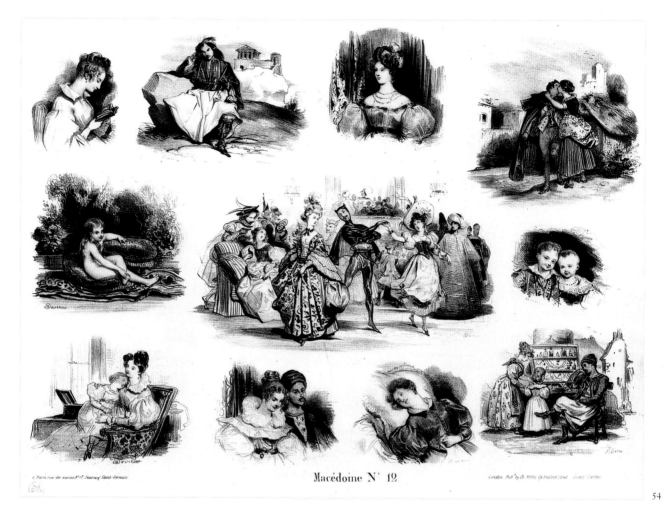

Macédoine N.° 12

54

order.[1]

Some of these medleys were probably intended to be used like decals on boxes, bookcovers, or cheap furniture. Others were intended to be framed and placed on the cluttered walls of bourgeois interiors. Monnier, Grandville, and Philipon also created *macédoines*. In a letter to Devéria of 17 February 1832, Philipon tries to persuade the artist to make a few *macédoines*, stating that times are hard and that the public feels it gets more for its money in these little medleys, a number of which he has been editing for his brother-in-law Aubert, the publisher. He describes it as a good merchandising technique and assures Devéria that many artists (Gavarni, Poitevin, Sabatier, and Watier) have already done them. (In fact, the record indicates that Devéria had already done quite a few himself.)[2]

This *macédoine* fills the sheet with eleven different vignettes, centering on the largest, which depicts a costume ball featuring the devil. The costumes of various periods and cultures here reflect

the nineteenth century's historical eclecticism, as does the entire medley.

The smaller scenes depict a number of Devéria's typical subjects: happy mothers and rustic lovers, as well as fashion and current events. Three scenes depict Greeks in ethnic costumes, one seated before a stylized representation of the Parthenon. Although the Greek war of independence from the Turks began in 1821, independence was not assured until the Russian-Turkish treaty of Adrianople of 1829. Greek independence was thus a current event when this lithograph was produced. In still another vignette, a mother and her daughter examine the wares of a Greek street vendor in Paris.

RP

1985.48.522 (ADB)

1 *Nouveau Larousse Illustré*, (Paris: Librairie Larousse, 1898-1904), 5:814.
2 Gauthier, *Devéria*, 80.

55

Fermez donc la porte, Justine!
Close the door, Justine!

1985.48.458 (ADB)

56

On n'entre pas. Fermez donc la porte, Justine!
Do not enter. Close the door, Justine!

Series: unknown, no. 10
Appeared: *La Caricature*, 4 November 1830, pl. 10
1985.67.181 (MW)

A special type of image, mostly on erotic themes, was made with a supplementary piece to be cut out and hinged (with pasted tabs going through slots) onto the main image. Numbers 55 and 56 constitute such an image "open" and "closed," and also uncolored and colored. Usually the viewer is expected to see the closed image, followed by some

55

56

risqué revelation upon opening the door or window. In this case the captions indicate a reverse order. The indiscretion is rectified by the maid closing the door, presumably against an importunate caller.

Each issue of *La Caricature* normally included two lithographic pictures, as loose sheets inserted into the folded small-format newspaper. This image is one of several that appeared in the first issue, dated 4 November 1830. The anomaly of more than two prints for the same issue is accounted for by the fact that, owing to its unexpected initial popularity, the paper's first twenty-six numbers were twice re-issued.[1] Obviously not all of these numbers were re-issued with the same prints as the original.

Since this image does not appear in the Bibliothèque nationale *Inventaire*, the question arises whether it was originally censored, or the impression deposited there has simply been lost. The impressions preserved at the Bibliothèque were deposited there under the *dépôt légal* system, after being submitted by the printer to the censorship office. This question remains unanswered at present.

RP/BF

[1] Getty, *Grandville*, 206.

57

Un Archange ramène à Dieu deux âmes qu'il vient d'arracher aux griffes de Satan.
An archangel brings to God two souls he has just snatched from the claws of Satan.

Series: *Images de Piété* (Images of piety), c. 1841-43, pl. 23
Printer: Godard
Distributor: J. Bulla et F. Delarue
Catalogued: *Inventaire*, no. 416(?)

In this lithograph a heroic and triumphant archangel guides two contrite women toward heaven after an encounter with the devil. The feathered wings of both souls bear the marks of manhandling by the renegade angel Satan, who still clutches the evidence of his attempt in his taloned right hand.

The magnificent figure of Satan, with his Michelangelesque musculature, bat wings, talons, curling horns, and pointed beard is a nineteenth-century romantic type (compare the dancer in devil's costume at the ball in Devéria's *Macédoine*, no. 54). Devéria's friend Delacroix had created a devil of remarkably similar mien in his *Mephistopheles in the Air* from the Faust illustrations of 1827. Jean-Jacques Feuchère modeled a sculpture of Satan almost identical to the devils of Devéria and Delacroix in 1833. Although not cast until 1850, Feuchère's *Satan* was admired and widely acclaimed in the form of a plaster model at the Salon of 1834.[1]

Devéria created a suite of saccharine and sentimental guardian angels in 1830, which was republished in 1839,[2] possibly with some additional plates. The commercial nature of his enterprise, or that of his publishers, is seen in the fact that he produced images of piety as readily as scenes of libertinage. This feature of Devéria's art may be contrasted with Daumier, or any of the politically committed caricaturists.

RP
1985.48.530 (ADB)

1 H. W. Janson and Peter Fusco, *The Romantics to Rodin* (Los Angeles County Museum of Art/G. Braziller, 1980) 266.
2 *Inventaire* 6:498; see also Farwell, *FPLI* 6:21 and 5B2-5B5, 5B9-5C3.

58

Le Corset.
The corset.

Printer: Lemercier
Distributors: H. Jeannin (Paris); Ch.
Tilt (London); Bailly and Ward
(New York); Colnaghi (London)
Catalogued: *Inventaire*, no. 165
References: Béraldi, 5:216;

Achille Devéria produced a whole body of *risqué* work, of which *Le Corset* is a good example. Although not one of his nude studies, it presents a woman in the act of undressing, regarded by many as more provocative than the simple nude. It belongs to the category of images of *la toilette*.

This type of imagery emerged in the engravings of the last third of the eighteenth century as the *"toilette galante"* with a special sub-category devoted to the corset. "The lady gazes into the mirror standing before her—or into her lover's enraptured eyes."[1] The corset was introduced in the rococo period between 1715 and 1730 when the full figures of the baroque gave way to a new body aesthetic that glorified the slender, delicate woman. The Revolution swept away the corset in favor of a more natural body inspired by the neoclassical admiration of the Greeks during the First Empire. With the restoration of the monarchy, the corset, too, was restored. By the 1830s it was once again hailed in the graphic arts as an erotic symbol. The corset shaped, protected, and hid the body beneath it, but also emphasized certain erogenous zones: "...her dainty waist had been constricted and the pressure of the corset had pushed out an alabaster bosom."[2] This new erotic iconography provided a very modern significance. "In Devéria the girl faces us, smiling in gentle invitation, holding the lace in her hand in symbolic significance of unlacing the chastity belt."[3] Devéria's corseted lady meets the viewer's eyes with her own, and proceeds to uncorset herself, making the bourgeois viewer an accomplice to her act.

RP
1985.48.477 (ADB)

Un Archange ramene à Dieu deux âmes qu'il vient d'arracher aux griffes de Satan

57

1 D. Kunzle, "The Corset as Erotic Alchemy," *Woman as Sex Object*, 98.
2 Ibid.
3 Ibid., 108.

59

Untitled (*Louise de Radepont*).

Series: *Le Goût nouveau* (The new style), 1831, no. 18
Printer: Lemercier
Distributors: Tessari and Aumont (Paris); Ch. Tilt (London)

Le Goût nouveau refers to the latest fashions in women's dress, to which this series like the series *Les Heures du jour* (no. 51) was devoted. In both groups, Devéria's models were his female relatives and in-laws whose names have come down to us in penciled notes on the mounts in the Cabinet des Estampes of which Devéria was once curator-in-chief.

Of particular interest is the album through which the young woman is leafing. It is impossible to tell whether it contains etchings, lithographs, or steel engravings, but the album's generous size would suggest lithographs, probably all of landscapes, as the album is bound in a horizontal format. Of further interest is the sofa on which she is informally seated. Consisting simply of cushions, it belongs to the vogue for orientalia that became an important part of romantic decor. When eighteenth-century Europe imported the idea of the sofa (and the word) from

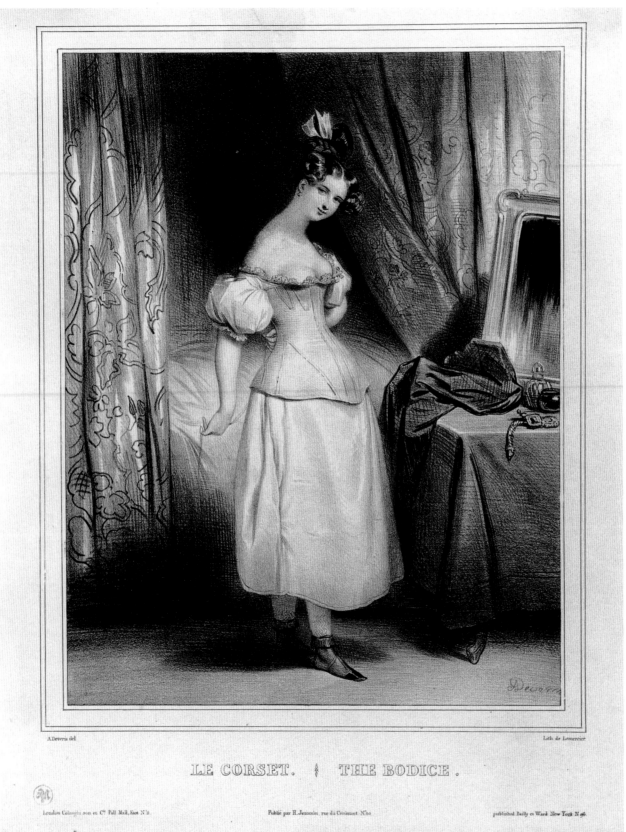

A.Deveria del.

Lith. de Lemercier

LE CORSET. | THE BODICE.

London Colnaghi son et C⁰ Pall Mall, East N°11.

Publié par H.Jeannin, rue du Croissant. N°30.

published Bailly et Ward, New York N°96.

Turkey, it was given legs and a wooden frame, but romantic bourgeois France wanted something closer to a harem divan. This form of sofa appears frequently in Devéria and Gavarni.

BF
1985.48.489 (ADB)

60

La Lettre.
1832
The letter.

Series: *Galerie fashionable*
 (Fashionable gallery), pl. 1
Printer: Lemercier
Distributors: François and Louis Janet
 (Paris); Ch. Tilt (London)
Catalogued: *Inventaire*, no. 236
References: Béraldi, p. 217; Thieme-
 Becker, 9:183-184
1985.48.469 (ADB)

61

La Lettre.
1832 (hand-colored)
The letter.
1985.48.468 (ADB)

This suite of lithographs combines fashion plates with genre scenes that derive from seventeenth-century Dutch painters such as Terborch and de Hooch. The *'fashionable'* of the series title is a reflection of the knowledge of English brought back to France with the return of aristocratic French *emigrés* during the Restoration. The subject and composition of Devéria's *La Lettre* resemble quite closely a painting entitled *The Letter* by Terborch (1660) in the Buckingham Palace collection.

Two examples of *La Lettre* are exhibited, one hand-colored, and the other black-and-white to be sold at a lower price. The colors could of course have been added at any time, but here they suggest the fashion colors of fabrics at the time of the 1830s. Printed color lithography was not commercially viable until the 1850s, though it was invented in 1839.

RP/BF

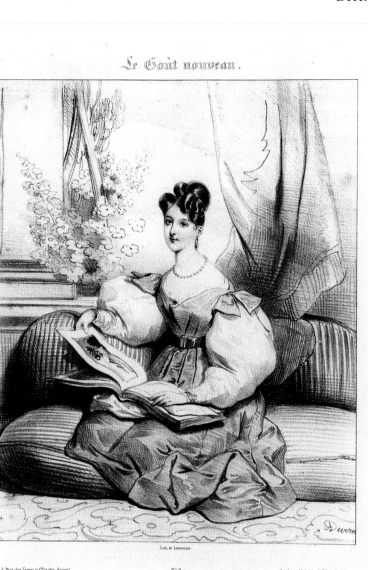

Le Goût nouveau.

59

62

Soins maternels.
1833
Maternal care.

Printer: Lemercier
Publishers: François et Louis Janet
 (Paris); Ch. Tilt (London); Bailly
 and Ward (New York)

This print is one of a large number by Devéria on the subject of motherhood (see also no. 50). The new emphasis in the nineteenth century on personal care for children (as opposed to wet nurses and nannies, or rather in addition to them, in practice) was a reflection of a new, smaller family structure as well as a role for women that stood in need of the propaganda provided by such prints.[1] Devéria, however, at times subverted this message with another: the young mother tending her baby could be depicted in a charming state of undress. Here we see her low-cut corset and generous *décolletage*, and a pretty striped silk negligee open to expose her charms. It is not clear what piece of furniture is being put to use for this vigil over the nap, but Devéria has managed to convey a seductive idea of the intimacy of home life.

BF
1985.48.524 (ADB)

[1] Duncan, "Happy Mothers," 577.

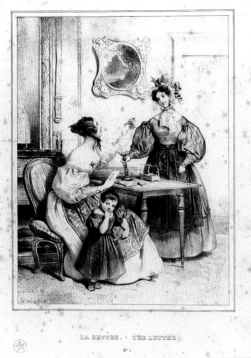

LA LETTRE. | THE LETTER.

N° 1

Publié par François et Louis Janet à Paris
Published by Ch. Tilt 86 Fleet Street London.

Lith. de Lemercier.

60

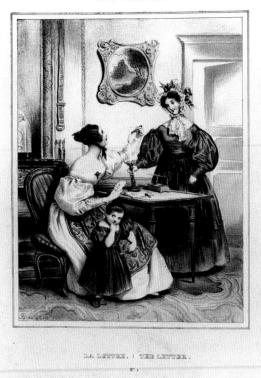

LA LETTRE. | THE LETTER.

N° 1

Publié par François et Louis Janet à Paris
Published by Ch. Tilt 86 Fleet Street London.

Lith. de Lemercier.

61

63

La Leçon paternelle. Terburg.
The paternal lesson. Terburg.

Series: *Ecole hollandaise* (Dutch
school), 1839
Printer: Aubert
Distributor: Challamel & Cie.

This reproductive lithograph is not
listed in the *Inventaire* or Béraldi, but
another Terborch genre painting is
reproduced in identical format, printed
and distributed by the same firms, and
identified in the same style of lettering
as *Ecole flamande* (the caption uses a
nineteenth-century French variant of
the Dutch painter's name). Another
Ecole hollandaise reproducing yet another
Terborch painting is included in the
museum's lithograph collection. None
of the images is reversed in printing.

Theodore Reff asserts that Blanc's
Histoire des peintres is "the first compre-
hensive illustrated history of European
painting."[1] It was published in install-
ments from 1849 to 1876. However, the
format of these lithographs by Devéria,
identifying the reproductions by title
and artist and classifying them accord-

ing to schools, suggests that Blanc's
concept was not entirely new.
Moreover, Blanc's reproductions were
only collected and issued as schools
from 1861 to 1876 (the chapters on
individual artists were first published as
separate installments). It may be signifi-
cant that Blanc's first and fourth schools
to be issued were the *Ecole Hollandaise*
and the *Ecole Flamande*, the two that
Devéria presents.

RP
1985.48.467 (ADB)

[1] Theodore Reff, "Manet and Blanc's
'Histoire des Peintres,'" *Burlington
Magazine* 113 (July 1970):457.

64

Le Mari dehors, la femme a la maison.
The husband out, the wife at home.

Printer: Delaporte
Distributor: Aubert
Appeared: *La Caricature*, 30 December
1831, pl. 24
Reference: Farwell, *FPLI* 6:6, 1F4

In the many prints Devéria made on
the subject of motherhood, the father is
almost never in evidence, a circumstance
underlined in the caption for this print.
Most such images represented things as
they should be (see also no. 50). Devéria
presented examples of two slightly dif-
ferent ideas: the good mother and the
happy mother. This print is an example
of the former, while no. 50 is closer to
the latter. The good mother's maternal
cares sometimes include weary vigils
and heartaches, while the happy mother
enjoys the sensuous charms and atten-
tions of the children—duty versus plea-
sure. The good mother type is
contrasted with the bad mother, who
also appears in prints (usually engaged
in an infidelity to her husband), while
the happy mother has no negative
counterpart.

BF
1985.48.495 (ADB)

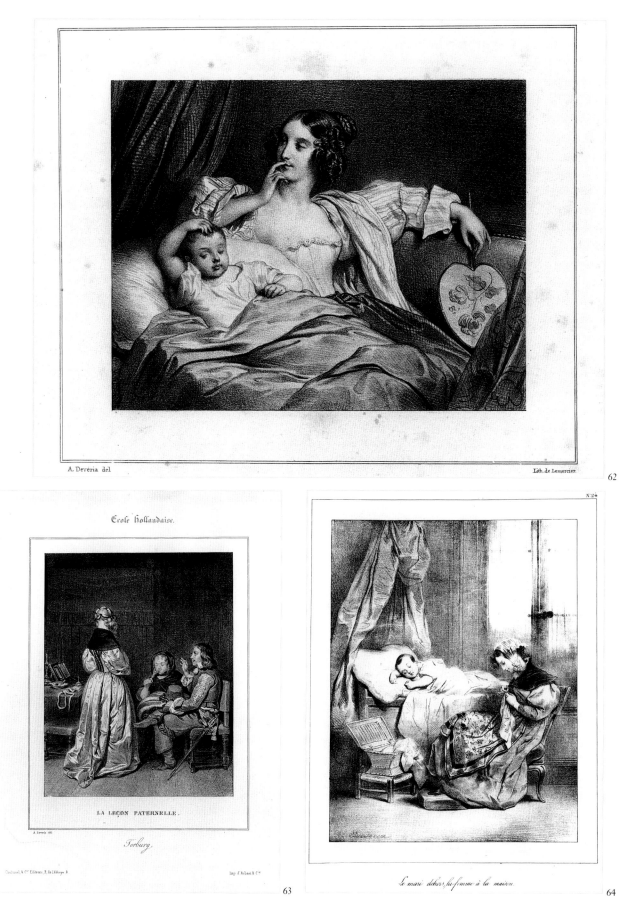

A. Deveria del

Lith. de Lemercier.

62

Ecole Hollandaise.

LA LEÇON PATERNELLE.

Terburg.

Le mari dehors, sa femme à la maison

63

64

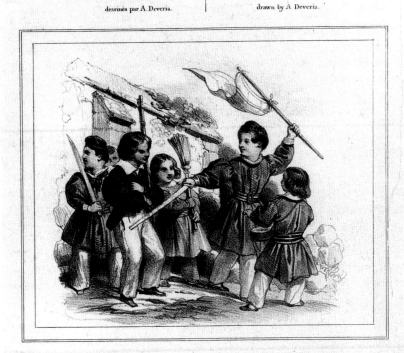

JEUX D'ENFANS. | CHILDREN'S GAMES

dessinés par A. Deveria. | drawn by A. Deveria.

LES PETITS SOLDATS. : THE LITTLE SOLDIERS.

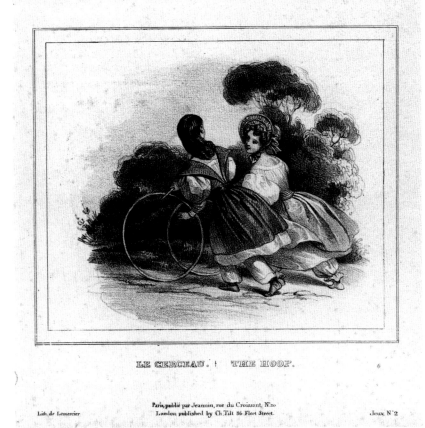

LE CERCEAU. : THE HOOP.

Lith. de Lemercier Paris, publié par Jeannin, rue du Croissant, N.20 Jeux N.2
London published by Ch. Tilt 86 Fleet Street.

65

Les Petits soldats. Le Cerceau.
c. 1830-35
The little soldiers. The hoop.

Series: *Jeux d'enfans* (Children's games),
 pl. 2
Printer: Lemercier
Publishers: Jeannin (Paris); Ch. Tilt
 (London)

 The subject of children's games goes back at least as far as Pieter Bruegel the Elder. But an emphasis on representations of children and the production of pictures and books created for children were developments of the nineteenth century. Among the great lithographers of the romantic period, Devéria and Charlet made something of a specialty of picturing the young (nos. 18, 21, 22, 26); Daumier in a series on schoolboys documented the war between *Professeurs et moutards* (no. 44). Devéria's are the most innocuous, conceived as they are for a market consisting of mothers who were likely to buy these prints and hang them up in the nursery. Then, as now, one could read in the images what activities were thought suitable for boys and girls, since these prints were certainly expected to serve as role models for gender differentiation as well as for decent behavior in general.

BF
1985.48.509 (ADB)

65

Paul Gavarni
(Guillaume Sulpice Chevalier)
(1804-1866)

Guillaume Sulpice Chevalier was born in Paris on 13 January 1804, the son of Sulpice Chevalier and Marie Monique Thiemet. In 1829, he adopted the name Paul Gavarni after a town in the Pyrenees. Showing an early ability in both drawing and mathematics, the young Guillaume entered the atelier of Professor Leblanc at the Conservatoire des Arts et Métiers in 1818, where he studied mechanical drawing. He sold his first lithograph for publication in 1824.

In 1830 Gavarni was hired by Emile de Girardin to draw fashion illustrations for *La Mode*. Through this work he met Victor Hugo and Balzac; the latter encouraged him to make illustrations for *L'Artiste*, a bi-weekly journal of art and literature. Encouraged further by his literary friends, Gavarni began to publish his own *Journal des gens du monde* in 1833, for which he wrote most of the text and drew many of the illustrations. This speculative business venture soon failed, however, and he was unable to pay his creditors. He was sentenced to debtor's prison for about nine months. Upon his release, Gavarni continued to collaborate with Balzac, making drawings for wood engravings illustrating some of the novelist's books, and with others in several multi-volume illustrated urban typologies such as *Les Français peints par eux-mêmes*, *Le Diable à Paris*, and various *physiologies*. In addition, he began to design theatrical costumes and carnival disguises, like the well-known *débardeur*, or longshoreman's costume adapted for both women and men.

In 1837 Philipon asked him to create a female counterpart to Daumier's Robert Macaire for *Le Charivari*, at a time when Gavarni's gentler, yet more cynical caricatures served better than Daumier's the publication's new editorial policy. This evolved into *Les Fourberies de femmes*, in which he exploited the myth of the hypocrisy and duplicity of the contemporary female. Gavarni, who wrote all his own captions, could draw from experience, as his two consuming passions were his work and women, whose charming and mysterious nature fascinated him. This series later gave way to *Les Lorettes*, a term coined in 1841 by Nestor Roqueplan to describe a new variety of middle-class courtesan, many of whom lived in the new quarter of Notre Dame de Lorette. During this time, Gavarni was far more interested in depicting the foibles of the different classes of Parisian society than in political satire, though he did on occasion take a swipe or two, as seen in the example of the series *La Politique*, published in *La Caricature*.

Gavarni married Jeanne Leonie Martin de Bonabry in 1844 and later illustrated an album of her songs. In 1847 he left Paris for England, remaining there, save for one short return to Paris, until 1851. In England he discontinued his satires on the Parisian scene, turning instead toward the lower classes and political satire, producing upon his return to Paris such series as *Histoire de politiquer*, *Les Lorettes vieillies*, and *Les Propos de Thomas Vireloque*, featuring the embittered old *chiffonier*. After the death of his young son in 1857, Gavarni gradually abandoned lithography and withdrew from society, working only in watercolor and renewing his early obsession with mathematics.

Second only to Daumier in reputation, Gavarni was preferred by many who responded to his ingratiating drawing and often erotic undertones more than to Daumier's relentless caricature and biting commentary. Although Gavarni's drawing style is very different from Daumier's, it is equally sophisticated, and far kinder to its human subjects. Gavarni forgives human foibles; Daumier condemns human folly. Both Champfleury and Baudelaire rate Daumier above Gavarni, and Baudelaire described Gavarni as "lightly touched with corruption." Degas however was an avid collector of Gavarni's lithographs as his letters and the contents of his studio revealed at his death.

BP

Bibliography:
Fryberger, *Gavarni*.
McPherson, *Les Femmes de Gavarni*.
Olson, *Gavarni: The Carnival Lithographs*.

66

Voyons! me trouvez-vous bien comme ça?
Let's see! Is this all right?

Series: *Les Artistes* (Artists)
Printer and Publisher: Aubert
Appeared: *Le Charivari*, 23 June 1838, pl. 7
Catalogued: Armelhaut and Bocher, no. 337; *Inventaire*, no. 146
Reference: Farwell, *FPLI* 3:14, 5B4

Nearly every lithographic artist recorded in caricature some aspect of his own profession. Gavarni devoted an entire series, *Les Artistes*, to this theme, usually exposing the contrast between the illusory nature of the image being represented and the more ludicrous reality of the subject, or sometimes, as here, treating confrontations between bohemian and bourgeois. The artist, as in this image, is often portrayed in some degree of bohemian dishevelment. The pose being adopted by the self-conscious bourgeois sitter bears a striking resemblance to the portrait of the publisher Louis Bertin, painted by Ingres in 1832.

BP
1985.48.2172 (ADB)

67

Viens me prendre ce soir je suis sortie pour la journée nous irons à la corniche je suis fièr[e] de ma toilette ma maîtresse est à la campagne et j'ai essayé une robe et un chapeau, une mantille à elle, tout cela me va à ravir.
Come get me tonight I've gone out for the day we'll go to the corniche I am proud of my outfit my mistress is in the country and I've tried on a dress and a hat, a mantilla of hers, it's all very becoming.

Series: *La Boîte aux lettres* (The mail box), no. 8
Printer: Cabache Gregoire Cie.
Appeared: *Le Charivari*, 5 January 1838, pl. 8
Catalogued: Armelhaut and Bocher, no. 89; *Inventaire*, no. 129

A maid dressed up in the clothing of her mistress, who is away in the country, is posting a letter to her lover. During this period, mail was collected from

Chez Aubert gal véro-dodat. Imp. d'Aubert et Cie.

Voyons! me trouvez-vous bien comme ça?

66

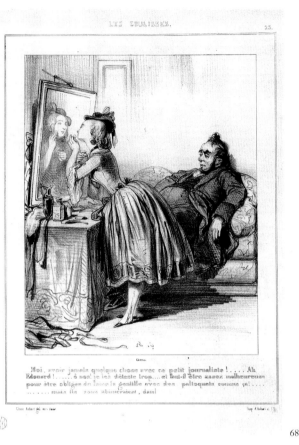

67

68

post boxes and delivered seven times a day; hence the request to her lover to come and get her that very evening. The handwriting, meant to indicate an unschooled hand, was more likely applied to the stone after first being executed on transfer paper, thus accomplishing the necessary reversal.

BP
1985.48.1673 (ADB)

68

Moi, avoir jamais quelque chose avec ce petit journaliste!... Ah Edouard!... ô non! je les déteste trop... et faut-il être assez malheureuse pour être obligée de faire la gentille avec des paltoquets comme ça!.... ...mais ils vous abîmeraient, dam[e]!

Me, have anything to do with that little journalist!... Ah Edouard!... oh no! I detest them too much... and do you think I'm unfortunate enough to have to treat such louts politely!... ...but they could ruin you, damn!

Series: *Les Coulisses* (In the wings), no. 23

Printer and Publisher: Aubert
Appeared: *Le Charivari*, 7 July 1838
Catalogued: Armelhaut and Bocher, no. 471; *Inventaire*, no. 145

From the same series as no. 70, this image depicts an actress in her dressing room accompanied by her portly protector whose ruffled feathers are being assuaged in the matter of a journalist he sees as a rival. Gavarni makes reference in the caption, however, to the perennial dilemma of the actress courted by the critic who holds power over her career.

Manet, some forty years later—undoubtedly influenced by popular images like this—was to address a similar subject in his painting *Nana*, of a young actress posed *en deshabille* with a fully dressed gentleman admiring her while she powders her nose at the mirror. Manet's painting was all the more shocking to the bourgeoisie because of its status as a Salon painting and its confrontational nature, since Nana is depicted with her gaze directed at the viewer of the painting.

BP
1985.48.1974 (ADB)

69

Une femme charmante vous a remarqué; vous la suivez longtemps, elle arrive au pont des Arts, vous allez lui parler... pas de bourse, pas un sou!! adieu le rêve.

A charming woman has noticed you: you follow her a long time, she arrives at the Pont des Arts, you're going to say something to her... but no wallet, not a cent!! goodbye sweet dreams.

Series: *Les Petits malheures du bonheur* (The little misfortunes of happiness), no. 6
Printer and Distributor: Aubert
Appeared: *Le Charivari*, 7 January 1838
Catalogued: Armelhaut and Bocher, no. 941.

Baudelaire defined the dandy as someone who did not work and had unlimited resources, or at least appeared fashionable and well-to-do and lived on unlimited credit. Gavarni, something of a dandy himself, here depicts a young bourgeois bachelor, obviously well-dressed, who pursues his quarry to the toll booth of the Pont des

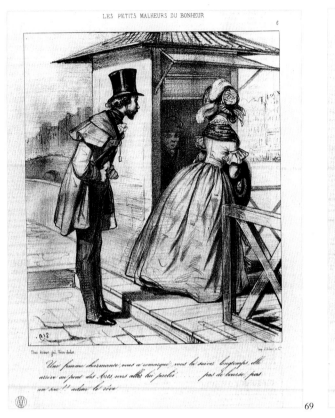

Une femme charmante, vous a remarqué, vous la suivez longtemps, elle arrive au pont des Arts, vous allez lui parler... pas de bourse, pas un sou!! adieu le rêve.

69

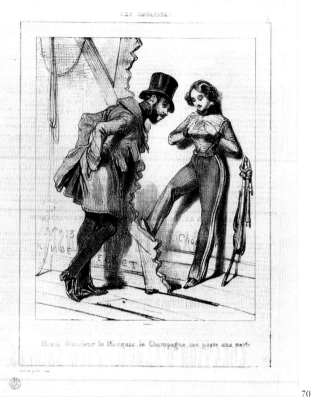

Merci Monsieur le Marquis, le Champagne me porte aux nerfs.

70

Arts, only to find himself without the money to pay the tariff for crossing the bridge.

BP
1985.48.2147 (ADB)

70

Merci monsieur le marquis, le champagne me porte aux nerfs.
Thank you monsieur le marquis, champagne affects my nerves.

Series: *Les Coulisses*
Distributor: Aubert
Appeared: *Le Charivari*, 1 February 1838, pl. 1
Catalogued: Armelhaut and Bocher, no. 449; *Inventaire*, no. 145

Gavarni frequently depicted backstage scenes from the theatre, a theme that Degas would turn to later in the century. Both treatments are indicative of the general fascination that theatrical glamour held for the French in the nineteenth century. Here the Marquis, a stage-door Johnny, is attempting to entice a young actress with champagne,

as she distractedly wards him off. Gavarni made a specialty of actresses and women at costume balls in male attire, graphically emphasizing the resulting revelations of the female anatomy that skirts and petticoats normally disguised. Here her quasi-Napoleonic military costume, coupled with a painted moustache, lend humor to the encounter expressed in the caption.

BP
1985.48.1970 (ADB)

71

Chicard (hand-colored).

Series: *Souvenirs du Bal Chicard* (Souvenirs of the Bal Chicard)
Printer and Publisher: Aubert
Appeared: *Le Charivari*, 25 March, 1839
Catalogued: Armelhaut and Bocher, no. 257; *Inventaire*, no. 173.

Costume balls had been a part of carnival celebrations in France since the fifteenth century, but their popularity was unprecedented during the period of

the July Monarchy. At first private and aristocratic, they became increasingly popular among the new bourgeoisie and the aspiring lower classes when they could afford them. One of the more exclusive, expensive (fifteen francs), and licentious of these *bal masqués* was also one of the most popular. The *Bal Chicard* was given by a prosperous businessman, Alexandre Lévêque, who was called by the nickname *Chicard*. Gavarni was a friend of Chicard's, and, as a result, was one of those regularly in attendance. In this image, from *Souvenirs du Bal Chicard*, a series of twenty lithographs published in *Le Charivari* between 1839 and 1843, we see one of the parodies of the earlier historic costumes of the *bal masqué* made famous at the *Bal Chicard*, along with some wilder forms of dancing.

BP
1985.67.192 (MW)

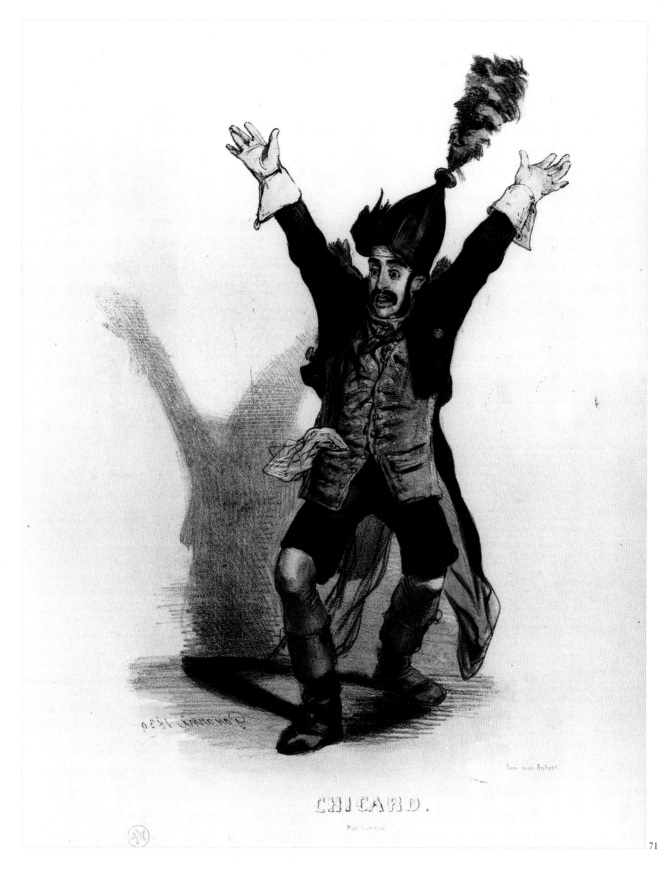

CHICARD.

Par Gavarni

72

6 heures du matin. Le Soleil est levé depuis vingt-cinq minutes, Monsieur le Baron!
c. 1840
Six o'clock in the morning. The sun has been up for twenty-five minutes, Baron!

Series: *Fantaisies* (Fantasies), no. 2
Printer and Distributor: Aubert
Catalogued: Armelhaut and Bocher, no. 106

The *bal masqué* of carnival would often last from midnight to six o'clock the following morning. Only the most amorously hopeful of the participants were anxious to end the festivities at dawn. Others emerged from the hall of revelry to face a harsher reality. As Nancy Olsen remarks, "Descriptions from the period admit to the disastrous financial consequences of attending too many masked balls—an empty larder, the need to borrow money, and the dreaded advent of one's creditors."[1] Here a bleary-eyed young nobleman is confronted by a man presenting him with a bill that has become due that day—or worse, a summons regarding legal action for debt (debtor's prison was still a reality when this print was made). The server, with legal exactitude, indicates how far beyond dawn the day has already progressed.

BP
1985.48.1932 (ADB)

[1] Olson, *Gavarni: The Carnival Lithographs*, 8.

73

Troubadour.

Series: *Souvenirs du Bal Chicard*, no. 9
Printer: Aubert
Distributor: Bauger & Cie.
Appeared: *Le Charivari*, 23 February 1841
Catalogued: Armelhaut and Bocher, no. 2280; *Inventaire*, no. 173

In another image from the same series as no. 71, Gavarni depicts an uninhibited dancer whose cap rests temporarily on the bottle of wine on the floor behind him. Gavarni's intention here has obviously been to capture the character of the wild dancing for which

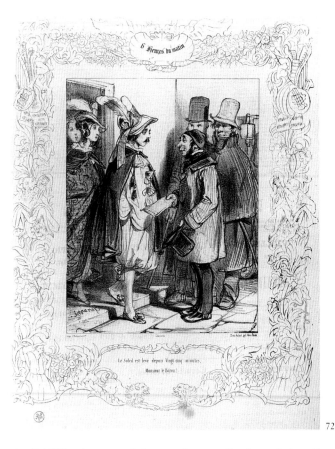

72

the *Bal Chicard* was noted. In a *pentimento*, he has disguised a previously drawn extended arm by incorporating it into the drapery that flies off at the left, but it remains easy to visualize the figure with three arms. Gavarni not only drew the costumes he saw at the balls, but also designed costumes for use there. This troubadour's costume purports to be a version of the late medieval doublet and hose, with anachronistic modifications frequently seen at the *Bal Chicard*, here emphasized by the pipe in the reveler's mouth.

BP/BF
1985.48.2113 (ADB)

74

Ton Alfred est un gueux: il est ici avec l'autre.....calme-toi!
Your Alfred is a rascal: he is here with the other one....keep cool!

Series: *Les Débardeurs* (The stevedores), no. 46
Publisher: Bauger & Cie.
Appeared: *Le Charivari*, 5 February 1841

Catalogued: Armelhaut and Bocher, no. 526; *Inventaire*, no. 212

In this work from a series of sixty-six lithographs published in *Le Charivari* between 1840 and 1843, Gavarni depicts a variation on the most famous of the costumes he designed for the masquerade balls, the *débardeur*. The braided wig, loose shirt, black velvet trousers fastened with brass buttons and tied with a fringed sash are derived from the working costume of the longshoreman or stevedore, who unloaded the barges that traveled up the Seine to Paris. As Nancy Olsen points out, the majority of Gavarni's carnival lithographs reflect his interest in the small groups that drift away from the crowd as a consequence of the romantic liaisons that preoccupied many of the participants at a masked ball.[1] Intrigue was the name of the game, and the information being conveyed in this scene comes in all probability from an *agent provocateur*.

BP
1985.48.2112 (ADB)

[1] Olson, *Gavarni: The Carnival Lithographs*, 8,14.

75

Dodophe et Titine.
Dodophe and Titine.

Series: *Les Etudians de Paris* (Students of
Paris), no. 53
Printer: Aubert
Distributor: Bauger & Cie.
Appeared: *La Caricature [provisoire]*, 24
May 1840; *Le Charivari*, 22 October
1841
Catalogued: Armelhaut and Bocher,
no. 297

The brief caption for this piece con-
sists of two pet names—Dodophe and
Titine—probably given by the pictured
grisette to herself and her student lover.
No further explanation was needed;
these were types that were easily recog-
nized by all Parisians. The university
student was always a male, as France was
among the most backward of European
nations in providing education for
women; even state secondary schools for
girls were not established until the
1880s, let alone university places. The
grisette usually earned a meager living as
a seamstress, attending *bals* on Saturday
nights or taking trips to the country on
Sundays with her *étudiant*.

This impression belongs to the sec-
ond edition of the print in *Le Charivari*
in 1841.

BP
1985.48.1824 (ADB)

Bibliography:
Farwell, *FPLI*, vols. 2 and 3.

76

*Bel ange vos cigares sont bons, mais je les
trouve durs.*
Sweet angel, your cigars are good, but I
find them strong.

Series: *Les Lorettes* (The lorettes), no. 3
Printer: Aubert
Distributor: Bauger
Appeared: *Le Charivari*, 22 September
1841
Catalogued: Armelhaut and Bocher,
no. 765; *Inventaire*, no. 145

The cigar, symbol of the successful
man among men in the nineteenth cen-

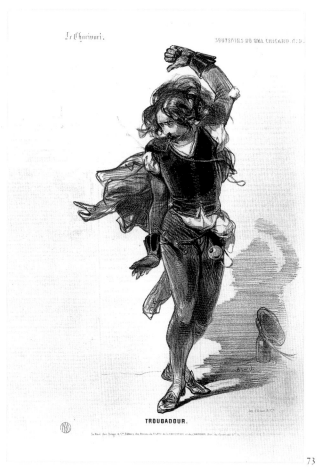

TROUBADOUR.

73

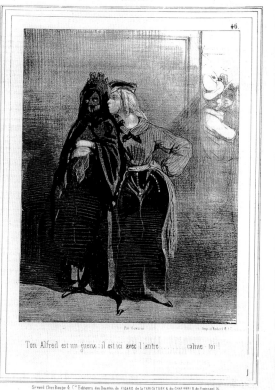

LES DEBARDEURS

Ton Alfred est un gueux : il est ici avec l'autre..... calme toi !

74

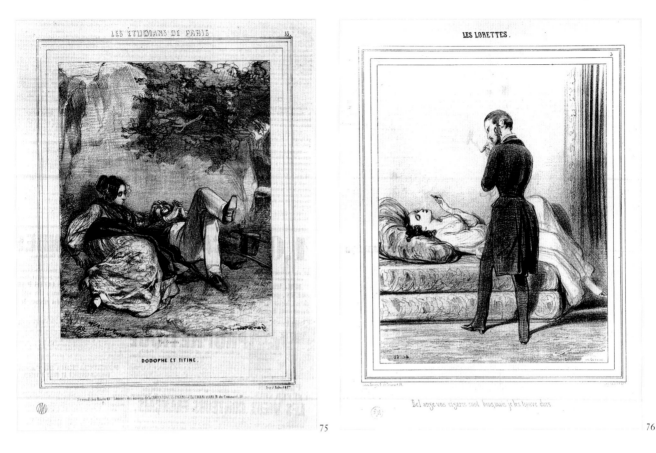

DODOPHE ET TITINE.

Bel ange vos cigares sont bons,mais je les trouve durs

75

76

tury, was also used in popular imagery to identify the *lorette* or *lionne* and her unladylike behavior. Indeed, women appear smoking in pictures more often than men, which is perhaps indicative of the tone of this type of imagery. Cigar and cigarette smoking was introduced into France from Spain, where it had been learned from conquered tribes in South and Central America. Originally a vice of the rural peasantry, its move to the city and elevation in status roughly parallels that of the *lorette* herself.

BP
1985.67.8 (MW)

77

–*T'en es donc bien coiffée du petit?* –*Tais-toi donc! voilà trois semaines... c'étaît le jour de la St. Médard, un mardi ma chère... il m'a plu tout de suite.* –*Ah! bien tu n'as pas fini avec cet Henri là... il à plu le jour de la St. Médard: t'en as au moins pour quarante jours.*

–You're quite smitten with the little one? –Shhh! it's been three weeks... it was St. Médard's Day, a Tuesday, my dear... I liked him right away. –Ah! so you're not finished with this Henri... it rained on St. Médard's day: you'll have him for at least forty days.

Series: *Les Lorettes*, no. 17
Printer: Aubert
Distributor: Bauger & Cie.
Appeared: *Le Charivari*, 4 November 1841
Catalogued: Armelhaut and Bocher, no. 779; *Inventaire*, no. 234

A consistently recurring theme in the popular lithographs of the nineteenth century is that of confidences between two young women, usually about their intrigues with men. Here, two *lorettes*, who rarely held jobs but lived by their wits and their ability to extract money, clothing, and living quarters from men, discuss a recent conquest. The feast day of St. Médard, patron saint of the weather and of good harvests, falls on 8 June. Legend has it

that if it rains on St. Médard's day, it will rain for forty days thereafter. The caption contains a pun in the word *plu*, past participle of both "to please" and "to rain."

BP
1985.67.38 (MW)

78

–*C'est un diplomate –C'est un épicier –Non! c'est un mari d'une femme agréable –Non! Cabochet, mon ami vous avez donc bu que vous ne voyez pas que Mosieu est un jeune homme farceur comme tout déguisé en un qui s'embête à mort, le roué masque!*

–It's a diplomat –It's a grocer –No! It's the husband of an agreeable woman –No! Cabochet, my friend, you're so drunk you can't see that Monsieur is a young joker like us all, disguised as someone who's bored to death, a masked rake.

Series: *Le Carnaval à Paris* (Carnival in Paris), pl. 15
Printer: Aubert

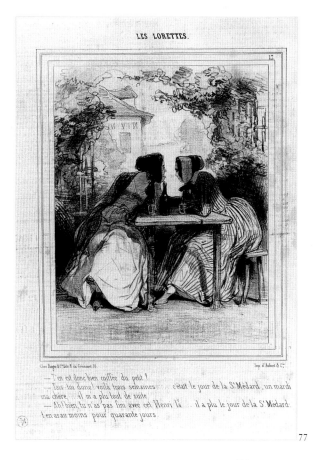

LES LORETTES.

17.

— T'en est donc bien coiffée du petit !
— Tais-toi donc! voilà trois semaines... c'était le jour de la St Medard, un mardi
ma chère... il m'a plu tout de suite.
— Ah! bien, tu n'as pas fini avec cet Henri là... il a plu le jour de la St Medard:
t'en as au moins pour quarante jours.

77

LE CARNAVAL A PARIS.

15.

— C'est un diplomate.
— C'est un Epicier
— Non! c'est un mari d'une femme agréable
— Non! Cabochet mon ami, vous avez donc bu... que vous ne voyez
pas que Mosieu est un jeune homme farceur comme tout deguise en un
qui s'embête à mort... le roué masqué.

78

Distributor: Bauger
Appeared: *La Caricature [provisoire]*, 21
 February 1841
Catalogued: Armelhaut and Bocher,
 no. 256; *Inventaire*, no. 233

The character pictured here is that of Coquardeau, Gavarni's personification of bourgeois resistance to the high-spirited lower-class merrymaking of carnival. His name includes the slang for "ridiculous old beau" or "booby"; he is bourgeois and middle-aged, hopelessly outside the ribald atmosphere of the festivities. He is often tricked, teased, and offered tongue-in-cheek advice at the masked ball as a foil to the unconfined social license practiced by the working-class participants. Costumes ranged from the traditional Harlequin and Pierrot, or the conservative *nez-de-carton* (cardboard nose) and *domino* (simple cloak and eye-mask) to the unnameable and ingenious. Men were admitted without costumes, but women were not.

BP
1985.48.1791 (ADB)

79

Ma tante Aurélie qui disait l'autre jour à Maman qu'elle t'en ferait voir des grises si tu deviens son mari... Papa l'a fait taire... Des grises quoi donc? dis.

My aunt Aurelie was saying to Mamma the other day that she'll lead you a dance if you marry her... Papa made her be quiet...What dance are they talking about?

Series: *Les Enfants terrible* (The terrible children), no. 34
Printer: Aubert
Distributor: Bauger et Cie.
Appeared: *Le Charivari*, 21 April 1841
Catalogued: Armelhaut and Bocher,
 no. 599; *Inventaire*, no. 191

As the historical antecedent to *Dennis the Menace* and *Calvin and Hobbes*, *Les Enfants terribles* was far more incisive and revealing in its social commentary. In its images, Gavarni regularly uses the quasi-innocent questions or remarks of children to put the world of the adults around them in disarray. The subject is more often than not the marital or extra-marital situations of the grown-ups.

BP
1985.48.1947 (ADB)

80

Voilà une jolie liberté et un beau pays! où un homme n'est pas seulement libre de vendre son nègre.
(hand-colored)
Some freedom and some fine country! Where a man can't even sell his own slave.

Series: *La Politique* (Politics)
Printer: Aubert
Appeared: *La Caricature [provisoire]*, 27
 February 1842
Catalogued: Armelhaut and Bocher,
 no. 1175; *Inventaire*, no. 184

LES ENFANTS TERRIBLES.

Ma tante Aurélie qui disait l'autre jour à Maman qu'elle t en ferait voir des grises si tu deviens son mari ... Papa l a fait aire ... Des grises quoi donc^dis

79

La Caricature-Journal.

Voilà une jolie liberté et un beau pays ! où un homme n'est pas seulement libre de vendre son nègre

80

The British officially abolished slavery in their colonies on 1 August 1834. In order to avoid economic turmoil, a time-table was set up, and through a gradual process, slaves were finally freed in practice as of 1 January 1838. In France the following year, a commission led by Alexis de Tocqueville filed a report with the Chamber of Deputies, citing the British example and recommending the establishment of a similar time-table. At the time, there were approximately 250,000 slaves in the French colonies. This lithograph, showing a plantation owner in the West Indies fuming about the new anti-slavery laws, is most likely a comment on the *Abolition immédiate de l'esclavage* of 1842, published by Victor Schoelcher in an attempt to precipitate the process. Slaves were not freed in practice, however, until the Revolution of 1848.

BP

1985.67.202 (MW)

Bibliography:
Toqueville, Alexis de, *Report on the Abolition of Slavery in the French Colonies, 23 July 1839*. Westport, Conn: Negro University Press, 1970.
Martin, Gaston, *L'Abolition de l'esclavage, 27 avril 1848*. Paris: Presses universitaires de France, 1948.

81

La Tentation d'une Sainte Antoinette.
1852
The temptation of a Saint Antoinette.

Series: *Masques et visages. Les Partageuses* (Masks and faces. The sharers), no. 8
Printer: Lemercier
Distributor: Librairie Nouvelle
Appeared: *Paris*, 27 October 1852
Catalogued: Armelhaut and Bocher, no. 1443; *Inventaire*, no. 310

This lithograph, published in *Paris* in 1852, is from the series *Masques et visàges*, published after Gavarni's stay in London from 1847 to 1851. The sub-series, *Les Partageuses*, refers to sharing, and is a new name for the *lorette* of the 1830s. The print is a fine example of the artist's late style.

In a reference to the temptation of St. Anthony, an older, more experienced

laundress counsels a pretty young novice on the advantages of a little compromise in her moral standards. Laundresses were seen as easy marks for the solicitous bachelor or married man looking for a little spice in his life. Encounters were facilitated by the laundress' practice of picking up and delivering her work at a person's home. Images of laundresses were commonplace in French nineteenth-century bourgeois culture—in the novel, the theatre, the painting and sculpture Salons, and in coveted pornographic photographs, as well as in popular prints. Degas, who collected Gavarni's lithographs, gave extensive treatment to the laundress theme in the 1870s and 1880s.

BP
1988.32.1 Museum Purchase with funds provided by gifts from Mr. and Mrs. Miklos Rozsa

Bibliography:
E. Lipton, *Looking into Degas*. Berkeley: University of California Press, 1987. Chap. 3, "Images of Laundresses: Social and Sexual Ambivalence."

82

Thomas Vireloque.
c. 1852-53 (with tint stone)

Series: *Les Artistes anciens et modernes* (Artists old and new), pl. 107
Printer: Bertauts
Catalogued: Armelhaut and Bocher, no. 1672; *Inventaire*, no. 341

During his stay in London, Gavarni for the most part withdrew from fashionable society, instead taking time to sketch and study the very conspicuous urban poor. The character of Thomas Vireloque was born of these studies, and Judith Wechsler sees in him the aging, disillusioned reflection of Gavarni himself.[1] Usually Vireloque is seen in situations calling for his pithy remarks, but this image is obviously conceived as a portrait of the character, treated like a painting. Indeed the work belongs to a series, *Les Artistes anciens et modernes* (printed by the art printer Bertauts rather than the journalistic Maison

Aubert), in which Gavarni takes his place among "old and modern artists," a status that was accorded him during his lifetime and for some time afterward.

The Goncourts describe Vireloque as a bestial-looking character with the skull of Socrates and the mouth of a monkey.[2] He wears the Phrygian bonnet, an attribute of the *chiffonier* or rag-picker (as well as of all figures representing liberty), and his appearance and argot contrast strikingly with the wisdom of his aphorisms. Gavarni had hoped to create a long series with his philosopher of the streets, but it was not well-received by the public, who wished to be amused and not lectured to. Fifteen images were published in the magazine *Paris* between 1852 and 1853, and an album was later issued containing twenty prints.

BP/BF
1985.67.196 (MW)

[1] Wechsler, *A Human Comedy*, 109.
[2] Goncourt, *O.c.* 19:261.

81

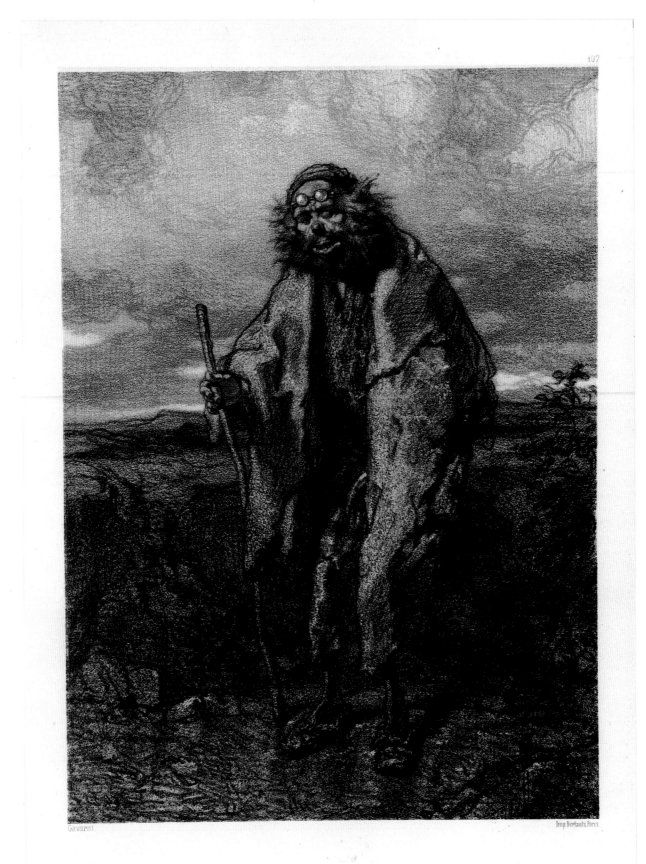

Gavarni

Imp Bertauts, Paris

Thomas Vireloque

Grandville
(Jean Ignace Isidore Gérard)
(1803-1847)

One of the great illustrators of the nineteenth century, Grandville was born at Nancy in 1803 and died at Vanves in 1847. The name 'Grandville' was a family tradition, a stage name used by his grandparents, who were comedians on the stage in Nancy. Grandville began his artistic career as a miniature painter, but by the late 1820s he had moved to Paris and begun to devote himself to lithography.

The series called *Les Métamorphoses du jour* (Today's metamorphoses), represented here by the lithograph *Omnibus royal des Pays-bas* (no. 83), was his first major success. The 'metamorphoses' are the replacement of human heads with satirically appropriate animals' heads on all the figures. Another early series is the *Galerie mythologique* of 1830, a ludicrous updating of mythological scenes, exemplified in the parody of the judgment of Paris (no. 85). Another series, *Voyage pour l'éternité*, a satirical dance of death, was so unsuccessful that its publication was never completed, though it was admired by Balzac. These works were executed in pen lithograph in a style lending itself to hand coloring, a technique Grandville shared with Monnier.

It is said that Grandville took part in the Revolution of 1830.[1] Afterwards he joined the attack on the new government through his work for Charles Philipon, editor of the satirical weekly, *La Caricature*.

Between 1830 and 1835, he made over two hundred designs for Philipon, mostly for the weekly *La Caricature*, but also for the publisher's other paper, *Le Charivari*, the less virulent daily paper. Grandville's work purported to suggest that the government of Louis-Philippe consumed gold rapaciously, snuffed out liberty, made a farce of justice, and was, in short, no better than the government of Charles X it had replaced. His caricatures express the bitter disappointment many of Grandville's generation felt about the consequences of the Revolution they had supported. Among the artists of Philipon's team, Grandville was unique in his penchant for identifying everything in his political images with labels or commentary incorporat-ing the pun and the metaphor. Baudelaire's opinion that Grandville's plastic talent suffered from an excessively literary mind seems at times justified.

The style of his lithographs for *La Caricature*, executed in crayon rather than pen, is smoothly polished but generally devoid of innovative or virtuoso technique. In their finished state, Grandville's designs from this period came out looking much like those of Daumier or Traviès, so much so that it seems as though all three were working in the house style of Philipon's papers. In fact, Grandville's designs for Philipon were not all lithographed by him; many were transferred to the stone by Julien, Forest, Desperet, and other members of Philipon's team. Perhaps the *Parisiens pittoresques* series of 1835 for *Le Charivari* can be regarded as exceptional in that Grandville's taste for the grotesque survives the copyist's crayon and the images bear the personal stamp of their creator.

After the demise of *La Caricature* in 1835, Grandville turned to book illustration. His usage of strange proportions and anthropomorphic animals attracted him to *Gulliver's Travels* and the *Fables of La Fontaine* which he illustrated in 1838 and 1841, respectively. Various writers collaborated with Grandville on *Scènes de la vie privée et publique des animaux* (Scenes of private and public life of animals) of 1842, but the text is really secondary to Grandville's illustrations. Grandville's famously bizarre imagination was freely expressed in *Un Autre monde* (Another world) of 1844, full of the strange metamorphoses and animated objects typical of his work in the last years of his life. He died in 1847, at the age of forty-four, after a series of personal misfortunes.

Grandville's talent was particularly versatile, and its variations are magnified by the media in which his work appeared. His own statements make it clear that he deplored the loss of subtlety and individuality in the work wrought by his copyists, especially the wood engravers who translated the designs of his book illustrations.

GB/BF

1 Béraldi, 7:204.

83

Omnibus royal des Pays-Bas.
1829
Royal omnibus of the Netherlands.

Series: *Les métamorphoses du jour*
 (Today's metamorphoses), pl. 71
Printer: Langlumé
Catalogued: *Inventaire*, no. 6
1985.48.631a (ADB)

84

Omnibus Royal des Pays-Bas.
(hand-colored; illustration page 30)

Series: *Les métamorphoses du jour*
 1829, pl. 71
Printer: Langlumé
Distributors: Valant; Bulla; Martinet
Catalogued: *Inventaire*, no. 6
1985.48.669 (ADB)

A crowd of reptilian figures, well-dressed in the latest fashion, is in the process of boarding a large fish skeleton on wheels, drawn by a team of horses with a bird-coachman. The flag announces the route, 'de la Place Louis XV aux Champs Elysées.' The series *Métamorphoses du jour*, to which this print belongs, tends to avoid political commentary, drawn as it was in 1829, when censorship was heavily in place. The image is not as enigmatic as it may look. It refers to a newsworthy event of 1829, the beaching of a whale on the shore at Ostend which had become a tourist attraction.[1] The Place Louis XV had long since been renamed Place de la Concorde, but under the old name it was the place of execution of both Louis XVI and Robespierre. It marks the beginning of the Champs Elysées, literally the Elysian Fields to which that earlier king and his revolutionary enemy presumably went. The establishment of Belgium as an independent state was at this very moment being worked out. The word 'royal' may be a key to the enigma.

Display of the hand-colored impression (no. 84) beside no. 83, the same print without color, demonstrates the difference made by the addition of color. The series *Les Métamorphoses du jour* was

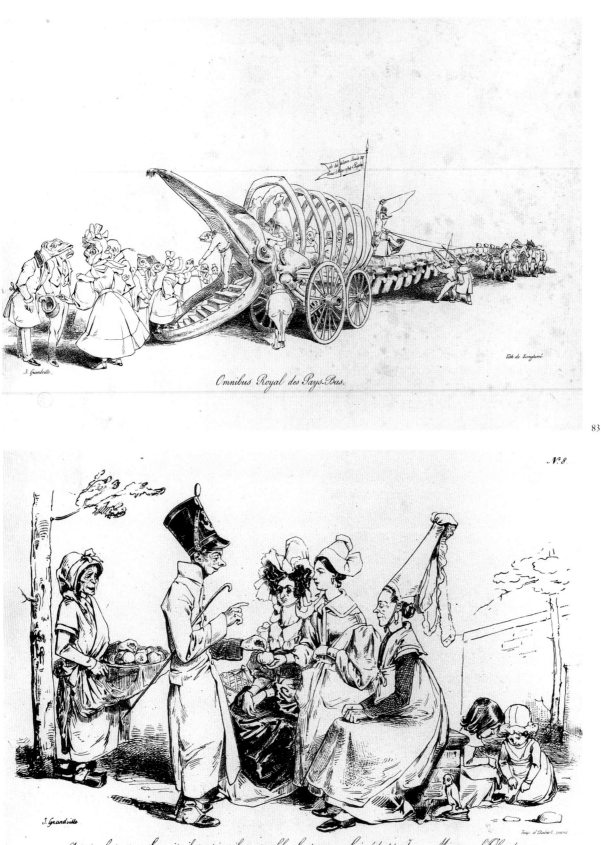

Omnibus Royal des Pays-Bas.

J. Grandville.

Lith. de Langlumé.

N° 8

J. Grandville

Imp. d'Aubert, rue...

A peine le pasteur la voit, il soupire, il se trouble, la pomme lui échappe, Junon, Minerve, l'Olympe,
tout disparait à ses yeux.

(Demoustier lettre XLIII)

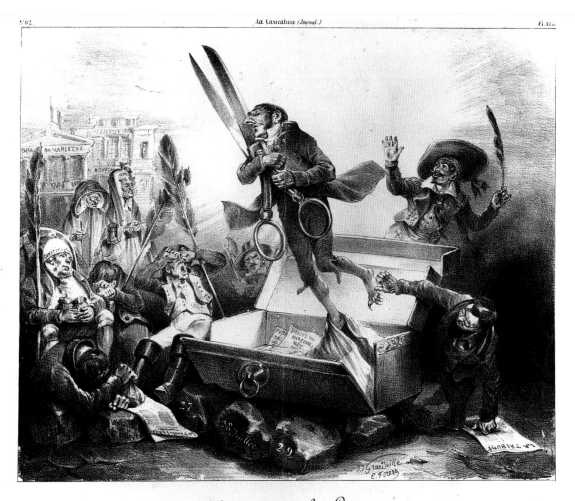

designed by Grandville in pen lithograph with extensive white areas in order to accommodate the watercolor washes added by a *coloriste*, usually a woman at low wages. While coloring was done by hand, identification of printer and distributor was printed from the stone. These two impressions represent in effect two states of the print, since it is only in the second (no. 84) that the distributors' names have been added. No. 83 was very likely a proof impression rather than part of the edition.

GB/BF

[1] Renonciat, *Grandville*, 62.

85

A Peine le pasteur la voit, il soupire, il se trouble, la pomme lui échappe, Junon, Minerve, l'Olympe, tout disparaît a ses yeux. (Demoustier lettre XLIII)

The moment the shepherd sees her, he sighs, he becomes confused, he drops the apple, for his eyes, Juno, Minerva, Olympus, everything else disappears. (Demoustier letter XLIII)

Series: *Galerie mythologique* (Mythological gallery), 1830, no. 8
Printer: Aubert
Catalogued: *Inventaire*, no. 8; Sello, no. 269

The image is a parodic update of the myth of the judgment of Paris. Paris is an ugly young soldier giving an apple to a beautiful young girl (Venus), who stands between an older, prosperous-looking Juno and an ascetic-looking old woman (Minerva). On the left of this group is an old apple-seller, and on the right are two playing children. Both Minerva and Venus wear provincial costume, while Juno, cast as a contemporary lady of the court, is coiffed in the city fashion of 1830.

GB
1985.48.606 (ADB)

86

Resurrection de la censure "Et elle réssuscita le troisième jour après sa mort" (évangile St. Luc).
Resurrection of censorship "And it rose again the third day after its death" (Gospel of St. Luke).

97

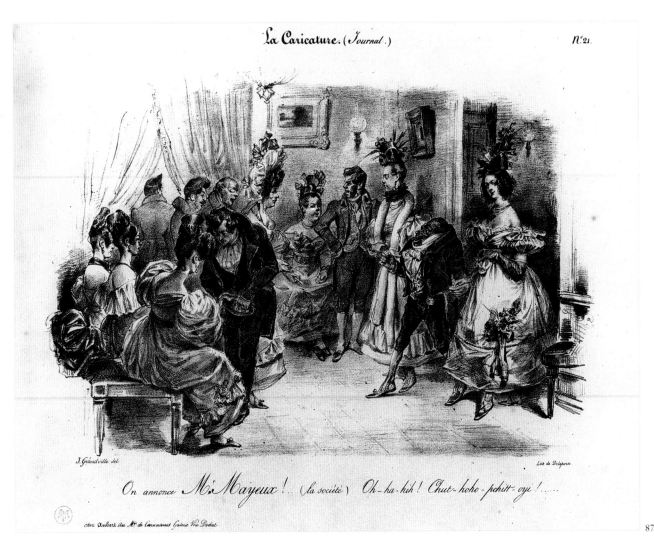

J. Grandville del.　　　　　　　　　　　　　　　　　　　　　*Lith. de Delaporte*

On annonce Mr. Mayeux!... (la société) Oh-ha-hih! Chut-hoho-pchitt-oyi!......

chez Aubert au Mo. de Caricatures Galerie Vero Dodat

87

Printer: Delaporte
Distributor: Aubert
Appeared: *La Caricature*, 29 February
　1831, pl. 125
Catalogued: Sello, no. 11
Reference: Farwell, *Cult of Images*,
　no. 35

This lithograph, signed on the stone by both Grandville and his lithographer, Eugène Forest, shows Louis-Philippe's Minister of the Interior, Count d'Argout (1782-1851), who was then in charge of press regulation. Philipon's caption for the image continues, "and the ministerial box having opened, there emerged an enormous pair of scissors, to which was attached a gigantic nose, after which followed the body of M. d'Argout."[1] (This extraordinary nose has been well-documented, first in prose by Balzac. "Of all the events connected with the July Revolu-

tion, one conspicuous fact unquestionably stands out as first-rank; it is the nose of M. d'Argout." He continued by recounting how one night the nose of d'Argout was seen emerging from the gates of the Tuileries one minute and thirty-five seconds before the rest of his person.)

The three stones below the box marked *27*, *28* and *29 Juillet* refer to *les trois glorieuses* (the three glorious days) of the July Revolution, brought about in part by the suspension of liberty of the press by Charles X, and they allude to the haste with which Louis-Philippe's administration reinstituted censorship practices after the initial press freedom at the beginning of the regime. The sleeping soldiers of the parodied resurrection of Christ are replaced here by figures symbolic of the journals, holding pens instead of swords. *Le Constitutionnel*, the government paper, is shown

clutching bags of money, asleep in its characteristic nightcap. Note the claws on the foot of d'Argout.

RP/BP
1985.48.697 (ADB)

1 "Et le carton ministériel s'étant ouvert, il en surgit une enorme paire de ciseaux, à laquelle était attaché un gigantique nez après lequel pendait la personne de M. d'Argout."

87

On annonce Mr. Mayeux!... (la société) Oh-ha-hih! Chut-hoho-pchitt-oyi!...
1831
Announcing Mr. Mayeux!... (the company) (sounds of conversation).

Printer: Delaporte
Distributor: Aubert
Appeared: *La Caricature*, 24 March
　1831, pl. 21

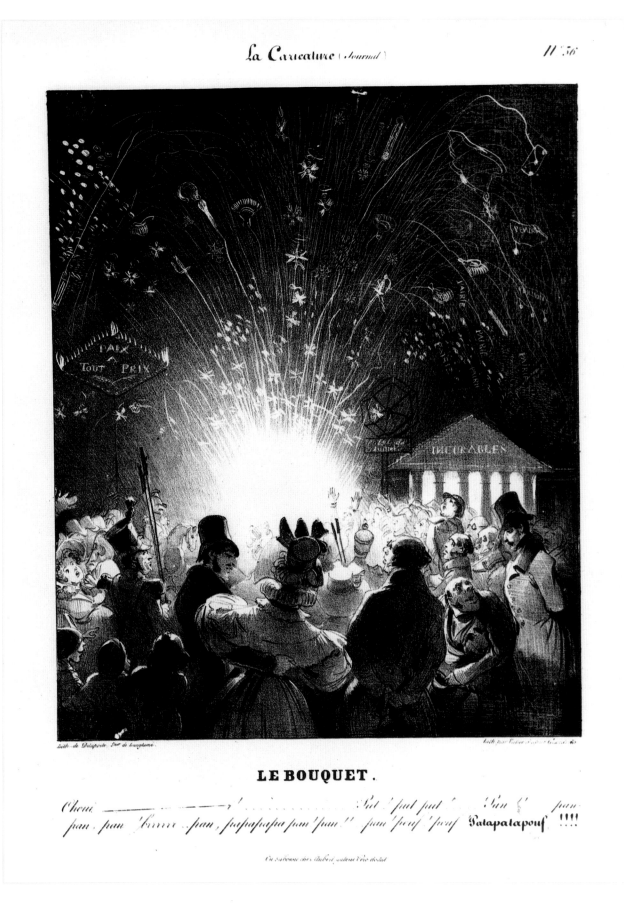

88

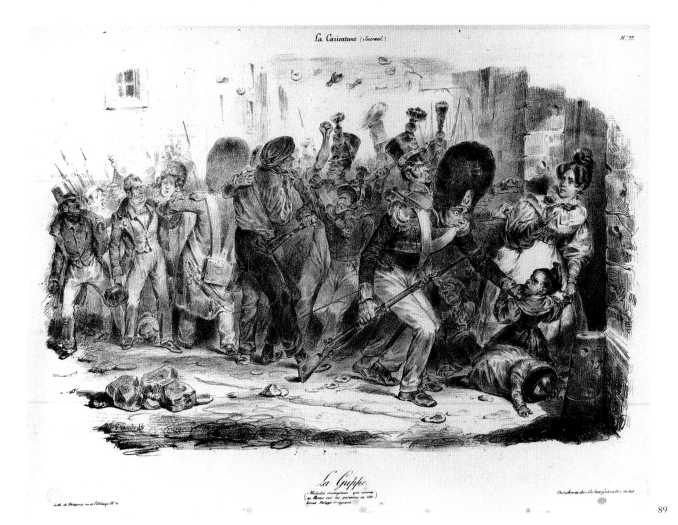

La Grippe.
(Maladie contagieuse qui exerça
sa fureur sur les parisiens en 1831
Louis Philippe 1er régnant.)

Lith. de Delaporte, rue de l'Abbaye N°4.

89

Catalogued: *Inventaire*, no. 37; Sello,
 no. 68
Reference: Getty, *Grandville*, 230, nos.
 178, 178A.

Mayeux, the inveterate hunchbacked
womanizer invented by Traviès, is
entering a salon with two pretty young
girls on his arm. His entry causes a stir.
The company is pointedly nouveau-
riche, displaying extremes of fashion for
both men and women. The room is lit
by gaslight which had recently been
installed in the bourgeois homes of the
Chaussée d'Antin. This is one of the
lithographs Grandville himself drew on
the stone.

GB/BF
1985.48.632 (ADB)

88

*Le Bouquet Choui.....i!.....Put! Put
put!....Pan!!...Pan-Pan, Pan!
Brrr...Pan, Papapapa Pan!
Pan!!...Pan! Pouf! Pouf. Patapa-
apouf!!!!*
The grand finale. (Sound effects)

Printer: Delaporte
Distributor: Aubert
Appeared: *La Caricature*, 5 May 1831,[1]
 no. 56
Catalogued: Sello, no. 82

Literally the image shows a fire-
works display in front of the *Incurables*
hospital. It symbolizes however the
shower of public honors with which
Louis-Philippe bought the approval of
rival factions in France. A flaming scaf-
folding reads '*paix à tout prix*' (peace at
any price), the policy the king pursued
of compromising with foreign enemies
in order to keep the peace. Many liber-
als opposed this policy (see Philipon,

no. 123). Scratched in white on the dark
background of the print are the differ-
ent honors showering from the night
sky onto the expectant crowd of digni-
taries: medals, epaulettes, pensions,
swords, money, peerages, etc.

GB/BF
1985.67.443 (MW)

[1] Sello gives 12 May. The print was found
 in the 5 May issue in the run of *La Carica-
 ture* at the Armand Hammer Foundation,
 Los Angeles. Reissues of early numbers of
 La Caricature make dates of appearance for
 specific prints inconsistent.

89

*La Grippe (Maladie contagieuse qui exerça
 sa fureur sur les parisiens en 1831)
 Louis-Philippe 1er regnant.*
The flu (contagious disease which
 exerted its fury on the Parisians in
 1831) during the reign of Louis-
 Philippe the First.

La Caricature *(Journal)* N° 69.

Je l'aurai ! tu ne l'auras pas ... je l'aurai ! tu ne l'auras pas
bouhiiii..................... !!!

Lith de Delaporte chez Aubert Galerie vero dodat

90

La Caricature (Journal)

Le cu du peuple

91

La Caricature (Journal)

92

La Grenouille qui demandent un Roi.
Devolus et contentous nous,
De peur d'en rencontrer un pire.

Printer: Delaporte
Distributor: Aubert
Appeared: *La Caricature*, 23 June 1831,
 pl. 72[1]
Catalogued: *Inventaire*, no. 37; Sello,
 no. 86
Reference: Getty, *Grandville*, no. 180

This lithograph is one of the last
drawn by Grandville himself before he
began turning his designs over to

Eugène Forest for execution on stone.
It refers to the tumultuous period
between April and September of 1831,
when rioting was almost constant in
the streets of Paris, mainly in response
to the government's neglect of workers'
demands for better wages and the pro-
tection of jobs and traditional crafts.
The riots peaked near the time of the 5
July elections. The despised officers of
the National Guard were sent repeat-

edly to quell the workers' uprisings,
and were continually harassed and pro-
voked by the crowds, which were often
composed of women, children, senior
citizens, and peaceable bourgeois. The
feverish situation was likened by
Philipon in his editorial commentary to
la grippe (the flu), a "contagious mal-
ady" which has everyone in its "grip."

 In the picture, a confused grenadier
on the right takes hold of a young girl
who stands over the fallen figure of
another, while two soldiers behind him
reach out to grab her mother. In the
center, three officers wrestle with a fig-
ure in the garb of a worker, which
Philipon identifies as a representation
of the artist himself. One of the officers
has thrust the butt of his rifle into the
groin of the worker, while rocks, bot-
tles, and other household items rain
down upon the police from above.
Philipon, implying government collu-
sion in the violence, identifies the sec-
ond figure from the left as the minister
Persil, "grand amateur de charivaris,"
thereby associating him with the name
(meaning hullabaloo) Philipon was soon
to give his second newspaper.

BP
1985.48.624 (ADB)

[1] Getty gives 7 July.

90

Je l'aurai! Tu ne l'auras pas... Je l'aurai!
 Tu ne l'auras pas bouhuu----------!!!

I'm going to have it! No you won't...
 Yes I will! No you won't
 boohoo----------!!

Printer: Delaporte
Distributor: Aubert
Appeared: *La Caricature*, 23 June 1831,
 pl. 69[1]
Catalogued: *Inventaire*, no. 37; Sello,
 no. 85
Reference: Farwell, *FPLI* 8, 2C8

 The scene is a Punch and Judy
show outside the palace of the Tui-
leries. The combatants are puppets
representing Louis-Philippe and
Charles X. The date of the print places
it within a year of the July Revolution.
Louis-Philippe is finally triumphant
but unaware that he is about to be

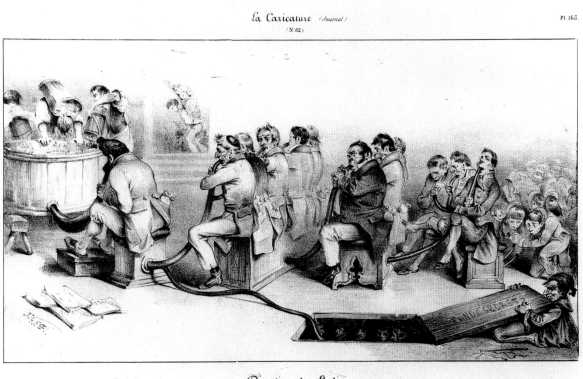

Digestion du Budjet
travail administratif, politique, moral et surtout économique.

93

clobbered with a huge iron fist on a stick labelled '*pouvoir*' (power) wielded by republican France wearing a Phrygian cap. Graffiti on the wall make references to other transfers of power in 1793 and 1815, as does the checkerboard of the clown's costume. The possession being contested is, of course, power.

GB/BF
1985.48.622 (ADB)

¹ Sello gives 30 June.

91

Le Cri du peuple.
1831
The cry of the people.

Printer: Delaporte
Distributor: Aubert

Appeared: *La Caricature*, 4 August 1831, no. 80
Catalogued: *Inventaire*, no. 37
Reference: Farwell: *FPLI* 8, 2D1

In the 1830 Revolution, the mob sacked the Tuileries, removed the throne, and paraded it through the streets. This image, made just one year later, may refer to that event, but the crowd surrounding the heroic worker (kneeling at left) is not composed of his fellow-revolutionaries but rather the historic forces of reaction, trying to hold down the floating throne. They have tethered it to stakes labeled '*Pairie héréditaire*' (hereditary peerage) and other royalist prerogatives. The Holy Alliance carries standards in the left background, while an army in historical costumes advances on the scene bearing clysters (enema syringes), the symbolic weapon of reaction in the caricaturists' repertory. The beleaguered worker appears to be refashioning a carved leg, broken away from the body of the

throne. A stone beside him is inscribed with the fateful date of July 1830. The total image refers to the forces that inhibited the Revolution, here represented as the dead hand of the past.

KO/BF
1985.48.1133 (ADB)

92

Les Grenouilles qui demandent un roi
De celui–ci contentons–nous
De peur d'en rencontrer un pire.
The frogs who ask for a king
Let's be satisfied with this one
For fear of getting a worse one.

Printer: Delaporte
Distributor: Aubert
Appeared: *La Caricature*, 11 August 1831, no. 82
Catalogued: *Inventaire*, no. 37

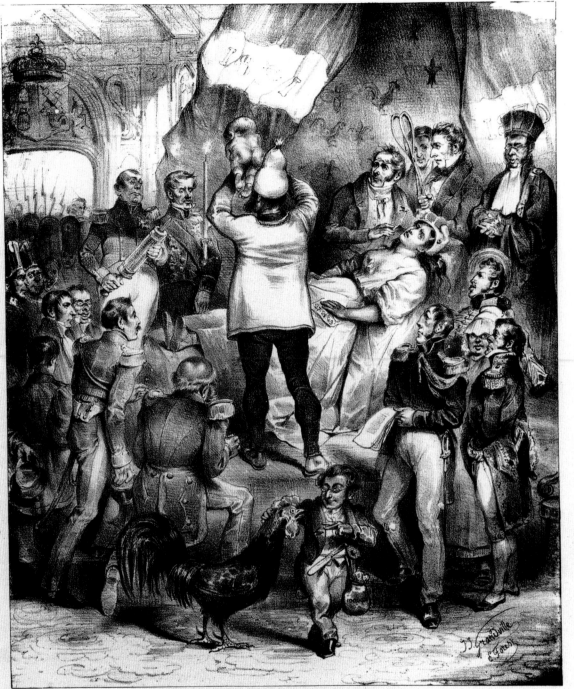

Lith. de Delaporte

Naissance du juste milieu.
Aprés un enfantement pénible de la Liberté.

Le parrain de l'enfant montre au peuple cet embryon monstrueux. Casimir Perier donner un coup de pouce
à l'accouchée souffrante. Guizot tient le forceps, Dupin le Docteur se frotte les mains de plaisir, Lancelot tient
ses adoucissans tous prés. le baron Athalin porte les lettres de faire part Sébasti..et sa nourrice Schonen toujours à
..eux le petit Thiers et le grand poulet Gaulois auquel il fait la nigue

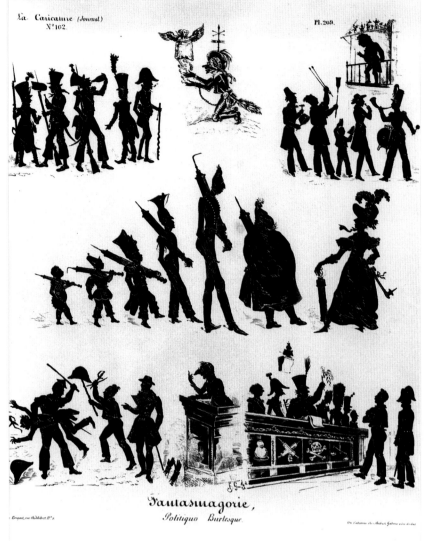

95

The fables of Aesop, who is believed to have been a hunchbacked Phrygian slave of the sixth century B.C., attained their greatest fame in France, where their retelling by La Fontaine, with additions and modifications, raised their status to that of a major literary monument. The caricaturists of the nineteenth century often used the fables as political analogies because of their familiarity. Grandville readily adapts the fable of *The Frogs Who Wanted a King* to the political situation in the 1830s. The frogs, living in liberty in their ditches and ponds, had asked Zeus to grant them a king. In response, he cast into their midst a great log. The frogs were fearful at first, but upon perceiving that their new king was but a piece of wood, petitioned Zeus once again for another. This time Zeus sent a heron, who began to devour the frogs one by one. The frogs then beseeched Zeus to deliver them from the false tyrant, but he refused, saying that "He who has liberty ought to keep it well." In the image, Zeus can be seen above the weather-beaten fence, while the menacing heron, with its large beak and sharp claws, is at the upper left. One of the frogs carries a frond topped with a Phrygian cap. The analogy with the First Republic and the regimes of the Restoration and Louis-Philippe is evident.

BP
1985.48.630 (ADB)

93

Digestion du budget. Travail administratif, politique, moral et surtout economique.
Digesting the budget. Administrative, political, moral, and above all, economic task.

Printer: Becquet
Distributor: Aubert
Appeared: *La Caricature*, 24 May 1832, pl. 165
Catalogued: *Inventaire*, no. 43; Sello, no. 138

Louis-Philippe is at the head of the rows of his ministers, counselors, and members of Parliment. They are all sucking on tubes coming from a giant wine vat of money being filled by working-class types. Louis-Philippe feeds on gold which is passed along, after digestion, to larger groups of ministers and lesser functionaries through a bizarre machine that recalls Daumier's image of *Gargantua*, for which that artist served a term in prison. A smaller tube diverts the nourishing stream before it reaches the ministers and feeds an underground gathering of those who receive secret funds, prominently including the police. The scatological implications of this print have been noted by James Cuno in an analysis of the image.[1]

The budget for 1832, passed a month before this caricature appeared, contained the *liste civile*, government programs and payoffs that laid a heavy tax burden on the populace for the first time since the Revolution of 1830.[2]

GB/BF
1985.67.223 (MW)

[1] Cuno, "*Grandville, dessins originaux*" (review), *Art Bulletin*, 70(Sept. 1988):533.
[2] Getty, *Grandville*, p. 246., nos. 186 and 186A.

94

Naissance du juste milieu. Après un enfantement pénible de la Liberté. Le parrain de l'enfant montre au peuple cet embryon monstrueux. Casimir Perrier veut donner un coup de pouce à l'accouchée souffrante. Guizot tient le forceps. Dupin le docteur se frotte les mains de plaisir; Lancelot tient ses adoucissans tous prêts, le baron Athalin

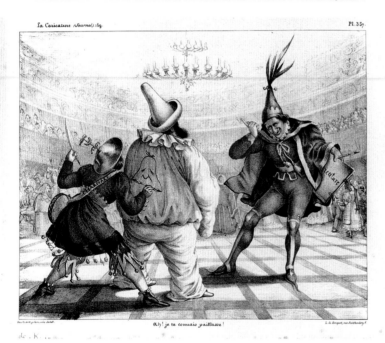

La Caricature (Journal) 124

Messieurs, l'auteur de la pièce que nous avons eu l'honneur de jouer devant vous désire garder l'anonyme.

96

La Caricature (Journal) 169

Pl. 357.

Oh! je te connais paillasse!

97

Louis-Philippe, is shown as his godson and the son of Liberty. Various other political figures play roles at the birth, as described in the caption. The image is a parody of Eugène Devéria's *The Birth of Henri IV*, which enjoyed a great success in the Salon of 1827.

GB
1985.48.673 (ADB)

95

Fantasmagorie, politico burlesque.
1832
Phantasmagoria, political burlesque.

Printer: Becquet
Distributor: Aubert
Appeared: *La Caricature*, 18 October 1832, pl. 209
Catalogued: Sello, no. 148

The image is divided into seven small scenes: a group of national guards, a figure with a weather vane on his head collecting money from heaven, a *charivari* mocking a citizen on a balcony, etc. The central group is the royal family, each member carrying a clyster, the instrument of medical douches frequently seen on the comic stage, and, as previously noted, used by the caricaturists as a symbol of political reaction. In the lower register a bastonnade is being administered, the censor d'Argout speaks from a podium, and a citizen is brought before a tribunal decorated with symbols of justice, death, and the *juste milieu*.

Grandville's eye for silhouettes is seen throughout his work. Here the representation is couched in terms of the Chinese shadow play, presentations of which the artist attended in Paris.[1]

GB/BF
1985.48.659 (ADB)

[1] Getty, *Grandville*, p. 26, note 13.

96

Messieurs, l'auteur de la piece que nous avons eu l'honneur de jouer devant vous désire garder l'anonyme.
Gentlemen, the author of the play we have had the honor of performing for you wishes to remain anonymous.

porte les lettres de faire-part, Sebastien et sa nourrice Schonen toujours à genoux, le petit Thiers et le grand poulet Gaulois au quel il fait la nique.
Birth of the "middle of the road" politics. After a painful delivery of Liberty. The godfather of the child shows the monstrous embryo to the populace. Casimir Perrier wants to lend a hand to the suffering mother. Guizot holds the forceps. Dupin, the doctor, rubs his hands with pleasure, Lancelot is at the ready with his emollients, Baron Athalin

carries the announcements, Sebastien and his nurse Schonen are still on their knees, little Thiers is there, and so is the big Gallic rooster, which he is teasing.

Printer: Delaporte
Appeared: *La Caricature*, 2 February 1832, pl. 134
Catalogued: *Inventaire*, no. 43; Sello, no. 113

The *juste milieu*, the spirit of political compromise that is supposed to have guided the July Monarchy of

Printer: Becquet
Distributor: Aubert
Appeared: *La Caricature*, 21 March
 1833, pl. 258
Catalogued: Sello, no. 175

The setting is a theatre; the players are lawyers and jury members. In the prompter's box appears the distinctive coiffure of Louis-Philippe. The words '*attentat*' (assassination attempt) and '*horrible*' can be made out in the title of the script before him. The king is evidently clandestinely calling the shots for the actions of the lawyer-ministers taking a bow (they are almost certainly caricatures of Dupin, a member of the privy council, and Montjau, a conservative from the Ardèche),[1] as the caption makes clear. The decoration of the descending curtain includes medals and money bags, crossed pistols, and the ubiquitous pear. Later an actual assassination attempt led to the censorship laws of 1835 that closed the paper *La Caricature* in which this image appeared.

GB/BF
1985.48.687 (ADB)

[1] Getty, *Grandville*, no. 185, p. 243, nos. 9 and 5 on chart.

97

Ah! Je te connais paillasse!
Oh! I know you, clown!

Printer: Becquet
Distributor: Aubert
Appeared: *La Caricature*, 30 January
 1834, pl. 357

Grandville presents a theatre scene, probably the Opéra, with a costume ball in progress. Three comic characters fill the foreground. One, recognizable by his sidewhiskers, is Louis-Philippe. The other two, mocking him, represent the newspapers owned by Charles Philipon, *Le Charivari* on the left, and *La Caricature* on the right. The figure representing *Le Charivari* is drawing a pear, the satirical symbol for Louis-Philippe, on the king's back. The figure of *La Caricature* represents Philipon himself. *Paillasse* was the traditional fall guy or patsy of the witty repartee forming the *parade*,

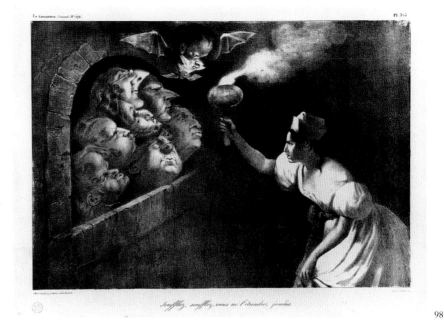

Soufflez, soufflez, vous ne l'éteindrez jamais.

98

the introduction to street-theatre shows. He is always dressed as a clown.

GB/BF
1985.48.2195 (ADB)

98

Soufflez, soufflez, vous ne l'éteindrez jamais.
Blow, blow, you will never put it out.

Printer: Benard
Distributor: Aubert
Appeared: *La Caricature*, 3 August
 1834,[1] pl. 375
Catalogued: *Inventaire*, no. 51; Sello,
 no. 199

The figure of France/Liberty with her Phrygian cap is holding up a torch marked '*Presse*' (the press). On the left of the picture, an arched opening encloses seven caricatures of political figures who are trying to blow out the torch. An eighth disembodied head with bat wings is hovering overhead. This image is the result of a rare collaboration between the artists Grandville and Daumier, both of whom signed it with their initials. It is probable that Daumier was responsible for the caricatures of government figures.

GB/BF
1985.48.646 (ADB)

[1] Sello gives 3 April.

99

L'Intervention déguisée. On ne passe pas, mille tonnerres!! –Mon cher Tartariscof ce sont des promeneurs, des flâneurs, des voyageurs pittoresques, laissez les passer, je vous en prie...
Disguised intervention. You cannot pass, by thunder!! –My dear Tartariscof these are strollers, loungers, picturesque travelers, let them pass, I beg of you...

Printer: Delaunois
Distributor: Aubert
Appeared: *La Caricature*, 9 July 1835,
 pl. 50
Catalogued: *Inventaire*, no. 65; Sello,
 no. 221

Louis-Philippe is standing by a sign reading '*Route d'Espagne*' (Road to Spain). An exotic armed figure holding the double-headed eagle, symbol of the Hapsburgs, is barring the way. A train of characters is lined up behind the king as he explains that they are simple tourists. However, this group consists of members of the French cabinet and army hiding their swords and rifles behind their backs. This "disguised intervention" refers to Louis-Philippe's attempts to intervene in the first Carlist war (1833-39) over the succession to the Spanish throne, despite his *entente* with Britain in which he made a com-

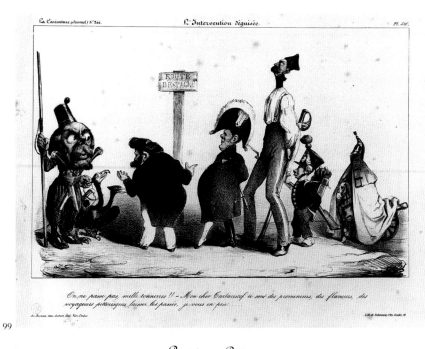

Catalogued: *Inventaire*, no. 64; Sello, no. 276
Reference: Getty, *Grandville*, no. 164

This image is among the first Grandville made after passage of the September Laws that closed *La Caricature*, hence its politically innocuous subject.

Grandville made a specialty of anamorphic distortions of the human anatomy. Here in an interior are three figures with weirdly distorted heads. The hairdresser is apparently causing *madame* pain, but for her a good coiffure is worth it. The subject presents different possibilities for systematic distortion: the maid is compressed and her mistress extended in the vertical dimension; the hairdresser is stretched in a horizontal direction.

GB/BF
1985.48.623 (ADB)

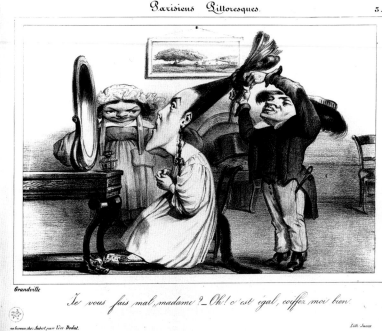

mitment to prevent other powers from intervening in Spanish affairs.
GB/BF
1985.48.633 (ADB)

100

Je vous fais mal, madame? –Oh! c'est egal, coiffez moi bien.
Am I hurting you, madam? Oh! never mind, do my hair nicely.

Series: *Parisiens pittoresques* (Picturesque Parisians)
Publisher: Aubert
Printer: Junca
Appeared: *Le Charivari*, 15 November 1835, pl. 3

Henry Monnier (1799-1877)

Henry Monnier, actor, writer, and draftsman, was born in Paris in 1799, the son of a modest civil servant. Leaving school at sixteen, he entered government service as a clerk in the bookkeeping department of the Ministry of Justice. His years there provided him with impressions of bureaucratic types which he later used as subjects for two lithographic series entitled *Moeurs administratives* (Administrative manners) nos. 107 and 108, and for the character written, acted, and drawn by him, Monsieur Joseph Prudhomme.

Bored with his job, Monnier decided to study art. After enrolling for a short time in the atelier of Girodet in 1817, he entered that of Baron Gros. While there, he entertained his fellow students by improvising and acting comic scenes of Parisian types. One of these satirized the master, who expelled Monnier from his studio.[1]

Attracted to the new art of lithography, Monnier made a few attempts at sketching actors and actresses in costume. The publication in Paris of prints by the English caricaturists, Thomas Rowlandson and George Cruikshank, also captured his interest. By 1825 he was living in London, where etching and aquatint were preferred to lithography for caricature. His contact and subsequent friendship with Cruikshank undoubtedly influenced the direction he later took of the comic study of manners.[2]

Monnier's return to Paris in 1827 marked the most prolific period in his life as a draftsman. Between 1827 and 1829 he produced numerous series of lithographs depicting the manners of the last years of the Restoration. These include *Esquisses parisiennes* (Parisian sketches), 1827; *Les Grisettes* (The grisettes), 1828; *Moeurs administratives*, 1828; *Galerie théâtrale* (Theatrical gallery), 1828; and *Jadis et aujourd'hui* (Yesterday and today), 1829.

Monnier usually worked in a linear, open manner in pen lithographs to which watercolor washes were added under his supervision. With an actor's eye for telling gesture and detail, he created a comic reflection of reality criticized by Baudelaire as having "the cold clarity of a mirror that does not think, and contents itself with reflecting the passers-by."[3] Champfleury, also noting these characteristics, saw them as excellent applications of realist doctrine. He added that Balzac discovered in Monnier a mine of comic observations which the novelist exploited in *La Comedie humaine* (The human comedy).

During the early years of the July Monarchy, Monnier published only a few albums depicting social types and customs, including *Les Contrastes* (Contrasts), 1830, and *Distractions*, 1832 . Thereafter his albums, while continuing to appear during the 1840s and 1850s, were infrequent. In the early 1830s, he occasionally made political caricatures, of which *Les Sauvers de la France* (no. 113) is one, for Charles Philipon's *La Caricature*. He also published an album of political lithographs, *Pasquinades* (Lampoons), 1830-31. He was not, however, a very successful political commentator, nor were his political opinions consistent with those of *La Caricature's* editors.

In order to supplement his income, Monnier published a book of dramatic sketches entitled *Scènes populaires* (Popular scenes). In July of 1831, he made his debut as an actor in *La Famille improvisée* (The improvised family), a play of which he was also one of the authors. Monsieur Prudhomme, a minor character in this play who represented the bourgeois stuffed shirt, was to become Monnier's favorite and best-known subject. Never a theatrical star, Monnier toured the provinces, often in the role of Prudhomme, in plays of his own authorship. Late in life, after his retirement from the stage, he was still writing about Prudhomme and drawing self-portraits in the role (no. 116). The character of Prudhomme was meanwhile taken up and exploited by Daumier in caricatures more biting than those of Monnier.

AL

[1] Melcher, *Henry Monnier*, 28-29.
[2] Ibid., 36.
[3] Baudelaire as quoted by Champfleury, *Henry Monnier*, 256.

101

Promesse de mariage.
(hand-colored)
Promise of marriage.

Series: *Récréations du coeur et de l'esprit* (Recreations of the heart and the spirit), 1826, no. 18
Printer: Bernard
Publisher: Giraldon Bovinet
Catalogued: Béraldi, no. 130; Marie, no. 253; Vanhevhe, no. 19(8)
References: Fleury, *Henry Monnier*, ill. p. 117; B. Hanson, "The Cardinal Family Monotypes" (thesis, University of California, Santa Barbara, 1981), p. 69, fig. 75.

By the mid-1820s, a myth had grown up about the stage mother. She is described as an *ex-portière* or *soubrette* who called herself Madame de Saint-Robert and claimed to be the widow of an officer killed during the Napoleonic campaigns, whom she had married against the wishes of her aristocratic family. Her dreams of glory were now centered on finding a rich husband for her daughter, whom she accompanied everywhere, as it was "more decent."[1] In this print, the mother of an actress has arranged a meeting for her daughter with a wealthy elderly banker, who has promised marriage.

More than a generation later, Degas included the dancer's mother in several of his paintings of ballet rehearsals and also treated the theme in a series of monotypes illustrating Ludovic Halévy's *La Famille Cardinal*, a novel about the stage mother as match-maker, first published in 1872.

AL
1985.48.893 (ADB)

[1] L. Couailhac, "La Mère d'actrice," *Les Français peints par eux-mêmes*, 1:75.

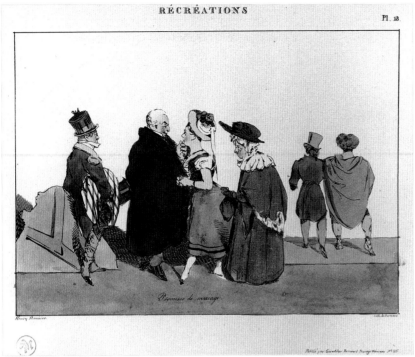

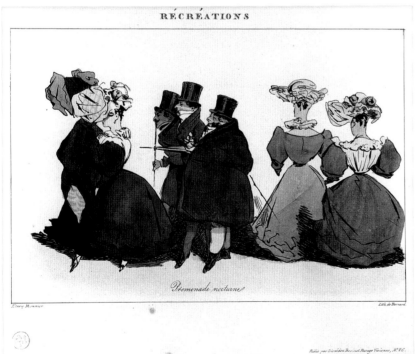

bred women of Paris, and by men of every class, the evening promenade. Here *grisettes*, dressed in their millinery best, are promenading on the boulevard, followed by their stalkers, well-to-do bourgeois gentlemen. Balzac describes the promenade in *Lost Illusions* "...it was only possible to move along at a snail's pace, as in a procession or at a fancy-dress ball. This slow progress worried no one since it gave an opportunity for gaping...The gleaming flesh of shoulders and bosoms stood out amid the almost invariably sombre hues of male costumes, producing the most magnificent contrasts. The hum of voices and the sound of pattering feet made a hub-bub which could be heard from the middle of the garden as one continuous bass note...Respectable persons and men of the greatest consequence rubbed shoulders with people who looked like gallows-birds."[1]

AL
1985.48.892 (ADB)

[1] Honoré de Balzac, *Lost Illusions*, translated by Herbert J. Hunt (Harmondsworth: Penguin, 1971), 265.

103

Il veut m'épouser... le scélérat!!
(hand-colored)
He wants to marry me...the scoundrel!!

Series: *Les Grisettes*, 1827, no. 6
Printer: Ardit
Distributor: Henry Gaugain
Catalogued: Béraldi, no. 321; Marie, no. 130; Vanhevhe, no. 64(6)
Reference: Ross, *Manet's Bar at the Folies-Bergere*, p. 45, pl. II.

The *grisette* was a Restoration type popularized by Monnier in three albums of lithographs of the late 1820s, all of which bear the title, *Les Grisettes*. The word *grisette* referred to a particular class of working girl, one who was either a seamstress, a shop assistant, or a milliner's assistant; her name derives from the gray dress worn by working-class women in the eighteenth century.[1]

The mythical *grisette* type was a young, naive, carefree creature who belonged only to Paris. Nowhere else would you find one with her sincerity,

102

Promenade nocturne.
(hand-colored)
Evening promenade.

Series: *Récréations du coeur et de l'esprit*, 1826, no. 26
Printer: Bernard

Publisher: Giraldon Bovinet
Catalogued: Marie, no. 265; Vanhevhe, no. 19(12)
References: Farwell, *FPLI* 3, 3B12; Champfleury, *Henry Monnier*, ill. p. 139

This print represents one of the pleasures indulged in by the less well-

Grisettes.
Pl.6.

Il veut m'épouser..... le scélérat!!

103

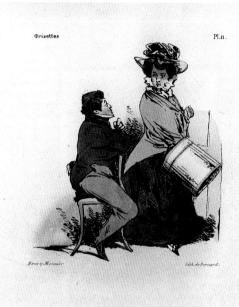

Grisettes
Pl.11.

C'est pas l'amitié que vous étouffe vous!

104

her abandon, her spontaneity, her liveliness, and bantering manner.[2] While in London, Monnier wrote, "Where are those naughty figures, those charming little faces, that would arouse the dead: I hunt everywhere for *grisettes*."[3]

According to myth, the *grisette*, being sincere, was more true to her student lover than the *grande dame* to her husband. Seeking love rather than money, she was both more responsible and more innocent than the *lorette*, popularized by Gavarni during the 1840s. Eventually she settled down and married one of her own class, rather than any of her bourgeois admirers from whom she did not expect offers of marriage.

Physically, Monnier's *grisette* is characterized by a round face and tiny waist and feet. She often wears a frilly white cap and, if she is a milliner's assistant, carries a hatbox. The *grisette* was the prototype for Mimi in Murger's *Scènes de la vie de bohème*, published in 1847.

AL
1985.48.847 (ADB)

[1] Novelene Ross, *Manet's Bar at the Folies-Bergères* (Ann Arbor: UMI Press, 1982), 43.
[2] Jules Janin, "La Grisette," *Les Français peints par eux-mêmes* 1:9.
[3] Ross, 45.

104

C'est pas l'amitié qui vous étouffe vous!
(hand-colored)
It's not friendship that's hushing you up!

Series: *Les Grisettes*, 1828, no. 11
Printer: Bernard
Distributor: Giraldon Bovinet
Catalogued: Béraldi, no. 42; Marie, no. 147; Vanhevhe, no. 24

A porter is teasing one of the tenants of his lodging house, a *grisette*, about some romantic intrigue she is trying to keep secret. The stock character of the *grisette* was a natural parallel to the gossipy porter, who was also a recurring comic type. As a writer, Monnier was famous for his short, mundane yet comic scenes of everyday life which he called *Scènes populaires*. One of the first collections, published in 1830, featured a meddling porter in a scene called *Roman chez la portière* (Novel at the doorkeeper's).[1]

GB
1985.48.828 (ADB)

[1] Melcher, *Henry Monnier*, 9.

105

Un Etudiant.
(hand-colored)
A student.

Series: *Paris vivant* (Living Paris), c. 1830
Printer: Bernard
Publisher: Bernard et Delarue
Catalogued: Béraldi, no. 270; Marie, no. 338; Vanhevhe, no. 102 (17)

The student's typical girl friend is the *grisette*. More than thirty years after Monnier's *Grisette* series, in 1862, a comic puppet play, written and with voices by Monnier, was performed at the *Théâtre érotique* in Paris, called *La Grisette et l'étudiant*.[1]

GB
1985.48.909 (ADB)

[1] Melcher, *Henry Monnier*, 158-159.

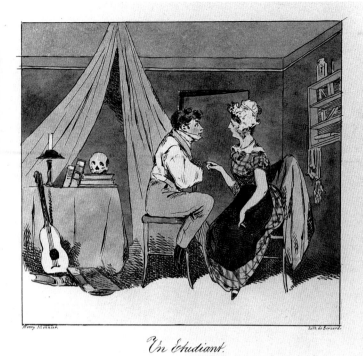

Un Étudiant.

105

106

Sauteurs.
(hand-colored)
Acrobats.

Series: *Galerie théâtrale* (Theatrical
 gallery), 1828, no. 1
Printer: Ardit
Distributor: Henry Gaugain
Catalogued: Béraldi, no. 398; Marie,
 no. 275; Vanhevhe, no. 93(1)
Reference: Farwell, *FPLI* 4, 2E7.

Toward the end of the eighteenth
century, the improvised pantomime of
the *Commedia dell'Arte*, which had been
an aristocratic diversion, was taken over
by acrobats, becoming a plebeian form
of entertainment which was presented
in fairgrounds or on the streets in the
proletarian areas of Paris.[1] Acrobats,
together with other *saltimbanques* such
as jugglers and conjurers, were the low-
est category in the social hierarchy of
public entertainers. Emile de la Bédol-
lière describes them as "charlatans of
public places... a race of vagabonds, a
race of bohemians, of outcasts."[2]
The theme of the street entertainer
was popular with lithographers,
although with the notable exception of

Daumier, their miserable state was not
often depicted. Among high artists,
Cézanne and Seurat treated the theme
in the 1880s, as did Picasso in the early
twentieth century.
Monnier, a playwright and actor as
well as a draftsman, included this low
theatrical form in his *Galerie théâtrale*,
which is otherwise devoted to scenes of
actors, rehearsals, and back-stage life of
the indoor legitimate theatre.

AL
1985.48.895 (ADB)

[1] Francis Haskell, "The Sad Clown; Some
 Notes on a 19th Century Myth," Ulrich
 Finke, ed., *French 19th Century Painting
 and Literature* (New York: Harper & Row,
 1972), 7.
[2] Emile de la Bédollière, "Les Banquistes,"
 Les Français peints par eux-mêmes 6:148.

107

Chef de bureau.
(hand-colored)
Office boss.

Series: *Moeurs administratives*, 1828,
 no. 2
Printer: Ardit
Distributor: Gaugain and Ardit
Catalogued: Beraldi, nos.377-383;
Marie, no. 186; Vanhevhe, no. 49

Before he attempted to make a liv-
ing by his art, Monnier had worked at
the lowest levels of the hierarchy of
clerks at the Ministry of Justice. His few
years in government service supplied
him with a lifetime of material for satire
in prints and plays. The series *Moeurs
administratives* represents the hierarchy
of a government bureau from the lowest
janitor to the *chef de division* and the
stultifying daily routine of the office.
The *chef de bureau* shown here is the
type of the idle self-serving bureaucrat.
GB
1985.48.835 (ADB)

108

*Messrs. Le directeur, chefs, sous-chefs,
employés, surnuméraires, etc. etc. etc. allant
complimenter une nouvelle excellence.*

(Messieurs the director, chiefs, assis-
tant-chiefs, employees, supernumer-
aries, etc., etc., going to
compliment a new excellency).

Series: *Moeurs administratives*, 1828
Printer: Delpech
Distributor: Delpech
Catalogued: Béraldi, no. 396; Marie,
 no. 202; Vanhevhe, no. 50
References: Farwell, *FPLI* 4, 4E11;
 Champfleury, *Henry Monnier*, ill.
 p. 11; Marie, *Henry Monnier*, ill.
 p. 9; Mespoulet, *Images et Romans*,
 ill. p. 32; Vanhevhe, p. 34

In the first of the two albums of this
series, Monnier represented some of the
innumerable variety of types to be
found in the office, among them the
chef de bureau (no. 107), the *sous-chef*,
and the *garçon de bureau*. This print
appeared in the second album, which
also included scenes of the hourly rou-
tine of the office. Here Monnier mocks
the hypocritical, self-seeking bureau-
crat. Vanhevhe suggests that Monnier

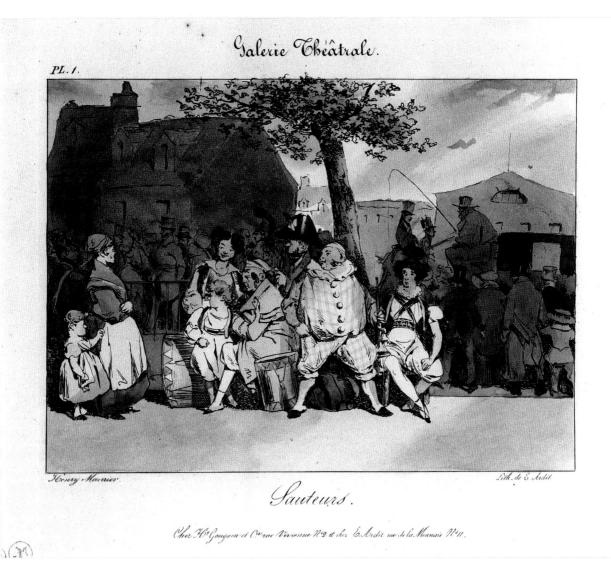

Galerie Théâtrale.

PL. 1.

Henry Monnier. Lith. de E. Ardit.

Sauteurs.

Chez M.ᵉ Gaugain et Cⁱᵉ rue Vivienne N.º 2 et chez E. Ardit rue de la Monnaie N.º 11.

has indicated the official hierarchy by the degree of submission, the line of the heads beginning with that of the director who bows lowest, ascending in inverse ratio to rank to that of the *garçon de bureau*, who appears to be uninterested in the proceedings.[1]

It has been pointed out that Monnier's images of the life of the employee offer visually the world of Balzac's César Birotteau and Baron Nucingen, antedating and perhaps influencing the novelist.[2] Monnier himself is said to have been the model for Balzac's bureaucrat Bixiou who, as had Monnier, countered the boredom and triviality of office life by drawing caricatures and playing practical jokes.[3]

AL
1985.48.872 (ADB)

[1] Vanhevhe, *Henry Monnier, l'homme et l'oeuvre*, 34. See also Paul Duval, "L'Employé," *Les Français peints par eux-mêmes* 1:503.
[2] Farwell, *FPLI* 4:15.
[3] Melcher, *Henry Monnier*, 18-19.

109

Une Soirée à la mode.
c. 1829
(hand-colored)
A fashionable party.

Printer and Distributor: Delpech
Catalogued: Marie, no. 303; Vanhevhe, no. 72
Reference: Farwell, *FPLI* 3, 3D9

During the Restoration in Parisian high society, the morning visit gave way to weekly evening parties. Mrs. Gore, a later English visitor to the city, writes of the soirée: "Every person once properly introduced into a house and invited by the master or mistress to return, is privileged to attend to the rest of his days. Thus, every house permanently established forms a coterie of its own;—centralizing the opinions and predilections of a knot of acquaintances, whom the progress of years naturally converts into friends."[1]

At these social gatherings, guests enjoyed conversation, cards, musical performances, and dancing. A print of the same subject, entitled *Le Jeu de l'écarté*, with an almost identical composition, was published by Boilly in the same year.[2]

AL
1985.48.925 (ADB)

[1] Gore, *Paris in 1841*, 247.
[2] Farwell, *FPLI* 3:9 and 3D10.

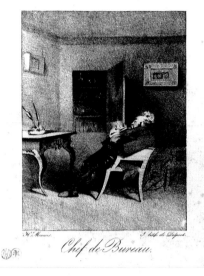

Mœurs Administratives.

Chef de Bureau.

107

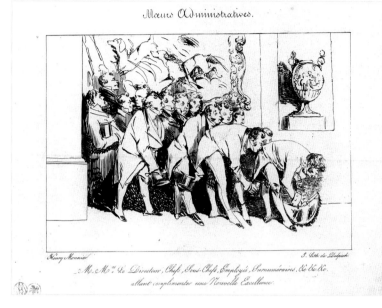

Mœurs Administratives.

Henry Monnier

J. Lith de Delpech

Mr. Mme. Le Directeur, Chefs, Sous-Chefs, Employés, Surnuméraires, &c. &c. &c.
allant complimenter une Nouvelle Excellence.

108

110

Marché aux poissons de Billingsgate.
(hand-colored)
Fish market at Billingsgate.

Series: *Voyage en Angleterre*
(Trip to England), 1829-30
Printer: Villain
Publishers: Firmin-Didot et Lami-
Denizan (Paris); Colnaghi Son &
Co. (London)
Catalogued: Béraldi, no. 173;
Vanhevhe, no. 74
Reference: Melcher, *Henry Monnier*,
32-40

The popularity of the paintings of
Constable and Bonington, among oth-
ers, made England attractive to artists
in the 1820s. After leaving Gros' ate-
lier, Monnier crossed the Channel,
perhaps with the specific aim of study-
ing aspects of lithography being devel-
oped there, and almost certainly to
make contact with English caricaturists.
In 1826 and 1827 he worked for the
London publisher Colnaghi on the
project *Voyage en Angleterre*, and collab-
orated with his friend Eugène Lami on
the work. In contrast with Lami's atten-
tion to high life, Monnier's subjects
focused more on the lives and types of
the common people, such as the fish-
mongers of Billingsgate.

GB
1985.67.289 (MW)

111

*Théâtre du vaudeville: Henry Monnier
dans La Famille improvisée.*
(hand-colored; illustrated on page 31)
Vaudeville theatre: Henry Monnier in
"The Improvised Family."

Printer: Delaporte
Distributor: Aubert
Appeared: *La Caricature*, 14 July 1831,
pl. 15
Catalogued: Béraldi, no. 509; Marie,
nos. 33 and 596; Vanhevhe, no. 108
References: Farwell, *Cult of Images*,
p. 43 (no. 29), ill. p. 49; Farwell,
FPLI 4, p. 31, 5F6; Champfleury,
Henry Monnier, p. 343, ill. fron-
tispiece; Marie, p. 5, ill. p. 87;
Melcher, *Henry Monnier*, pp. 100-
01, and 7th plate (not numbered);
Wechsler, *Human Comedy*, fig. 89.

Monnier made his debut as an actor
at the Théâtre du vaudeville on 5 July
1831, in *La Famille improvisee*. In this
comedy, written in part by Monnier, he
played Albert, the friend of the juvenile
lead Adolphe Coquerel, as well as
Adolphe's four relatives. The title of the
play refers to the fact that Adolphe,
wishing to extricate himself from a mar-
riage betrothal, has Albert improvise a
"family" which he is certain will prove
unacceptable to his prospective in-laws.

This lithograph represents Monnier
in a quadruple self-portrait as the four
improvised relatives. From the left, they
are: Coquerel senior, Adolphe's sup-

posed father, who is a retired notary and
old *roué*; Monsieur Prudhomme, a
pompous bourgeois; and two country
cousins, *la mère* Pitou, an older and
loquacious governess, and the gangly
cousin Jacques Rousseau.[1] M. Prud-
homme was to be one of Monnier's
continuing characters in the theatre and
in lithographs.

The lithograph appeared in *La Car-
icature*, was published separately by
Aubert, and in 1889 was used by
Champfleury as the frontispiece for his
biography of Monnier.

AL
1985.48.843 (ADB)

[1] Melcher, *Henry Monnier*, 100.

112

Un Ami du peuple.
A friend of the people.

Printer: Delaporte
Distributor: Aubert
Appeared: *La Caricature*, 30 December
1831, pl. 19
Catalogued: Béraldi, no. 504;
Vanhevhe, no. 108

Monnier, born in 1799, grew up
during Napoleon's supremacy, and the
adoration Monnier's generation felt
for Napoleon was not diminished by
his fall.

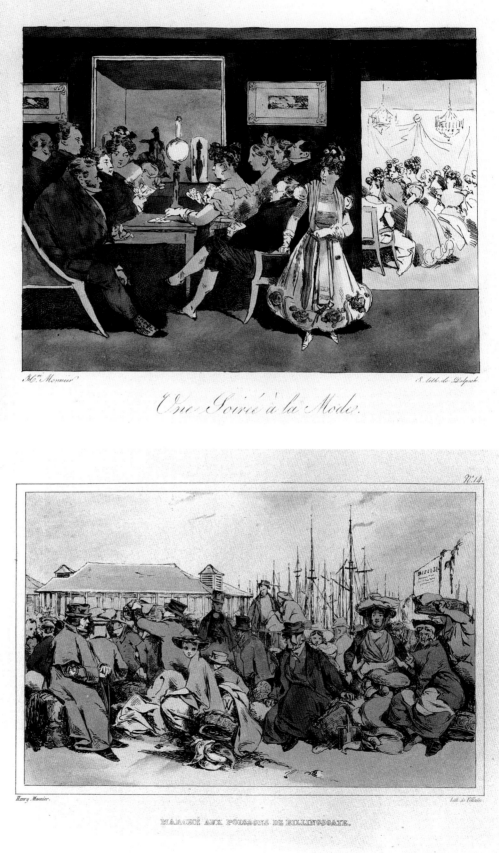

Une Soirée à la Mode.

109

Henry Monnier.

MARCHÉ AUX POISSONS DE BILLINGSGATE.

Publié à Paris par Rittner-Didot et Aubert-Boucher, Éditeurs. London published 1829 by Colnaghi and Co. N° 11, Pall Mall East.

110

"I saw enough of the Empire to remain entirely faithful to that regime," he said later.[1] Although during the Restoration republicans and Bonapartists were united in their hatred of the established regime, relationships between them were not necessarily friendly, as this apparently satirical portrait of a bloodthirsty republican by a Bonapartist seems to show.

GB
1985.67.429 (MW)

[1] Melcher, *Henry Monnier*, 3.

113

Les Sauveurs de la France.
(hand-colored)
The saviors of France.

Printer: Cluis
Distributor: Aubert
Appeared: *La Caricature*, 1831(?)
Catalogued: Béraldi, no. 509; Marie, no. 596 (6 in second list); Vanhevhe, no. 108.

Vanheve lists this lithograph as having been published in *La Caricature* in 1831. We have not found it there. Both Béraldi and Marie list it, undated, as *Les Sauveurs de la France* (or *Les Aboyeurs du lendemain*), while Vanheve treats these two titles as separate works. Whatever the meaning of this confusion may be, the print represents lawyers or perhaps members of Parliament jumping on the revolutionary bandwagon after the July Revolution of 1830.

During the Revolution, people who went to the assembly to "cry out" their revolutionary sentiments were referred to as '*aboyeurs*'.[1] '*Aboyeurs du lendemain*' refers to those who expressed revolutionary sentiments only after the Revolution had been accomplished and could safely be joined.

AL
1985.48.869 (ADB)

[1] *Grand larousse de la langue française* (Paris: Librairie Larousse, 1971), 2625.

114

Petite réunion de famille. Cinq heures de chant et de musique sans rafraîchissemens. Small family party. Five hours of singing and music without refreshments.

Series: *Impressions de voyage* (A traveler's impressions), 1839, no. 4
Printer and Distributor: Aubert
Catalogued: Béraldi, nos. 532-537(?); Marie, no. 495; Vanhevhe, no. 146(4)
1985.48.820 (ADB)

115

Petite réunion de famille
(hand-colored; illustrated on page 32)
Small family party

Series: *Impressions de voyage*, 1839
Printer and Distributor: Aubert
Catalogued: Béraldi, no. 532-537(?); Marie, no. 495; Vanhevhe, no. 146(4)
1985.48.2942 (ADB)

No. 114 was most likely executed during a brief return to Paris while Monnier was touring the provinces in theatrical companies. It mocks the boredom of guests who must listen to piano and vocal performances.

The scene depicted here is parallel to Balzac's treatment of provincial receptions in such works as *Les Illusions perdues* and *Le Deputé d'Arcis*, in which one finds "a festival of silliness, stupidity and pretentiousness."[1] The titles of other prints in this series by Monnier suggest that he shared Balzac's criticism of the provinces where local society encouraged pettiness of mind, and where conversations were "stupid, empty, or filled only with matters of local or personal interest" (*Curé de village*).[2]

No. 115 is the same lithograph with color applied by hand. Even though Monnier's style by 1840 contained far more dark tones than his works of the 1820s, color still transforms the image, making it an attractive spot of liveliness on a bourgeois wall.

AL

[1] Felicien Marceau, *Balzac and His World*, 378.
[2] Ibid., 377-78.

112

116

Untitled [before letters]
(Self-portrait as M. Prudhomme), 1860

This lithograph—uncatalogued and perhaps never published for distribution—shows Monnier in the role of Monsieur Joseph Prudhomme. Prudhomme, professor of penmanship, with his dignified solemnity and pompous speech, was a subtle parody of the smugness and mediocrity of bourgeois values. Represented as short and stout, with a bald head and gold-rimmed spectacles, Prudhomme wears a well-cut tail coat, trousers which reveal white gaiters over polished boots, and a large white cravat which, with its stiff collar, contributes to his air of pompousness. He was, Baudelaire wrote, "a monstrously true type."[1] While the sole creation of Monnier, M. Prudhomme was later adopted in caricatures by Daumier, who interpreted the character with an expressive exaggeration foreign to Monnier.[2]

M. Prudhomme first appeared in Monnier's *Scènes populaires*, a book of written sketches published in 1830. For the rest of his life, Monnier continued to write about him, to act him on the stage, and to draw portraits of himself in the role. Prudhomme, like *Commedia dell'Arte* characters, remained the same throughout the years, although situations of his life changed from one work to the next. In 1858 in the book *Memoires de Monsieur Joseph Prudhomme*, Monnier recorded the history of Prudhomme's life, which was, essentially, the

history of the activities and attitudes of the bourgeois from the Bourbon Restoration through the early days of the Second Empire.[3]

Champfleury suggests that the model for Prudhomme was M. Petit, the *chef de bureau* under whom Monnier worked when he was an office clerk.[4] However, prototypes for Prudhomme can be found in French literature, going back to characters such as the vain, self-seeking burgher Maître Pethelin of medieval farces.[5]

Monnier's Prudhomme, Champfleury states, together with Daumier's Macaire and Traviès' Mayeux were the most faithful representations of the bourgeoisie during the years 1830 to 1850. These three artists, he adds, were the most persistent adversaries of the bourgeoisie.

AL

1985.48.821 (ADB)

[1] Baudelaire, *Baudelaire: Selected Writings*, 225.
[2] Farwell, *FPLI*, 2:12.
[3] Melcher, *Henry Monnier*, 190.
[4] Champfleury, *Henry Monnier*, 13f.
[5] Melcher, *Henry Monnier*, 198.

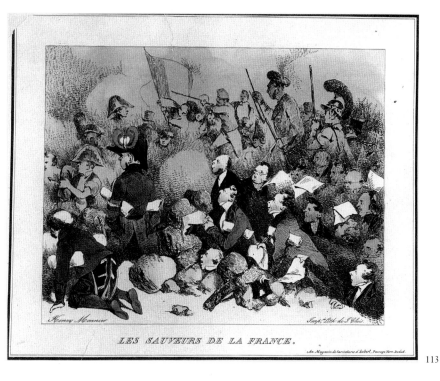

LES SAUVEURS DE LA FRANCE.

113

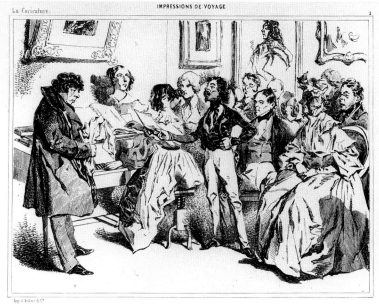

PETITE RÉUNION DE FAMILLE.

Cinq heures de Chant et de Musique sans rafraichissemens

114

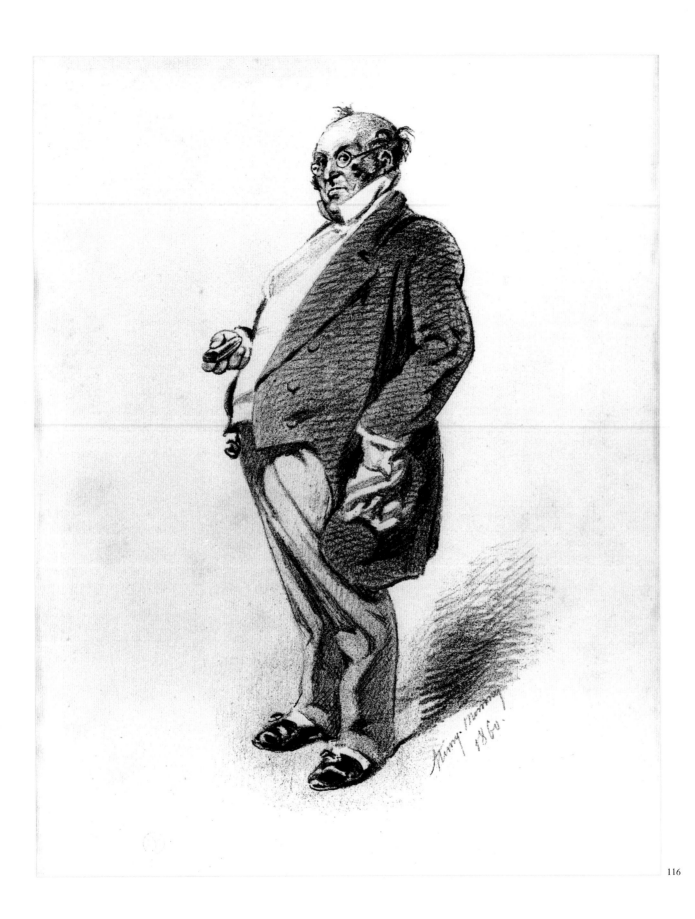

116

Charles Philipon (1806-1862)

Charles Philipon—caricaturist, lithographer, and liberal journalist—is by far best known today for his role as journalist and political gadfly. Born in Lyons in 1806, he went to Paris in 1823 where he studied painting under Baron Gros, and learned lithography. For a short time he drew caricatures and made lithographs for a living. Under the regime of Charles X, censorship prohibited political caricature, and Philipon's work, from this time until the Bourbons' downfall in the Revolution of 1830, was characterized by mild social satire and the depiction of popular Parisian types.

Almost all of Philipon's original lithographic work was made during this period. Although he was not a great artist, his draftsmanship was adequate and was characterized by a strong line and a minimum of dark tones. Philipon created two types of imagery: attractive women (suitable for framing), and social or political commentary of a topical nature (intended for newspapers or magazines and only preserved by specialized collectors).

Philipon saved his sister's husband from financial ruin by helping to set him up in Paris as a printer. The subsequently successful Maison Aubert was to publish not only Philipon's lithographs, but much of the radical political caricature of the period and indeed, much other early French nineteenth-century lithography. With the accession of the July Monarchy in 1830, censorship in France was momentarily lifted, and in November of 1830, Philipon began publishing his weekly journal of political satire, *La Caricature*, with a stable of the best caricaturists of the day that included Monnier, Grand-ville, and Traviès. Daumier and Gavarni were later added to the team. Under Philipon's leadership, a satirical on-slaught against the government, though suppressed in 1835, eventually contributed to the downfall of Louis-Philippe's regime.

From 1830 to 1835 Philipon's persistent caricature of the government of the "citizen-king" brought repeated and ever harsher legal actions against him, his collaborators, and the Maison Aubert. He published special litho-graphs (the famous *Association mensuelle*) to pay the fines, and served time in the Ste. Pélagie prison. *La Caricature* was finally suppressed altogether by the new censorship laws of 1835.

La Caricature, a weekly, had been Philipon's major political vehicle, but in 1832 he had established a new, daily satirical journal, *Le Charivari*, which carried a new lithographic caricature every day. Twenty years later it became the inspiration for the English *Punch*, which was subtitled *The London Charivari*.

Philipon himself produced a few political lithographs early in his journal-istic career, but he was more effective in partnership with Daumier and other artists in the Aubert stable. With Daumier he gave birth to the socio-political villain, Robert Macaire: Daumier produced the drawings and Philipon produced the ideas and captions. It was Philipon who introduced the motif of the pear to lampoon Louis-Philippe, probably the single most effective device in his campaign against the king (see the accompanying essay by Stuart Kadison).

In 1838 *La Caricature* had a short-lived rebirth, with lithographs, under the title *La Caricature provisoire*. Other papers run by Philipon include *Le Journal pour rire* of 1849 which later became *Le Journal amusant* of 1850-57. These were large format journals illustrated with wood engravings. More and more of the production of the Maison Aubert came to be devoted to non-caricatural lithography such as the work of Achille Devéria, Jules David, and others, though Aubert continued to publish *Le Charivari* with heavy contributions by Daumier and Gavarni. Philipon's many publications helped to establish the traditions of the illustrated press, but lithography was largely supplanted by wood engraving in the 1840s, and both in turn were supplanted by line cuts and half-tone reproductions of photography by the 1880s.

Philipon died in Paris in 1852. Most of his lithographs in this exhibition are early examples from his pre-journalistic days. These works show us the witty and sometimes satiric mind of his early years and give us a glimpse of the great conductor of the caricatural orchestra that was to perform so well in the decades to follow.

PH/RP/BF

Bibliography:
Béraldi, vol. 10.
Cuno, "Charles Philipon."
Farwell, *The Cult of Images*.
Farwell, *FPLI*, vol. 1.

117

L'Agréable parfumeuse.
The pleasant perfume seller.

Series: *Genre parisien* or *Têtes de femmes* (Paris types or women's heads), 1827-29, pl. 2
Printer: Melle Formentin
Distributor: F. Janet
Catalogued: Béraldi, 10:268-9 (mentions series)

In the mythology of Paris shopgirls it would be difficult to imagine a *dis-agreeable* perfume seller. The appropriate epithet is characteristic of Philipon's entire series from which this image comes: the sweet candy-seller, the insensible tobacconist, the tender mattress-merchant, the piquant seamstress, the decent lingerie seller, and the nice laundress.[1] According to the popular pseudo-science of Lavater and Gall, people come to be affected by their typical activity or job—thus individuals become types and mythology is born.

The depiction of types did not originate with Philipon, but had a long tradition in popular art that sought to entertain with familiar images in recording the types of a stratified society. Other examples of this tradition in the exhibition are street vendors (C. Vernet, nos. 188-191) and the cafe singer (Daumier, no. 46).

PH/BF
1985.48.975 (ADB)

[1] Farwell, *FPLI* 2:18-19.

118

Elle s'habille. Babille. Se deshabille. (hand-colored)
She Dresses. Chatters. Undresses.

Series: *Occupations d'une femme* (Occupations of a woman), 1827-30
Printer: V. Ratier
Catalogued: Béraldi, 10:268-9 (mentions series)

L'agréable Parfumeuse.
(Paris.)
Nº 25.

Se Dépôt chez F Janet, rue des St Pères Nº 10. Imp. Litho. de Mⁱˡˡᵉ Formentin, rue des St Pères, Nº 10.

Published by Charles Tilt, 86, fleet street, London.

117

Occupations d'une femme

Elle s'habille. · *Babille.* · *Se déshabille.*

118

These three small scenes represent classic stereotypes of the activities of women as seen by a man in a male-dominated society. This series is representative of Philipon's fondness for making pictures of pretty and fashionable young women during the last years of the Restoration. On another level it may owe its combination of images simply to the rhyming available in the French language.

PH/BF
1985.48.979 (ADB)

119

Melle Félicité, agée de 18 ans... et quelques mois, blonde, d'un Caractère et d'un physique agréables, désire se placer chez un homme seul pour tout faire. S'adresser rue Poupée, No. 1, demander la Lyonnaise.
(hand-colored)

Miss Felicity, age 18... and a few months, blonde, with a nice personality and physique, seeks a position in the home of a single man for all work. Apply to No. 1 Doll Street and ask for the girl from Lyons.

Series: *Les Annonces. Petites-affiches parisiennes*, no. 2, 1828-30 (Advertisements. Little Parisian posters)
Printer: V. Ratier
Distributors: Hautecoeur Martinet; Gihaut; Violet
Catalogued: Béraldi, 10:268-9 (mentions series)

Philipon's series of *Les Annonces* parodies newspaper want ads. In this work Mlle. Félicité is advertising herself in a thinly veiled appeal for a male protector. As in the other prints from this series, much of the humor comes from the contrast between the formality of the newspaper-like ad and the illustration which tells the real story. The young miss of this ad flirts with a middle-aged bourgeois and the picture expresses what the words do not.

'La Lyonnaise' as a mode of identification suggests the low-brow dancers and inmates of brothels who were called by their place of origin, as in *Alice la Provençale*, an entertainer of the Second Empire.

PH/BF
1985.48.977 (ADB)

120

Vingt années de recherches savantes et de travaux assidus viennent enfin d'être recompensées par une de ces découvertes qui illustrent leur siècle... Mr. Toupignac, chimiste coiffeur, possède aujourd'hui le secret d'une merveilleuse eau capillaire qui fait pousser en un clin d'oeil sur la tête la plus aride une forêt

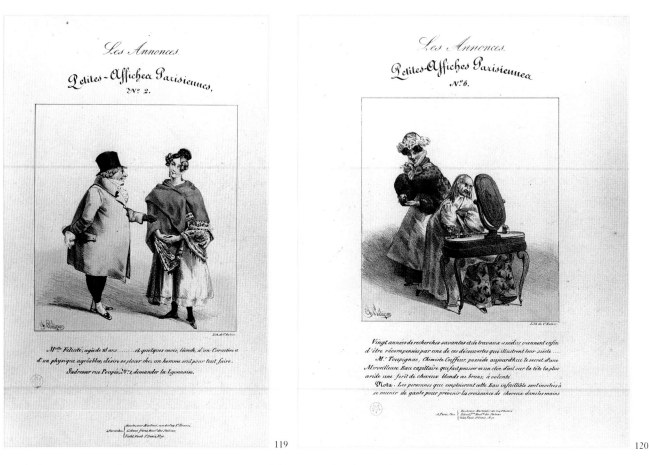

de cheveux blonds ou bruns, à volonté. Nota. Les personnes qui emploieront cette eau infaillible sont invitées à se munir de gants pour prévenir la croissance de cheveux dans les mains.

Twenty years of brilliant research and assiduous effort have finally paid off in one of those illustrious discoveries of the century... Mr. Toupignac, a chemist/hairdresser, possesses today the secret of a marvellous capillary lotion that, in a twinkling of an eye, grows on the most barren head a forest of hair, blonde or brown, as you like. N.B. People using this infallible lotion are advised to provide themselves with gloves to prevent the growth of hair on their hands.

Series: *Les Annonces Petites-affiches parisiennes*, 1828-30, no. 6
Printer: V. Ratier
Distributors: Hautecoeur Martinet; Gihaut; Violet
Catalogued: Béraldi, 10:268-9 (mentions series)

Here Philipon parodies the "snake oil" ads of his day. An old woman awaits her forest of hair while her maid laughs at her gullibility. Similar subject matter was treated by Goya in *Los Caprichos*. Age seeking the fountain of youth has been a universal target of the social satirist.

PH
1985.48.2924 (ADB)

121

Mme de Saucisses.
c. 1828-30 (finished by Julien; hand-colored)
Madam of the sausages.

Series: *Genre parisien* (Parisian genre), pl. 14

Mme de Saucisses, selling her hot wares, is another of the many street vendors celebrated in popular imagery. Others are seen in the work of Carle Vernet (nos. 188-190). These familiar and picturesque figures slowly disappeared from the streets of Paris in the

course of the nineteenth century. Philipon's penchant for pretty girls idealizes and mythologizes the working-class personages engaged in this trade.

BF
1985.67.305 (MW)

122

Il est beau comme un amour!
He is handsome as a god.

Series: *Les tentations du diable* (Temptations of the Devil), 1829, pl. 1
Printer: Delaporte
Distributor: Aubert

In this scene a young woman is being tempted to give up her virtue by the devil dressed as a matronly procuress. The devil holds out a letter from a client whom she describes in glowing terms, probably inaccurately. The young woman looks tempted. This was the beginning of the path to perdition

taken by many young women without dowries and without hope of honest work at a living wage.

Diablery in caricature took its cue from high artists such as Delacroix and from the literature of the major figures of romanticism: Goethe, Chateaubriand, and Victor Hugo.[1]

PH
1985.48.974 (ADB)

[1] Grillet, *Le Diable dans la littérature*, 1-60.

123

Armes du peuple. Misère toujours misère. Armes du juste milieu. La France n'[....] sentira pas. Mieux vaut la honte que la guerre. Ch. Ph. premier blasonnier de la meilleure des républiques.

Arms of the People. Misery always misery. Arms of the *juste milieu.* France will not [.....]. Better shame than war. Ch. Ph. first blazoner of the best of republics.

(hand-colored; illustrated on page 33)

Printer: Delaporte
Distributor: Aubert
Appeared: *La Caricature*, 26 May 1831, no. 59

Philipon's parodic coats of arms set forth symbolically the great rivals of the nineteenth century: the working class and the bourgeoisie. The Arms of the People display a shield with three paving stones (used to build the barricades and therefore symbolizing the Revolution), the pick and broom of the laborer and street sweeper, the foot-soldier's hat, the lantern of Diogenes (broken), the fasces of brotherhood, and a decoration for military valor, all topped by the Phrygian cap of Liberty with its tricolor cockade. The motto: "Misery, always misery."

The Arms of the *juste milieu* represent an opposition view of Louis-Philippe's government, less than a year after its inauguration. The central shield with the colors of the new French flag bears the *fleur-de-lis* of the Bourbon Monarchy, the bee of Napoleon, and a dishevelled turkey that probably is meant as a mockery of the Gallic cock of France. Behind it are two syringes, an enema and a douche (the famous clyster props of the *commedia dell'Arte* and universal symbol of the forces of reaction in French caricature),

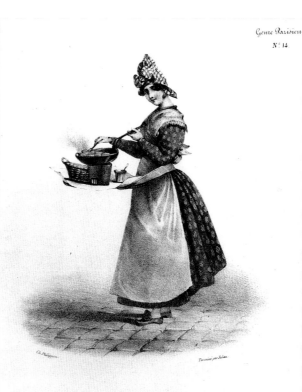

Genre Parisien
N.º 14

M.ᴰᴱ DE SAUCISSES.

121

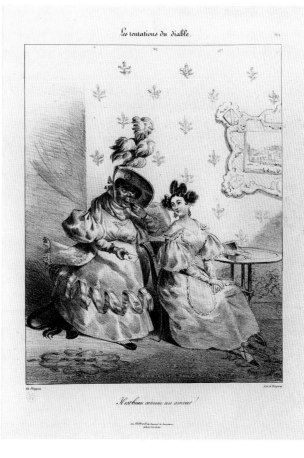

Les tentations du diable.

M..beau comme un amour!

122

Projet

Le monument Expia-poire à élever sur la place de la révolution, précisément à la place où fut guillotiné Louis XVI inventé par Ch. Philipon, et dessiné par M.....

and other shields detailing "insults" (favors to the aristocracy) and "secret police" (sums allocated for surveillance of newspapers, etc.). The night cap is frequently the symbol of the government newspaper *Le Constitutionnel*. The upper motto is somewhat ambiguous because it is incomplete, but seems to refer to insensitivity on the part of France. The lower one criticizes Louis-Philippe's foreign policy of appeasement, at this date probably referring to the uprising of the Poles against their Russian masters, a popular cause not supported by the French government.

BF
1985.48.972 (ADB)

124

Projet. Le Monument expia-poire à élever sur la place de la révolution, précisément à la place où fut guillotiné Louis XVI. Inventé par Ch. Philipon, et dessiné par M.......

Project. The Expia-pear [expiatory] monument to be erected on the Place de la Revolution, precisely on the spot where Louis XVI was guillotined. Designed by Ch. Philipon, and drawn by M.....

Printer: Becquet
Distributor: Aubert
Appeared: *La Caricature*, 7 July 1832

Projet is the only example in the exhibition by Philipon himself of his famous pear, the symbolic caricature of Louis-Philippe. This absurd monument is named, in Philipon's caption, after the *Monument expiatoire* that was raised dur-

ing the Restoration to commemorate the regicide of Louis XVI and Marie Antoinette in 1793. Philipon's monument is placed in the center of the Place de la Concorde (formerly Place Louis XV, in whose reign the Place was designed), where the obelisk of Luxor now stands. The obelisk was given by Mohammed Ali of Egypt to Louis-Philippe in 1831, but was not installed until 1836. Plans for its placement may have triggered Philipon's print.

The Place Louis XV was renamed Place de la Révolution in 1792, and the guillotine was set up there. After the Terror, it became Place de la Concorde. It reverted to Place Louis XV during the Restoration, and was returned to its present name when Louis-Philippe came to the throne.

Philipon's demonstration in his own defense in court of the resemblance of Louis-Philippe to a pear did not save

Règne de l'égalité.

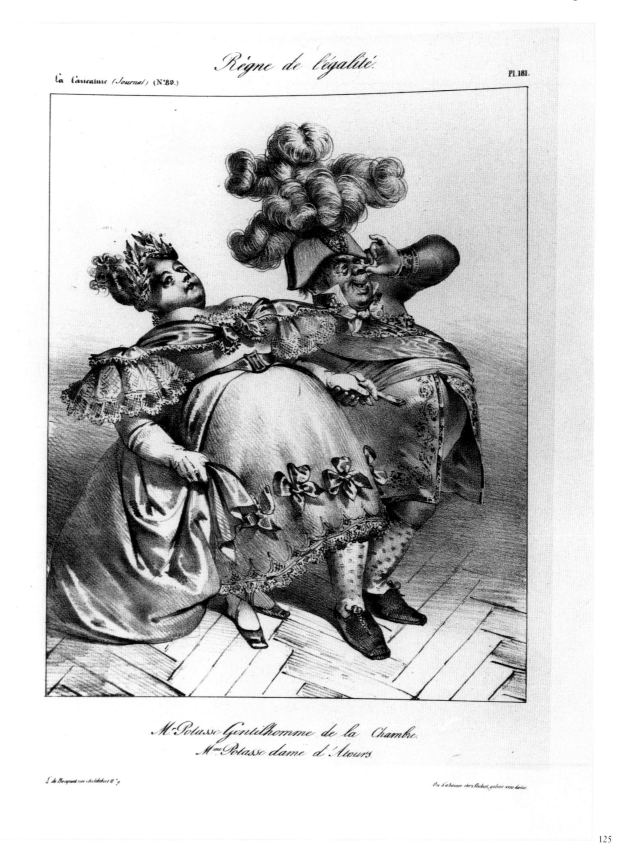

la Caricature (Journal) (N.º 89.)

Pl. 181.

M.º Potasse Gentilhomme de la Chambre.
Mme Potasse dame d'Atours.

him; he was found guilty and fined. He finally dropped the use of the pear when a picture of a monkey stealing a pear proved to be an indictable offense.[1]

BF
1985.48.982 (ADB)

[1] Maurice and Cooper, *Nineteenth Century in Caricature*, 72.

125

*Règne de l'égalité. Mr. Potasse gentil-
homme de la chambre. Mme. Potasse
dame d'atours.*
Reign of equality. Mr. Potasse, gentle-
man of the [king's] chamber. Mrs.
Potasse, lady of the bedchamber.

Distributor: Aubert
Appeared: *La Caricature,* 19 July 1832,
no. 181

Bourgeois courtiers, a couple here identified as attendants to the royal family in *ancien-régime* style, are announced at a court function. Their exaggerated *avoirdupois* was the badge of success among middle-class citizens who were exhorted by the regime of Louis-Philippe to "get rich." Over-dressing in an attempt to mimic the old aristocracy became a target of the caricaturist as well. This mockery was however not restricted to the '*Règne de l'égalité.*' It calls to mind the image of M. Jourdain in Molière's *Le Bourgeois gentilhomme* of more than a century earlier.

BF
1985.67.51 (MW)

Edme Jean Pigal (1798-1873)

Edme Jean Pigal was born in Paris and in the 1820s, like many other aspiring artists of his generation, entered the studio of Baron Gros. In 1827 he made his debut at the Salon with two entries that suggest an early interest in comical themes: *Le Ménage d'un vieux garçon* (The household of an old bachelor), and *Un Consultation de médecins* (The doctors' consultation). He continued to show at the Salon every year until after 1870, exhibiting both genre paintings and religious works, with comical genre dominating his entries until the middle to late 1830s. Pigal is an anomaly in that painters choosing caricature as subject matter are relatively rare in French high art, or at least in high art that has remained famous.

As an artist, Pigal is far better remembered for his lithographs than for his paintings. From the late 1820s to the late 1830s, he produced numerous lithographs caricaturing contemporary customs and social types, in which he ridiculed the hypocrisy of the bourgeoisie and the vulgarity of the lower classes. His favorite characters were the street urchins of Paris, servants, coachmen and doormen, and lecherous old men. *La Silhouette*, *La Caricature*, and *Le Charivari* all published his caricatures at one time or another, though he was not a regular in any of them.

Pigal's earlier lithographs, like Boilly's, vignette one or two figures with the minimal suggestion of a setting. Some examples such as *Vanité des vanités* (no. 145) provide fuller backgrounds filling up a frame and therefore suggest a later date, though there is no secure chronology of Pigal's lithographs. Works made for the single-sheet market and not for newspapers were usually hand-colored. Most of the artist's work in the exhibition belongs to this category.

After 1838 Pigal produced fewer lithographs. He shifted increasingly to painting religious and historical themes, including commissions for the Ministry of the Interior. In later lithographs, his humor turned away from the vulgar comedy of his youth to a gentler caricature of manners. Pigal's caricature was never directly or overtly political, but the conservative shift in his work also reflected his mounting prestige as a painter commissioned by the government and his position as a professor at a *lycée* in Sens, where he continued painting until his death in 1873.

The critics disagreed on Pigal's work as a caricaturist. To Baudelaire, he was an illustrator of manners, the delineator of the life of the bourgeoisie, and a chronicler of the fashions of the 1820s. Baudelaire saw Pigal as a transitional figure between the styles of Carle Vernet and Charlet, not very original, but rather a purveyor of commonplace truths, popular sayings, family scenes, and the ironies of everyday life. He calls Pigal "an essentially *reasonable* caricaturist."[1]

Not everyone was amused by Pigal. Béraldi finds his draftsmanship excellent but his comedy trivial. In a list of caricaturists he describes as "common," he ends with "And Pigal? Superlatively common!"[2]

On the other hand, Pigal's greatest champion, Champfleury, describes the artist as "the *doyen* of caricaturists, who represents one side of the old French spirit: Joy."[3] For him, Pigal raises the life of the gutter to a sort of hedonistic philosophy: "Enjoy life while you may, for when it is over—it's over for a long time!"[4]

RP

1 Baudelaire, *O.c.* 2:546.
2 Béraldi, 10:277.
3 Champfleury, *Histoire*, 282.
4 Ibid., 283.

126

Baissez les yeux, petite sotte.
c. 1820 (hand-colored)
Lower your eyes, you little fool.

Series: *Scènes de société* (Scenes of
 society)
Printer: Langlumé
Distributor: Gihaut et Martinet

Pigal depicts a bourgeois mother instructing her daughter to lower her eyes from the appreciative gaze of an approaching dandy who scrutinizes the young lady's budding charms through his lorgnette. Rules of conduct for well-brought-up girls included not making eye contact with strangers, particularly men, who might otherwise consider their gaze an invitation. It is this protocol that gives such pointed meaning to the direct, brazen gaze of the model in paintings such as Manet's *Olympia* and *Déjeuner sur l'herbe*.

The type of dandy shown in this print has survived to the present day as the symbol of the connoisseur in the famous *New Yorker* magazine logo.

RP
1985.48.993 (ADB)

127

La paix, mes bons amis.
c. 1825 (hand-colored)
Peace, my good friends.

Series: *Médailles ou contrastes* (Medal-
 lions or contrasts), no. 1
Printer: Langlumé
Distributor: Gihaut
1985.48.1027 (ADB)

128

Tu vas me l'payer, scélérate!
c. 1825 (hand-colored)
You'll pay me for this, madam scoundrel!

Series: *Médailles ou contrastes*, no. 1 bis
Printer: Langlumé
Distributor: Gihaut
1985.48.1080 (ADB)

These prints are pendants illustrating the nostrum that people do not always practice what they preach. The medallions also relate to two ancient comic motifs: the fighting boys and the fighting husband and wife. The former was a frequent theme in Pigal's prints while the latter formed the basis of some of his best-known comic paintings.

The history of pendants showing contrasts is a long one that can be traced through eighteenth-century rococo examples back to Renaissance and medieval themes of virtue and vice. Pigal thus employs a traditional form to present his traditional commonplace truths.

RP

Scènes de société.

chez Gihaut et Martinet.

Lith. de Langlumé.

Baissez les yeux, petite sotte.

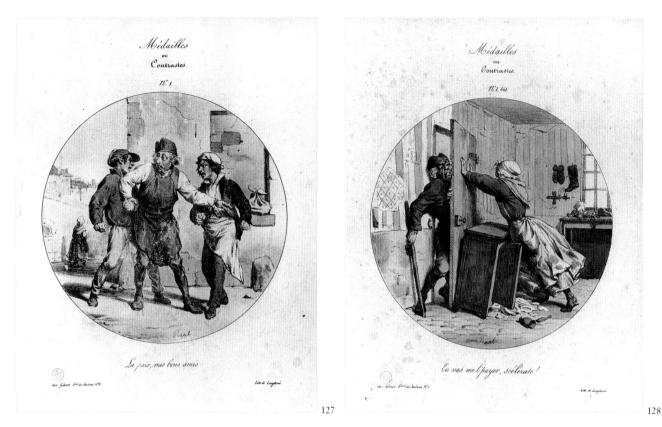

127

128

129

C'que c'est que d'nous!
c. 1825 (hand-colored)
That's what will become of us!

Series: *Scènes populaires*
 (Popular scenes), no. 7
Printer: Langlumé
Distributor: Gihaut et Martinet

Pigal portrays a *chiffonnier* (rag-picker) in a characteristically philo-sophical moment. The *chiffonnier* contemplates a dead dog lying on a grave whose headstone significantly bears Pigal's signature. A dead cat rests on top of the *chiffonnier*'s basket.

Although Paris was full of these poor types in the nineteenth century and they served a real function through their salvaging of everything of value in the trash (dead cats and dogs went to the glue factory), the *chiffonnier* had also become a symbolic figure in literature and art. A free man, never a beggar, who earns enough to eat and get drunk on cheap wine, he was unencumbered by material possessions beyond his bas-ket and pick, and came to be assimilated to Diogenes in his barrel. Caption writ-ers attributed to him pithy propositions and philosophical observations. The ragpicker-philosopher inhabits the paintings of Manet and the poetry of Baudelaire, but his image and myth appeared long before in such popular lithographs as this one (see also nos. 82 and 163).

RP/BF
1985.48.998 (ADB)

Bibliography:
Berthaud, L.A., "Les Chiffonniers," *Les Français peints par eux-mêmes* 3:333-344.
La Bédollière, *Les Industriels*, 170-176.

130

Ah! J'ris ti!......
c. 1825 (hand-colored)
Hah! You kids are some laugh!.....

Series: *Scènes populaires*, no. 19
Printer: Langlumé
Distributor: Gihaut et Martinet

Four of Pigal's favorite type, *galopins* (Parisian street urchins), cavort in the street. These types have a long antecedent in works of realist art, not the least of which are Murillo's urchins of the seventeenth century. The two barefoot boys are contrasted with the two richer boys with coats and shoes who form a barrier over which one of the urchins has just leapt. The pose of the ragged boys may refer to a famous Renaissance sculpture, *Hercules and Anteus* by Vincenzo de Rossi, which was well known in the nineteenth century. The image of these cocky, streetwise children is that of the *gamin de Paris* as described by Jules Janin.[1] He refers to these incorrigible boys as the sovereigns of Paris who are intent on amusing themselves by turning everything upside down.

RP
1985.48.989 (ADB)

[1] *Les Français peints par eux-mêmes* 2:161-170.

131

Pas mauvais, pas mauvais.
c. 1825 (hand-colored)
Not bad, not bad.

Series: *Moeurs parisiennes* (Parisian
 manners)

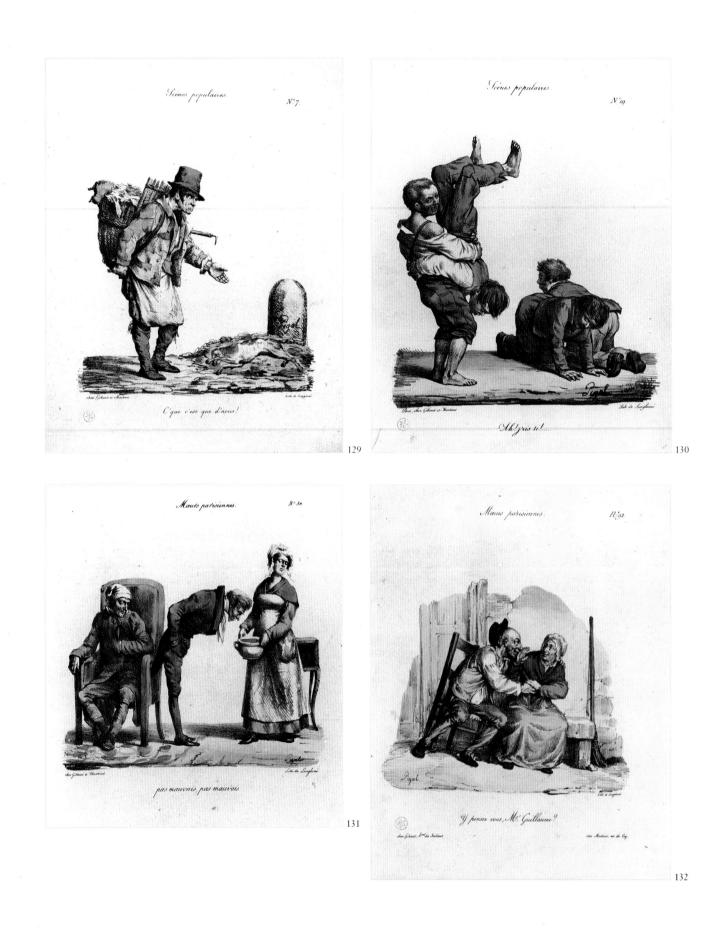

Scènes populaires. N°7.

C'que c'est que d'nous!

129

Scènes populaires. N°19.

Ah! zis ti!....

130

Mœurs parisiennes. N°50.

pas mauvais, pas mauvais

131

Mœurs parisiennes. N°92.

Y pensez vous, M.r Guillaume?

132

Printer: Langlumé
Distributor: Gihaut et Martinet
Reference: Farwell, *FPLI* 3,5C1

The large series *Moeurs parisiennes* consists of one hundred lithographs on a wide variety of subjects; nos. 132-134 are also from this series.

The doctor's visit is a comic theme in art, familiar since the seventeenth century. Its particularly scatological character in this print is typical of Pigal, whose humor comes closer than that of any French caricaturist to the more earthy humor of English caricatures (see no. 133).

BF
1985.48.2934 (ADB)

One of Pigal's favorite types was the timeless character of the lecherous old man. This comic type appears in all periods, from the ancient Greek comedies of Aristophanes to the modern shenanigans of Benny Hill or Carol Burnett and Harvey Corman. Baudelaire comments that Pigal's compositions "show a spontaneous predilection for elderly types... His are common-place truths, but they are truths for all that."[1]

Pigal often combines an interest in the peasant types of Greuze with the naughty rococo humor of Moreau le Jeune and Cochin *fils*, thereby uniting two mainstreams of French art of the previous century.

RP
1985.48.1087 (ADB)

[1]Baudelaire, *O.c.* 2:545.

This lithograph humorously depicts the dangers of the age of the chamber pot. "*Gare l'eau*" is argot for "gardez l'eau," the polite warning uttered before emptying a chamber pot into the street. According to one theory, this phrase was imported into Great Britain where by the nineteenth century it became corrupted into "Gardy-loo," which eventually evolved into the English slang term "loo" for the toilet.[1]

Bathroom humor such as this has earned Pigal the epithet of "vulgar" from some critics, but the problems of waste disposal in the first half of the nineteenth century were part of everyday reality. As late as 1850, most Parisian streets had open sewers that ran along the gutters in front of buildings. To solve the concomitant health problem, Baron Hausmann and his engineers under Napoleon III's regime mobilized massive resources of labor and money to construct a modern hygienic system. Between 1854 and 1870, every street received its own enclosed sewer which emptied into a system of enclosed collectors emptying into the Seine miles below Paris, thus finally separating the

132

Y pensez vous, Mr. Guillaume?
c. 1825 (hand-colored)
What can you be thinking of,
 Mr. William?

Series: *Moeurs parisiennes*, no. 92
Printer: Langlumé
Distributors: Gihaut; Martinet

133

Gare l'eau!
c. 1825 (hand-colored)
Mind the water!

Series: *Moeurs parisiennes*, no. 94
Printer: Langlumé
Distributors: Gihaut; Martinet

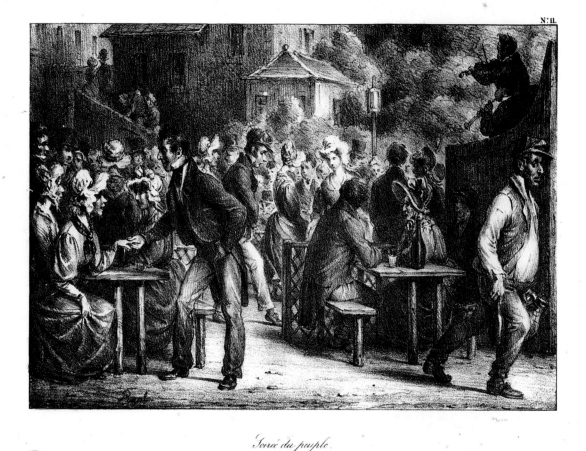

La Caricature (Journal.)

N: 11.

Soirée du peuple.

139

drinking water from the refuse. By 1870 Paris possessed the state of the art in sewage disposal, and water was available to every building.

RP

1985.48.1013 (ADB)

[1] Roy Palmer, *The Water Closet: A New History* (New York: Newton Abbot, David and Charles, 1973), 27.

Bibliography:
Chapman, J. W. *The Life and Times of Baron Hausmann*. London,1957.
Pinkney, David H. *Napoleon III and the Rebuilding of Paris*. Princeton: Princeton University Press, 1958.

134

Je ne suis qu'amateur.
c. 1825 (hand-colored)
I'm just an amateur.

Series: *Moeurs parisiennes*, no. 96
Printer: Langlumé
Distributors: Gihaut; Martinet

Pigal, like other caricaturists, managed to find humor in the cliches of his own profession (Boilly, no. 15; Daumier, no. 27; Gavarni, no. 66). The usual confrontation between painter and viewer has the painter suffering the inept remarks of the philistine. This print reverses the situation: a sophisticated viewer confronts the work of an amateur painter.

BF
1985.48.1021 (ADB)

135

Qui se ressemble s'assemble.
c. 1825 (hand-colored)
Birds of a feather flock together.

Series: *Les Proverbes* (Proverbs), no. 9
Printer: Langlumé
Distributors: Noël; Noël et Dauty

Pigal produced an album illustrating proverbs which is not listed in standard reference books. Precedent for this subject had been set by Bruegel in the sixteenth century and Goya in the early nineteenth, but Goya's *Disparates* were not published until 1864. The French proverbs represented in the exhibition are by and large close to similar sayings in English, and the pictures are self-explanatory.

BF
1985.48.1063 (ADB)

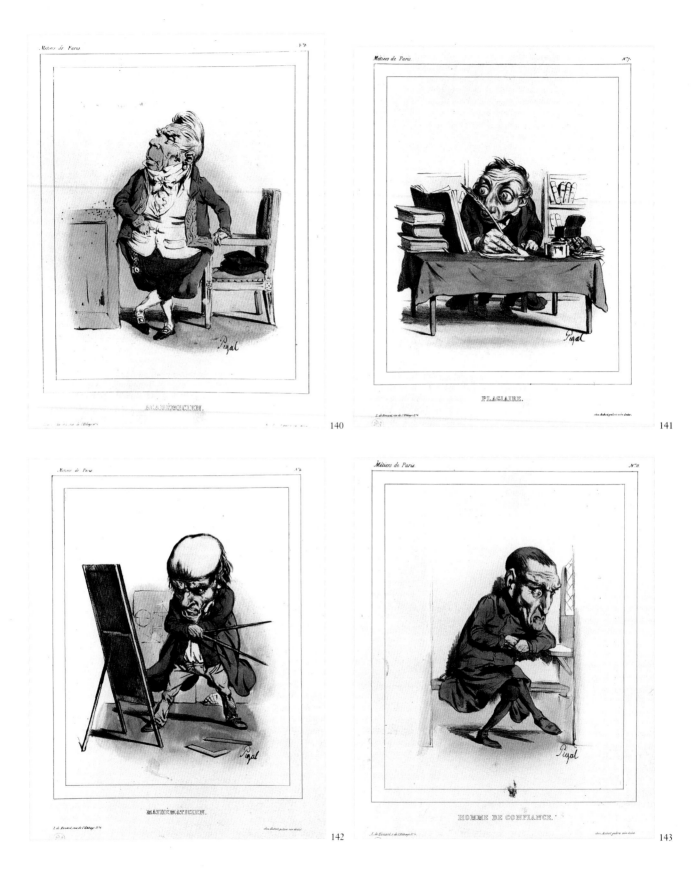

136

La nuit tous chats sont gris.
c. 1825 (hand-colored; illustrated on
page 34)
All cats are gray in the dark.

Series: *Les Proverbes*, no. 36
Printer: Langlumé
Distributors: Noël; Noël et Dauty

A young rake is picking up a lady of
the night whose dubious charms are
disguised in the dark.

Prostitution was legal, indeed quite
open and visible in Pigal's Paris of the
1820s. One out of ten women was so
employed in 1831.[1]

This lithograph maintains Pigal's
usual format of a few figures acting out
their roles within a shallow space, with
one exception: here he provides a sim-
ple background, almost a backdrop, to
indicate the night. Although more com-
plex than his usual backgrounds, it is
still much simpler than the spatial com-
plexity and detail of the lithographs of
the 1830s (compare no. 140).

RP
1985.48.1029 (ADB)

[1] Blanquefort, *Maisons de Plaisirs*, 42.

137

Peril passé, promesses oubliées.
c. 1825 (hand-colored)
Danger past, promises forgotten.

Series: *Les Proverbes*, pl. 51
Printer: Langlumé

The young man of this image is
graphically throwing caution to the
winds. The implication is that he, or his
companion, has been declared free of
venereal disease—so far.

Prostitution, generally legal in
Europe, did not become a medical
problem until the introduction of
syphilis in the late fifteenth century.
The sixteenth century witnessed wave
after wave of unsuccessful attempts at
repression or regulation of prostitution,
but in most European countries, gov-
ernments soon recognized the futility of
suppression and concentrated on regu-
lation. A system of registration and
medical examinations introduced in
France by Napoleon in 1802 was finally
perfected in 1822.[1] Nevertheless, until

Ehrlich discovered an effective treat-
ment much later in the century, syphilis
continued to be a scourge.

RP/BF
1985.48.1054 (ADB)

[1] George Ryley Scott, *A History of Prostitu-
tion from Antiquity to the Present Day* (Lon-
don, 1940), 91-93, 96. See also A.J.-B.
Parent-Duchatelet, *De Prostitution dans la
ville de Paris* (Paris: J.-B. Baillière, 1836).

138

Un peu d'aide fait grand bien.
c. 1825 (hand-colored)
A little help does a lot of good.

Printer: Langlumé
Distributors: Noël; Noël et Dauty

Since Pigal's oeuvre remains uncata-
logued except for Béraldi's rather
sketchy treatment, it is impossible to
know in what series this image was plate
no. 1. Inconsistency in titling was more
the rule than the exception until much
later in the lithographic industry. At a
guess, this piece may belong to the
Proverbes, with which it is consistent in
style. Its date would therefore be in the
early to mid-1820s.

Pigal's choice of action to fit his cap-
tion is characteristic of his earthy humor.
A vagabond interloper's entry is assisted
by an eager woman at the sign of the stag
whose antlers are prominently displayed.

BF
1985.48.1082 (ADB)

139

Soirée du peuple.
Party of the people.

Printer: Delaporte
Distributor: Aubert
Appeared: *La Caricature*, 4 November
1830, pl. 11

This image of the people, produced
for the very first issue of *La Caricature*,[1]
is certainly calculated to allay bourgeois
fears with regard to the mob that had
lately assisted in overthrowing a king
and a regime. Working men in their
Sunday best are politely inviting part-
ners to dance, and stepping demurely to

the sounds of a small orchestra at a
guinguette outside the city gates. In
another couple of hours, however, if
convention runs true, the scene will
look more like Traviès' *Les Joies du pau-
vre peuple* (no. 174).

Pigal's style has changed abruptly
from his vignetted and silhouetted
hand-colored figures of the 1820s to the
rich black-and-white pictorial manner
in which most of the prints for *La Cari-
cature* were done by all of the contribu-
tors—a house style. Other post-1830
works by Pigal (nos. 145, 146) are also
executed in this style, which may have
evolved for use in illustrated journals
where hand coloring was seldom
intended. In any case, it assimilates
Pigal's work to the work of other carica-
turists, notably Grandville, Raffet, and
Traviès, in a way that robs it of some of
its earlier individual character.

BF
1985.67.419 (MW)

[1] *La Caricature* included two prints per issue,
but more than two prints are indicated as
having appeared in many of the early issues.
Owing to the immediate popularity of the
paper, the first twenty-six issues were twice
republished, sometimes with different
prints than those in the original issue. See
Getty, *Grandville*, 206.

140

Academicien.
(hand-colored)
Academician.

Series: *Métiers de Paris* (The professions
of Paris)
Printer: Benard
Distributor: Aubert
Appeared: *Le Charivari*, 2 October
1833, pl. 6
1985.67.308 (MW)

141

Plagiaire.
(hand-colored)
Plagiarist.

Series: *Métiers de Paris*
Printer: Benard
Appeared: *Le Charivari*, 9 October
1833, pl. 7
1985.67.330 (MW)

142

Mathematicien.
(hand-colored)
Mathematician.

Series: *Métiers de Paris*
Printer: Benard
Distributor: Aubert
Appeared: *Le Charivari*, 23 October
1833, pl. 9
1985.48.323 (ADB)

143

Homme de confiance.
(hand-colored)
Confidence man.

Series: *Métiers de Paris*
Printer: Benard
Appeared: *Le Charivari*, 25 November
1833, pl. 11
1985.67.312 (MW)

Pigal's series *Métiers de Paris* seems to have been drawn at least in part for publication in *Le Charivari*, with which he had been associated since its start in 1832. In this series he joined the throng of artists and journalists who in their passion for classifying human types, showed themselves devotees of the theories of Lavater and Gall. The older tradition from which such series evolved usually presented market types and *cris de Paris* (Carle Vernet, nos. 189-191), but Pigal now includes an academician and a mathematician, hardly métiers, in his array of types. Before 1840 the idea of fully exploring in words the professions as well as the trades led to the production of the *physiologies*, small books on all manner of city inhabitants from low to high, and also to the nine-volume compendium *Les Français peints par eux-mêmes*, a collaboration of writers and artists, published 1840-1842.

Peculiar to Pigal is his penchant for really low, quasi-criminal types, whom he mingles with their betters. It is hard to imagine anyone else coming up with a plagiarist, and while Daumier's Robert Macaire might also be called a confidence man, Pigal's is a more furtive imposter, apparently receiving the confidences of unsuspecting people at the confessional.

La soupe avant tout.

144

Although given the standard framing and lettering of *Le Charivari*, these prints revert somewhat in style to Pigal's earlier vignetted manner, thus constituting an oddly hybrid format.

BF

144

La soupe avant tout.
(hand-colored)
Soup first.

Series: *Scènes familières* (Familiar
scenes), no. 16
Printer: Benard
Distributor: Aubert
Appeared: *Le Charivari*, 4 March 1833

This print affirms the basically happy, if not necessarily optimistic, quality of Pigal's art. He shares with Traviès his concern for the lowly, the humble, and the outcasts. Paralleling novelists Eugène Sue in France and Dickens in England, this scene of a happy family at a meager meal could almost stand in for Bob Cratchit and Tiny Tim of *A Christmas Carol*.

The print appeared in *Le Charivari*, and again presents a compromise in style (altered in this impression by heavy-handed coloring) between Pigal's

vignetted manner of the 1820s and publisher Philipon's house style of the 1830s.

BF
1985.48.1034 (ADB)

145

Vanité des vanités!!......
c. 1835
Vanity of vanities!!......

Distributor: C. Motte
Catalogued: Béraldi, 15:277
Reference: Champfleury, *Histoire*, 284

Béraldi lists this lithograph as a single sheet under *sujets divers* with the comment *Méditation au cimetière* (meditation at the cemetery). Champfleury praised it as Pigal's most serious and philosophical. He describes the poor man contemplating the bustle of Paris from the quiet peaceful heights of Père Lachaise cemetery. A sign beside the contemplator reads '*Rêveries rénouvellées des Grecs*' (renewed dreams of the Greeks). A classic (or neoclassic) bust lies at his foot.

This lithograph is one of Pigal's latest and most complex. The *vanitas* theme in European art can be traced from the Renaissance back through the Middle Ages to the ancients. Such a *memento mori* on the brevity of life is

often indicated by a skull or some other funerary accessory; here Pigal gives us the entire cemetery. "Renewed dreams of the Greeks" may have several connotations, but whether it refers to styles of art or to western culture altogether is not made clear in this print.

Like certain other images of the *chiffonnier* or the diligence coachman, this man may himself represent death contemplating Paris. Or perhaps it is a self-portrait of Pigal contemplating his own death, in a posture as precarious as the human situation. This turn to a grimmer subject matter may reflect the increasingly religious direction of his painting in the 1830s.

The style and technique of this print sets *Vanité des vanités* apart as one of Pigal's best lithographs. The attention to detail, the deep and complex recession into space, the *chiaroscuro*, and the sense of atmosphere all surpass in complexity and sophistication any of the other Pigal lithographs in this exhibition. In this regard it appears that his lithography experienced a crescendo of achievement in content and style before being eclipsed by his painting in 1838.

RP
1985.48.1083 (ADB)

Vanité des Vanités!!

145

146

L'Arracheur de dents.
Salon de 1837.
The tooth extractor.

Printer: Benard et Frey
Appeared: *L'Artiste*

This print is reproductive of a painting by Pigal exhibited at the 1837 salon—about the time he gave up lithography. Although his painting is said to have become more serious and more religious as it became more important to him, this work retains the humor that characterizes nearly all his earlier work.

In a shabby interior, the dentist extracts a tooth while a smiling woman, perhaps the victim's wife, contemplates his agony. The traditional image of the dentist is that of a charlatan who performs his services at country fairs. This dentist, presumably urban and a cut above the charlatan, is practicing in his

own quarters of dubious hygienic quality for a working-class clientele.

This print differs from Pigal's earlier lithographic work in presenting a far more complete background for the figures, resulting from the exigencies of reproducing a painting. The work and its letters are in the standard format for lithographic reproductions in the review *L'Artiste*, but the print was not located in a search through the appropriate volumes. The printer, Benard et Frey, specialized in printing tasks more artistic than journalistic.

BF
1985.48.1023 (ADB)

147

Il dolce far niente.
c. 1825 (hand-colored)
Sweet idleness.

Series: *Rome, affaires du jour* (Rome, business of the day), no. 1
Printer: Langlumé
Distributor: Gihaut

The suite of twelve prints, *Rome, affaires du jour*, caricatures Roman customs and manners in much the same way that *Moeurs parisiennes* lampoons daily affairs of the French capital. The Roman suite possesses, however, the added bite of exploiting a regional stereotype, the lazy Italian.

In this scene Pigal sets the tone for the suite, when he presents sweet idleness as the first business of the day. Not

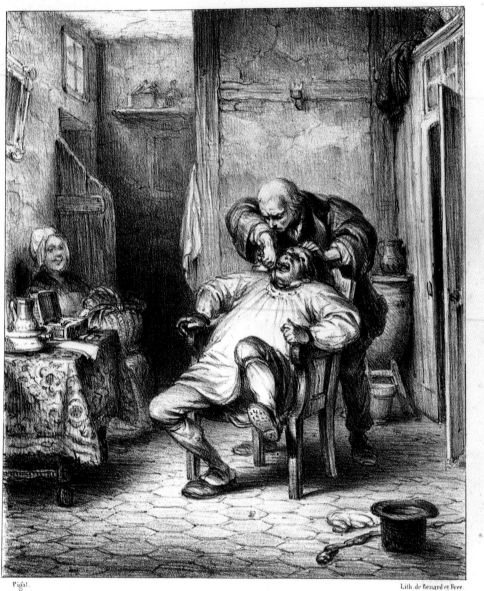

Pigal.

Lith. de Benard et Frey.

l'Arracheur de dents.

(Salon de 1839.)

146

very much is known of Pigal's life, but the landscape in this print suggests that he probably travelled to Rome in the 1820s and perhaps sketched this figure and the background from life, although surely on two separate occasions, since the figure floats before the landscape as if applied to it. If such a journey took place, as seems likely, then Pigal was following in the footsteps of all the high artists who won the *Prix de Rome*, an achievement far beyond his own aspirations. Their customary exploitation of Roman scenery and use of Italian models for serious art may well be the subject of parody in this print and others in the series.

RP/BF
1985.48.1016 (ADB)

Denis Auguste Raffet (1804-1860)

The nostalgia-laden Napoleonic imagery of Raffet inspired many of his generation. "Sublime" and "genius" are terms in which his talent and his work were described. Raffet's heroism of subject and his powerful technique approach the realms of high art. Born in 1804, he began his artistic career as a wood turner and decorator of porcelain in the studio of Cabanal. He became Charlet's apprentice in 1824. His first lithographic album, *L'Histoire de Jean-Jean* (The Story of John-John), is the saga of a young army recruit. After five years with Charlet, he left for the studio of Baron Gros, where many other lithographers also studied. The melancholic grandeur of his battle scenes betrays the influence of Gros.

Although Raffet's failure to win the *Prix de Rome* in 1830 ended his aspirations as a serious painter, the elegant tonal variations in his lithographic images suggest his abilities as a colorist. His most famous lithographic works, *La Revue nocturne* (Midnight Review) of 1836 and *Le Réveil* (Reveille) of 1846, are among the most poignant and nostalgic manifestations of the Napoleonic legend. No. 157 in the exhibition is in much the same style. An astonishingly virtuosic artist, Raffet was capable of working in a variety of styles. He was an irregular fighter in Philipon's battle against the July Monarchy; although not particularly renowned for his political caricatures, several appear in the exhibition (nos. 151-153) and his *La Barbarie et le choléra morbus entrant en Europe* (Barbary and deadly cholera entering Europe) of 1831 possesses a savagery in its political commentary akin to Goya. Raffet executed many noble and military portraits and his images of soldiers in full regalia were avidly collected. His book illustrations include Béranger's *Poems*, Thiers' *History of the Revolution*, Norvin's *The History of Napoleon*, and Bérat's *Songs*.

Raffet's trip to the Crimea in 1837 with his friend and protector Prince Demidoff resulted in the monumental *Voyage dans la Russie méridionale et la Crimée* (Voyage to southern Russia and the Crimea), an album of acutely observed ethnic types and exotic scenery. Raffet's interest in costume ranged from these ethnic types to all of the minutiae of the military uniforms of different periods in various countries. His productivity decreased significantly in the last ten years of his life, which were spent travelling with his constant noble companion, Demidoff. Raffet died in Genoa in 1860. His lifespan is roughly parallel to that of Delacroix, and within the limits of his genre, Raffet expressed the same romantic spirit.

KO/RP

148

Le fils du brave Canaris. Le Fils de l'Amiral Grec Canaris placé dans une maison d'éducation à Paris, par les soins et aux frais du Comité Philhellénique, étant en promenade, un jour de de congé avec ses camarades fit la rencontre d'un Turc; l'un d'eux le lui fit remarquer; aussitôt le jeune Canaris, enflammé d'une noble colere, à la vue d'un ennemi de sa patrie, s'élance vers le Musulman, et lui montrant le poing, l'apostrophe ainsi: Apprends que je suis le fils de Canaris.
1827
The son of the brave Canaris. The son of the Greek admiral Canaris, placed in a boarding-school in Paris, through the goodness and at the expense of the Philhellenic Committee, met a Turk while taking a walk on holiday with his friends; as soon as one of them pointed him out, the young Canaris, inflamed with noble anger at the sight of an enemy of his fatherland, rushed toward the Muslim, and shaking his fist at him, exclaimed: I want you to know that I am the son of Canaris!

Printer: Villain
Distributor: Gihaut
Catalogued: Béraldi, no. 61; Giacomelli, no. 61

The Greek war of independence from the Ottoman Empire began in 1821. In April 1822, twenty thousand people were massacred at Chios, an event immortalized in Delacroix's celebrated painting (1824, Louvre). A year later, a group of Greek sailors under the leadership of Canaris (1790-1877) fired on the Ottoman fleet, killing three thousand Turks. Canaris was proclaimed a national hero, and eventually became a member of the Greek government.[1]

French political sympathies were strongly in favor of the Greek cause; Greece was revered as the foundation of Western culture and a symbol of the civilized world. Delacroix's *Greece Expiring on the Ruins of Missolonghi* (1826, Musée des Beaux Arts, Bordeaux) is the epitome of impassioned feeling for the troubled nation. The Greek statue in the background of Raffet's lithograph, although not an exact representation of any known work, evokes in its Praxitelean grace the heritage of Greek thought and art. This print was made while Raffet was still a student of Charlet; the features of the young Canaris betray the influence of the older master, who was known for his sentimental portraits of apple-cheeked, cherubic youngsters.

KO
1985.48.1134 (ADB)

[1] Dayot, *Histoire Contemporaine*, 199.

149

Garde royale. Régiment, grenadier.
1827-28
Royal guard. Regiment, grenadier.

Series: *Costumes militaires de la Restauration, 2e. série, Garde royale* (Military costumes of the Restoration, 2nd series, Royal Guards), no. 18
Printer: Villain
Distributors: Frérot; Rittner
Catalogued: Béraldi, no. 476; Giacomelli, no. 476

Lithographic entrepreneurs catered to the market for depictions of soldiers of every degree and station. The army was considered sacred and never subject to ridicule in either words or pictures; it was more sacrosanct than the clergy, for it was viewed as the instrument of France's greatest triumphs under Napoleon.[1] In contrast to his visionary battle scenes, Raffet's soldier portraits are of an astonishing historical accuracy. Along with Charlet and Carle and Horace Vernet, he was one of the unquestioned masters of the genre.

The dashing grenadier is visually heroicized to emphasize the glamour of

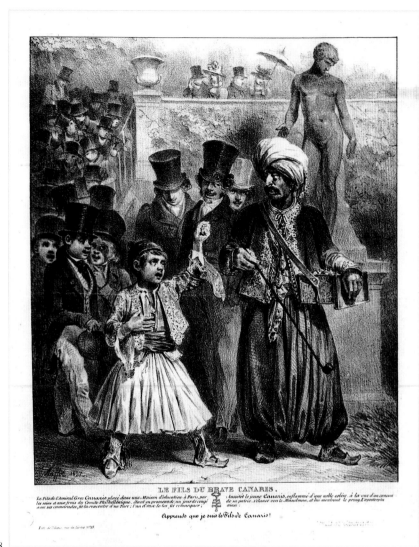

LE FILS DU BRAVE CANARIS.

Le Fils de l'Amiral Grec Canaris placé dans une Maison d'éducation à Paris, par les soins et aux frais du Comité Philhellénique, étant en promenade un jour de congé avec ses camarades, se fit à la rencontre d'un Turc : l'un d'eux lui fit remarquer ; Aussitôt le jeune Canaris, enflammé d'une noble colère à la vue d'un ennemi de sa patrie, s'élance vers le Musulman, et lui accentuant le poing, l'apostrophe ainsi :

Apprends que je suis le Fils de Canaris!

his station. The grenadiers were immediately recognizable by their monumental headgear, the *ourson*; they were also known for their trim elegance and excellent movement on the march.[2]

This series of prints was divided into two parts: the regular army and the *garde royale*. It was in the course of being published when the July Revolution began, and the editor had to hide the stones representing the costumes of the *garde royale*. Some were erased and others were somewhat modified. The original page numbers were changed, and therefore it is impossible to determine the original order of publication.[4] It would seem, however, that this particular print was issued well in advance of the July Revolution.

KO
1985.48.1126 (ADB)

1 Farwell, *FPLI* 3:16.
2 M. A. Legoyt, "Le garde national," *Les Français peints par eux-mêmes* 5:167.
3 Ibid., 167.
4 Giacomelli, 154.

150

27 Julliet 1830. La Charte, la Charte, vive la Charte! Caporal, mais montrez leu zy c'te Charte.
c. 1830
July 27, 1830. The Charter, the Charter, long live the Charter! But Corporal, show these people here the Charter.

Printer: Delpech

This unsigned print on heavy stock, by its format and letters obviously not intended for *La Caricature*, is uncatalogued by either Giacomelli or Béraldi. Its style seems consistent with other work by Raffet of the early 1830s, but no secure documentation guarantees the attribution to him.

On the first day of the Revolution of 1830, a pistol-brandishing Parisian urchin marching along to general shouts of "Vive la Charte!" taunts a panic-stricken corporal at a guard house where members of the Royal Guard seem to be timidly hiding, challenging him to produce *la Charte*. The episode is set on the Ile de la Cité, with the towers of Notre Dame beyond the marching populace. These people, urchin, workman, and top-hatted bourgeois carrying rifles, are the same cast of characters that appear in Delacroix's great painting of *Liberty Leading the People* (1830, Louvre).

Abrogation of the Charter, under which the Bourbon Restoration started out as a constitutional monarchy in 1814-15, was a basic cause of the 1830 Revolution. It became the watchword of the successful uprisings of *les trois glorieuses*, the three glorious days that saw the overthrow of Charles X and the accession of Louis-Philippe to the throne. Raffet made many prints on the events of these days.

BF
1985.48.1131 (ADB)

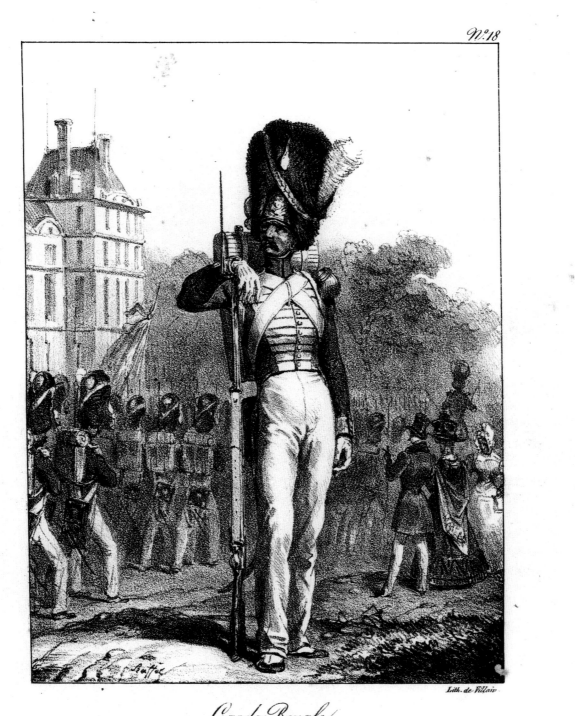

Lith. de Villain.

Garde Royale.
Régiment, Grenadier.

A Paris, chez Frérot, éditeur, rue N.re des petits champs, N.º 53 Et chez Rittner, boulevard Montmartre, N.º 12.

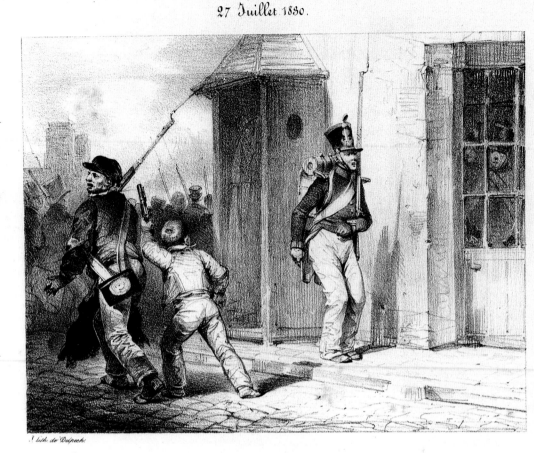

27 Juillet 1830.

lith. de Delpech.

La Charte, la Charte, | Caporal, mais montrez
vive la Charte! | leu zy donc c'te Charte.

151

Adoration des Mages.
Adoration of the Magi.

Printer: Delaporte
Distributor: Aubert
Appeared: *La Caricature*, 22 September
 1831, pl. 95
Catalogued: Béraldi, no. 137;
 Giacomelli, no. 137

As in Grandville's *La Naissance du juste milieu* (no. 94), the appearance of the new order in France after 1830 is here treated as a nativity. Raffet showed the throne of Louis-Philippe decked with decorations and scrolls and being worshipped by the bewigged old aristocracy, the peerage, and called it *Adoration of the Magi.* Louis-Philippe, the incarnation of the compromise, having been elevated to the throne by popular action, is now recognized by the peerage. The presence of the honors on the throne betrays, however, the self-interest of the peers.

The general feeling among the bourgeois electorate in 1831 was hostile toward the peerage. It was a matter of significant debate whether Louis-Philippe's throne should be the only heredity office or whether additional hereditary offices, i.e., the peerages, should be retained. Raffet's vision, the possibility that numerous peers would continue to exist and prosper around the throne, was, however, not fulfilled—two months after the lithograph was published, the elected assembly voted to abolish the hereditary peerage altogether by a vote of 386 to 40. Although Thiers, Guizot, and other influential members were against abolition, the radical Lafayette, himself a marquis, spoke in its favor.

GB
1985.67.342B (MW)

152

L'Archevêque a toujours été farceur.
The Archbishop has always been a
 practical joker.

Printer and Distributor: Aubert
Appeared: *La Caricature*, 24 February
 1831, pl. 35
Catalogued: Béraldi, no. 130;
 Giacomelli, no. 130
Reference: Farwell, *FPLI* 8, 2C2.

Since the Revolution of 1789 the clergy had been a focus of hatred as one of the two ruling classes; after Napoleon's reconciliation with the

church it was associated with the incumbent government, especially during the neo-Catholic Restoration regime. After the July Revolution, however, the new government had shown a hostile attitude towards religion. This inspired a movement led by Lamennais proclaiming church independence from the state. Conflicting tendencies within the new regime, combined with a still-restless public and the church's aggressive new stance, led to acts of popular violence directed against the clergy in February 1831. The palace of the Archbishop of Paris and other buildings were sacked; priests dared not show themselves on the streets.[1] Raffet has taken advantage of this event to impute hypocritical debauchery to the clergy. While one armed citizen kneels amongst the Archbishop's books and rosary, another triumphantly holds up a corset.

KO

1985.48.1130 (ADB)

[1] *War and Peace in an Age of Upheaval, 1793-1830*, 361-362.

153

Parade. Mrs. et Mesdames il ne faudrait pas avoir dans sa poche la bagatelle de dix-huit millions pour se priver de voir la meilleure des républiques... objet rare et curieux qui ne se trouve qu'en Amerique.

Side-show. Ladies and Gentlemen, it is not necessary to have in your pockets the trifling sum of eighteen millions to deprive yourself of seeing the best of republics...a rare and curious thing, which is only found in America.

Printer: Delaporte
Distributor: Aubert
Appeared: *La Caricature*, 13 January 1831
Catalogued: Béraldi, no. 129; Giacomelli, no. 129

The *parade*, or sideshow, was the platform pitch for the hidden attractions within the circus tent. The beat of the drum, the clashing of cymbals, and the ridiculous banter between the clowns and the carnival barker was a well-known and popular spectacle. The performances of traveling acrobats, charlatans, and *saltimbanques*—a tradition with its roots in the Middle Ages—appealed to many artists of the nineteenth and early twentieth centuries, most notably Seurat (*La Parade*, 1887, Metropolitan Museum, New York).

The sideshow motif often symbolized the government in political caricature; Daumier and Grandville frequently used its stock characters to

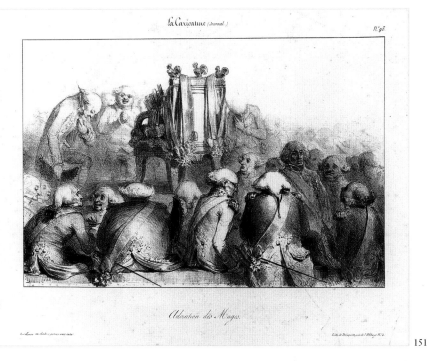

Adoration des Mages.

151

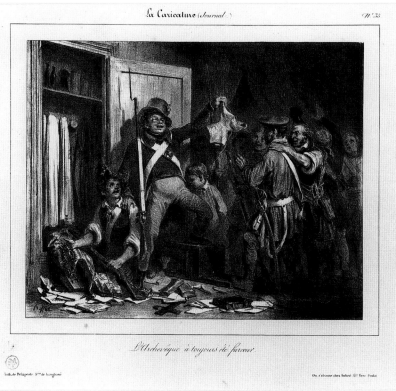

L'Archevêque a toujours été farceur.

152

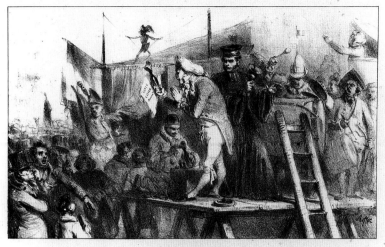

M.rs et Mesdames Il ne faudrait pas avoir dans sa poche la bagatelle de dix huit millions pour se priver de voir la meilleure des républiques ... Objet rare et curieux qui ne se trouve qu'en Amérique

153

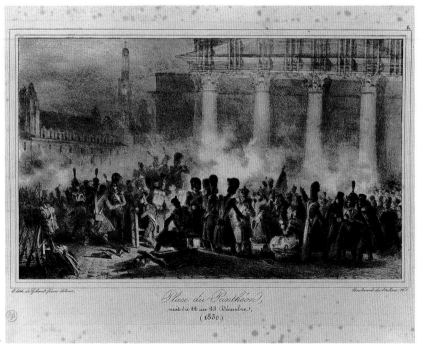

Place du Panthéon,
nuit du 22 au 23 Décembre,
(1830.)

154

mock specific members of the government. The '*18,000,000* [francs] *Liste Civile*' refers to the excessive number of sinecures given to supporters of the new regime to control their votes. Bottles with this label topped with liberty caps are being sold like snake oil. A peer and a clergyman acting as barker and noise-maker on the *saltimbanques'* platform make it clear who is 'selling' to the pop-ulace this dubious product.

KO
1985.48.1138 (ADB)

154

Place du Panthéon, nuit du 22 au 23 Décembre, (1830).
Place du Panthéon, the night of the 22nd to the 23rd of December, (1830).

Series: *Album lithographique de 1831*, pl. 1
Printer and Distributor: Gihaut
Catalogued: Béraldi, no. 339;
 Giacomelli, no. 339

After the tremendous upheaval of the July Revolution, the new regime experienced many aftershocks as it attempted to gain a firm foothold. The ministers of the deposed Charles X were tried for treason in December 1830 and received sentences of life imprisonment. The Parisian crowd, however, had been clamoring for a death sentence, and threatened violence several times during the trial. When the press announced the verdict on 22 December, the people were infuriated and the military prepared for civil war.[1]

The National Guard of Paris ordered the beating of the general call; the legions responded promptly and occupied their assigned posts in the city. They were reinforced by 2,700 National Guards from the suburbs, and the troops of the line were sent to the Chamber of Deputies, the Place Vendome, the Louvre, and the Palais-Royal.[2] The soldiers bivouacked in the Place du Panthéon where a black flag was raised, and remained after dark. Exhausted by several days of extraordinary duty and displeased by the verdict, some of the Guards are drinking, dancing, or playing music to dispel the tension. The next day the crisis had passed, and the streets were calm.

In the left background can be distinguished the tower of the church of Saint-Etienne-du-Mont; at the right, the scaffolding prepared for the sculptor David D'Angers can be seen on the facade of the Panthéon.

Raffet's silvery atmospheric effects which dramatize the sweeping power in his Napoleonic subjects, create in this contemporary military night scene a sense of volatile uneasiness.

KO
1985.48.1140 (ADB)

[1] Pinkney, *The French Revolution of 1830*, 354.
[2] Ibid.

155

Repas du peuple.
Meal of the people.

Printer: Delaporte
Distributor: Aubert
Appeared: *La Caricature*, 26 January
 1832, pl. 131
Catalogued: Beraldi, no. 140;
 Giacomelli, no. 140
Reference: Farwell, *FPLI* 8,2E5
1985.48.1142 (ADB)

156

Repas d'un réprésentant du peuple.
Meal of a representative of the people.

Printer: Delaporte
Distributor: Aubert
Appeared: *La Caricature*, 26 January
 1832, pl. 132
Catalogued: Béraldi, no. 141;
 Giacomelli, no. 141
References: Dayot, *Les Peintres
 militaires*, pl. 24-25; Farwell, *FPLI*
 8:2E6.
1985.48.1143 (ADB)

These two images were presented in the same issue of *La Caricature*. In no. 155, a worker, his bread under his arm, has just entered a greasy-spoon establishment with a plate of food, probably fried potatoes, in one hand and a pot of wine in the other. At the left, a group of workers listen to a comrade read an excerpt from the *National*, a left-wing journal. A print of Naploeon hangs on the wall. In no. 156, a deputy decorated with medals gorges himself while servants bring more plates heaped with delicacies and the smiling waiter opens another bottle of wine.

The theme of contrasts in dining was popular with many lithographers, including Daumier; Traviès presented a fascinating and keenly observed saga of diners and dining (nos. 180-183). The image of the corpulent, unattractive rich man had its origins in English caricature and was given definitive form in the French lithographs of the 1830s.[1] The particular target here is the bourgeois who, as member of the Chamber of Deputies, probably has received bribes in addition to his regular income. Election to the Chamber was open only to property owners of a certain wealth

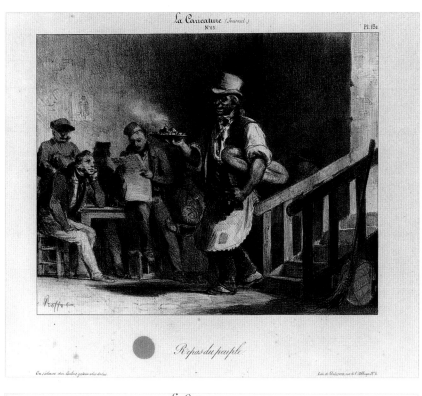

155

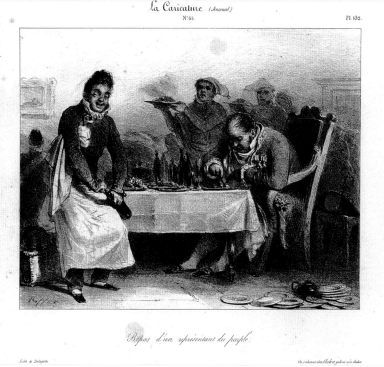

156

and status, thus the representative was bound to be resented by the poorer echelons he represented.

KO
[1] Farwell, *FPLI* 2:13.

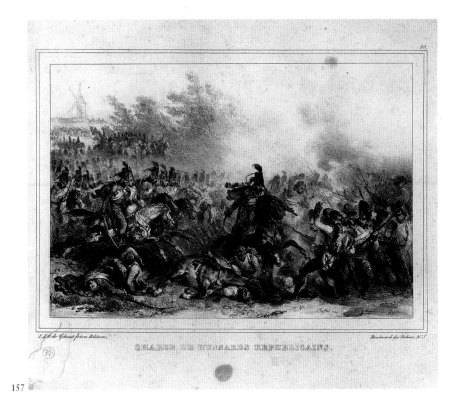

CHARGE DE HUSSARDS REPUBLICAINS.

157

rounded by the swirling masses of a ghostly army, bathed in an unearthly moonlit glow.

In typical nineteenth-century fashion, the frontispiece cleverly incorporates lettering into a picture which itself refers to the selling of images, and like most album covers, it is printed on heavier, colored stock. Conventional depictions of popular entertainments were often used on album covers with an announcement of the low-brow diversions found inside; Raffet represented the circus sideshow (no. 153) on the cover of the *Album* of 1835. Here the various posters advertise other suites by Raffet issued by his printer-publisher Gihaut *frères*.

KO
1985.48.1148 (ADB)

[1] Giacomelli, xix.

157

Charge de Hussards Républicains.
The charge of Republican Hussars.

Series: *Album lithographique de 1833,*
 pl. 10
Printer and Distributor: Gihaut
Catalogued: Béraldi, no. 374;
 Giacomelli, no. 374

In an epic image drawing on the Revolutionary wars, wave after wave of French cavalry attack the enemy in an overpowering onslaught. By the 1830s there was a huge market for images of past military glory; the glamour and panache of the cavalry particularly delighted the public. Many people were inspired by Raffet's romantic visions, including Balzac, who had at one time dreamed of creating his own *Bataille*.[1] In 1829 Raffet left Charlet's atelier to study with Gros whose brilliant battle scenes inflamed his imagination. Here Raffet seems to divest himself of the lingering traces of Charlet's influence and to assert his own individual style which is less concrete, more visionary, more romantic. Indeed the style of this print prefigures the great *Revue nocturne* (Midnight review) of 1836.

Here the dream-like aura is enhanced by the brilliant silver light for

which Raffet was famous. In his superbly arranged compositions, he knits the flock of individuals into one seamless body. It is this surging mass of soldiers, combined with his elegant precision of drawing and emotional power, that thrilled Raffet's public.

KO
1985.48.1124 (ADB)

[1] Mespoulet, *Images et romans*, 28.

158

Frontispiece

Series: *Album lithographique* (Lithographic album), 1836
Printer and Distributor: Gihaut frères
Catalogued: Beraldi, no. 403;
 Giacomelli, no. 403.

Raffet's albums, published yearly between 1830 and 1837, were eagerly awaited, despite the misgivings of his editor who attempted to get Raffet to "be more amusing."[1] They constituted the flowering of Raffet's art. This particular album contained one of the greatest masterpieces of the military genre, *La Revue nocturne*: Napoleon, mounted on a white charger, is sur-

159

1813.

Printer: Benard et Frey
Appeared: *L'Artiste,* tome XII, 20e.
 Livraison,[1] 1836; also in *Galerie Durand Ruel*
Catalogued: Beraldi, no. 149;
 Giacomelli, no. 149

The heroic figure of a pensive Napoleon silhouetted against the hazy smoke of the campfire, his coat swirling about him, is the quintessential Raffet image. The emperor stands leaning against the rail of a chair, his hands behind his back. At the right, two aides-de-camp write while an officer awaits the orders; to the left, a dream-like regiment of grenadiers marches out of the misty background.

After the disastrous retreat from Russia in November and December of 1812, a fourth coalition had been formed against Napoleon. This was not fatal, however, since Austria was still an ally of France, and in May 1813 Napoleon defeated the Russians at Lutzen in Saxony. But when Austria joined the allies in August, he faced for the first time a unified coalition of four great powers. When he withdrew across the Rhine at the close of 1813, his remaining allies abandoned him and his empire collapsed.

158

In a very similar print for his *Album* of 1836, Raffet represented Napoleon as a young general in 1797, his slim figure silhouetted against a glowing campfire as he looks into his destiny of glorious leadership. This Napoleon of 1813, in the twilight of his glory, is somewhat paunchy; his face seems shadowed with care as his world begins to dissolve around him. The two prints may well have been conceived as pendants.

The three separate segments of the composition are expertly unified by the atmospheric smoke and subtle tonal gradations. Raffet imbues the final chapters of the Napoleonic epic with the haunting splendor of a vanishing dream.

KO
1985.48.1112 (ADB)

[1] According to Giacomelli, 19e Livraison, 2me. tirage (19th installment, 2nd printing).

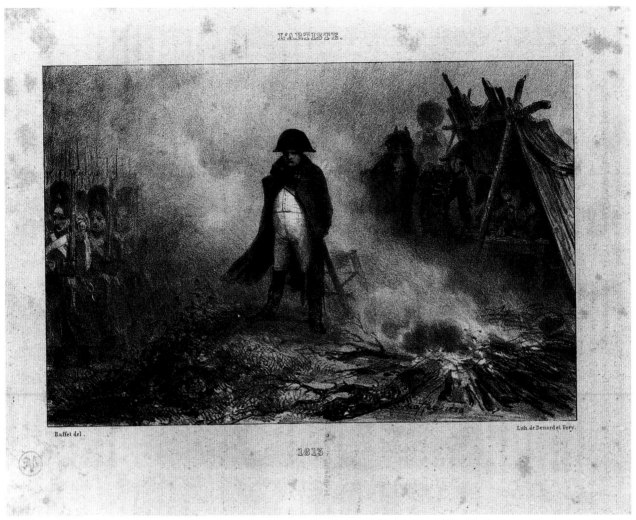

Raffet del.

Lith. de Benard et Frey.

1813

Charles-Joseph Traviès (1804-1859)

Proclaimed the "Prince of Bad Luck" by Baudelaire, Charles-Joseph Traviès de Villers has often been overlooked by critics of French caricature, yet his rough and wispy crayon, so often accused of awkwardness, lends a piquancy and pathos to the working-class heroes he represents.

Traviès was born near Winterthur, Switzerland, on 21 February 1804. His parents were of English origin, although it was long assumed they were French emigrants. Traviès' younger brother Edouard became a painter of birds and insects. Contrary to tradition, Traviès was never enrolled in the Ecole des Beaux-Arts, but probably worked in the studio of Frans J. Heim. His first prints date from 1822, and he worked fairly steadily until 1845.

Described by the novelist Champfleury as storklike and melancholic in appearance, Traviès had a penchant for drinking and for *bals publiques*, especially those of the *barrières*. Champfleury records that once Traviès, dead drunk, had himself carried to the novelist's quarters in a body wagon. In contrast to the robust dandies and *lorettes* of Gavarni, Traviès penetrates the humble sphere of the poor with touching sincerity and tenderness. His association with working-class people lent fuel to his tendency toward socialist sympathies. He joined the Saint-Simonians and even more esoteric utopian cults (see no. 176), and he became also a friend and admirer of the early feminist Flora Tristan, Gauguin's grandmother.

Traviès is credited with the invention of the irrepressible little republican hunchback Mayeux, whose antics enjoyed immense popular success not only in Traviès' oeuvre but in the work of others as well (nos. 162, 173). He was also the most important creator of images of the *chiffonnier*, the legendary Parisian ragpicker (no. 163), street philosopher of the people and symbol of the vanguard artist whose position in bourgeois society had become marginal.

Traviès' lithographs were published in Philipon's *La Cariacature* and *Le Charivari*, where he became acquainted with Charlet, Grandville, and Daumier.

He illustrated Eugène Sue's *Les Mystères de Paris* and contributed works to *Les Français peints par eux-mêmes* and other publications. Traviès' *Comme on dîne à Paris* (nos. 180-183) is a treasure of Parisian manners and morals at the public dinner table, and his *Scènes bacchiques* (no. 175) offer benignly charitable views of the sway over the lower classes held by demon alcohol. Traviès' only biographer, Claude Ferment, has indicated the importance of this caricaturist as an influence on Daumier and as a harbinger of the realist movement of the 1840s.[1]

KO/RP

[1] Ferment, "Le Caricaturiste Traviès," 67, 75.

160

Un Provincial/Un Fat.
c. 1825-28 (hand-colored; illustrated on page 35)
A provincial/A dandy.

Series: *Les Contrastes* (Contrasts), pl. 3
Printer: Imprimerie Lithographique, rue du Bouloi, no. 19

A provincial, fresh from the country in his ill-fitting clothes, stands flat-footed and grins stupidly in contrast to the posturing Parisian dandy in the latest fashions. Most of the contrasts in this series are self-explanatory, and are typically treated in pendant form like this example.

GB
1986.71.97 (SK)

161

Corruption/Innocence.
c. 1825-28
Corruption/Innocence.

Series: *Les Contrastes*, pl.13
Printer: Imprimerie Lithographique, rue du Bouloi, no. 19

Corruption takes the form of a girl with an elaborate hairstyle and off-the-shoulder dress in the latest fashion. The scene is at night in a Parisian street with another similar girl in the background and a man who is urinating against the wall. Innocence is dressed modestly and stands alone in the country, in a

Rousseauian reference to the corrupting influences of modern civilization. A majority of the *contrastes* deal with themes of virtue and vice.

GB
1986.71.104 (SK)

162

Facèties de M. Mayeux. Avec un garde du corps! vengeance bon dieu! Femme sensible entends tu le ramage? Oh! la belle enfant je veux lui apprendre un petit jeu. Assez! assez! bon dieu!... assez! On nous dessine d'après la bosse. Enfonçons le passage véro dodat. A-t-on jamais fichu un canon si haut que ça! On tire à hauteur de ceinture d'homme, ça ne me regarde pas! Appelez votre bête ou je l'étoufe.

Facetious sayings of Mr. Mayeux. With an honor guard! vengeance, good god! Sensitive woman, do you hear the birds singing? Oh! the pretty child. I want to teach her a little game. Enough! enough! good god!... enough! We've been drawn "in the round." Let's put down the Passage Véro-Dodat. Has anyone ever loaded a cannon this high! They're shooting at the height of a man's waist, that doesn't concern me! Call off your beast or I'll strangle it.

Printer: Delaporte
Distributor: Aubert
Appeared: *La Caricature*, 19 May 1831, pl. 57

Mayeux, the boorish hunchback, a character created by Traviès, is similar as a type to Daumier's Robert Macaire and Monnier's Joseph Prudhomme; all evolved from characters presented in theatrical farces. He is most often depicted pursuing erotic escapades and in mock-heroic military scenes, as he was a member of the National Guard, which gave him license to exercise petty tyranny over all. Baudelaire claims that Philipon drew the female figures in Traviès' Mayeux caricatures; the *lorette* in the second scene is certainly Philipon's, but the others are not far from Traviès' own depictions of women such as those in no. 161, an earlier work.

The left-most scene in the lower register includes a picture of the third scene

Les Contrastes.

Corruption.
N°. 3.

Imp. Lith. rue du berites, N° 69

Innocence.
N°. 13.

161

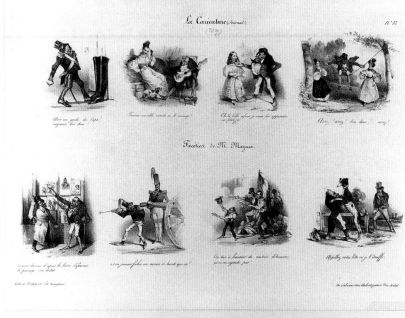

La Caricature (Journal)
(7 e an)

N° 57.

Facéties de M. Mayeux.

162

in this same row, with Mayeux pointing to it. He is here conversing with another hunchback, and the caption contains a pun on the word *bosse*, the hunchback's hump. In art school to draw *d'après la bosse* was to draw from casts of statuary in three dimensions as opposed to drawing from flat engravings. The two dwarfs are standing before the windows of Aubert et Cie., Philipon's publisher, which was located in the Passage Véro-Dodat. Such

self-referential humor is frequent in Traviès' work.

BP/BF
1986.71.8 (SK)

163

Voulez-vous me permettre d'allumer mon brule-gueule?
1832
Would you permit me to light my pipe?

Series: *Scènes de moeurs* (Scenes of manners)
Printer: Aubert
Distributor: Bauger
Catalogued: Ferment, no. 546
Reference: Farwell, *FPLI 2*, 6A12

During the July Monarchy, many caricatures dealt with small-scale confrontations between the bourgeoisie and the poor. Here, the ragpicker-philosopher, his *hotte* on his back, accosts a dandy on the street for a light. The frequency with which this motif appears in lithographs of the time suggests its significance as myth. The ragpicker is somehow elevated to a status the equal of the dandy, at least for the moment, and his undeferential approach bespeaks his proverbial freedom and independence.
BP
1986.71.196 (SK)

164

L'Ordre le plus parfait règne aussi dans Lyon.
The most perfect order also reigns in Lyon.

Printer/Distributor: Aubert
Appeared: *La Caricature* 5 July 1832, pl. 126
Catalogued: Béraldi, p. 149, no. 2
Reference: Farwell *FPLI* 8,2F8

In a country where population increased faster than production, growing tensions between the bourgeoisie and the working classes were aggravated by economic difficulties early in the July Monarchy.[1] This social malaise erupted into violence in Lyons in November 1831. The government forbade workers to unite in defense of their interests, but the workers had managed to secure a ruling from the prefect prescribing a minimum wage. The factory owners, however, refused to apply it. The workers then rioted and occupied public buildings; the government dismissed the prefect and sent National Guard troops

SCÈNES DE MŒURS.

Voulez-vous me permettre d'allumer mon brule-gueule?

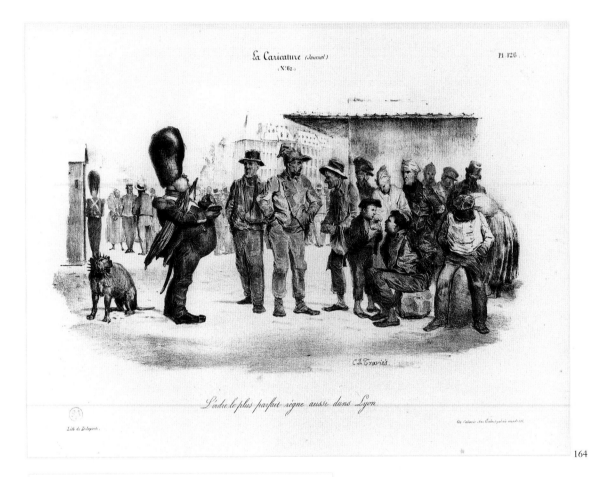

C. J. Travies

L'ordre le plus parfait règne aussi dans Lyon

Lith. de Delaporte.

164

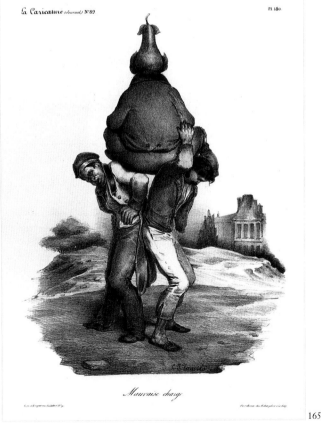

C. J. Travies

Mauvaise charge

165

to Lyons to subdue the uprising. Lyons was frequently the scene of working-class unrest (see Daumier, no. 29).

The caption is derived from an earlier lithograph of Traviès, *L'Ordre le plus parfait règne dans Varsovie!!!!*, which depicts a heap of bloody corpses. The unfortunate words were originally pronounced by General Sebastiani while addressing the Chamber of Deputies on the misfortunes of Poland in 1831. It is therefore an uneasy peace indeed which reigns in both images. The message here is clear: working-class poverty must not disturb bourgeois order.[2]

The realistic treatment of the grim and frustrated workmen with their coarse features, rumpled clothes, and slumping postures, is seen in contrast to the officer of the National Guard, who is portrayed as a caricature; he is the archetype of the bourgeois official (everyone above a certain tax bracket was required to serve in the Guard if called). His enormous *shako* subtly suggests the famous pear, symbol of Louis-Philippe whose regime is served by the Guard.

KO
1985.48.1205 (ADB)

[1] *War and Peace in an Age of Upheaval*, 357-8.
[2] Ibid., 358.

165

Mauvaise charge.
Wretched burden.

Printer: Becquet
Distributor: Aubert
Appeared: *La Caricature*, 19 July 1832, pl. 180

Traviès shows two honest worker types supporting a fat pear-shaped figure with a pear-shaped head topped by a stem. The *poire*, meaning both "pear" and "idiot," was a way of caricaturing King Louis-Philippe, based on an exaggeration of the shape of his head and sidewhiskers, invented by Philipon, the editor of *La Caricature*, and used also by Daumier and others. The title, also a pun, refers to the image's caricature as well as to the load carried. *Charge* means the same in French as *carica* in Italian.

GB/BF
1986.71.22 (SK)

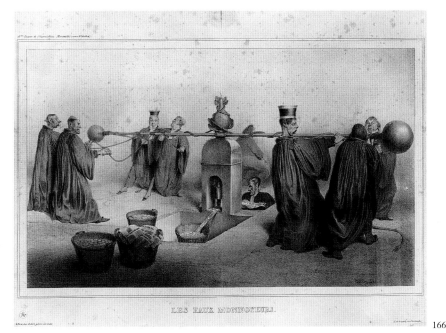

LES FAUX MONNOYEURS.

166

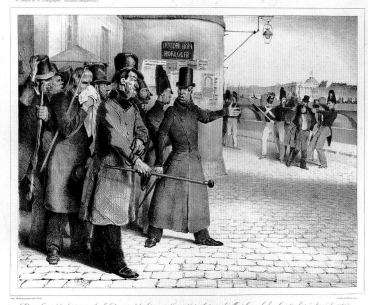

167

166

Les Faux monnoyeurs.
1833
The counterfeiters.

Series: *L'Association mensuelle*, 1833-34, no. 15
Printer: Becquet
Distributor: Aubert
Reference: Bechtel, *Freedom of the Press*, xv.

Though an attempt by Charles X to suspend the liberty of the press was instrumental in bringing about the July Revolution and his downfall, government harassment of the press began again within a few months of Louis-Philippe's accession to the throne. On 28 July 1832 Philipon announced the formation of an association to be composed of friends of his publications, which would help provide a reserve fund, or war-chest, to offset the costs of the fines and prison sentences levied by the courts against his newspapers and himself. *L'Association mensuelle lithographique* issued twenty-four

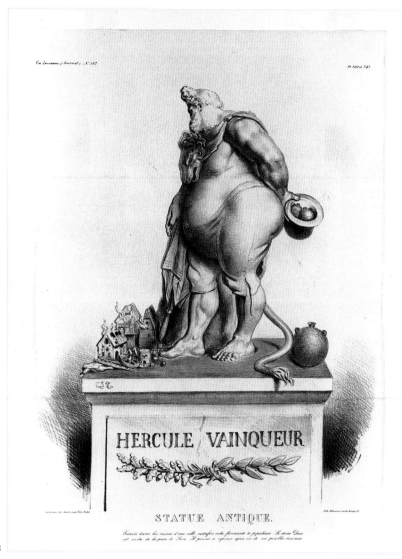

pear-shaped finial, entwined with ropes that lead like tentacles into the hands of each magistrate.

RP/BP
1985.48.1275 (ADB)

167

Le Docteur Gervais prétendait avoir vu cela, les prisonniers prétendaient avoir été assassinés par les Sergens de ville et les mouchards—la justice leur a prouvé le contraire.

Doctor Gervais claimed he had seen this, the prisoners claimed they had been assassinated by the police and the informers—justice has proved the contrary.

Series: *L'Association mensuelle*, 1834, no. 23
Printer: Delaunois
Distributor: Aubert
Reference: Bechtel, *Freedom of the Press*, xxiii.

This print, the twenty-third issue of *L'Association mensuelle* for June-July 1834, is the second of two drawn by Traviès. Its almost reportorial imagery and caption are described by Philipon in an accompanying explanation as "une scène fantastique" (a fantastic scene), not intended to support the allegations of the witnesses to the incident being depicted (for fear of further fines or lawsuits). The incident itself is seen at the right, on the quay opposite the Louvre in front of the shop of the clockmaker Houdrichon, where members of the municipal guard are taking several enemies of the monarchy into custody. Dr. Gervais, an eminent physician, in testimony corroborated by two other witnesses, called the police "assassins" for clubbing and stabbing the prisoners. On the left we see the detectives of the *Brigade de Sûreté*, called *mouchards* (spies, informants) by the republicans, with their trenchcoats, top hats, and truncheons, led by the chief of the *Sûreté* himself, who appears to be rolling up his sleeves to join the beating. The face of the figure holding a handkerchief to his nose shows a vast forehead, resembling that of the minister Soult, suggesting the complicity of the government in the brutal attack. Gervais was

168

monthly caricatures, beginning in August 1832 and ending with Daumier's *Rue Transnonain* in August 1834, sold on a subscription basis for twelve francs a year. These lithographs, twice the size of those published in *La Caricature* or *Le Charivari*, were far more threatening to the monarchy than any written diatribe, as they were so readily comprehensible to the average Parisian, even the illiterate.

Traviès drew the fifteenth and twenty-third of these images, both of which are found in this exhibition. In the first of these, for October-November 1833, he represents the seizure of copies of republican journals (*La Tribune*, *Le National*, *La Caricature*, *Le Charivari*, and *Le Corsaire* are depicted) and the imposition of con-

stricting fines as an immense counterfeiting machine being operated by Louis-Philippe's magistrates. Most of those pictured are identifiable: beginning at the left we see Fulchiron (?), Gaudry, Le Comte, Jollivet (?), Louis-Philippe (in the background hauling off a bushel of money), Persil (in pit), Plougoulm, an unidentifiable figure with his back to us, and Dubois. (The identifications of Fulchiron and Jollivet are probable but not certain.) A majority of these caricatures are derived from earlier versions drawn by Daumier, those of Plougoulm and Dubois being nearly exact copies. The counterfeiting press, which churns out the ill-gotten gains from confiscated issues of the papers being fed into it by Persil, the *Procureur-général*, is surmounted by a

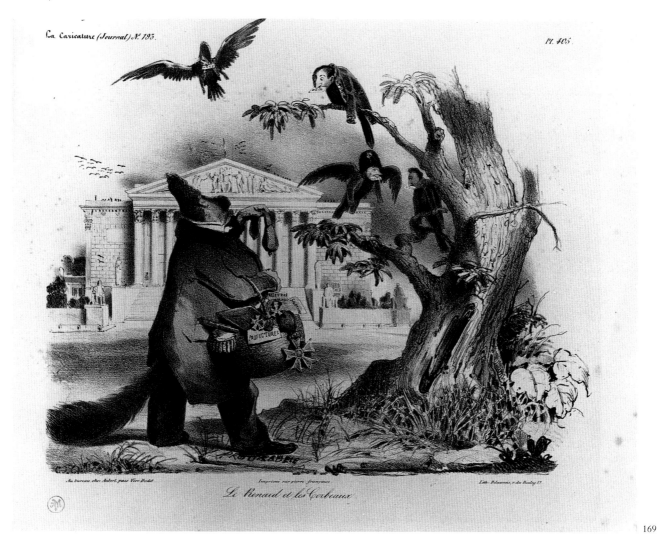

La Caricature (Journal) N.º 193. *Pl. 405.*

Au bureau chez Aubert, pass Véro-Dodat. *Imprimé sur pierre française.* *Lith: Delaunois, r. du Bouloy 13.*

Le Renard et les Corbeaux.

169

later arrested, tried, and convicted of defamation, his testimony having been "proved otherwise" by "justice."

BP
1985.48.1214 (ADB)

168

Hercule vainqueur. Statue Antique. Trouvée dans les ruines d'une ville autrefois riche, florissante et populeuse. Le demi-Dieu est revetu de la peau d'un lion. Il paraît se reposer apres un de ses pénibles travaux.

Hercules the conqueror. Antique statue. Found in the ruins of a city once rich, flourishing and populous. The demi-god is dressed in a lion skin. He seems to be resting after one of his difficult labors.

Printer: Delaunois

Distributor: Aubert
Appeared: *La Caricature*, 1 May 1834, pl. 382-383

 In this, one of Traviès' masterpieces, Louis-Philippe is presented as the classical demi-god, Hercules, or at least an ancient statue of Hercules. In his *culotte* the corpulent king, with his pear-shaped and anything but god-like body, has his ever-present umbrella and top hat. He stands in the pose of the Farnese Hercules in Naples (Archaeological Museum), holding bombs in his hat. A large bomb rests on the pedestal behind him and a smoldering ruined city lies before him, perhaps representing Lyons (Daumier, no. 29).

RP
1986.71.41 (SK)

169

Le Renard et les corbeaux.
The fox and the crows.

Printer and Distributor: Aubert
Appeared: *La Caricature*, 17 July 1834, pl. 405

 Traviès' satire is here based on La Fontaine's fable of the fox and the crows. Louis-Philippe as fox offers patronage in the form of money and offices (*préfectures*) to the deputy-crows of the Chamber in the hope they will drop their votes for him to devour. The shape of the king's head not only suggests the ears of a fox, but also the ubiquitous pear, like his money bags.

 The Chamber of Deputies, formerly the Palais-Bourbon, serves as a background for the farce, which plays on the corruption of the July Monarchy. The

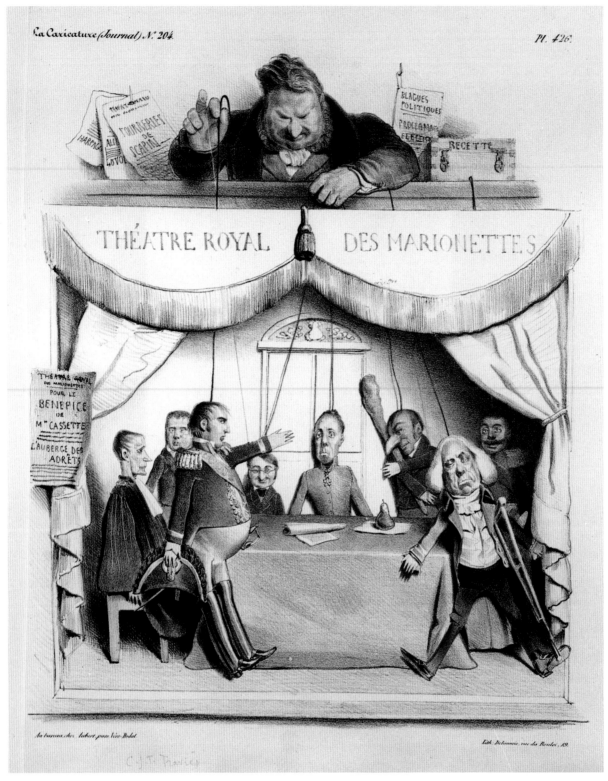

Pl. 426.

170

votes of the deputies were easily swayed by bribes or other means, and the government therefore had easy control of the elected representative body. More crows, smelling a hand-out, hover over the Chamber building.

KO
1985.48.1223 (ADB)

171

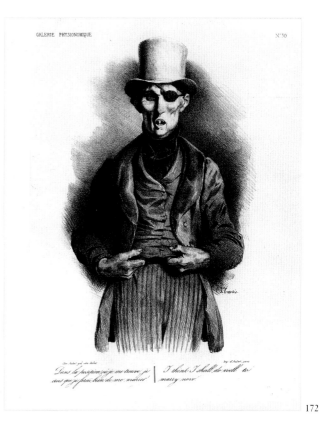

172

170

Théâtre royal des marionettes.
Royal puppet theatre.

Printer: Delaunois
Distributor: Aubert
Appeared: *La Caricature*, 2 October
 1834, pl. 426

Traviès shows Louis-Philippe as a
puppeteer controlling his ministers by
pulling their strings. The minister-pup-
pets are gathered around a table on
which stands a pear, the satirical symbol
of Louis-Philippe. A poster on the
proscenium advertises *L'Auberge des
Adrêts*, the play by Benjamin Antier,
Saint-Armand and Paulyanthe, first
produced in 1823, that introduced
Robert Macaire (no. 32). Besides the
figure of Napoleon in the foreground,
with whose memory the king is evi-
dently attempting to influence his min-
isters, others can be identified: most
notably Persil at the extreme left,
Thiers in spectacles next to Guizot in
the center, d'Argout the censor with
nose and club, and possibly Odier in the
right foreground.

GB/BF
1986.71.50 (SK)

171

Ah! Eh! titi, la Galette...
Oh boy! the tough guy of La Galette...

Series: *Galerie physionomique*, no. 25
Printers: Aubert; Junca
Distributor: Aubert
Appeared: *Le Charivari*, 9 September
 1837, pl. 25
Catalogued: Béraldi, p. 152, no. 7;
 Ferment, no. 444
References: Champfleury, *Histoire*,
 215; Farwell, *FPLI* 2, 6A3

Although the *physiologies*, the depic-
tion of physical types, can be traced to
the seventeenth- and eighteenth-cen-
tury works respectively of LeBrun and
Lavater, Traviès transcends the scope of
their techniques and approaches real-
ism. His piercing insight and social con-
science foreshadow the novels of Zola,[1]
and his raillery at human foibles is
related to Balzac.[2] In this series, which
he shared with Daumier, Traviès pre-
sents a host of Parisian working-class
types who retain a certain toughness
and resiliency despite their poverty-
racked existences. Traviès' slightly acidic
touch, described by Champfleury as an

"expressive rancor,"[3] delineates the
gamin de Paris with pungent clarity.

The *gamin* as a type was a cult fig-
ure, the Huckleberry Finn of France.[4]
He is usually depicted as about age
twelve. Streetwise, roguish, imperti-
nent, he nevertheless represents *l'esprit
français*; it was he who sat on the throne
in the Tuileries in July 1830, and it is he
who charges into the fray in Delacroix's
Liberty Leading the People.

Another print on the same subject
by Traviès bears the title "*Titi, le
talocheur, employé aux trognons de pomme
du théâtre des funambules*" (Titi, the plas-
terer's mate, employed for the apple
cores at the Funambules Theatre).[5]
The Funambules, located on the
Boulevard du Temple, was close to the
working-class districts of St. Antoine
and St. Denis. From its opening in
1816, the theatre had presented perfor-
mances of traveling troupes, especially
acrobats and tightrope dancers (hence
the name *Funambules*)[6]. *Commedia
dell'Arte*-type plots, featuring
Harlequin, Columbine, and Pantalon,
were also shown. The small, squalid
theatre only seated five hundred, and
had its own regular audience composed
of street urchins, apprentices, and work-

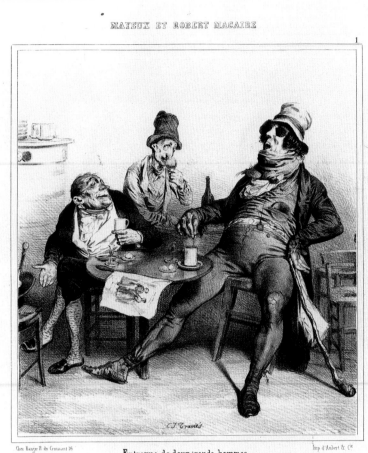

MAYEUX ET ROBERT MACAIRE

Chez Bauger B du Croissant 16 Entrevue de deux grands hommes. Imp. d'Aubert & Cⁱᵉ

C'est vrai, mon vieux, je vous ai dégommé: pourtant il y avait du bon dans votre système; vous vous adressiez au beau sexe ... polisson! moi je me suis voué à l'industrie, mais la société n'est pas raisonnable! croiriez vous qu'on me fait des difficultés? devenez mon auxiliaire. Le nigaud de Bertrand vous servira depage. Parcourez les boudoirs; emparez vous des femmes !.... j'ai mon plan?

173

Robert Macaire (no. 173) in his seedy costume and sinister eye patch.

BP
1986.71.154 (SK)

173

Entrevue de deux grands hommes, 1839
C'est vrai, mon vieux, je vous ai dégommé: pourtant il y avait du bon dans votre système; vous vous adressiez au beau sexe...polisson! moi je me suis voué à l'industrie; mais la société n'est pas raisonnable! croiriez-vous qu'on me fait des difficultés? devenez mon auxiliaire. Le nigaud de Bertrand vous servira de page. Parcourez les boudoirs; emparez vous des femmes!... j'ai mon plan?

Interview of two great men. It's true, old man, I have ousted you; however, there was some good in your system; you addressed yourself to the fair sex...Rascal! I was devoted to business; but society is not reasonable! Can you believe they give me difficulties? Become my aide. The simpleton Bertrand will serve as a page. Run through the boudoirs; get yourself some women. Do I have a plan?

Series: *Mayeux et Robert Macaire*
 (Mayeux and Robert Macaire), no. 1
Printer: Aubert
Distributor: Bauger
Catalogued: Béraldi, p. 148, no. 2;
 Ferment, no. 505
References: Farwell, *FPLI* 2:12, 3G8
 Mespoulet, *Images et romans*, 60

The little hunch-backed figure of Mayeux was immensely popular. At the height of patriotic fervor in 1830, the French public recognized him as a true picture of their baser selves—a French Mr. Hyde lurking behind the Dr. Jekyll of smug bourgeois respectability.[1] He was a small self-seeker who had chosen the revolutionary side, and as a member of the National Guard was in a position to exercise petty tyranny and exploitation, not least over women,[2] and he had naive ambitions to positions of influence under the new regime. Traviès drew Mayeux in a variety of situations over a period of about twenty years: he was a schoolmaster, wine merchant, dancing master, and most of all an insatiable womanizer.[3] Not only was the

ers. Urchins in the top balcony (*paradis*) gave rise to the title of the well-known French film *Les Enfants du paradis*, which is about this theatre. *Titi* was (and still is) a familiar generic nickname for an insolent Parisian working-class youth, appearing sometimes in feminine form as *Titine* (Gavarni, no. 75).

La Galette merely identifies him with some Parisian neighborhood or other feature of the city.

KO
1986.71.1268 (SK)

1 Wechsler, *A Human Comedy*, 91.
2 Farwell, *FPLI* 1:5.
3 Champfleury, *Histoire*, 225
4 Farwell, *FPLI* 2:23.
5 Ibid., 6A5
6 Wechsler, *A Human Comedy*, 42.

172

*Dans la position où je me trouve, je
 crois que je ferai bien de me marier.*
1836-37
In the position I find myself in, I believe
 I would do well to marry.

Series: *Galerie physionomique*
 (Physiognomical gallery), no. 30
Printer and Distributor: Aubert

This series, published in *Le Charivari* in 1836-37, was shared between Traviès and Daumier (nos. 20, 31), though Traviès' contributions were far more biting and cynical than Daumier's. In this portrait, a shabby ruffian with a virtual death's-head of a face contemplates marriage, probably to recoup the shaky financial position to which the caption refers. His image is related to that of

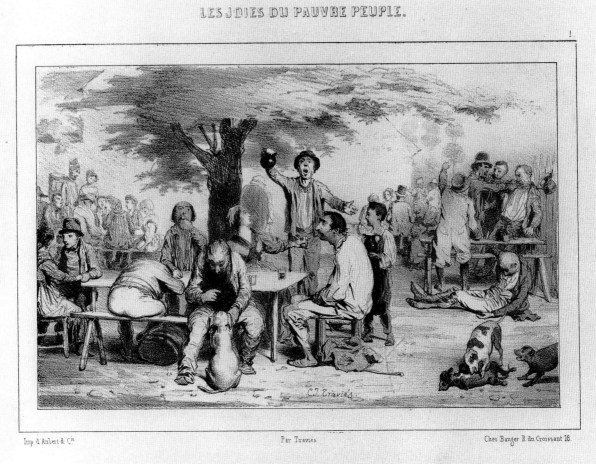

LES JOIES DU PAUVRE PEUPLE.

Imp. d'Aubert & Cⁱᵉ. Par Traviès Chez Bauger R. du Croissant 16.

Quand il n'y en a plus, il y en a encore!.... après nous le déluge..... et en avant le vin a 6 sous.

174

feisty little creature copied by other artists, but he gave his name to a host of objects, including clothes, handkerchiefs, hats, and statuettes.[4] However, his fame was usurped in 1839 by Robert Macaire, Daumier's shameless racketeer (no. 32), a character who originated in the theatre in a role created by a popular actor, Fréderic Lemaître, as a vehicle for political burlesque.[5]

Traviès depicts Mayeux and his own version of Macaire plotting to join the business swindles of one with the erotic escapades of the other. Traviès' Macaire, with his outmoded neckwear and eyepatch, seems closer than Daumier's version to the seedy character played by Lemaître.

KO
1986.71.228 (SK)

[1] Maurice and Cooper, *Nineteenth Century in Caricature*, 91.
[2] Wechsler, *A Human Comedy*, 84.
[3] Farwell, *FPLI* 2:12.
[4] Wechsler, *A Human Comedy*, 84.
[5] Maurice and Cooper, *Nineteenth Century in Caricature*, 94.

174

Quand il n'y en a plus, il y en a encore!... après nous le deluge... et en avant le vin a 6 sous.

1839

When there's nothing left, there's still some more!... after us the deluge... and bring on the ten-cent wine.

Series: *Les Joies du pauvre peuple* (The joys of the poor), pl. 1
Printer: Aubert
Distributor: Bauger

Catalogued: Béraldi, p. 152, no. 7; Ferment, no. 503
Reference: Farwell, *FPLI* 4:14, 4D11

At the *barrières* on the outskirts of Paris, the poor gathered to eat, quarrel, commiserate, dance, and drink cheap wine at a few sous a litre. The portals at the borders of the city, where customs barriers taxed and regulated goods, were the scene of many cheap outdoor restaurants and drinking establishments. Eventually many of the poverty-stricken came to live there as well, because of rising rents in the city proper.

The *barrière* was like a working-class carnival: stray dogs and ragpickers mingled among cocoa-sellers and vegetable and gingerbread merchants. Frenchmen of all regional backgrounds could forget their miseries in drink.

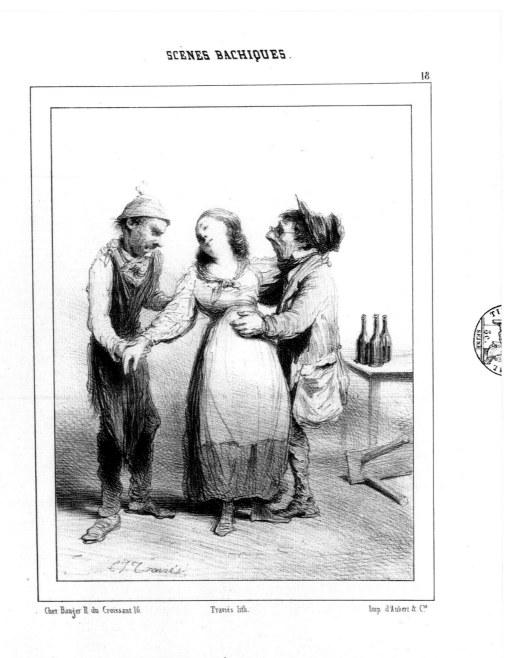

Chez Bauger R. du Croissant 16. Traviès lith. Imp d'Aubert & Cⁱᵉ

AHÉ ! JE SUIS CASQUETTE, MES PETITS CHÉRUBINS. MES P'TITS AMOURS. VOUS FAITES MON BONHEUR !

175

Here the worker was a free man. One could sit at a long table and eat roast veal and salad, and perhaps absorb the wisdom of the slum-philosopher, here depicted facing the spectator and holding a pot of the infamous watered-down wine. The slum-philosopher of the *barrière* was said to combine the genius of Diogenes with the spirit of a *gamin de Paris*, and his sense of humor was sharper than that of Rabelais or Swift. He "knew all the tricks" and "spoke all the languages."[1] "Après nous le deluge" is the familiar quotation of Louis XV.

Scenes of drinking and camaraderie at the *barrières* were also portrayed by Pigal (no. 155), Boilly, and Daumier.

Traviès' lithograph, however, in its panoramic view of dishevelled and besotted humanity, is more akin to the ebullience of Bruegel or Brouwer.

KO
1986.71.108 (SK)

[1] M. L. Roux, "La Barrière de la Villette," *Les Français peints par eux-mêmes* 9:212.

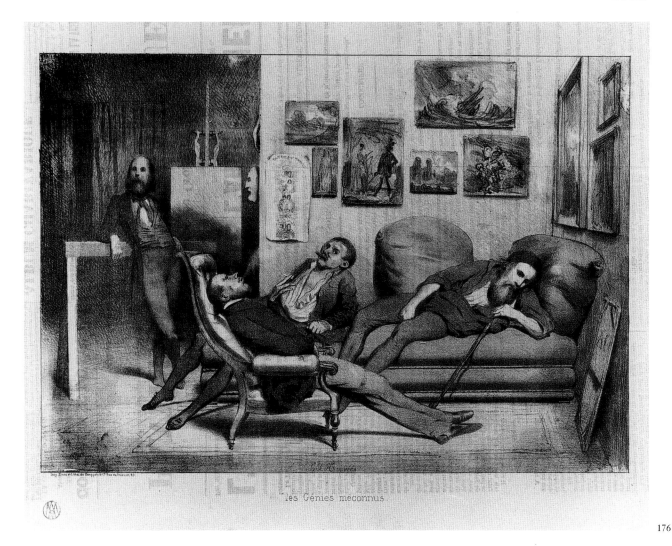

les Génies méconnus

175

Ahé! Je suis casquette, mes petits cherubins, mes p'tits amours. Vous faites mon bonheur!

Ah! I'm drunk, my little cherubs, my little loves. You don't know how happy you make me!

Series: *Scènes bachiques* (Bacchic scenes), no. 18
Printer: Aubert
Distributor: Bauger
Appeared: *Le Charivari*, 7 July 1839, pl. 18
Catalogued: Béraldi, p. 152, no. 7
References: Baudelaire, *The Mirror of Art*, 176; Ferment, "Le Caricaturiste Traviès," 72.

Two scraggly characters, probably at one of the *barrières*, accompany an intoxicated young woman and are per-

haps preparing to take advantage of her vulnerable state. Traviès' thin, dry outlines admired by Champfleury[1] express perfectly the characters' lower-class station; the agitated strokes in the girl's sleeves, the scratching in her hair, and the wispy cross-hatching around the figures also create a sense of pathos. The *Scènes bachiques*, a series which presents a gallery of the besotted in various situations, was praised highly by Baudelaire. This print is unusual in presenting a drunken young woman. Most of Traviès' drunks are old, shabby men.

KO
1985.48.1165 (ADB)

[1] Champfleury, *Histoire*, 224.

176

Les Génies méconnus.
c. 1840
Unsung geniuses.

Printer: Kaeppelin & Cie.
Catalogued: Béraldi, no. 7

Traviès' frequent visits to the *barrières* of Paris and his associations with simple working people aroused in him a tendency towards socialism.[1] He became a Saint-Simonist and was converted around 1840 to a cult formed by a curious figure known as *Le Mapah*,[2] who is shown here lying on a divan surrounded by his devotees. Characterized by Champfleury as "un apotre romantique," *Le Mapah* was a sculptor named Ganneau or Ganeau (1805-1850) who was ruined by gambling. His title is derived from the Latin *mater* and *pater*, symbolizing a major tenet of his sect,

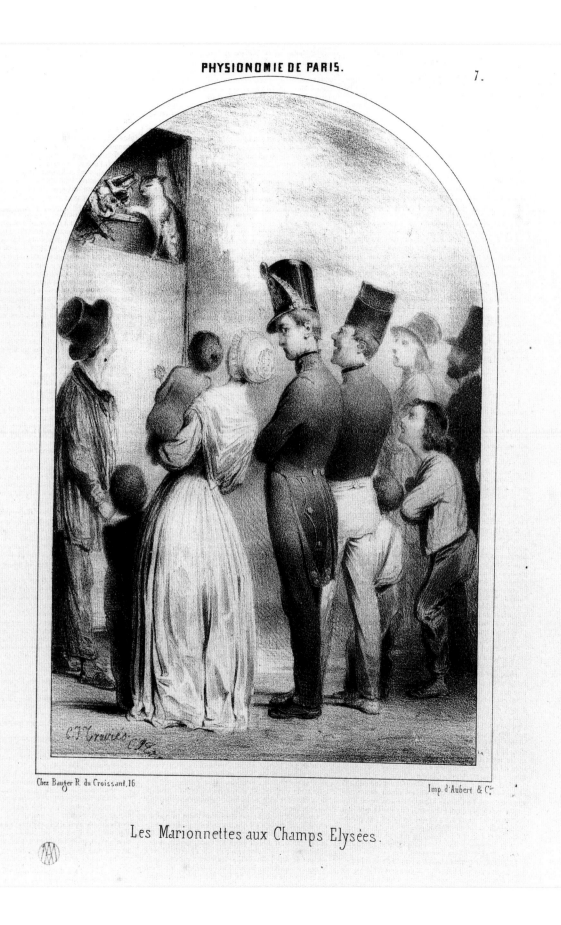

Chez Bauger R. du Croissant, 16.

Imp. d'Aubert & C.ie

Les Marionnettes aux Champs Elysées.

known as *Evadisme* (combining Adam and Eve). The cult promoted the equality of the sexes and deplored injustice to women, including the sacrifice of their names at marriage.[3] Traviès also drew a separate portrait of *Le Mapah* in which the same illustration appears as that seen on the wall at left in this print. It may represent the Indian *lingam* on which the sect was based.

The bohemian lifestyle of the artist represented an individualistic and rebellious strain of romanticism, a "cult of multiple sensation."[4] Props such as the hashish pipe held by *Le Mapah* further reinforce the romantic identity; Baudelaire regarded wine and hashish as a "means of multiplying individuality." [5]

The theme of the brooding artist alienated from his public can also be found in works of high art such as Delacroix's *Michelangelo* (Montpellier, Musée Fabre, 1851). The dusky, smoke-laden atmosphere of Traviès' world, however, suggests a certain self-mockery, and despite the comic intention, Champfleury notes that Traviès' oeuvre, along with that of Grandville, was laced with bitterness.[6]

The satire is a forerunner of later outright spoofs on the theme, such as Doré's *Trois artistes incompris et mécontens* (Three misunderstood and discontented artists), of 1850, or Daumier's *Coin des poètes ravagés* (Corner of ravaged poets) of 1863 (D. 3258-2).

KO
1985.48.1226 (ADB)

[1] Ferment, "Le Caricaturiste Traviès," 64.
[2] Ibid., 72. (Hence the tentative dating of this plate c. 1840.)
[3] Farwell, *FPLI* 2:8.
[4] Baudelaire as quoted in Timothy J. Clark, *Image of the People*, (Princeton: Princeton University Press, 1973), 34.
[5] Ibid.
[6] Champfleury, *Histoire*, 225.

177

Les marionnettes aux Champs Elysées.
1841
The puppets on the Champs Elysées.

Series: *Physiognomie de Paris* (Physiognomy of Paris), pl. 7
Printer: Aubert
Distributor: Bauger

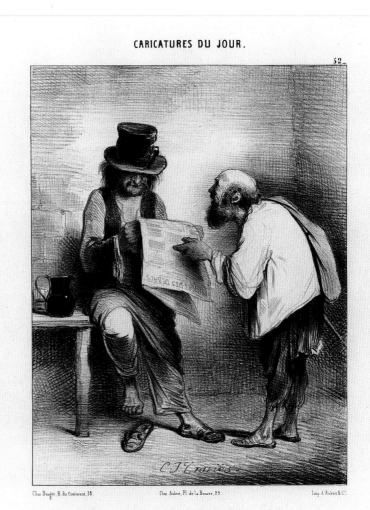

LA LECTURE DES MYSTÈRES DE PARIS.
Après vous, monsieur, s'il vous plaît!

178

Catalogued: Ferment, no. 534
Reference: Farwell, *FPLI* 4, 2F1

Soldiers, children, their parents, and other adults gather to watch the marionettes on the Champs Elysées, a public entertainment that formed an important aspect of nineteenth-century Parisian social life. While Punch and a cat have it out in the puppet booth, a soldier keeps a depraved (or wary) eye on a young mother and her child next to him. Punch and Judy shows, a long Parisian tradition originating in the eighteenth century, continue to this day, often presenting somewhat risqué topics aimed at adults rather than children. The cat was a regular part of the show and is almost always in evidence in representations of puppet theatre performances.

BP
1985.67.403 (MW)

178

La Lecture des Mystères de Paris. *Après vous monsieur, s'il vous plaît!*
1842
Reading *The Mysteries of Paris*. After you sir, please!

Series: *Caricatures du jour* (Today's caricatures), pl. 52
Printer: Bauger
Distributor: Aubert
Catalogued: Ferment, no. 580
Reference: Farwell, *FPLI* 1, 5F10

Two Parisian low-life characters are sharing a copy of the *Journal des débats*. Eugène Sue's very popular novel, *Les Mystères de Paris*, was serialized in this paper in 1842-43. The subject of the novel concerned the same Parisian types that Traviès represented in this print,

179

though it is unlikely they formed the readership of the conservative *Journal des débats*. In the novel Sue crusaded on various social issues with an ensuing response from his readers similar to that of Dickens' audience in England.

In these same years that the novel was unfolding in the newspaper, Traviès made an extensive series of illustrations for it, not for publication in book form (lithography was seldom used for this purpose), but to sell as single sheets and eventually as an album, to an audience thoroughly familiar with the story.[1]

GB
1986.71.63 (SK)

[1] Farwell, *FPLI* 1:22 and 5G1-5G9.

179

Le Juif Errant. Hazard, vouloir ou fatal-ité, sous la semelle Ferrée de l'homme, sept clous saillans forment une croix.......... Alors lui, poussant un soupir douloureux, m'à dit: Tu marcheras sans cesse jusqu'à ta rédemp-tion; ainsi le veut le Seigneur qui est aux cieux....Par J. Michaeli.
c. 1845
The wandering Jew. Chance, will or fate, under the iron sole of man, seven protruding nails form a cross......... Then, heaving a sorrow-ful sigh, he said to me: You will walk unceasingly until your redemption; this is the will of the Lord who is in heaven...by J. Michaeli.

Printer: Guillet
Distributor: Alphonse Leduc

The mythic theme of the Wandering Jew inspired many popular prints, nov-els, and songs, among them this quadrille for the piano illustrated by Traviès. Champfleury devoted an essay to the subject, and Courbet alluded to the motif in his well-known *The Meeting* (Montpellier, Musée Fabre, 1854).[1]

By the middle of the nineteenth century, the legend of the Wandering Jew had evolved from a simple tale of sin and retribution into a richly reso-nant morality tale. Champfleury observed that the Jew served as a sym-bol for all modern aspirations. Eugène Sue's popular serialized novel, which was published in *Le Constitutionnel* in 1844-45, casts the Jew as a spokesman for labor and a protestor against those who oppress him. The role of Traviès as harbinger of the realist movement becomes more sharply focused when his Wandering Jew is viewed in the context of Courbet's Fourierist lithograph *The Apostle Jean Journet Setting Off for the Conquest of Universal Harmony*. The fig-ure in Courbet's lithograph, no longer a

helpless victim, has been transformed into an active witness to a new social order. The image of the Wandering Jew is also identified with the artist as rest-less voyager, another version of the searching, melancholic, creative bohemian who is never truly at home anywhere on earth. This romantic aspect is enhanced by the troubled upward gaze, the flying, wind-tossed locks of hair, and the dark, mysterious shadows that surround the figure. The deep velvety blacks in the folds of the garment, which may have been created using a brush and lithographic ink, are a hallmark of Traviès' later style.

KO
1985.48.1219 (ADB)

[1] For a discussion of the Wandering Jew theme in Courbet's art, see Linda Nochlin, "Gustave Courbet's *Meeting*: A Portrait of the Artist as a Wandering Jew," *Art Bulletin* 49 (1967): 209-222. Most of the informa-tion given here is from this source, espe-cially pp. 214-216.

180

Manière de dîner en reniflant. –Oh! comme cha chent bon... c'hest fricot maintenant... Jean laiche moi me met-tre au choupirail pour manger mon pain avec ce bon fricot... tu t'y remettras ensuite pour le poichon... moi je n'aime pas le poichon, il y a trop d'arêtes!..
1845
A way of dining by sniffing. –Oh! how good dat smells...now it's a stew... John, let me get to da grill so dat I can eat my bread wit dat good stew... you'll get back dere after, for da fish.. me, I don't like fish, dere's too many bones!...

Series: *Comme on dîne à Paris* (How one dines in Paris.), pl. 4
Printer and Distributor: Aubert
Catalogued: Ferment, no. 619
Reference: Farwell, *FPLI* 4, 3A3

Traviès' series on how people dine in Paris (nos. 180-183) is extensive and poignant. It concerns the staff of life, pitting rich against poor in an eloquent discourse. A related scene from another series is also shown (no.187). Here three urchins share bread on the side-walk beneath an open window—where a

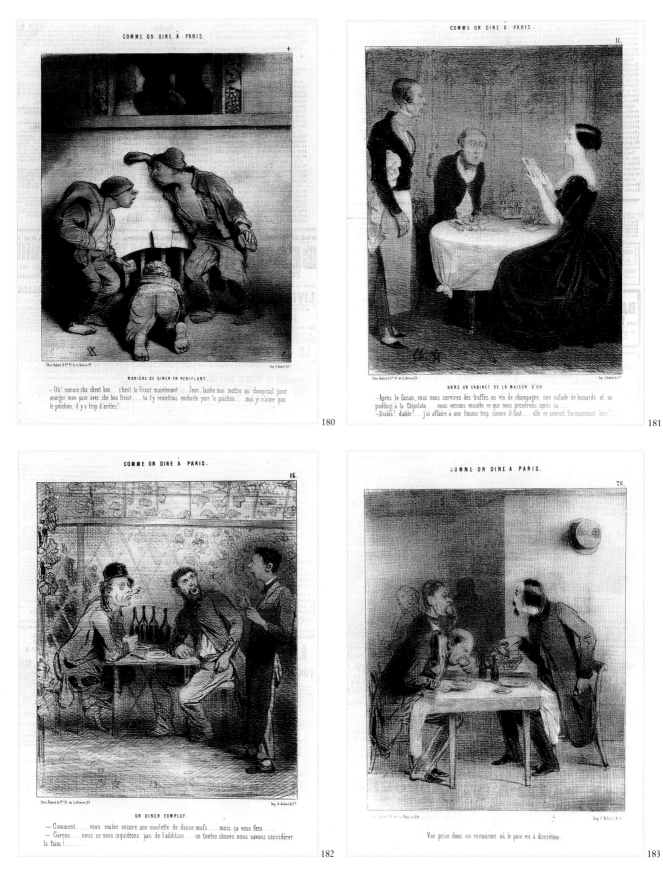

COMME ON DINE A PARIS.

MANIÈRE DE DINER EN RENIFLANT.

— Oh! comme cha chent bon... c'hest le fricot maintenant... Jean, laiche moi mettre au choupirail pour manger mon pain avec che bon fricot... tu t'y remettras enchuite pour le poichon....moi je n'aime pas le poichon, il y a trop d'arètes!...

180

COMME ON DINE A PARIS.

DANS UN CABINET DE LA MAISON D'OR

— Après le faisan, vous nous servirez des truffes au vin de champagne, une salade de homards et un pudding à la Chipolata.... nous verrons ensuite ce que nous prendrons après ça....
— Diable! diable!... j'ai affaire à une femme trop comme il faut..... elle se nourrit furieusement bien!...

181

COMME ON DINE A PARIS.

UN DINER COMPLET.

— Comment.... vous voulez encore une omelette de douze œufs ... mais ça vous fera.....
— Garçon ... nous ne nous inquiétons pas de l'addition ... en toutes choses nous savons considérer la faim!......

182

COMME ON DINE A PARIS.

Vue prise dans un restaurant où le pain est à discrétion.

183

165

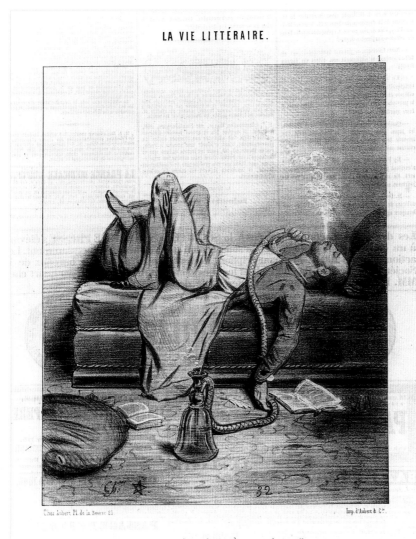

LA VIE LITTÉRAIRE.

Un écrivain qui a depuis dix ans l'intention de travailler.

184

man raises a glass of champagne to a woman in ironic juxtaposition—but their attention is fixed on the aromas coming from the kitchen below. The picturesque lower-class speech of the boys is rendered phonetically in the caption. It loses much in the translation.

RP/BF
1986.71.71 (SK)

181

Dans un cabinet de la Maison d'Or. –Après le faisan, vous nous serverez des truffes au vin de champagne, une salade de homards et un pudding à la chipolata.. nous verrons ensuite ce que nous prendrons après ça... –Diable! diable!... j'ai

affaire à une femme trop comme il faut... elle se nourrit furieusement bien!...

In a private dining room at the Maison d'Or. –After the pheasant you will serve us some truffles in champagne, a lobster salad and a sausage pudding... we'll see then what we'll have after that... –The devil! the devil!... I am dealing with a woman who is too elegant... she feeds herself fantastically well!...

Series: *Comme on dîne à Paris*, pl. 11
Printer and Distributor: Aubert
Appeared: *Le Charivari*, 13 August 1845
Catalogued: Ferment, no. 626
Reference: Farwell, *FPLI* 4, 3A6

A young woman orders the most expensive items on the menu, saying

they will order more later, as her host stares dumbfounded and the waiter remains nonplussed. The private dining room is lavishly paneled, and the bell-pull to call the waiter can be seen behind the host. The Maison d'Or was one of the most fashionable restaurants in Paris. Its private rooms were in great demand by bourgeois protectors and their kept women.

RP
1986.71.78 (SK)

182

Un dîner complet. –Comment... vous voulez encore une omlette de douze oeufs.. mais ça vous fera... –Garçon... nous ne nous inquiétons pas de l'addi-tion... en toutes choses nous savons con-sidérer la faim!...

1845

A complete dinner. –What!...you want another twelve egg omelette...but that will come to... –Waiter...we're not worried about the bill...we know the exact price of hunger!...

Series: *Comme on dîne à Paris*, pl. 16
Printer and Distributor: Aubert

Two shifty types sit at a table in an outdoor eating establishment at the *bar-rière* with four bottles of cheap wine on the table. They are presumably dead-beats who have arranged a scam that will permit them to leave without paying.

RP
1986.71.83 (SK)

183

Vue prise dans un restaurant ou le pain est à discrétion.
Scene in a restaurant where the bread is free.

Series: *Comme on dîne à Paris*, pl. 26
Printer and Distributor: Aubert
Appeared: *Le Charivari* 10 April 1845
Catalogued: Ferment, no. 641
Reference: Farwell, *FPLI* 4, 3B1

In a restaurant where bread comes with the meals, two men stuff bread into their mouths as a third surveys the place while discreetly tucking bread into his pockets. There appears to be as

yet no other food on the table.

RP
1986.71.90 (SK)

184

Un écrivan qui a depuis dix ans l'intention de travailler.
A writer who has been intending to work for ten years.

Series: *La Vie littéraire* (Literary life), no. 1
Printer and Distributor: Aubert
Appeared: *Le Charivari*, 1 October 1845
Catalogued: Ferment, no. 598; Béraldi, 12:152 (series mentioned)
Reference: Farwell, *FPLI* 1, 4C11

Nineteenth-century French lithographic artists, who saw their journalistic counterparts as more or less brothers-in-arms due to their equally low economic status, nonetheless lampooned them regularly, as they did their fellow artists. This would-be writer is represented as a Baudelairean pipe-dreamer, with much evidence of the romantic vogue of orientalism: silk-embroidered slippers, pillowed divan, and hookah. While Baudelaire is known to have been a hashish smoker, tobacco was commonly smoked in the hookah in the Middle East, and it may well be tobacco smoking that is represented here.

BP
1986.71.211 (SK)

185

On cherche un titre pour fonder un journal au capital de pas de millions.
Looking for a title to found a paper without millions in capital.

Series: *La Vie littéraire*, pl. 7
Printer and Distributor: Aubert
Appeared: *Le Charivari*, 17 December 1845
Catalogued: Ferment, no. 604; Béraldi, 7:152
Reference: Farwell, *FPLI* 1, 4D1

Despite the continued repression of the freedom of the press through censorship, fines, and prison sentences, the growth of newspapers and periodicals

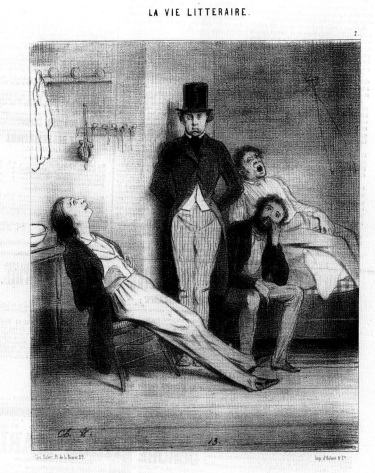

LA VIE LITTERAIRE.

On cherche un titre pour fonder un journal au capital de pas de millions.

185

during the July Monarchy was phenomenal, not only in number but in circulation as well. In 1830 there were approximately ten daily journals available to the Parisian public, with a combined circulation of around 62,000 copies, led by *Le Constitutionnel* with 18,622. By 1837 the number of dailies had mushroomed to more than seventy, with a circulation of over 275,000.[1] Many, of course, were short-lived due to high competition and low budget capital. These four journalists, shown in various states of contemplation, are apparently engaged in dreaming of one of the low-budget papers that would quickly fade into obscurity.

BP
1986.71.213 (SK)

[1] Pierre Albert, Gilles Feyel, and François Pliard, *Documents pour l'histoire de la presse nationale aux XIXe et XXe siècles* (Paris: Editions du C.N.R.S., 1980), 14-16.

186

Le droit de visite. J'espère ne pas vous gêner? –Comment donc! au contraire. –Tiens! tiens! ça n'a pas l'air difficile de dessiner là dessus, mais il faut beaucoup de patience? –Oui, comme vous voyez. –Etant jeune Monsieur, j'avais aussi des dispositions pour la miniature, moi mais ma foi, on m'a lancé dans le commerce, et alors vous concevez. –Ah! c'est bien dommage.

Visitation rights. –I hope I'm not bothering you? –Oh no, not at all. –Well, well! it doesn't seem to be difficult to draw on that, but you need a lot of patience? –Yes, as you

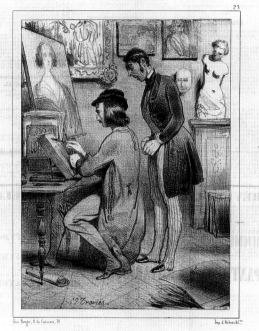

LE DROIT DE VISITE.

– J'espère ne pas vous gêner ! – Comment donc ! au contraire –Tiens ! tiens ! ça
n'a pas l'air difficile de l'essuyer là dessus ,mais il faut beaucoup de patience !
–Oui comme vous voyez. –Étant jeune , Monsieur, j'avais aussi des dispositions pour
la miniature, mon cher, ma foi, on m'a lancé dans le commerce, et alors vous concevez
– Ah ! c'est bien dommage.

186

Comme on dîne à Paris.
DÎNERS A VINGT-CINQ SOUS.

Trois plats au choix du traiteur. – Un carafon de liquide vain, un dessert très varié
et du bruit, de la chaleur et des taches à discrétion.

Les mortels sont égaux: ce n'est pas la naissance.
Mais ce sont les repas qui font la différence.

(Romieu. Préfet.)

187

see. –When I was young, Monsieur, I also had the inclination to do miniatures, but, in faith! I was started in commerce, so you understand. –Ah! it's a pity.

Series: *Scènes de moeurs* (Scenes of manners)
Printer: Aubert
Distributor: Bauger
Catalogued: Béraldi, 12:152

While most of the lithographic artists of the nineteenth century produced images dealing with the trials and tribulations of their own profession, this one by Traviès is of particular interest, as it shows an artist at work drawing with lithographic crayon on the stone. The stones were unwieldy, as they were required to be two to three inches thick to withstand the pressure of the press without breaking. Here, a bourgeois visitor given right of entry to the studio perhaps by virtue of his status as a client, conducts an inane running commentary as the artist tries to work.

A noteworthy feature of this image is that it presents the artist as a painter, with all the trappings normally found in a painter's atelier including an easel with a portrait resting on it. This surely reflects the caricaturist's interest in upgrading the status of his métier.

BP
1986.71.194 (SK)

187

Comme on dîne à Paris. Dîners a vingt-cinq sous. Trois plats au choix du traiteur.–Un carafon de liquide vain, –un dessert très varié et du bruit, de la chaleur et des taches à discrétion. Les mortels sont égaux: ce n'est pas la naissance, Mais ce sont les repas qui font la différence. (Romieu, Préfet).
c. 1845
How one dines in Paris. Twenty-five sou dinners. Three courses of the restaurateur's choice. A decanter of ineffectual liquid, a very varied dessert, and noise, heat and stains free. Mortals are equal: it's not birth, but meals that make the difference. (Romieu, Prefect).

Series: *Scènes de moeurs*
Printer: Aubert

Distributor: Bauger

This isolated sheet on dining in Paris appeared in the suite *Scènes de moeurs*. Its subject could easily have been included in *Comme on dîne à Paris*, its subtitle (nos. 180-183). If *Scènes de moeurs* preceded *Comme on dîne*, this print might be seen as the inspiration for the latter series but these are unresolved questions since Traviès' work remains without a proper *catalogue raisonnée*.

BF
1986.71.195 (SK)

Carle Vernet (1758-1836)

Carle Vernet was born in Bordeaux where his father Joseph Vernet, a successful seascape painter, was engaged in carrying out a commission for Louis XV of a suite of paintings of the ports of France. Carle was given a conventional artistic education under Lepicié, who taught him to paint traditional religious and classical subjects. He won the Prix de Rome, was admitted into the Academy in 1788, and was decorated with the Legion of Honor in 1808, a span of years which also saw the French Revolution and the advent of Napoleon's Empire. In 1787 he married the daughter of the engraver Moreau le Jeune, and the young couple moved into an apartment in the Louvre Palace left to Carle upon the death of his father in 1789. The Revolution brought tragedy to the family as Carle's sister, the wife of the noted architect Chalgrin, was guillotined during the Terror for concealing correspondence with royalty. Vernet's wife bore him a son, Horace, who became a more famous painter than his father.

During the Directory and the First Empire, Vernet became known as a painter of battle scenes, one of which won him the Legion of Honor. During the Restoration, however, he turned to scenes of horses, horse racing, hunting, and the cavalry. Like Géricault, he was himself an avid horseman, and was known to have been racing just days before his death at the age of seventy-eight. It is these subjects and Parisian street scenes and types that furnished the subject matter of his lithographs.

Carle and his son Horace encountered lithography at the same time in 1816 when the new technology first became commercially viable. Horace is said to have made the first commercial (that is, published) lithograph in France, an impression of which is in the exhibition (no. 199). Father and son must have worked side by side, often choosing similar subjects, though the style of the father, formed during the neoclassical period, is more linear and his compositions more planar than that of the son whose more tonal and spacious representations might be called pseudo-romantic. Late in life, Carle won the popularity as a lithographer

that he had never achieved as a painter. Never a great colorist, he came into his own as a draftsman in the black and white lithograph.

As a lithographer, Carle Vernet was never a true caricaturist, with the exception of a few plates lampooning fashions (no. 196), no doubt stemming from his own earlier engravings of the *Incroyables* and *Merveilleuses*, dandies and their female counterparts of the Directory. Yet, in a sense, every visual commentator on the contemporary Parisian scene was deemed a caricaturist, since such subject matter was not considered serious art. Among Carle's lithographs in the exhibition, most represent ambulatory vendor types in an old tradition of the street cries of the city, a feature that was rapidly disappearing from the urban scene in Vernet's time.

Carle Vernet, the son and the father of greater painters than he, recognized his own shortcomings on his deathbed, proclaiming, "They will say about me what they said about the great Dauphin: son of a King, father of a King, but never a King."[1] This is not to denigrate his contribution to art. Baudelaire in "Quelques caricaturistes français," acknowledged Vernet's importance, calling him "un homme étonnant" (an astonishing man) and his work "a world, a little *Comédie humaine*," thus putting him in a class with Balzac.[2]

NS/BF

[1] Dayot, *Carle Vernet*, 55.
[2] Baudelaire, *O.c.* 2:544.

188

Imprimerie Lithographique de F. Delpech.
1818
Delpech Lithographic Print Shop.

Printer: Delpech
Catalogued: Béraldi, 12:507

The lithographic work of Carle Vernet was regularly printed at the shop of François Seraphin Delpech, who, aside from the pioneers Engelmann and Lasteyrie, was one of the earliest in the business of lithographic printing in Paris. Originally an artist and a print-seller, he received authorization to operate his lithographic presses on 16 June

1818, the very year of this print. A police report assured the Ministry of the Interior that he would devote his presses exclusively to the printing of pictures, and "not for any literary or political works." When Delpech died in 1825, his widow applied for and was granted permission to continue his business. A new police report on this occasion indicates that she had been professionally involved in the shop's affairs, seeing to the making of tools and preparation of stones. It notes that she was now well-off, and that the shop had conducted a broad commerce that extended to foreign countries. Mme. Delpech's political opinions are characterized as insignificant; those of her late husband had shown a tendency to liberal ideas, but he had neither printed nor sold any lithographs that were obscene or contrary to the government.[1]

In this image, an advertisement for Delpech's wares, the display in the windows has attracted a small crowd of passers-by, some in elegant street clothes suggesting a well-to-do market, and one military officer, smartly uniformed, with his wife on his arm. A messenger boy leaves the shop carrying a lithographic stone on his head.

BF
Anonymous Loan

[1] Information from Archives nationales, Paris, F18/1754.

189

Marchand de tisanne. À la fraîche, qui veut boire? V'là l'coco.
Seller of herb tea. Fresh beverage, who wants a drink? Here's the cocoa.
(hand-colored; illustrated on page 36)

Series: *Cris de Paris* (Paris street cries), c. 1820, no. 13
Printer: Delpech
Catalogued: Dayot, no. 147
Reference: Farwell, *FPLI* 2:20, 5D5

The subject of *Cris de Paris*, street vendors who had long since been represented in engravings and popular woodcuts, dates from the seventeenth century. In the nineteenth, they continued to find a place in lithography as well as in literary classifications such as Emile de la Bédollière's *Les Industriels*

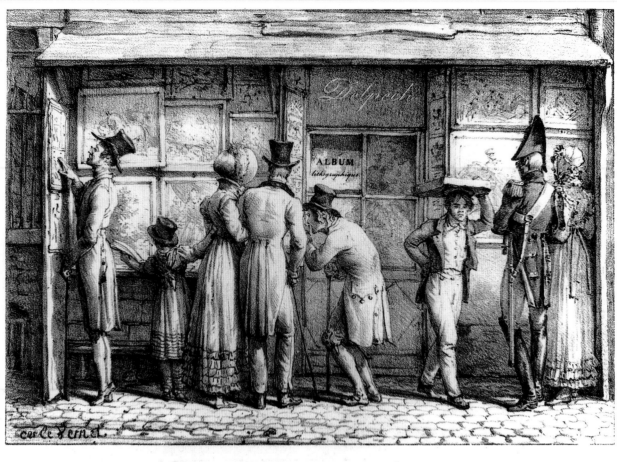

Imprimerie Lithographique de F. Delpech

(1842), where many of Vernet's street vendors are described. The herb tea seller and the cocoa seller were interchangeable, since they used the same equipment and the same cry, "à la fraîche!" Both carry a cistern of painted, tinned sheet-iron fastened to their backs. Although ambulatory, the vendor could rest by leaning on the staff connected to the cistern. A tube from the cistern ended in a spigot in front of the vendor, who rang a bell to announce his approach like the Good Humor man. He made regular visits to workshops, printing offices, and factories.

The *Marchand de tisane* wears something like a uniform of the Empire period and his hat is the Napoleonic *bicorne*. (The trade was not confined to men. A female counterpart, the *Marchande de tisane*, is also found in the suite.) The earnings of the *Marchand de tisane* allowed him hot meals twice a week and a room of reasonable size

shared with his wife, typically a fifth-floor rear garret. Although the merchant depended on good weather to sell his product, his business was not necessarily interrupted by winter.

NS
1985.48.1306 (ADB)

190

Marchande de chiffons. Chapeaux à vendre, des vieux chapeaux. Avez vous des vieux chiffons à vendre? V'là la marchande de chiffons.

Rag seller. Hats for sale, old hats. Do you have old rags to sell? The rag seller's here.

Series: *Cris de Paris*, c. 1820, pl. 28
Printer: Delpech
Catalogued: Dayot, no. 147

The vendor is ambulatory; the trap-

pings of her trade are simply the products she bought and sold: hats and old clothes. The old woman, matching her merchandise, appears considerably older than the *Marchande d'oranges* (no. 191), since women were matched in age and trade. The flower or fruit seller was usually depicted as youthful.

Some of the street trades depicted in this series would shortly become extinct (e.g., the water seller), but the depiction of a merchant selling hats on a cobblestone street could be seen later in the photographs of Eugène Atget (1857-1927). Just as Vernet had documented a segment of Parisian society in lithographs, Atget carried on the *Cris de Paris* tradition in photographs at the turn of the century. Both artists conveyed a sympathetic concern for a way of life jeopardized by the modernization of their city.

NS
1985.48.1304 (ADB)

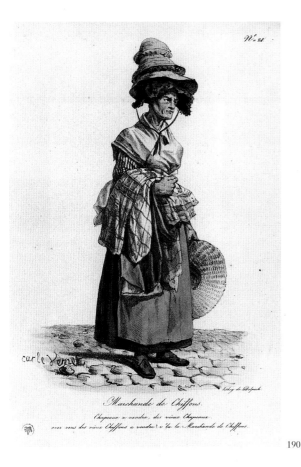

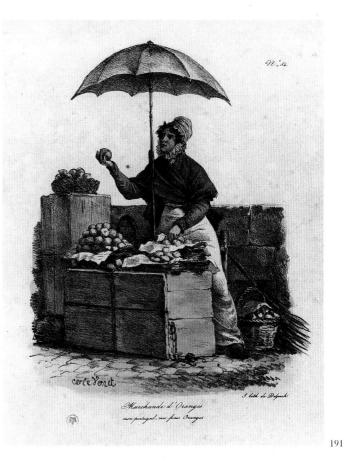

190

191

191

Marchand d'oranges. mon portugal, mes fines oranges.
Seller of oranges. My portugal, my excellent oranges.

Series: *Cris de Paris*, c. 1820, pl. 54
Printer: Delpech
Catalogued: Dayot, no. 147
Reference: Farwell, *FPLI* 2:20, 5D7

The merchants who sold their produce in fixed spots at the market were considered middlemen between farmers of the suburbs and Parisian consumers. They paid a weekly rent to set up their boxes and umbrellas. The seller was barred from owning a shop while operating a station at the market. Furthermore, he/she was limited to one station only. Before one could obtain a permit for a station, one had to establish a year's residence in Paris and a record of good conduct. In addition, one had to secure strong recommendations from the community to persuade the commissioner to grant a permit. Once granted, the recipient was obligated to display a sign with his name and permit number next to his station.

The stationary vendor's was a coveted and privileged profession as compared to the ambulatory seller's. The latter carried his produce on a board in front of him, or simply carried it in his hands, and was required by law to keep moving. In this lithograph, the dealer is obviously stationary with a chain and lock on her boxes. She is also represented as younger, prettier, and more prosperous than the ambulatory rag-seller of no. 190.

NS
1985.48.1310 (ADB)

Bibliography:
La Bèdolliére, *Les Industriels.*

192

Untitled
(Cavalryman mounting his horse)
c. 1820

Printer: Lasteyrie

A horse and rider are the central focus of this lithograph. Instead of using a diagonal or horizontal view, as in nos. 195 and 198, Vernet here depicted the horse extremely foreshortened. A virtuoso at equine anatomy, he could draw the horse in any position and from any angle. The rider is a cavalryman, perhaps a *carabinier*, known as the elite of the cavalry with the flashiest uniforms. The popular cavalry were admired by the populace for conquests both on and off the battlefield.[1] Vernet devoted several lithographic suites solely to military costumes. The subject was in demand by a large market consisting of veterans of the old Napoleonic army in a nation thoroughly militarized by Napoleon's exploits of only a few years earlier.

The gentleman printer Comte Charles de Lasteyrie, one of the earliest to run a commercial lithographic shop, belonged to the eighteenth-century tradition of the aristocratic hobbyist-researcher in science and technology.

NS/BF
1985.48.1316 (ADB)

[1] Farwell, *FPLI* 3:19.

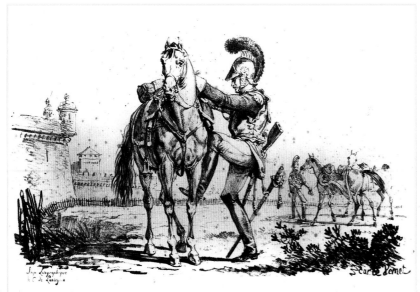

192

the treatment is more exotic. The scene is replete with Arab costuming, a camel, and palm trees that form part of the tent structure. Although the subject may be strictly genre, parallels can be drawn with the traditional image of the Holy Family's flight into Egypt. Also, the child playing with the palm frond may be symbolic of Christ's eventual martyrdom. The real focus of this picture, however, is the magnificent Arab horse.

Vernet's neoclassical style is still evident in the arrangement of the figures parallel with the picture plane, and in the light, silvery tonality comparable to the early lithographs of Charlet.

NS
1985.48.1288 (ADB)

193

Fort de la halle.
c. 1820 (hand-colored)
Market-porter.

Reference: Farwell, *FPLI* 2:22, 5G7

The *Fort de la halle* carried produce to and from the great central wholesale market in Paris. His image is comparable to those of the other market folk and street vendors (nos. 189-191) that Vernet produced in the *Cris de Paris* series, and was probably made about the same time. In the isolation of the figure, Vernet's lithograph is similar to that portion of Boilly's work done before 1830. Carle Vernet and Boilly are the oldest lithographers represented in this exhibition, both having had careers as painters before the new medium became available.

The style of both Vernet's and Boilly's images of workmen suggests their possible role in the formation of the American George Caleb Bingham's drawing style in his images of Mississippi boatmen.[1]

RP/BF
1985.48.1289 (ADB)

[1] See E. Maurice Bloch, *George Caleb Bingham: The Evolution of an Artist* (Berkeley and Los Angeles: University of California Press, 1967), 99.

194

Le marché aux chevaux.
1821
The horse market.

Catalogued: Béraldi, no. 509

Carle Vernet was exceptional as a nineteenth-century lithographer with a foundation in eighteenth-century taste. (Most of the pioneers of lithographic imagery in the nineteenth century were young men born during or after the Revolution.) His specialty of depicting horses was an extension of eighteenth-century English sporting genre, which included portraits of horses, scenes from horse races, and hunting imagery. The subject of the horse market gives Vernet an opportunity to represent a diverse assortment of horses in a variety of forms of movement.

RP/BP
1985.48.1297 (ADB)

Bibliography:
Early Lithography 1800-1840.

195

Famille arabe en voyage.
Travelling Arab family.

In this, as in most of Vernet's lithographs, his basic subjects are present—the horse and its rider—but here

196

Costumes d'hiver.
1825
Winter costumes.

Printer: Delpech
Catalogued: Dayot, no. 158

Prior to making this lithograph, Vernet had collaborated with his son Horace on the lithographic suite *Fables de La Fontaine* (Fables of La Fontaine) (c. 1820), in which animals portray the full gamut of human foolishness. He continued the satirization of human folly in the lithograph *Costumes d'hiver.* He paid particular attention to details of the clothing, and indeed this image is a parody of a fashion plate. The La Fontaine illustrations and subsequent images of this type antedate by three years Grandville's similar *Métamorphoses du jour* (nos. 83-84). Such fantasies derive from earlier illustrations for La Fontaine's *Fables.*

NS
1985.48.1286 (ADB)

N.º 90.

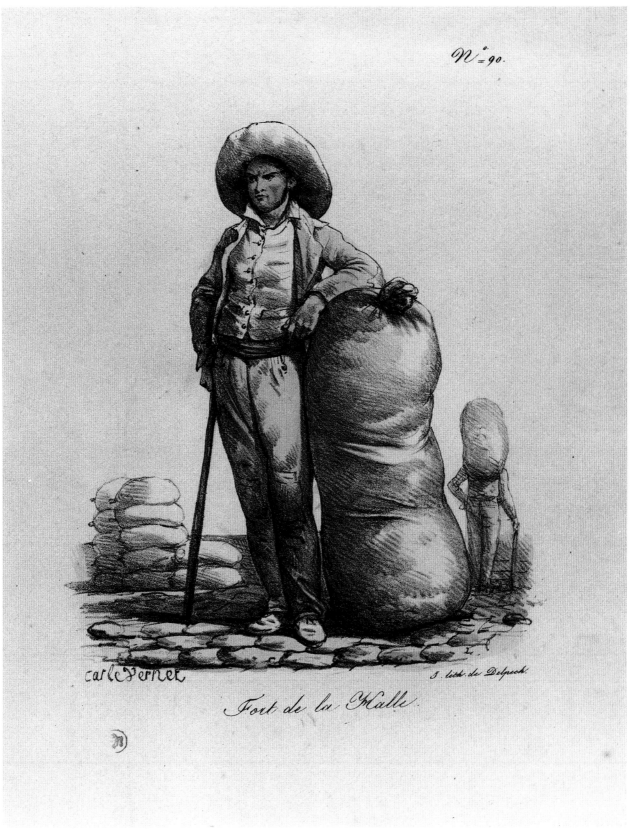

carleVernet

J. lith. de Delpech.

Fort de la Halle.

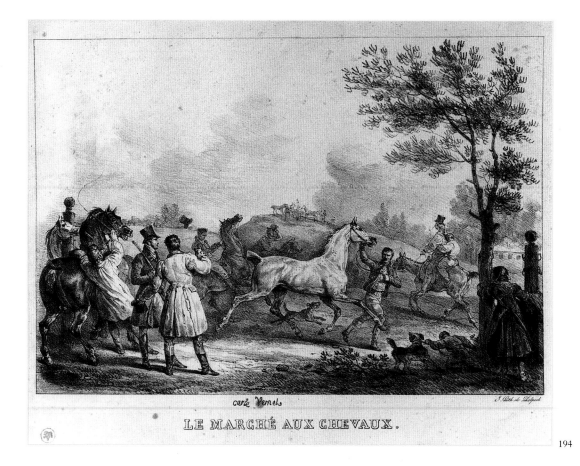

LE MARCHÉ AUX CHEVAUX.

194

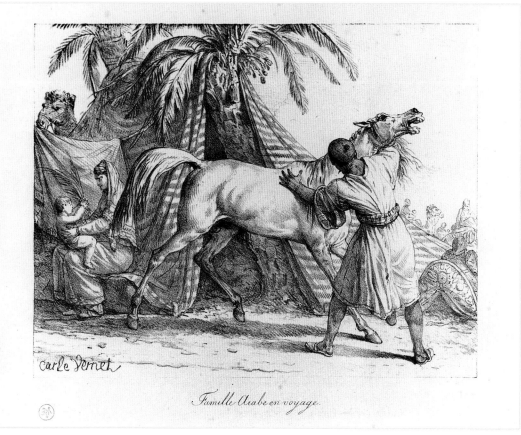

Famille Arabe en voyage.

195

174

Costumes D'Hiver.
1825.

196

197

La prise de tabac derrière la toile.
Taking tobacco behind the curtain.

Catalogued: Dayot, no. 154

The appeal of theatre is its ability to transform the stage into various illusions of reality. In Vernet's lithograph another reality is depicted—the backstage scene. Rarely is the viewer allowed to see an actor in costume but out of character. The incongruous pairing of the two characters in a mundane exchange of tobacco presents with humor the theme of reality versus illusion.

The subject of such encounters in the wings of the theatre was also of interest to Gavarni (no. 70), and later to Degas in backstage scenes of the ballet.

NS
1985.48.1295 (ADB)

198

Untitled
(Hunting accident)
c. 1825

Printer: Delpech

This undated hunting scene is similar to a number of lithographs in Vernet's suite *Les Accidents de la chasse*, c. 1825. The subject of horses in any context was Vernet's primary interest. He conveyed the essence of country life through his numerous depictions of all aspects of the chase. His compositions varied from static, with very little action portrayed, to extremely dynamic as in this lithograph. The agitation of the horse is clearly delineated by the outline of its muscles. Horse anatomy was of interest to a whole generation of earlier English artists, most notably George Stubbs (1724-1806), who furnished

precedent for Vernet's art. Like Vernet, Stubbs recorded sporting genre of all kinds, but especially the sport of the day, the chase.

NS
1985.48.1290 (ADB)

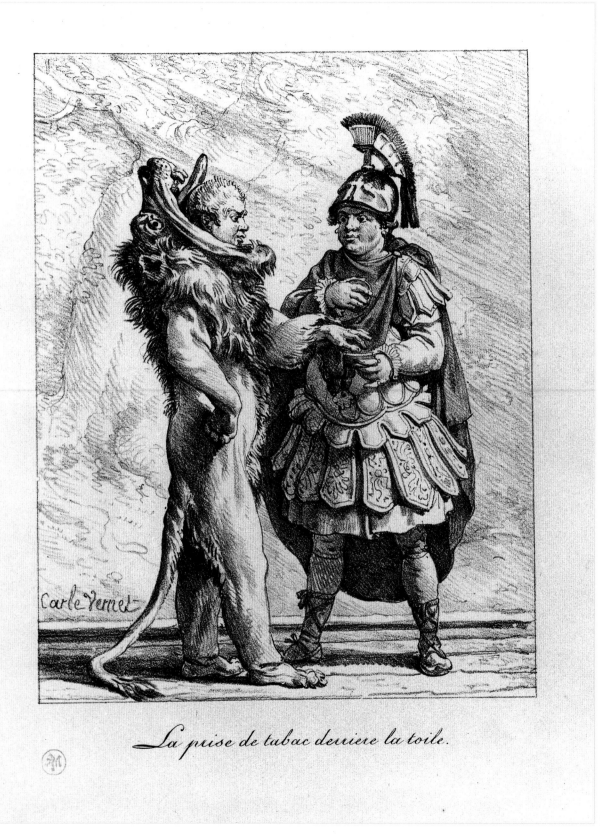

Carle Vernet

La prise de tabac derriere la toile.

197

176

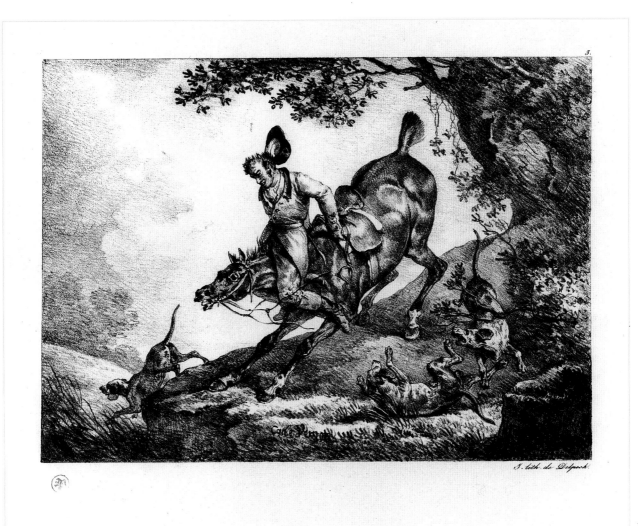

Horace Vernet (1789-1863)

Horace Vernet made the first commercially published lithograph in France, *Le Lancier en vedette* (no. 199). Born into a family of painters and the son of Carle Vernet, he eventually made a fortune as a painter mainly of military subjects. His lithographic work was all made in the first half of his career from 1816 to 1839, perhaps because in this period he could not support himself by painting alone.[1] Much of his lithography is also on military subjects, but extends into a variety of other genres. Lithographs after his own paintings were not made by him but by Jean-Pierre-Marie Jazet (1788-1871?).[2]

Some of his work was illustrative, including the series for *Fables de La Fontaine* (1818). On this commission he collaborated with his father, Carle, and Hippolyte Lecomte. He also contributed to *Voyage dans le Levant* by the Comte de Forbin (also 1818).[3] Other lithographs have literary, especially Byronic, subject matter. The exhibition includes an example from *The Corsair* (no. 200).

Vernet's interest in the Orient, which became quite scholarly after he visited North Africa and elsewhere in the 1830s, 1840s, and 1850s,[4] began as a sort of romanticism. The *Slave Merchant* (no. 209) is typical of his early Byron-influenced understanding of the Near East.

Horace's father, Carle, had made his name as a horse painter and Horace continued the family tradition with scenes of racing and hunting as well as of military horsemen.

Vernet grew up an avid admirer of Napoleon. Although he was famous as a painter of grand set piece battles, his prints tended towards small scale, often humorous or sentimental scenes of military life, of ordinary soldiers relaxing together or out foraging. What battles he depicted are shown from the point of view of the common soldier. An undated series called *La Vie d'un soldat* (nos. 203, 204) presents the life of a soldier in five scenes, from childhood military games to drunken brawling after the conclusion of peace. The typical soldier who perhaps bought Vernet's prints is glorified here through the generic person of "young Grivet."

As a painter, Vernet contributed heavily to the military museum established in Versailles by Louis-Philippe in 1834, and became a court painter to the king. His travels in the Orient gave him a deepening understanding of Arab life which, like Delacroix, he saw as having changed little since antiquity. He painted Old Testament subjects in Arab dress, a tactic that received mixed reviews at the Paris Salons and in one case earned him charges of immorality (*Judah and Tamar*, 1840, Wallace Collection). Vernet's early Bonapartist sentiments gave way to loyalty to the *juste milieu* compromise of the July Monarchy, causing little controversy. His youthful lithographs of horses and soldiers, however, reveal an artist of talent and élan comparable to and perhaps better than Charlet, and to his father Carle, whom he ultimately surpassed in his profession.

A beloved and popular figure and an influential teacher, Vernet had failed in his youth to win the *Prix de Rome*, but was appointed Director of the French Academy in Rome from 1829 to 1835, when he was succeeded by Ingres. His first visit to North Africa was made in 1833, with the king's permission, while still director of the Academy. He returned to Paris to a professorship at the Ecole des Beaux-Arts, a position he held until his death.

GB

[1] Béraldi, 12:210-223.
[2] Ibid., 8:231
[3] Ibid., 12:210-223
[4] Durande, *Joseph, Carle et Horace Vernet*, 96-102, 112-22, 124-25, 283-297, 307-10.

Bibliography:
Dayot, *Les Vernet*.
Athanassoglou-Kallmyer, "*Imago belli.*"

199

Le Lancier en vedette, 1816
The lancer sentinel.

Publisher: Lasteyrie

This lithograph, generally accepted as Horace Vernet's first, is claimed by the publisher Lasteyrie to be the first published lithograph in France (1816). Lithographs had been made in France earlier, but the commercial publishing of editions began only in 1816, and Lasteyrie's shop was among the first to do so and to survive as a viable enterprise. The linear character of the images betrays Vernet's unfamiliarity with the medium and his reliance upon the more familiar practice of pencil sketching. It is related in spirit to his 1817 lithographic sketch of a grenadier, quickly dashed off and labelled with the handwritten caption 'En 10 minutes.' Vernet quickly adapted his methods to the new medium and learned to exploit the soft, textural qualities of the crayon in the depiction of light and shadow. Vernet and his father Carle took up lithography simultaneously, and both made notable contributions to the technique's early development, particularly in military and equestrian subject matter.

BP

1985.67.378 (MW)

Bibliography:
Man, *150 Years of Artists' Lithographs*.

200

Conrad sauve Gulnare de l'incendie. (Le Corsaire par Lord Byron.)
1819
Conrad saves Gulnare from the fire.
(The Corsair by Lord Byron.)

Vernet exhibited orientalizing tendencies long before he left his post as Director of the French Academy in Rome to follow the armies of the occupation into Africa and the Middle East in 1833. Early romantic painters were greatly influenced by Byron, and Vernet illustrated several French translations of his work, including *Don Juan, Manfred, The Bride of Abydos,* and *Mazeppa.* Here, in a scene from *The Corsair* (canto II, verse 5), Conrad, leader of a band of Greek pirates, with his scimitar drawn, rescues Gulnare from the flames of the seraglio of Seyd Pasha, which the pirates have put to the torch.

BP
1985.48.1330 (ADB)

Bibliography:
Horace Vernet (1789-1863).

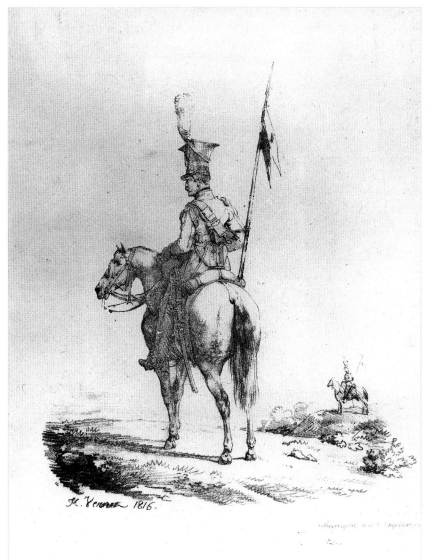

199

201

Manejo del sable. Colección de 40 diseños lithográficos que representan las diversas posiciones de este ejercicio a caballo dedicado a sus compañeros de armas para J.V.M. de P. año de 1819.
The handling of the sabre. Collection of 40 lithographic images representing the various positions of this exercise on horseback dedicated to his companions in arms by J.V.M. de P. in the year 1819.

Printer: Engelmann

In 1819 Vernet, an expert swordsman, collaborated with Eugène Lami on a treatise on sabre-fighting,

Maniement du sabre, which Engelmann published in both French and Spanish editions.[1] With its hand-lettered Spanish inscription, this lithograph is probably a proof of the title sheet for the Spanish edition and is an indication of the early marketing of French graphics in other countries.

The title dedication is by the Marquis de Caza de Pontejos (Juan Vasquez Marquis de Pontejos).

RP
1985.48.1360 (ADB)

[1] Athanassoglou-Kallmyer, "*Imago belli*," 275.

202

La Chatte metamorphosée en femme.
1818-20
The cat that turned into a woman.

Printer: Engelmann

One hundred and nine of La Fontaine's *Fables* were illustrated with 120 full-page lithographs by Carle Vernet, his son Horace, and his son-in-law Hippolyte Lecomte: 64 by Carle, 20 by Horace, and 36 by Lecomte. The project, published by Engelmann, extended over at least two years (1818-1820), and was first issued in *livraisons* (periodic subscription series) before being bound in complete sets. In this scene, the woman reveals her true identity as she leaps out of bed to chase after some mice which are scurrying across the floor.

GB/BP
1985.48.1345 (ADB)

Bibliography:
French Lithographs 1815-1840. Sale catalogue. San Francisco: R.E. Lewis, Inc., 1971.

203

Equipement militaire du jeune Grivet, 1794.
Young Grivet gets his military equipment, 1794.

Series: *Le Vie d'un soldat* (The life of a soldier), 1819-21
Printer and Distributor: Delpech

Vernet was one of several lithographers to contribute to the rapidly evolving Napoleonic legend, Charlet and Raffet being the most notable. His sentimental and anecdotal portrayals were preferred by many of the old soldiers of the Grand Army to the more penetrating works of Charlet, and to those of Géricault, which often leaned toward the tragic. *La Vie d'un soldat*, a suite of five plates published by Delpech between 1819 and 1821, illustrates an interval in the fictional life of a young soldier, Jacques Grivet, with whom the old veterans in the 1820s could identify. This scene, representing the year 1794, shows Grivet receiving his uniform, boots, rifle, and other military gear.

GB/BP
1985.48.1359 (ADB)

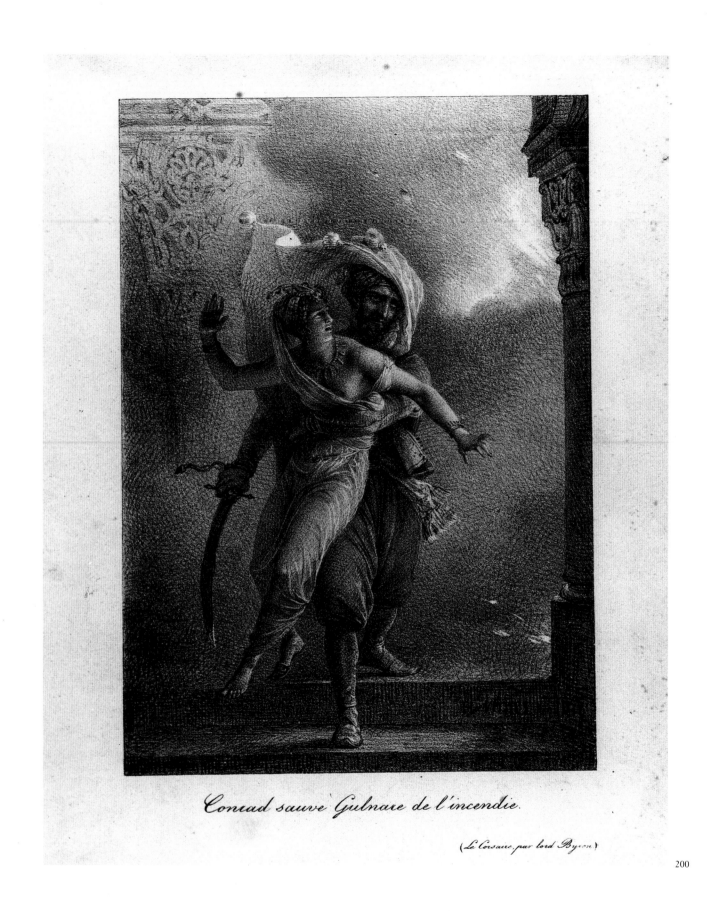

Conrad sauve Gulnare de l'incendie.

(*Le Corsaire, par lord Byron*)

200

204

Amusement du jeune Grivet pendant la paix, 1797.
Amusement of young Grivet during the peace, 1797.

Series: *La Vie d'un soldat*, 1819-21
Printer and Distributor: Delpech

In this final scene from the five-piece suite *La Vie d'un soldat*, young Jacques Grivet, second from the left, is being restrained from fighting with another soldier outside a tavern, during the brief peace which followed Napoleon's Italian campaign. Lithographic imagery, along with popular songs, played an important role in the development of the Napoleonic myth in a country where the proportion of illiteracy was still rather high. A similar series featuring a fictional young conscript named Jean-Jean was drawn by Raffet between 1825 and 1827.

GB/BP
1985.48.1355 (ADB)

205

C'est n'est pas un lapin non, c'est le chat!
1823
This isn't a rabbit no, it's the cat!

Printer: Delpech

Military genre scenes such as this one of billeting and foraging, or the expropriation of temporary living quarters and foodstuffs for soldiers on the march, were popular among old soldiers of the Grand Army during the Restoration. A certain amount of ingenuity was required, and often the victims of such forays were domestic animals. In this print, one soldier sits before a fire with the carcass of a small animal roasting on a spit. Another holds aloft the skin to an old woman, who immediately recognizes the striped tail of her housepet.

BP
1985.48.1327 (ADB)

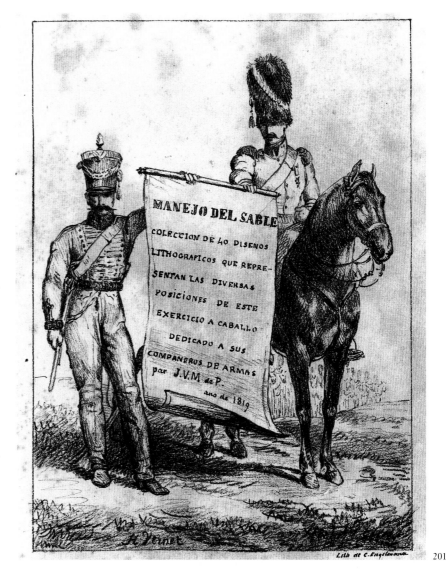

201

206

Tiens ferme.
1823
Hold tight.

In this image, one soldier holds onto the belt of another, who is straining against the weight of an unwilling hog which he has by the tail. The commandeering of farm animals to feed the troops was common among soldiers on the march. This print was one of three by Vernet that were republished as engravings for an 1880 English biography of Vernet by Janet Ruutz-Rees, attesting to its continued popularity.

BP
1958.48.1373 (ADB)

Bibliography:
Ruutz-Rees, *Horace Vernet*.

207

Après, après la, mes beaux.
1823
After, after him, my beauties.

Catalogued: Béraldi, no. 108
Reference: Farwell, *FPLI* 5, 3A2

Much of the work of Horace Vernet betrays a strong paternal influence. The Vernets were both avid horsemen and hunters, and would often travel to such places as Normandy on hunting excursions. It is interesting to observe that while Béraldi notes several early works on military subjects as being collaborations with Hippolyte Lecomte in which Lecomte drew the landscapes, Vernet evidently felt competent enough in this later suite of four prints to tackle the

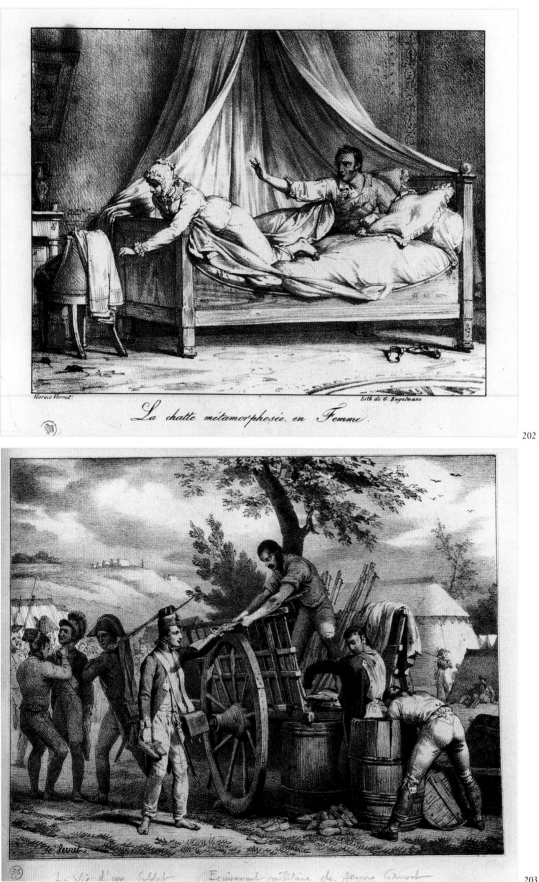

La chatte métamorphosée en Femme.

Horace Vernet. Lith de G. Engelmann

202

La Vie d'un Soldat Enterrement militaire de Horace Vernet

203

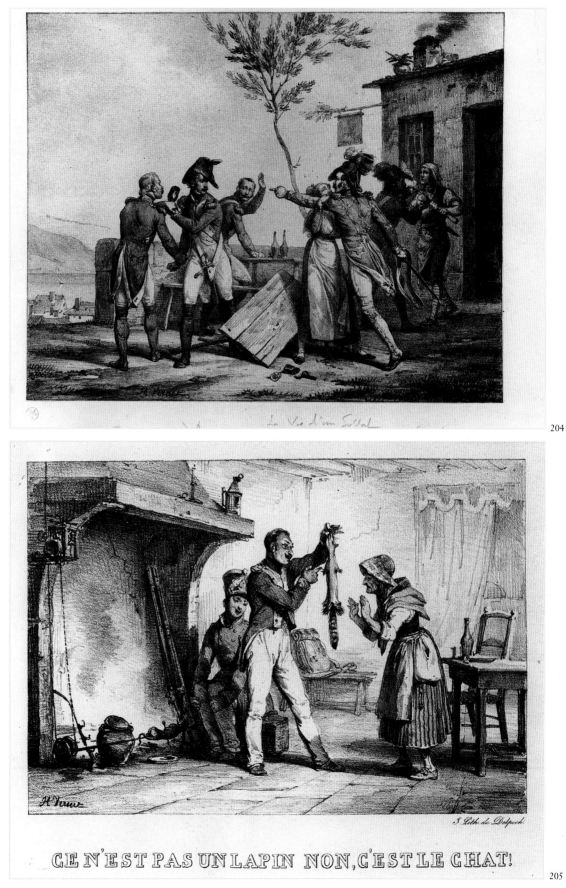

204

CE N'EST PAS UN LAPIN NON, C'EST LE CHAT!

205

TIENS FERME.

206

APRES, APRES LA, MES BEAUX.

207

184

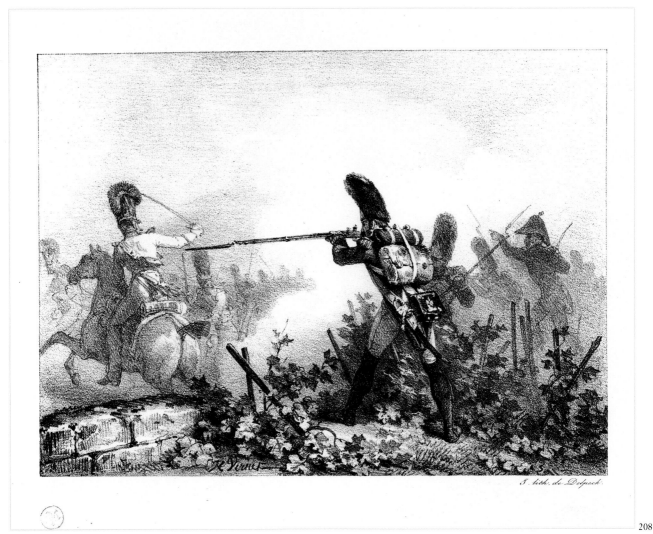

208

landscape himself, and with some success. It was customary to trim the horse's tail and mane to avoid entanglement in the underbrush.

BP
1985.48.1321 (ADB)

208

J'te va descendre.
I'm going to kill you.

Printer: Delpech

Vernet's knowledge of the details of military life led many to believe that he had had a long and distinguished military career. Baudelaire called him "a soldier who paints." In fact, he served only briefly—he enlisted with his friend Géricault in 1814 in a company of Hussars and served a few days in the defense of Paris, for which he received the cross of the Legion of Honor. For the Revolution of 1848, Vernet received an appointment as a Colonel of the National Guard at Versailles, a post at which he saw several months of duty. The National Guard was reserved primarily for the affluent, taxpaying bourgeoisie, and by this time, Vernet was not only well-known but wealthy, owing to his painting commissions.

BP
1985.67.394 (MW)

Bibliography:
M.C.H. "Horace Vernet, His Life and Works."

209

Marchand d'esclaves.
Slave merchant.

Printer: Delpech

White slavery had been practiced in the Barbary States since ancient times, though it was more of a traffic in males used for forced labor than in *odalisques* (harem slaves). It is said that Cervantes was held captive for five and one-half years before being liberated for a sum of about six hundred dollars, the veiled autobiographical account of which appears in *Don Quixote*. This print is an example of the orientalizing trend in romanticism: the unveiling of a young, white slave girl for a prospective buyer to add to his harem. The port scene presumably indicates that she has been captured by pirates. Vernet was relying

185

MARCHAND D'ESCLAVES.

209

210

on literary and pictorial sources here, but he later travelled extensively in North Africa and the Near East, making friends with the Bedouins and executing numerous paintings of more realistic Arab life and of biblical subjects translated into Bedouin costumes and mores.

BP
1985.48.2969 (ADB)

Bibliography:
Julian, Philippe. *The Orientalists*. Oxford. Phaidon Press, 1977.
Sumner, Charles, *White Slavery in the Barbary States.* Boston: Ticknor, 1847. Reprint. Miami: Mnemosyne Publications, 1969.

210

Untitled. (Racing scene)

Previously an English gentlemen's sport, horse racing became a popular public spectacle in France during the July Monarchy. This undated print, probably from the late Restoration, seems to emphasize private betting (the gentlemen in street clothes) more than public entertainment, though in the distance a grandstand with flags is indicated. The venue, if in Paris, would be the Champ de Mars, the only racetrack in Paris until the late 1850s, where turf races were held in the spring and fall. But since there is no sign of the Invalides buildings, it may represent a track outside the city. Vernet is sometimes criticized for his over-attenuation of the lean, slender bodies of the race horses, and the foreleg of the horse to the right, with a rider in top hat and tails, seems to bear this out.

BP/BF
1985.67.369 (MW)

BIBLIOGRAPHY

Catalogues Raisonnées, Encyclopedias, Collection Catalogues, and Other Reference Works

Adhémar, Jean, et al. *Inventaire du fonds français après 1800.* 15 vols. Paris: Bibliothéque nationale, 1930-.

Armelhaut, J., and E. Bocher. *L'Oeuvre de Gavarni.* Paris: Librairie des Bibliophiles, 1873.

Bénézit, E. *Dictionnaire critique et documentaire des peintres, sculpteurs, dessinateurs et graveurs.* 10 vols. Paris: Grund, 1976.

Béraldi, Henry. *Les Graveurs du XIXe siècle.* 11 vols. Paris: C. Conquet, 1891.

Dayot, Armand. *Carle Vernet: Etude sur l'artiste.* Paris: Le Goupy, 1925.

Delteil, Loÿs. *Le Peintre-graveur illustré.* 32 vols. Paris: Chez l'auteur, 1906-70.

Ferment, Claude. "Charles-Joseph Traviès, catalogue de son oeuvre lithographié et gravé." Cabinet des Estampes, Bibliothèque nationale Yb³ 2774.

Giacomelli, Hector. *Raffet, son oeuvre lithographique.* Paris: Bureau de la Gazette des Beaux-Arts, 1862.

Harrisse, Henry. *L.-L. Boilly.* Paris: Société de propagation des livres d'art, 1898.

Hatin, Eugène. *Bibliographie historique et critique de la presse périodique française.* Paris: Firmin Didot, 1866.

La Combe, Joseph Felix Leblanc de. *Charlet, sa vie, ses lettres.* Paris: Paulin et le Chevalier, 1856.

Marie, Aristide. *Henry Monnier (1799-1877).* Paris: Floury, 1931.

Sello, Gottfried. *J.-J. Grandville, 1803-1847: Das Gesamte Werk.* 2 vols. Munich: Rogner V. Bernhard, 1969.

Thieme, Ulrich, and Felix Becker. *Allgemeines Lexicon der Bildenden Künstler.* 37 vols. Leipzig: Seeman, 1907-50.

Vanhevhe, Marie-Anne. *Henry Monnier, l'homme et l'oeuvre, 1799-1877, dessins et lithographies.* Thesis and catalogue, Brussels: Université Libre de Bruxelles, 1953-54.

Exhibition Catalogues

Abèlés, Luce and Guy Cogeval. *La Vie de Boheme.* Les Dossiers du Musée d'Orsay, no. 6. Paris: Editions de la Réunion des musées nationaux, 1986.

Adhémar, Jean. *Gavarni.* Paris: Bibliothèque nationale, 1954.

Coyle, Susan. *The Human Comedy: Daumier and His Contemporaries.* Minneapolis: University of Minnesota Art Gallery, 1981.

Early Lithography 1800-1840. Providence: Brown University, 1968.

Farwell, Beatrice. *The Cult of Images: Baudelaire and the 19th Century Media Explosion.* Santa Barbara: University of California Art Museum, 1977.

Fryberger, Betsy G. *Gavarni.* Stanford: The Stanford University Museum of Art, 1971.

Getty, Clive F. *Grandville: Dessins originaux.* Nancy: Musée des Beaux Arts, 1986.

Horace Vernet (1789-1863). Académie de France à Rome. Rome: De Luca Editore s.r.l., 1980.

Johnson, W. McAllister. *French Lithography: The Restoration Salons, 1817-1824.* Kingston, Ont.: Agnes Etherington Art Centre, Queen's University, 1977.

Kinsman, Jane. *Two Great French Caricaturists: Daumier and Gavarni.* Canberra: Australian National Gallery, 1985.

Mantz, Paul. *Exposition des peintures, aquarelles, dessins lithographiés des maîtres français de la caricature et de la peinture de moeurs au XIXe siècle.* Paris: Quantin, 1888.

McPherson, Heather. *Les Femmes de Gavarni: Gavarni's Images of Women.* Birmingham: University of Alabama Press, Visual Arts Gallery, 1985.

Mongan, Elizabeth. *Daumier in Retrospect, 1808-1879.* Los Angeles: The Arm and Hammer Foundation, 1979.

Olson, Nancy. *Gavarni: The Carnival Lithographs.* New Haven: Yale University Art Gallery, 1979.

Senefelder à Daumier: Les Débuts de l'art lithographique. Munich: Haus der Bayerischen Geschichte, 1988.

Books and Articles

Adhémar, Jean. *Daumier: Les Gens d'affaires (Robert Macaire).* Paris: Vilo, 1968.

Ariès, Philippe. *Centuries of Childhood.* New York: Knopf, 1962.

Athanassoglou-Kallmyer, Nina. "*Imago belli*: Horace Vernet's *l'Atelier* as an Image of Radical Militarism under the Restoration." *Art Bulletin* 68 (June 1986):268-80.

Baudelaire, Charles. *The Mirror of Art.* Translated by Jonathan Mayne. Garden City, New Jersey: Doubleday, 1956.

_____. *The Painter of Modern Life.* Translated by Jonathan Mayne. London: Phaidon, 1964.

_____. *Baudelaire: Selected Writings on Art and Artists.* Harmondsworth: Penguin, 1972.

_____. *Oeuvres complètes.* 2 vols. Paris: Gallimard, 1975-76.

Bechtel, Edwin de T. *Freedom of the Press and L'Association Mensuelle: Philipon versus Louis-Philippe.* New York: Grolier Club, 1952.

Blanc, Charles. *Une Famille d'artistes: Les Trois Vernet: Joseph – Carle – Horace.* Paris: Librairie Renouard, 1882.

Blanc, Louis. *Histoire de dix ans, 1830-1840.* 5 vols. Paris: Pagnerre, 1846.

Blanquefort, A. de. *Maisons de plaisirs: Distractions parisiennes.* Paris: Librairie artistique et éditions parisiennes réunies, 1926.

Bouchot, Henri. *La Lithographie.* Paris: Ancienne maison Quantin, Librairies – imprimeries reunies, May and Motteroz, 1895.

Bouret, Claude, and Blandine Bouret. *La Lithographie en France des origines à nos jours.* Paris: Fondation nationale des arts graphiques et plastiques, 1982.

Cailler, Pierre. *Daumier raconté par lui-même at par ses amis.* Geneva: Vesenaz, 1945

Champfleury (see Fleury, Jules)

Cuno, James. "Charles Philipon, La Maison Aubert, and the Business of Caricature in Paris, 1829-41." *Art Journal* 43, no. 4 (Winter 1983):347-354.

_____. "Grandville: dessins originaux, by Clive F. Getty" (review). Art Bulletin 70, no. 3 (Sept. 1988):530-34.

d'Alméras, Henri. La Vie parisienne sous la Restauration. Paris: Michel, n.d.

Daumier, intellectuelles (bas bleus) et femmes socialistes. Preface by Françoise Paturier and catalogue and notices by Jacqueline Armingeat. Paris: Vilo, 1974.

Dayot, Armand. Histoire contemporaine par l'image, d'après les documents du temps. Paris: Flammarion, 1905.

_____. Les Maîtres de la caricature française au XIXe siècle. Paris: Quantin, 1888.

_____. Les Peintres militaires: Charlet et Raffet. 2 vols. in 1. Paris: Librairies-imprimeries réunies [1892?].

_____. Les Vernet. Paris: Armand Magnier, 1898.

Delaborde, Henri. Le Département des estampes à la Bibliothèque nationale. Paris: Plon, 1875.

Driskel, M.P. "Singing 'The Marseillaise' in 1840: The Case of Charlet's Censored Prints." Art Bulletin 69, no. 4 (Dec. 1987):604-25.

Duncan, Carol. "Happy Mothers and Other New Ideas in French Art." Art Bulletin 55 (Dec. 1973):570-83.

Durande, Amédée. Joseph, Carle et Horace Vernet, correspondance et biographies. Paris: Hetzel, 1863.

Farwell, Beatrice. French Popular Lithographic Imagery, 1815-1870. 12 vols. Chicago: Chicago University Press, 1981-.

Ferment, Claude. "Le Caricaturiste Traviès: La Vie et l'oeuvre d'un 'Prince de Guignon' (1804-1859)." Gazette des Beaux-Arts, 6th ser., 99 (Feb. 1982):63-77.

Fleury, Jules. Histoire de la caricature moderne. Paris: Dentu, 1871.

_____. Henry Monnier, sa vie, son oeuvre. Paris: Dentu, 1889.

Gallo, Max, and Jacqueline Armingeat. Daumier: Les Transports en commun. Paris: Vilo, 1976.

Garcin, Laure. J.-J. Grandville, revolutionnaire et précurseur de l'art du mouvement. Paris: Eric Losfeld, 1970.

Gauthier, Maximilien. Achille et Eugène Devéria. Paris: Floury, 1925.

Goncourt, Edmond and Jules de Goncourt. Oeuvres complètes, vol. 19, Gavarni, l'homme et l'oeuvre. Geneva: Slatkine Reprints, 1986.

Gore, Catherine Grace Frances. Paris in 1841. London: Longman, Brown, Green & Longmans; Philadelphia: Lea and Blanchard, 1842.

Grand-Carteret, John. Les Moeurs et la caricature en France. Paris: La Librarie illustré, 1888.

Grillet, Claudius. Le Diable dans la littérature au XIXe siècle. Paris: Desclée de Brouwer, 1935.

Haraucourt, Edmond. L'Amour et l'esprit gaulois à travers l'histoire du XVe au XXe siècle. 4 vols. Paris: Martin-Dupuis, 1927.

Hind, Arthur Mayser. A History of Engraving and Etching from the 15th Century to the Year 1914. New York: Dover, 1963.

_____. An Introduction to a History of Woodcut. New York: Dover, 1963.

M.C.H. "Horace Vernet, His Life and Works." Fine Arts Quarterly Review 2 (Jan.-May 1864):126-160.

Kahn, Gustave. Europas Fürsten, im Gittenspiegelder Karikatür. Berlin: H. Schmidt, 1908.

La Bédollière, Emile Gigault de. Les Industriels: Métiers et professions en France. Paris: L. Janet, 1842.

Larkin, Oliver. Daumier, Man of his Time. New York: McGraw-Hill, 1966.

Ledré, Charles. La Presse à l'assaut de la monarchie, 1815-1848. Paris: A. Colin, 1960.

Lemoisne, Paul A. Gavarni peintre et lithographe. 2 vols. Paris: Floury, 1924.

Les Français peints par eux-mêmes. 9 vols. Paris: Curmer, 1840-42.

Mabille de Poncheville, A. Boilly. Paris: Plon, 1931.

Marceau, Félicien. Balzac and His World. Translated by Derek Coltman. New York: Orion Press, 1955.

Man, Felix H. 150 Years of Artists' Lithographs. London: William Heinemann, 1953.

Maurice, Arthur B., and Frederic T. Cooper. The History of the Nineteenth Century in Caricature. New York: Dodd, Mead & Co., 1904.

Melcher, Edith. The Life and Times of Henry Monnier, 1799-1877. Cambridge, Mass.: Harvard University Press, 1950.

Melot, Michel. "La Mauvaise mère: Etude d'un thème romantique dans l'estampe et la littérature." Gazette des Beaux-Arts. 6th ser., 79 (March 1972):167-76.

Mespoulet, Marguerite. Images et romans: Parenté des estampes et du roman réaliste de 1815 à 1865. Paris: Société d'edition "Les Belles Lettres," 1939.

Nollet (Fabert), Jules. Eloge historique de J.-J. Grandville. Antwerp: Max Kornicker, 1853.

Passeron, Roger. Daumier. New York: Rizzoli, 1981.

Pinkney, David H. The French Revolution of 1830. Princeton: Princeton University Press, 1972.

Ramus, Charles D., ed. Daumier, 120 Great Lithographs. New York: Dover, 1978.

Renonciat, Annie. La Vie et l'oeuvre de J.-J. Grandville. Paris: Vilo, 1985.

Richardson, Joanna. The Bohemians: La Vie de Bohème in Paris 1830-1914. London: Macmillan, 1969.

Roberts-Jones, Philippe. Daumier: Moeurs conjugales. Paris: Vilo, 1967.

Ruutz-Rees, Janet. Horace Vernet. London: Sampson, Low, Marston, 1880.

Stamm, Therese D. Gavarni and the Critics. Ann Arbor: UMI Research Press, 1981.

Terdiman, Richard. Discourse/Counter-Discourse. Ithaca: Cornell University Press, 1985.

Trollope, Frances. Paris and the Parisians in 1835. 3 vols. Paris: Baudry's European Library, 1836.

Twyman, Michael. Lithography 1800-1850. London: Oxford University Press, 1970.

Vincent, Howard P. Daumier and His World. Evanston: Northwestern University Press, 1968.

War and Peace in an Age of Upheaval, 1793-1830. C. W. Crawley, ed. New Cambridge Modern History, vol. 9. Cambridge: Cambridge University Press, 1965.

Weber, Wilhelm. A History of Lithography. New York: McGraw-Hill, 1966.

Wechsler, Judith. A Human Comedy: Physiognomy and Caricature in 19th-Century Paris. London and New York: Thames and Hudson, 1982.

Woman as Sex Object. Edited by Thomas B. Hess and Linda Nochlin. Art News Annual 38, New York: Newsweek, 1972.

Yriarte, Charles. Les Célébrités de la rue. Paris: Dupray de la Mahérie, 1864.

The Zenith of European Power, 1830-70. J.P.T. Bury, ed. New Cambridge Modern History, vol. 10. Cambridge: Cambridge University Press, 1971.